Night on Earth

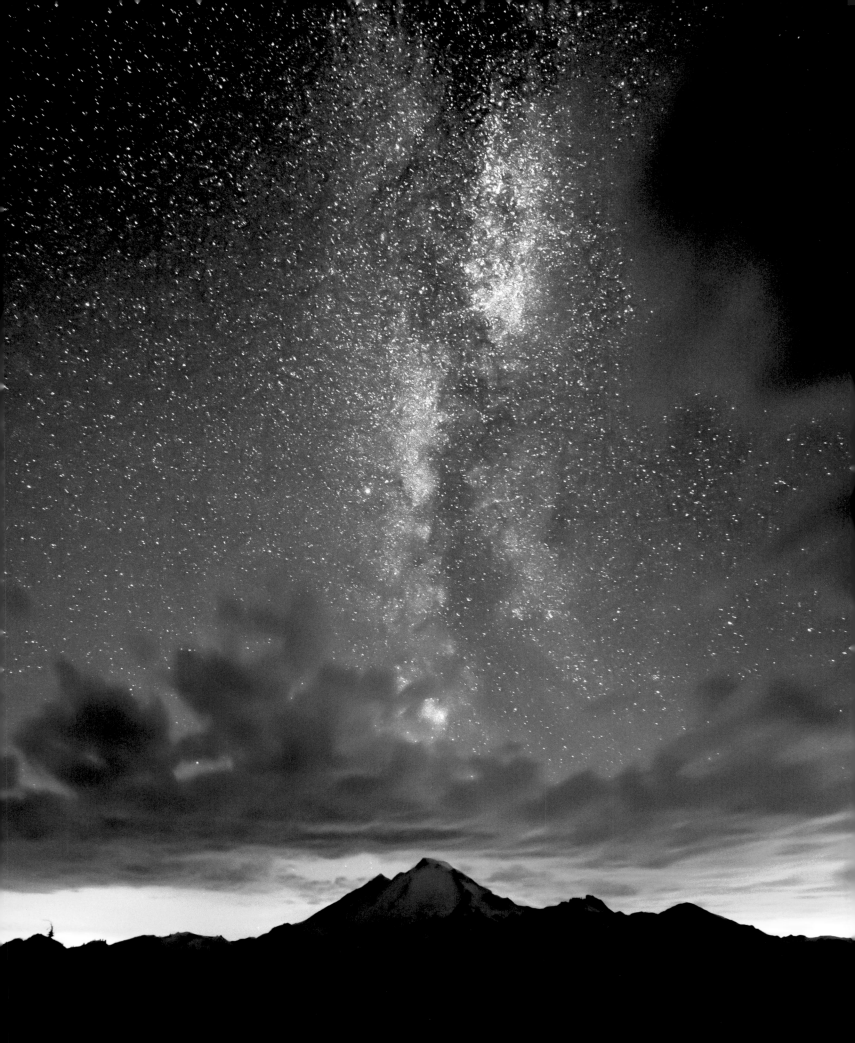

Night
on Earth

Photography by
ART WOLFE

INTRODUCTION BY DAVID OWEN

EARTH AWARE

SAN RAFAEL • LOS ANGELES • LONDON

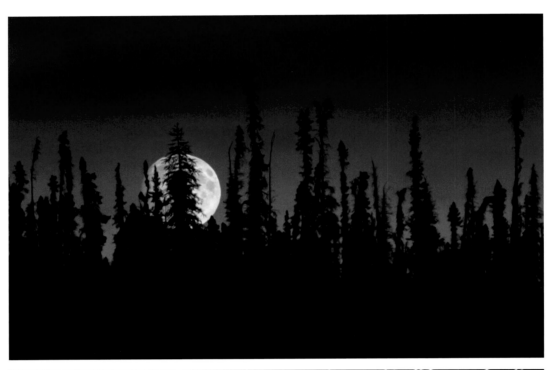

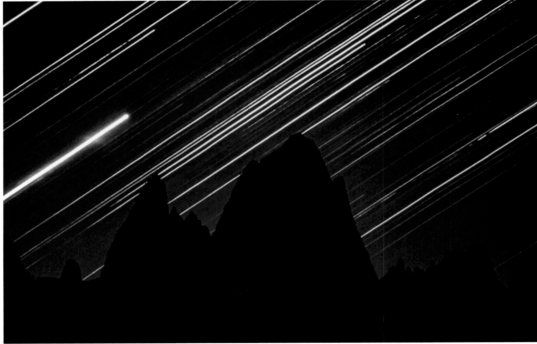

CONTENTS

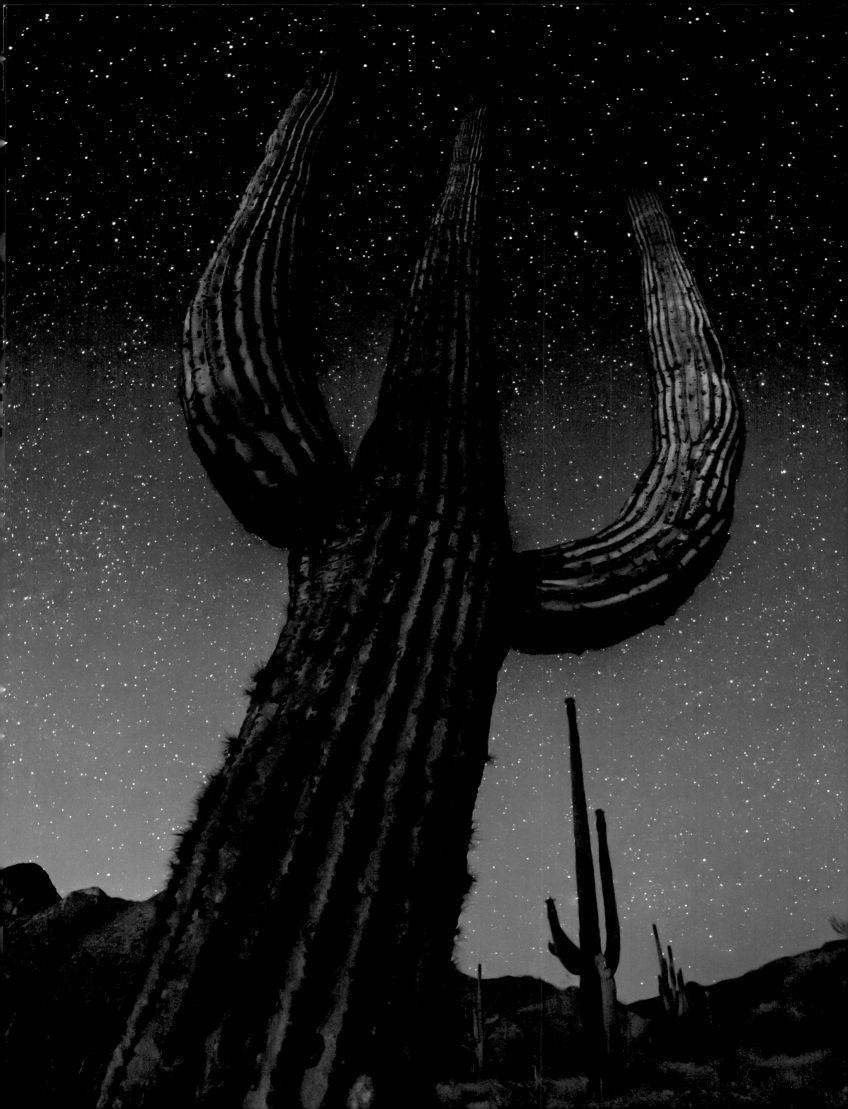

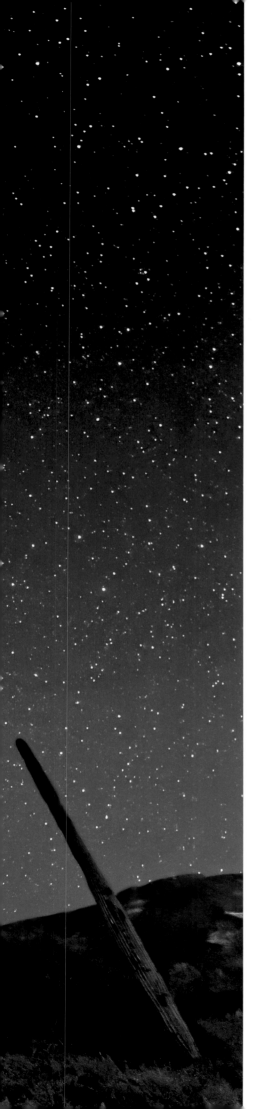

FOREWORD

Ruskin Hartley

INTERNATIONAL DARK-SKY ASSOCIATION

IN 2019, MY FAMILY RELOCATED TO TUCSON, ARIZONA, from the San Francisco Bay Area. On one of our first evenings in our new home, we headed out for a night walk. Out of habit, we grabbed a flashlight, but it quickly became apparent that it was not needed. Far from lighting our way, the flashlight created shadows and enhanced the sense of darkness. Without the added light, our eyes quickly adapted, and the night started to come to life. Bats darted overhead. A great horned owl hooted from a telephone pole. A slender moon lit our way, and overhead, the stars shone brilliantly.

We learned a powerful lesson that night. Contrary to common belief, more light does not necessarily enhance visibility or the sense of safety. My family is now fortunate to live in a place where we can experience the beauty of the night right outside our front door. For our ancestors, this was the norm, but today, the majority of people worldwide are robbed of this connection by light pollution.

Light pollution is destroying natural darkness with severe consequences: It is linked to a global insect decline, the death of millions of migrating birds, increased carbon emissions, and increased disease in humans. Scientists estimate that 83 percent of people worldwide, including 99 percent in Europe and North America, live under a light-polluted sky. And a 2020 study from the University of Utah found that populations of color in the United States are exposed to double the amount of light pollution.

Unlike other types of pollution, such as water or air, light pollution is readily solvable. By turning off unneeded lights, choosing warmer colors, not overlighting, and pointing lights down toward the ground rather than up at the sky, we see immediate results. The City of Tucson, population five hundred thousand, upgraded its streetlights in 2018. By introducing some simple measures, it reduced light pollution by 7 percent and realized $2.3 million in annual energy savings. That also meant that on the edge of town where I live, I could look up and see the Milky Way.

From small beginnings in Tucson, the International Dark-Sky Association has galvanized a global movement to protect and restore dark skies. As of 2021, there are more than 170 protected International Dark Sky Places in the world. From the first International Dark Sky Park at Natural Bridges National Monument in remote southeastern Utah, there are now protected places in twenty-three countries on six continents where people can experience the beauty of the night and enjoy the benefits of responsible outdoor lighting.

While "dark sky" is in our name, anyone who has experienced a truly dark sky knows that it is, in fact, alive with light. As you will see in the pages of this book, the natural light of the night, from the moon, stars, aurora, and airglow, is exquisitely beautiful. For millennia, people have gathered under the stars to share stories and explore what it means to be human and to understand their place in the universe. And for most wildlife, darkness is as essential as air or water. Light pollution robs us of these connections and diminishes us all.

We hope the work of Art Wolfe will encourage you to rethink your relationship to the night and natural darkness. Reclaiming our connection to the night is an essential first step in tackling light pollution and fostering a more just, sustainable, and beautiful planet for all.

Saguaro National Park, Arizona, USA

LET THERE BE DARK

David Owen

IN 2007, THE INTERNATIONAL DARK-SKY ASSOCIATION (IDA)—an organization dedicated to treating the nighttime sky as a precious but threatened natural resource—chose Natural Bridges National Monument as the world's first International Dark Sky Park. Natural Bridges is named for its most conspicuous features: three huge sandstone arches that were carved thousands of years ago by rushing water. The IDA made its designation after determining that at night the stars above Natural Bridges are less obscured by urban sky glow than they are at any other spot in the continental United States, and that the park is "notable for its almost perfect lack of light pollution." It is situated in a virtually uninhabited part of southeastern Utah, near Four Corners, the point where the borders of Utah, Colorado, New Mexico, and Arizona all meet. The nearest town, Blanding, Utah, is forty miles away, and it's tiny.

Not long after the IDA made its announcement, Chad Moore, the program director of the National Park Service's Night Sky Team—which Moore himself created in 1999—made an inspection trip to the park. (Since then, he has taken a different conservation-related job at the US Bureau of Reclamation.) Corky Hays, who at the time was Natural Bridges' superintendent, said, "Our buildings were pretty dark already, but Chad and his team have helped us make [them] even darker, by upgrading a lot of our outdoor lighting. That's let us cut our energy use and operational costs, too, which is important, because the entire park is solar powered." Moore showed Hays how to further shrink the park's already modest light footprint. He pointed out several outdoor fixtures that could be replaced with fully shielded versions, and he suggested removing some of the tubes in the fluorescent fixtures mounted on a ceiling near the park's public restrooms, which are kept open all night for people who visit the park when the other buildings are closed. "The darker the area, the less light you need," he said. "People coming here at night will be dark-adapted, so having more light would actually make it harder for them to see when they leave."

The night before his visit, Moore had made the same point, repeatedly, at an astronomy demonstration near the visitors' center of Bryce Canyon National Park, 275 miles to the west. Bryce isn't as dark as Natural Bridges, but it's plenty dark. Volunteers had set up several high-powered telescopes in a parking lot, and two hundred visitors had come to look at the sky. Moore had to ask quite a few of the visitors to turn off their flashlights and explained that they would actually see better without them. Our eyes adapt to the brightest object they can see, and when we move from full illumination into darkness, they can take as long as an hour to fully adjust. "When the moon is low in the sky like this, there's about two-thousandths of a foot-candle of light on the ground," he said. That's only about one five-millionth as bright as full sunlight on a clear day, but our eyes evolved to see in such conditions. "I can see individual pebbles on the ground, and if I dropped a quarter I could find it," he said.

Through one or another of the telescopes at Bryce that night, people saw the rings of Saturn, the moons of Jupiter, and a star formation called a globular cluster. Most were amazed that such things were visible, telescope or not. "Many people who come to our programs have never really looked at the night sky," Moore said. "A woman once came up to me and said, 'The moon was out during the day this morning—is that OK?'" No one in the parking lot needed a telescope to see something that children nowadays often know only as the name of a candy bar: the Milky Way, the lateral edge of our own galaxy, a broad celestial spiral, the visible parts of which contain at least a hundred billion stars. Even people who don't live in brightly lit cities sometimes have trouble seeing it. The main reason is that we've become extraordinarily careless with darkness: By over-illuminating the world at night, we have washed out the sky above.

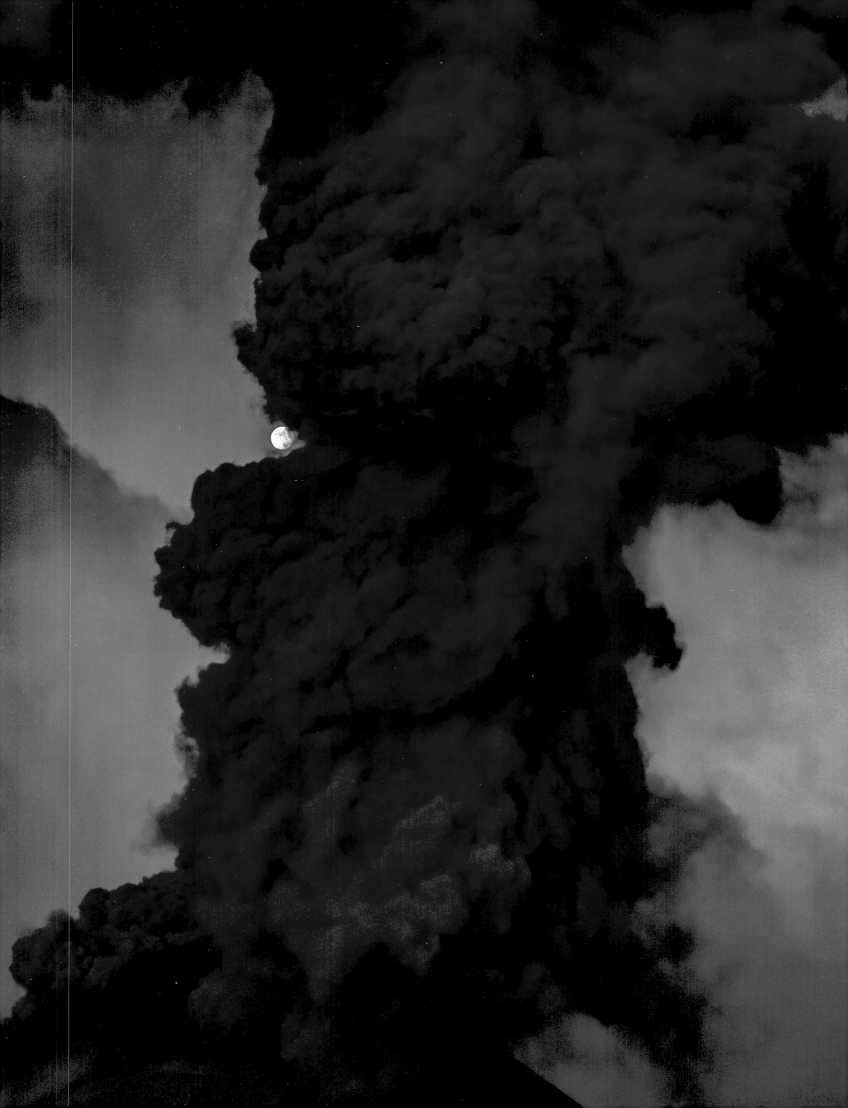

"I think that one of the reasons this issue is important to me is that I lived in Hawaii when I was in high school," Moore said. "I got into astronomy in tenth grade, and in just the three years before I went off to college, I noticed a change in the sky above Oahu. We used to go out to what was basically the corner of the island to look at the stars. But then the sky started getting brighter, and after a while, there were no more places to go."

"Our brains were sculpted as much by darkness as by light," the naturalist Chet Raymo has written. For most of human history, night was a palpable, inescapable presence. Darkness and the sweeping star field overhead inspired awe, terror, reflection, discovery, and dread: The nighttime sky was mankind's first window on the infinite. Darkness had its own deities and demons. For the ancient Mayans, the archaeologists Nancy Gonlin and April Nowell wrote in *Archaeology of the Night* in 2018, "Night was both an ominous and sacred time. People made offerings to appease the gods who ruled the underworld, thereby ensuring the rising of the sun. The Moon Goddess rode her deer across the night sky, keeping watch over those who dared to venture into darkness. Sacred ceremonies took place in which royal persons imbibed hot, inebriating cacao drinks and danced at midnight." Night has always been a thought-provoking mystery as well as an unavoidable reminder of human vulnerability.

Every culture has had to account for the starkest division in the passage of time: "Let there be light." Consider how different mythology, astrology, theology, philosophy, literature, science, and our conception of both the universe and our place in it—all of human thought, really—would be if the sky were always the low-lying and uniformly featureless ceiling it appears to be on an overcast day. In the ancient world, the nighttime sky was a scrim onto which the human imagination could project itself. Until the beginning of the spread of electric-powered illumination, just a century ago, the Milky Way on a clear night anywhere in the world would have looked almost three-dimensional. People through most of human history have gazed at it and the rest of the celestial dome and resolved the pinpoints into narratives.

There is a tight cluster of seven bright stars that the ancient Greeks called the Pleiades; for them, the cluster's annual appearance above the horizon marked the beginning of the season when it was safe to sail far from shore. A seventeen-thousand-year-old cave painting in Lascaux, France, is believed to depict the same seven stars. In Hindu mythology, they were the seven daughters of Brahma. In ancient Egypt, they were associated with the goddess Hathor, "the mistress of the sky," and were invoked in burial rites. For the Maori, they were

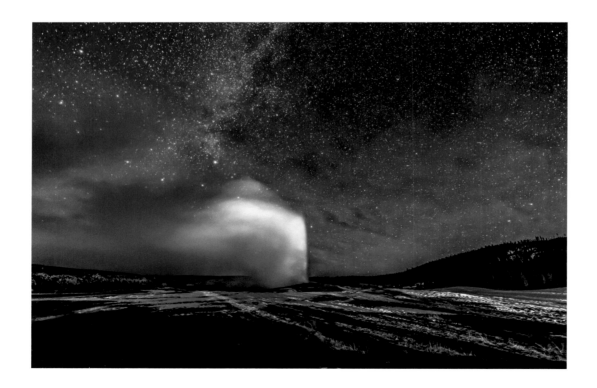

Matariki, the "eyes of god." For ancient Polynesians, they were a navigational aid. In the Hebrew Bible, God asks Job if he can "bind the chains of the Pleaides"—and Job acknowledges that he cannot. In eighth-century Japan, the Pleaides were called *Mutsuraboshi*. The Ainu called them *Subaru*, and if you drive a Subaru, you carry their idealized image on the nameplate of your car (though just six stars, rather than seven). English farmers centuries ago called them "the hen and her chicks"; they told time at night based on the position of the stars in the sky. Galileo studied them through his telescope in 1610 and discovered that the cluster contains more than seven stars. He also saw that there are mountains on the moon, that Jupiter has moons of its own, and that even the milkiest parts of the Milky Way are made up mainly of individual stars.

In many parts of the world today, even the brightest of the Pleaides are impossible to see. On a cloudless night, a resident of a big city will usually have trouble picking out more than the moon, a few planets, and a few stars. If you look down from an airplane flying at night over New York, Paris, Tokyo, or almost any other inhabited part of the world, you can easily see why: We light up the earth so extravagantly that the sky can no longer compete. Our terrestrial light show is often breathtaking—from the air, London on a clear night is almost hallucinogenically beautiful—but our profligacy with illumination carries a heavy cost. Even in places where the Pleaides are still visible, at least one or two of the principal stars are often impossible to see with the naked eye. You can locate the cluster with the help of a star-identification app on your smartphone or your tablet—but the app will have the perverse effect of making the stars themselves invisible by dazzling your eyes with its own bright screen.

For almost a hundred years, both the Canadian and the American sides of Niagara Falls have been brightly illuminated at night in lollipop colors. Since 2016, the colors have been produced by fourteen hundred programmable LED luminaires, which are switched on as soon as the sun goes down, every day of the year. Several times each night, the standard light show is replaced by "Inspired by Nature," a five-minute presentation that "features colour palettes and movements inspired by nature, including the sunrise, aurora borealis, rainbow and sunset," according to the Canadian commission that operates the lights. Even—or maybe especially—when the supposedly "natural" palette is in use, the water looks less like water than like the frosting on a child's birthday cake. The commission describes the show as a "tribute to the natural beauty all around us." But, of course, natural beauty is exactly what you cannot see at Niagara Falls after the sun has gone down—unless you're willing to stay up past 2 a.m., when the people who run the lights at last turn the job back over to the sky.

The contrast between "Inspired by Nature" and actual nature couldn't be starker. On a clear night at Natural Bridges, you can hike to the base of Owachomo, the smallest of the park's three arches, and watch a light show that's both more subtle and more powerful than the phony lollipop colors of Niagara Falls. Against the backdrop of a star-filled sky, the sandstone arch is a perfect void, a ragged strip of blackness torn from the star-spattered fabric of the night. If you stand very still, you can watch stars seeming to blink off on one side of the arch, and blink on on the other. What you are actually seeing is not the movement of the stars but the rotation of the Earth—something we can experience directly only by looking upward, and only if we know where and how to do it.

Our profligacy with nighttime lighting is more than an aesthetic issue. Virtually all living things are affected, both directly and indirectly, by the intensity, composition, and timing of artificial illumination. Life evolved against a predictable background of alternating periods of natural light and dark, and species of all kinds, ours among them, adapted to the regularity of that cycle. "A circadian clock binds the rhythms and habits of each plant and animal to the amount of light in the sky," Christina Robertson wrote in her essay "Circadian Heart" in 2008. "Butterflies and bees pollinate morning glories. Moths pollinate moonflowers." This is not a recent discovery. Twenty-three centuries ago, in his *History of Animals*, Aristotle wrote, "The crow at midday preys upon the owl's eggs, and the owl at night upon the crow's, each having the whip-hand of the other, turn and turn about, night and day." Aristotle knew that even candlelight could alter the behavior of living things, and since his time, our ability to disturb the natural succession of sun and stars has increased by orders of magnitude—as has our ability to inflict harm, including on ourselves.

Six of the world's seven species of sea turtles are now classified as threatened or endangered. There are many reasons, all of which have to do with us. One of the reasons is the profusion of artificial light in places where sea turtles breed. When hatchlings emerge from their eggs, which their mothers buried in sand along the shore, they instinctively move toward the brightest thing they can see. For millions of years, that brightest thing was the starlit sky above the ocean; today, it's often the lights in a shopping-mall parking lot or the windows of a condominium. Volunteers assemble at hatching time to turn the babies in the right direction, but it's a losing battle in an ongoing war that the turtles have been losing, on many fronts, for decades.

Air traffic controllers, meteorologists, vulcanologists, and others use a device called a ceilometer to measure the altitude of clouds. The first versions were powerful searchlights; they were aimed at the sky, and the distance of the covering clouds could be calculated, by triangulation, based on the angle of the returning light beam. On a single night in 1954, at Robins Air Force Base in Georgia, the beam from a ceilometer killed fifty thousand birds, representing more than fifty species, by disorienting them in flight and causing them either to fall to the ground exhausted or to collide with other birds. Modern ceilometers, which use brief pulses of invisible laser light to measure the same thing, are far less likely to harm living things of any kind, but since the 1950s we have devised many other methods of using light to wreak havoc on the natural world. Many migrating birds use constellations as navigational aids, just as human sailors always have; brightly illuminated office buildings can draw them to their deaths, an occurrence so common that ornithologists often gather specimens at the buildings' bases.

Gas stations are among the world's most brightly lit commercial establishments. A German study showed that the lights above the pumps at a newly opened station attracted huge swarms of insects during its first year of operation, but that the swarms shrank dramatically thereafter. The inescapable conclusion was not that insects learn to avoid artificial light, but that artificial light irresistibly draws them to their annihilation. Insects are especially vulnerable, because many species have evolved to feed, breed, and rest in response to the daily cycle of the sun; artificial sources throw their biological clocks into confusion. Recent scientific studies in several parts of the world have documented huge declines in insect populations. There are a number of plausible explanations, including habitat destruction and pesticide use, but the proliferation of nighttime lighting surely contributes. And losses of insects affect every other species in the food chain. They also affect plants, many of which depend on insects for pollination.

A paradox of the environmental movement is that successful efforts to increase energy efficiency have in many ways made nighttime light pollution worse: As lighting has become more efficient, it has also become less costly, and we have responded by lighting up more and more of our world. The fourteen hundred LED luminaires at Niagara Falls consume much less electricity than the twenty-one xenon spotlights they replaced, but they produce twice as much light. Lighting a building, a parking lot, or an intersection with super-efficient LEDs costs so little today that there's less incentive than ever to turn them off. Even worse, LEDs produce light at wavelengths that have been shown to be unusually harmful to living things—including ourselves, in part by potentially damaging our retinas. Similarly perverse unintended consequences can be observed in connection with efficiency improvements of all kinds. When we make energy cheaper by extracting more value from every watt, we make it more useful to ourselves, and as we do, we find more uses for it. People today are generally more cognizant than they used to be of the ecological significance of outdoor lighting, but even environmentalists still often treat it as a minor concern or as no concern at all.

Light is easy. Dark requires patience and imagination. But dark is worth the effort. The natural light show overhead is in many ways less spectacular than the artificial light show we've created down below, but in every way, it is more profound.

You don't have to believe that the stars and planets are gods or demons in order to be awed by the nighttime sky. But in order to be awed by it, you have to be able to see it. "Many men walk by day; few walk by night," Thoreau wrote in his journal in 1850. "It is a very

different season." Even fewer walk by night today—by real night, lit only by stars and planets and the moon. We will never fully recreate the skyscape that Thoreau knew or the one that our parents knew or even the one that we remember from our own childhoods—but we can resist further losses. There are now nearly a hundred certified International Dark Sky Parks, in more than a dozen countries. All of them are worth preserving. Their very existence is an important reminder that darkness has meaning, or should have meaning, in our lives.

At our own homes, we can stop lighting the trees in our yards, and we can leave our phones indoors when we walk our dogs at night, and when the sun begins to set, we can make a conscious effort not to reach immediately for the nearest lamp. Some of our other options, unfortunately, are limited. Most residential outdoor lighting fixtures, even expensive ones, are disasters. They're insufficiently shielded, they're hard to aim properly, and they're usually much brighter than they need to be to do the job they're supposed to do. Many are impossible to install except in ways that turn them into what David Crawford, the cofounder of the IDA, used to call "glare bombs." The cluster of mailboxes in Crawford's own apartment complex in Tucson was a good example. A powerful unshielded fixture, mounted on top of the cluster, was intended to make it both easier and safer for residents to pick up their mail in the evenings, but actually it had the opposite effect. "When you have glare, the eye adapts to the glare, but then you can't see anything darker," Crawford explained. The fixture was positioned so that it shone directly into the eyes of anyone approaching the mailboxes, forcing them to look away. It also created a large visually impenetrable area directly behind the boxes, where an attacker could stand without being noticed—a configuration that Crawford called "criminal-friendly."

But Crawford, of all people, had been unable to persuade even his own neighbors that lighting less would enable them to see more. Conventional wisdom holds that light equals safety and that if a little light is good, then a lot must be better. And of course, as folks contend, whether individuals or businesses choose to turn on the night-light, it's nobody's business but their own. But light beams don't stop at lot lines. If you mount a halogen wall pack on the side of your house, you will light your neighbor's yard as well as your own. "Light trespass" from your property directly affects your neighbor's ability to enjoy their own property, just as "sound trespass" would if you installed loudspeakers in your trees and played Sousa marches all night.

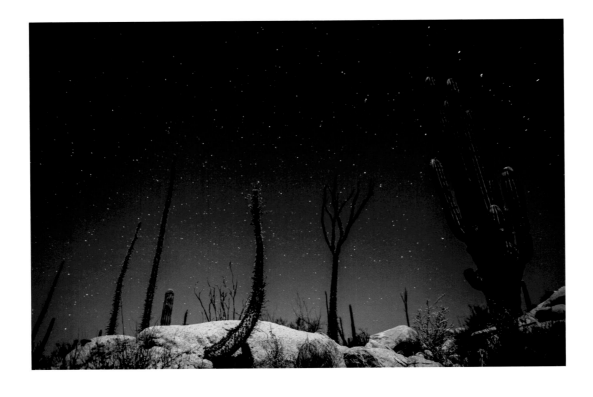

Cataviña Desert, Baja California, Mexico

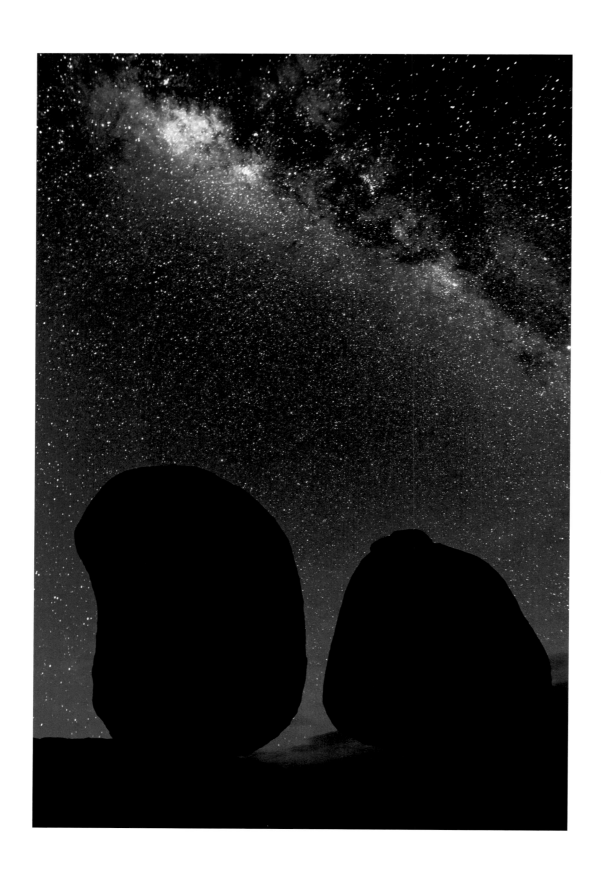

Karlu Karlu/Devils Marbles Conservation Reserve, Northern Territory, Australia

"Amid the gathering darkness and cold, our prehistoric for[e]bears must have felt profound fear, not least over the prospect that one morning the sun might fail to return," the historian A. Roger Ekirch, a professor at Virginia Tech, writes in *At Day's Close*, published in 2005. At the same time, though, he writes, "Darkness, for the greater part of humankind, afforded a sanctuary from ordinary existence, the chance, as shadows lengthened, for men and women to express inner impulses and realize repressed desires both in their waking hours and in their dreams, however innocent or sinister in nature." In the same book, Ekirch explores a tantalizing conclusion, which he had first proposed in an essay published a few years earlier, that the way people in modern societies usually sleep or try to sleep—in one solid block, between late-night exhaustion and the alarm clock—is not the way all humans have always slept. "Until the close of the early modern era," he writes, "Western Europeans on most evenings experienced two major intervals of sleep bridged by up to an hour or more of quiet wakefulness." He has found evidence of this distinction between "first sleep" and "second sleep" all over the historical and literary records—hiding in plain sight, as it were, and not just in western Europe.

Twenty-five years ago, I sat with a small group of friends in an unelectrified barn on Martha's Vineyard, looking out on the evening through the barn's big sliding doors. One of those friends pointed out that we were doing something that people hardly ever do anymore: watching it get dark. Indeed, we were experiencing night as Ekirch describes it, as "a sanctuary from ordinary existence." And we had the immense pleasure of contemplating the darkening ocean, a quarter mile to the south, as the moon turned the water an eerily luminous silver-gray, as though it were a sea of mercury, an ocean on some world other than ours.

Most of us spend most of our waking hours "in a box, looking at a box"—as David Crawford once described it. When the sun begins to set, we treat the gathering shadows as a problem, which we solve by throwing switches—so many switches that we effectively turn the windows of our houses into mirrors, blinding ourselves to the extraordinary world beyond those windows. You can't see starlight from a room in which you're watching TV. When the Northridge earthquake knocked out the power in almost all of metropolitan Los Angeles early in the morning on January 17, 1994, people all over the city were awakened by the shaking. Many of them rushed outdoors, worried that their houses were about to fall in on them. Once they were in the street, many of them saw something they hadn't seen since the last time the power went out: a sky full of stars. That night, more than a few of their children saw the Milky Way for the first time. It just took an earthquake to do it.

Once or twice a year, the power goes out in the small Connecticut town where my wife and I live—never because of an earthquake; almost always because of wind or snow. Typically, the lights come back on in an hour or two, but occasionally they stay out for several days. That happened recently when a big storm left us without electricity for most of a week. Each night during the outage, I was amazed by how much brighter the stars appeared than they usually do, even though I think of our town as so sparsely populated and so far from big cities as to be almost free of light pollution even when the power is on.

I was also amazed by how different nighttime seemed when candles and flashlights were my wife's and my only means of lighting it up. Daytime was different, too, of course—no computers, no TV, no household appliances—but nighttime was transformed. The difference between inside and outside shrank. We sat in darkness on our screened porch and talked. We heard a barred owl, as we often do, but with no lights burning to divert our senses, the owl seemed both louder and closer. We read by candlelight. We talked some more. Then, hours earlier than usual, we went to bed.

A power outage is a useful reminder that, in the absence of widespread artificial illumination, night and day are truly separate worlds. When the power goes out at my house, my wife and I sleep more or less in the manner that Ekirch describes: early to bed, up for a while, back to bed, early to rise—a glimpse of what life was like for many before we learned to erase the difference between day and night.

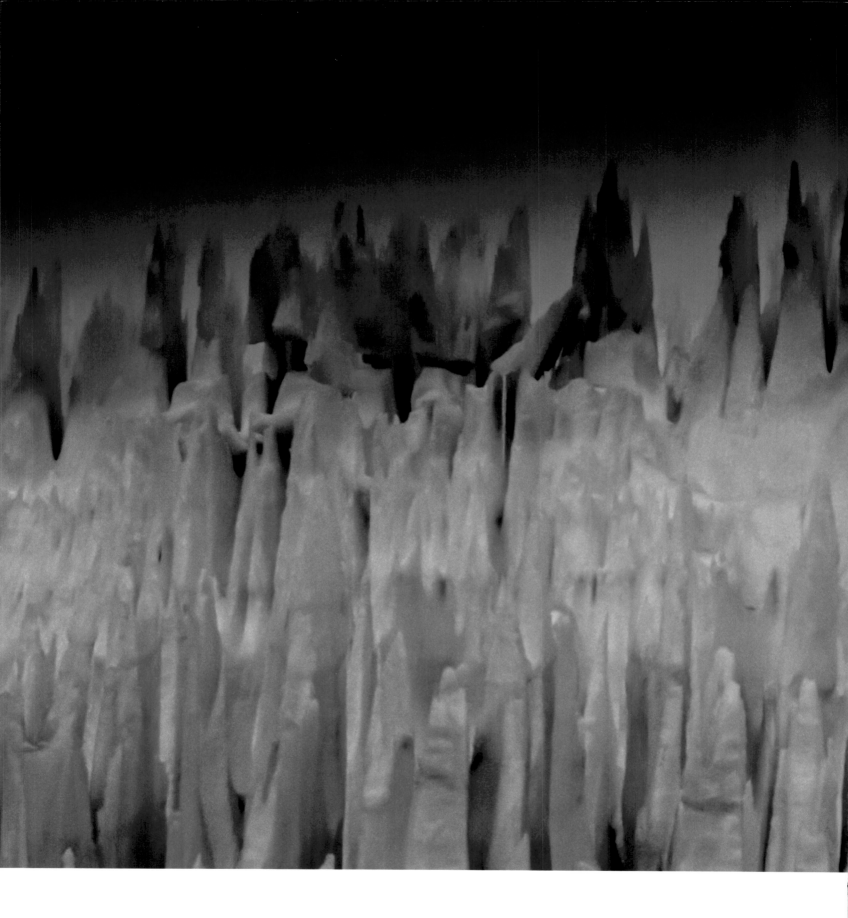

STARS AND SHADOWS

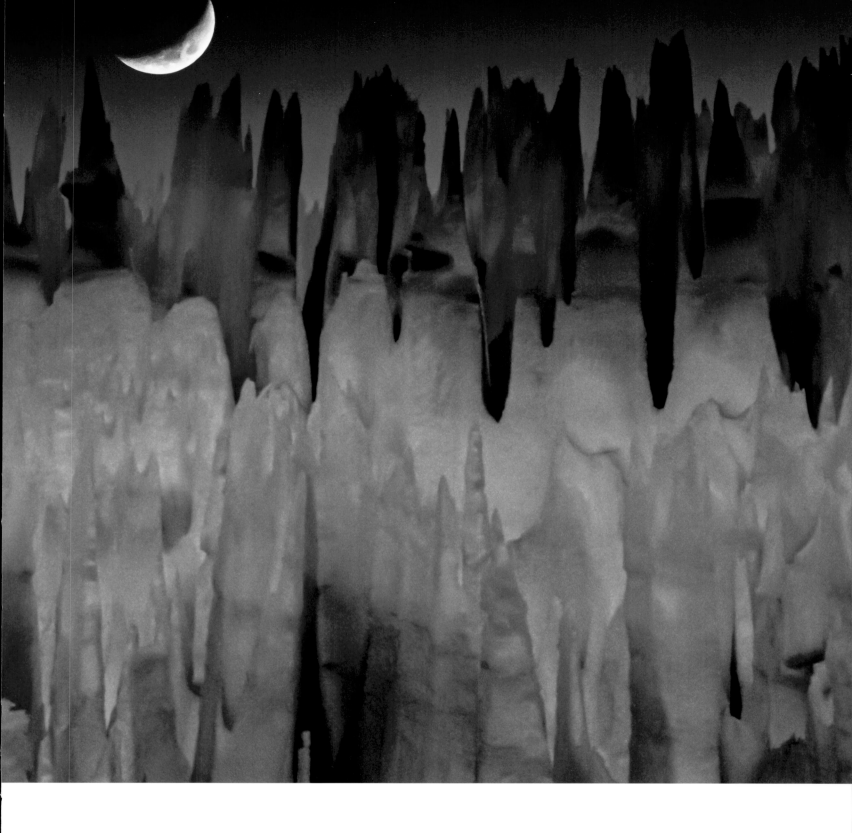

Constellations dance, twinkling in the black night, and we're inspired to think about the mystical beyond: a place in the sky where our planet is only a distant speck in an ever-expanding galaxy. The stars tell of times past when other humans looked toward the heavens with only their imaginations to define what hung so well in the sky and what might live beyond. Across the globe, the sky continues to mesmerize, holding stargazers in rapt attention in search of something greater than themselves.

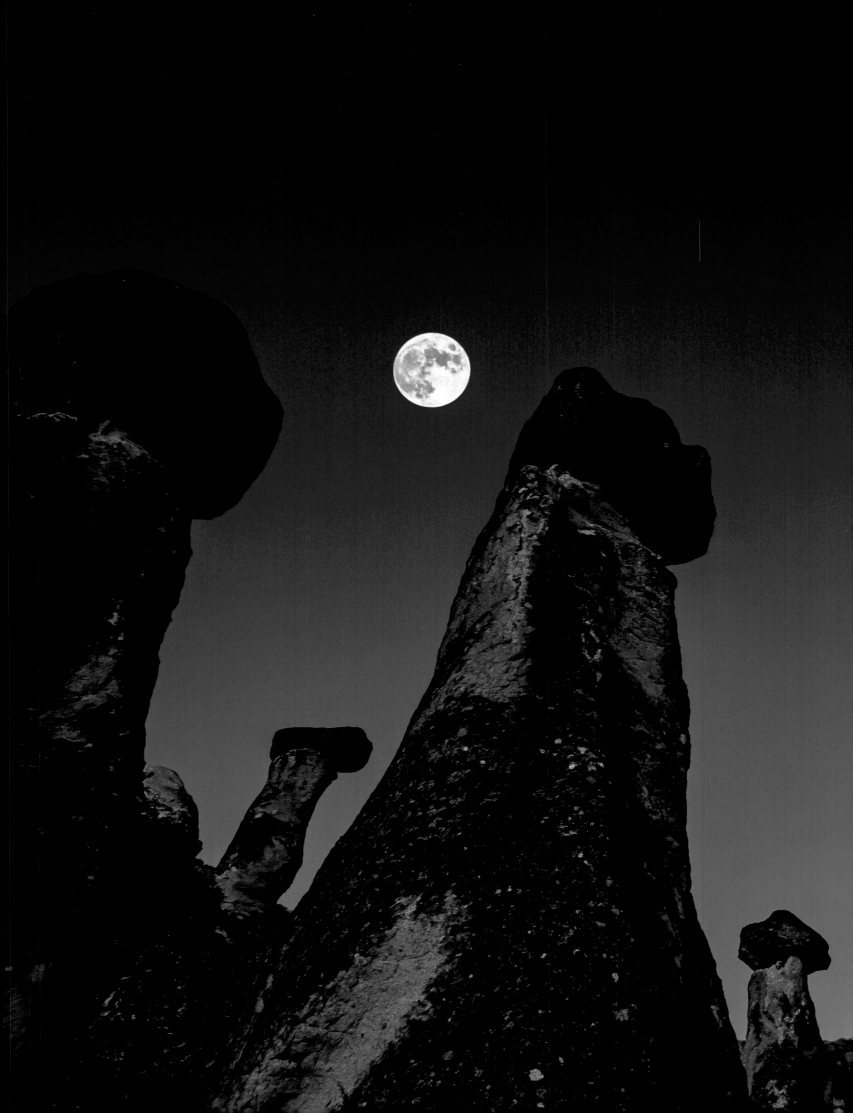

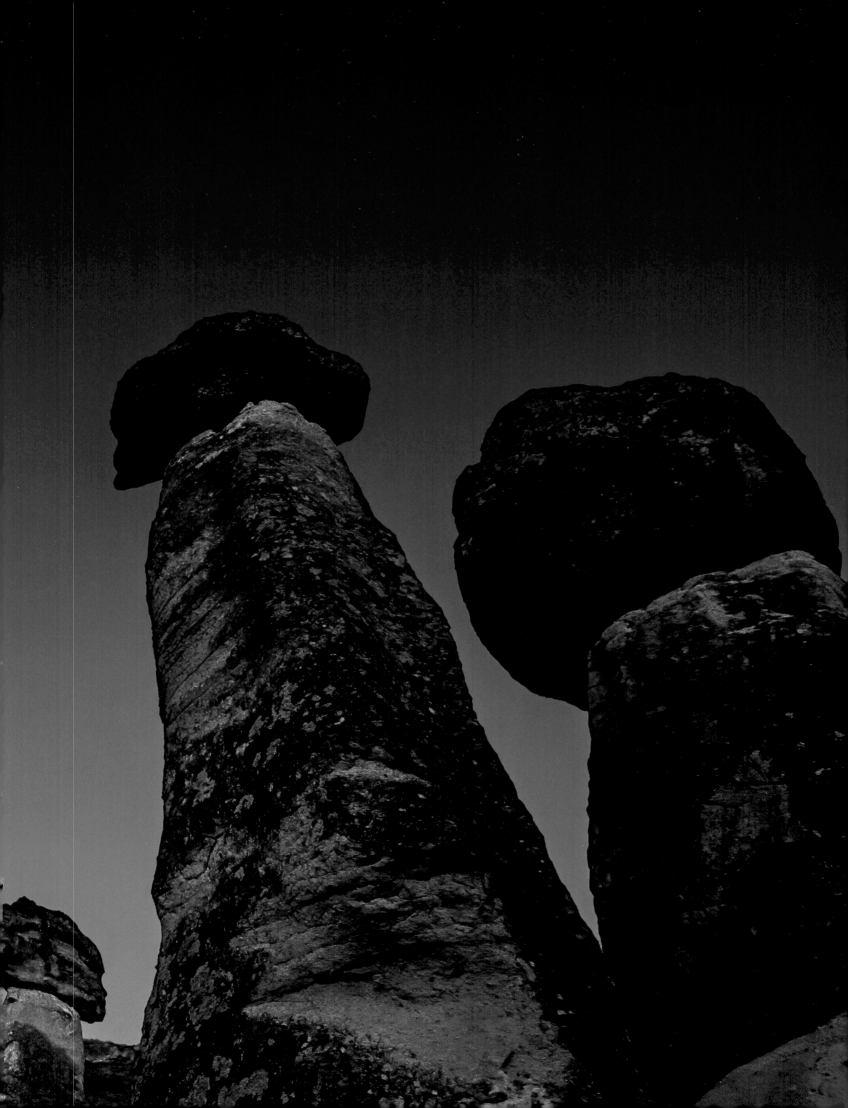

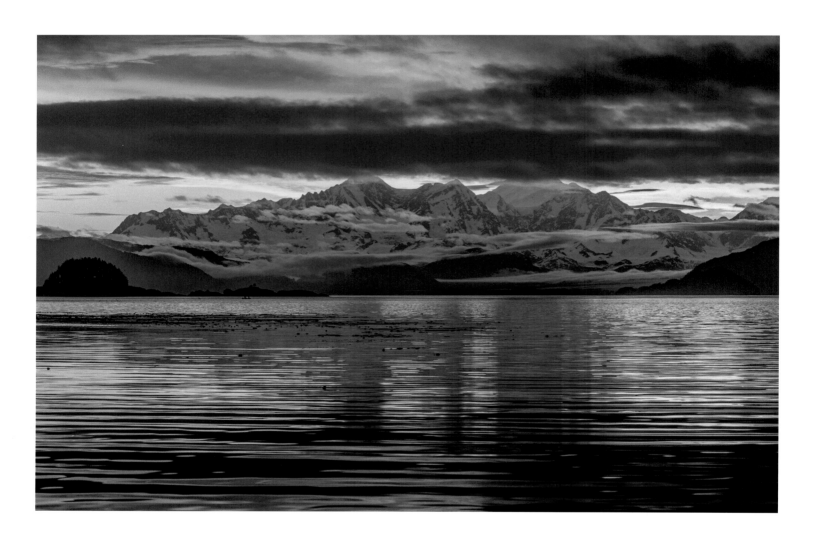

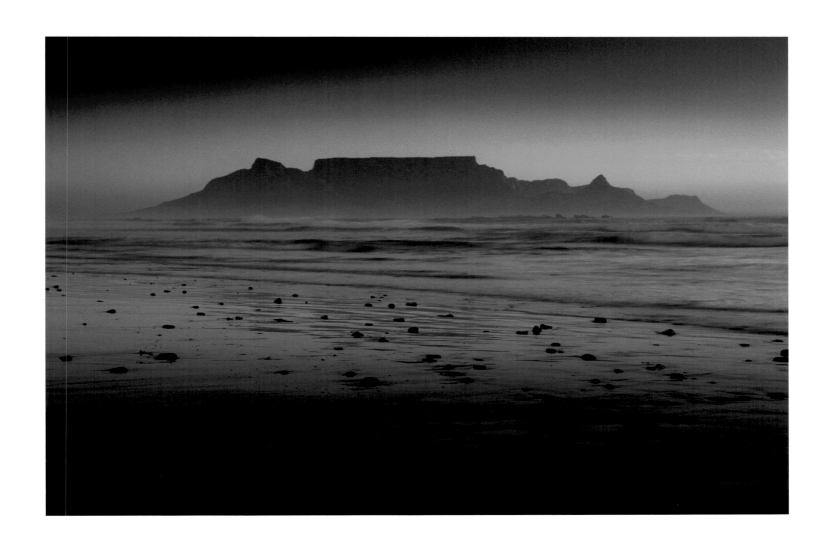

CHAPTER OPENER: Nieves penitentes, Paso de Agua Negra, Andes, Chile
PREVIOUS PAGES: Full moon at dawn over tufa fairy chimneys, Cappadocia, Turkey
OPPOSITE: Glacier Bay National Park and Preserve, Alaska, USA
ABOVE: Table Mountain as seen from Table Bay, Western Cape, South Africa

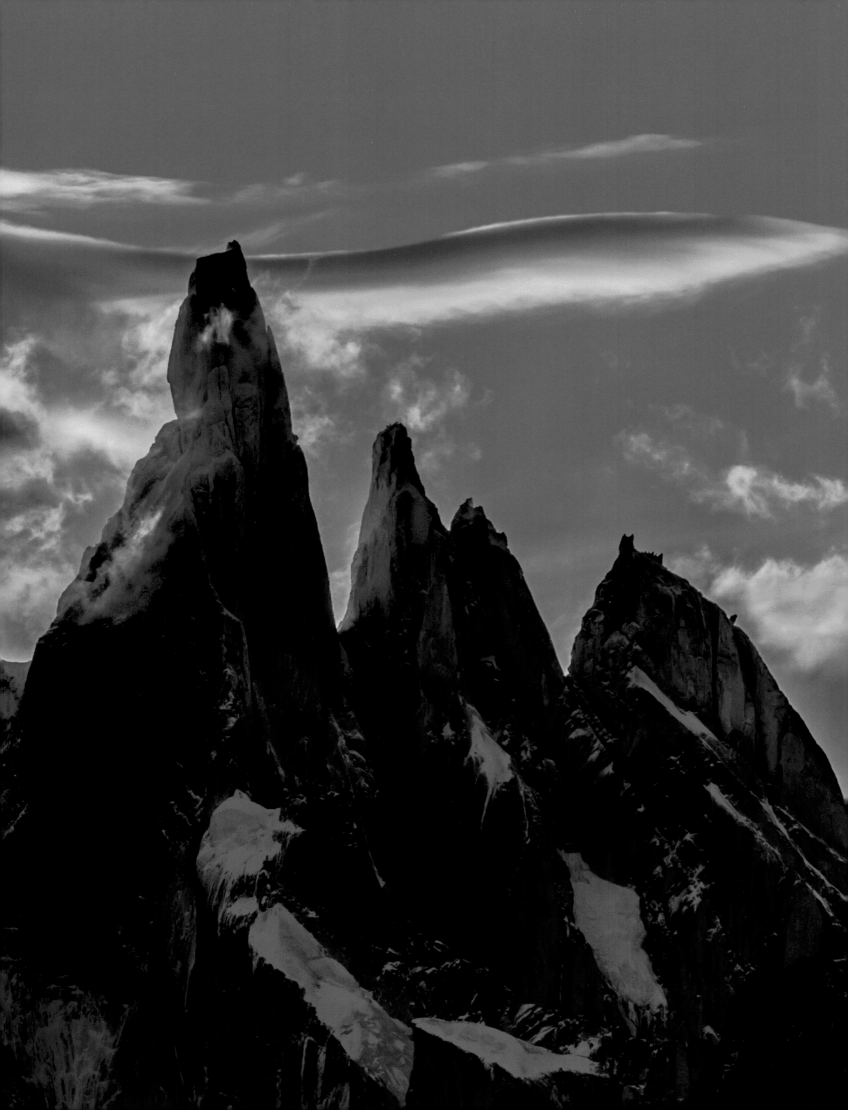

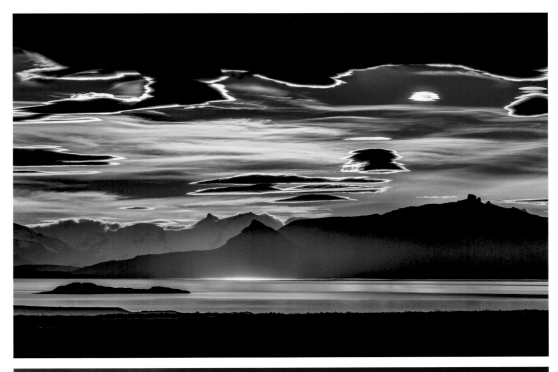

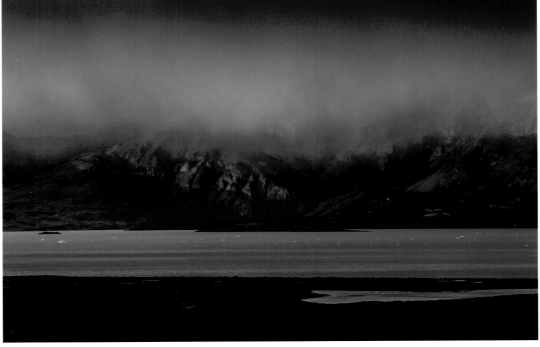

OPPOSITE: Cerro Torre, Los Glaciares National Park, Santa Cruz, Argentina
ABOVE TOP: Golden light over Los Glaciares National Park, Santa Cruz, Argentina
ABOVE BOTTOM: Los Glaciares National Park, Santa Cruz, Argentina

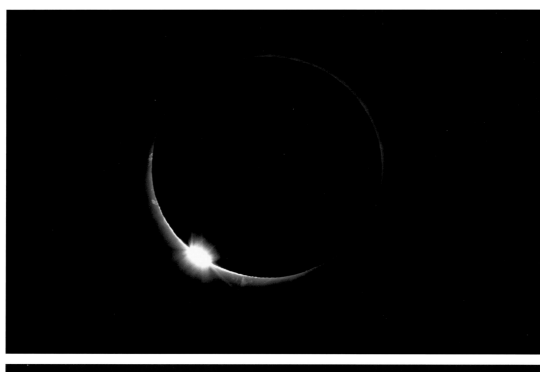

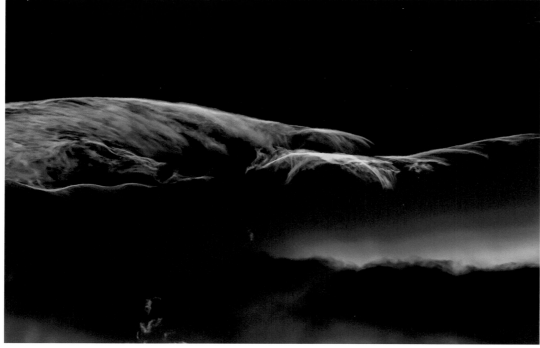

ABOVE TOP: Baily's beads or diamond ring effect of a solar eclipse, Coquimbo, Chile
ABOVE BOTTOM: Cloudscape, Torres del Paine National Park, Magallanes and Chilean Antarctica, Chile
OPPOSITE: A solar eclipse turns day into night, Coquimbo, Chile

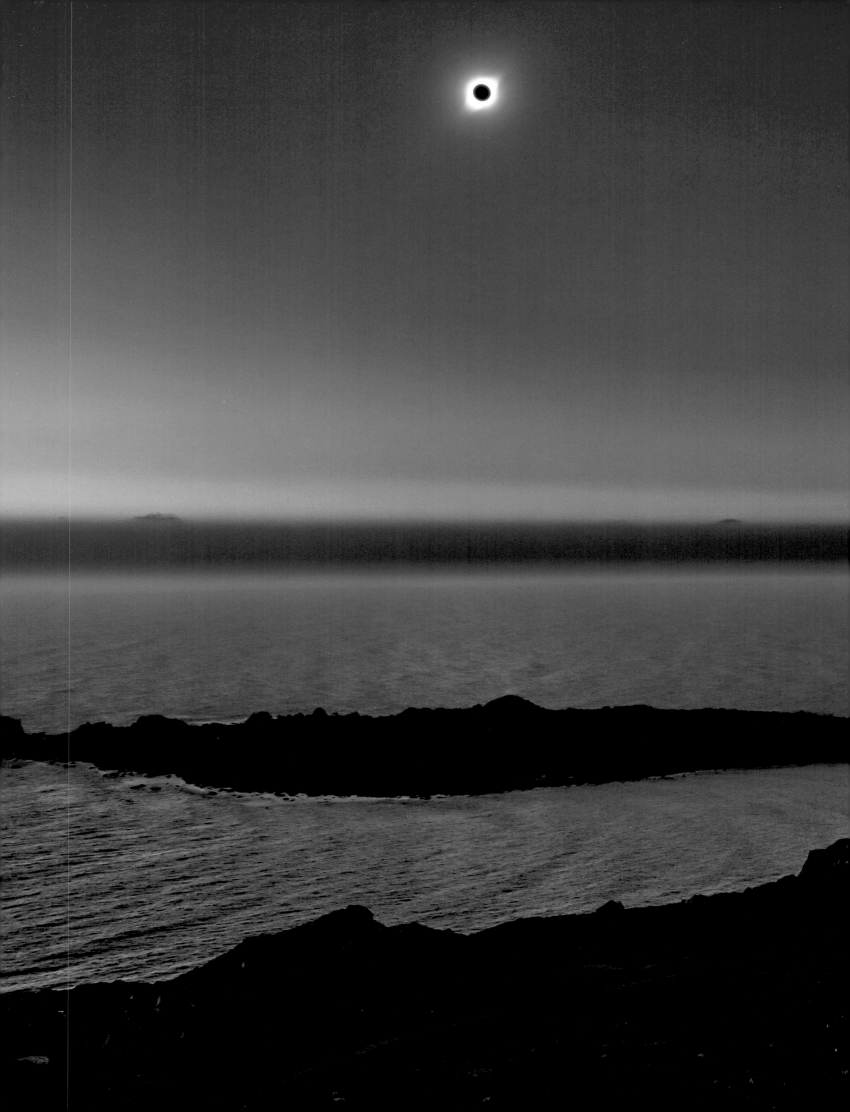

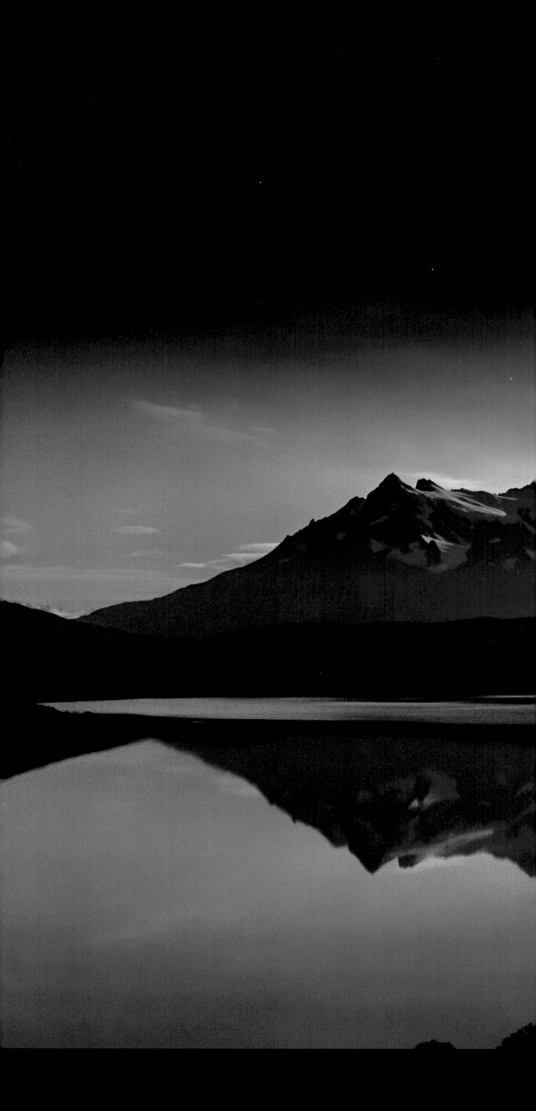

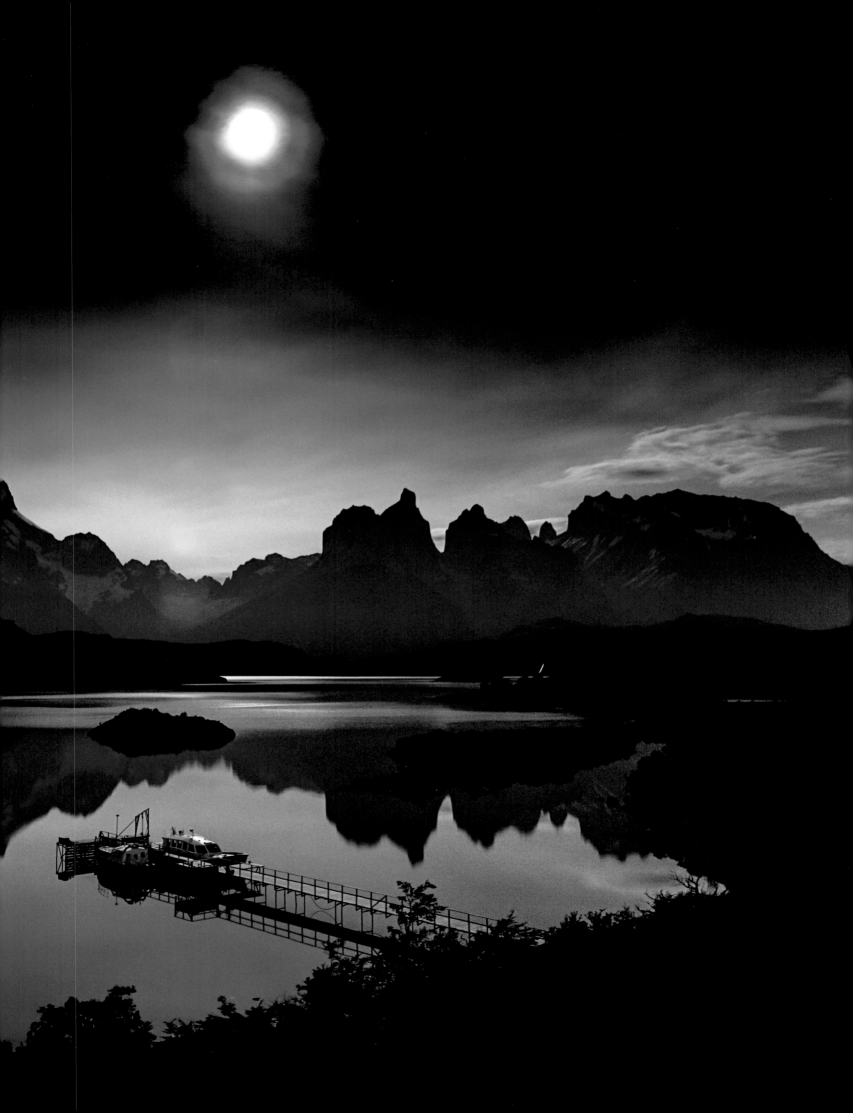

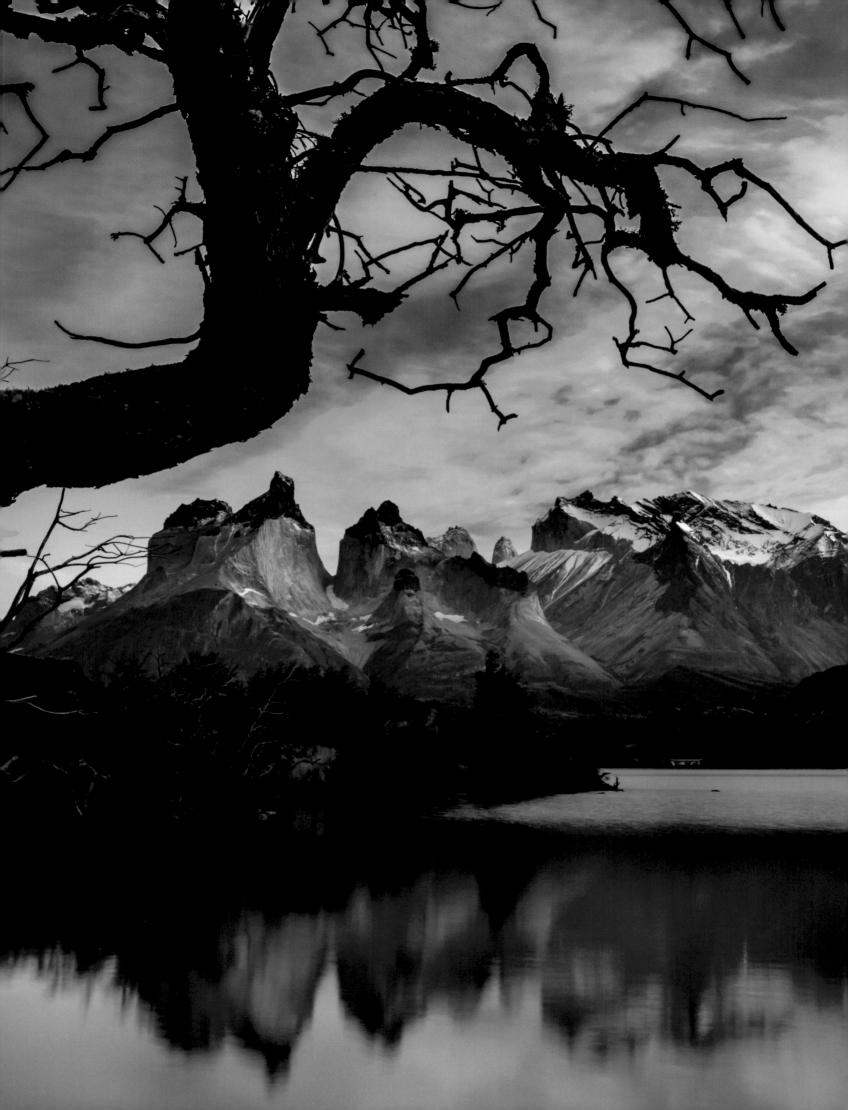

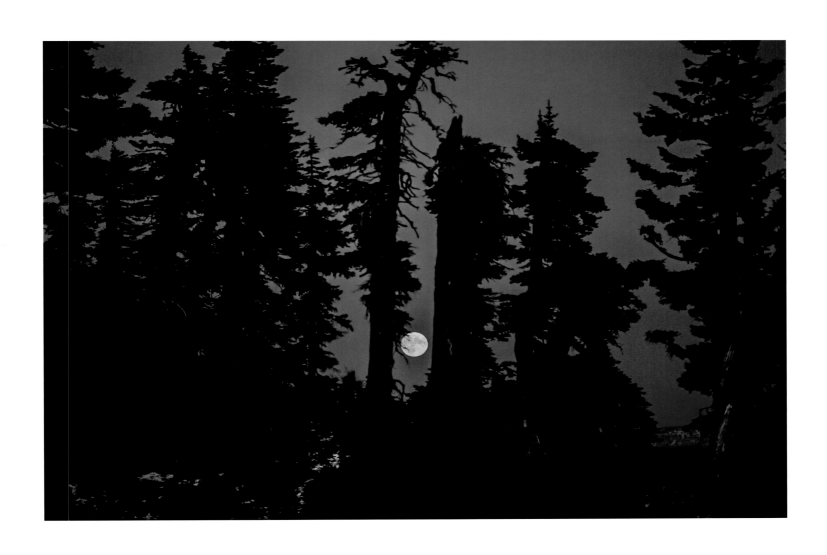

PREVIOUS PAGES: Moon over Lake Pehoé, Cordillera del Paine, Torres del Paine
National Park, Magallanes and Chilean Antarctica, Chile
OPPOSITE: Lake Nordenskjöld, Cuernos del Paine, Torres del Paine National Park, Chile
ABOVE: Moonrise, North Cascades National Park, Washington, USA

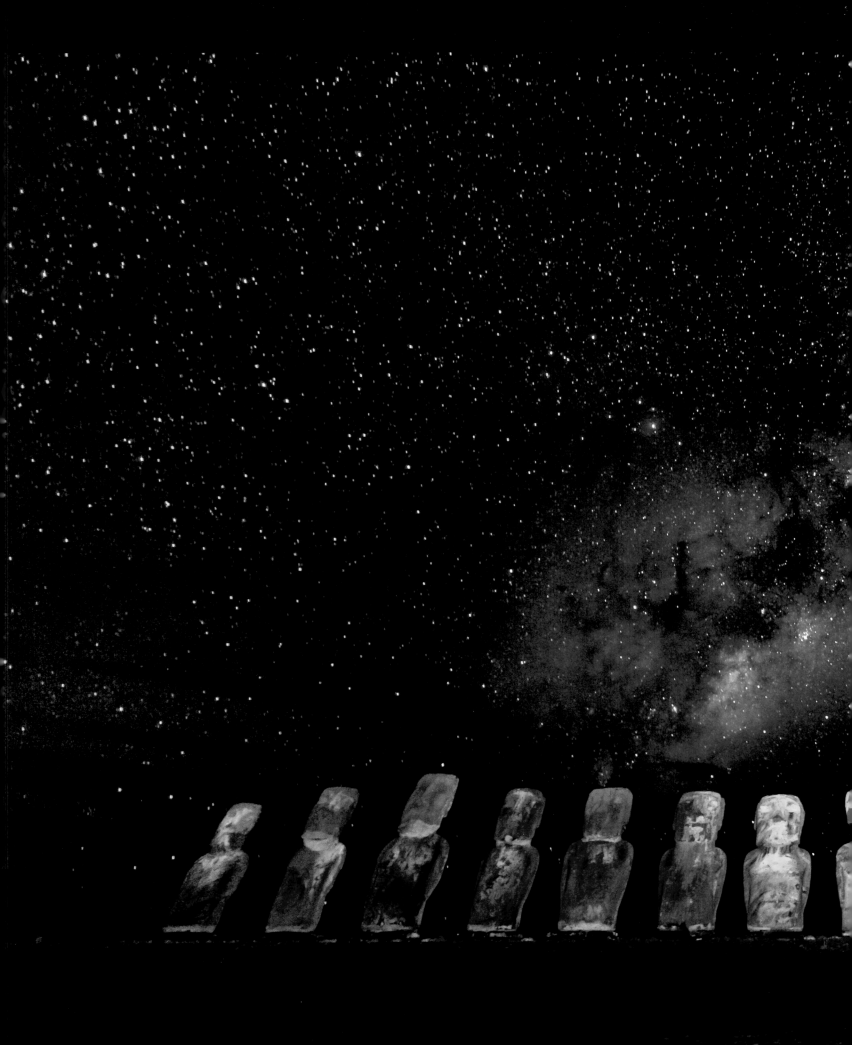

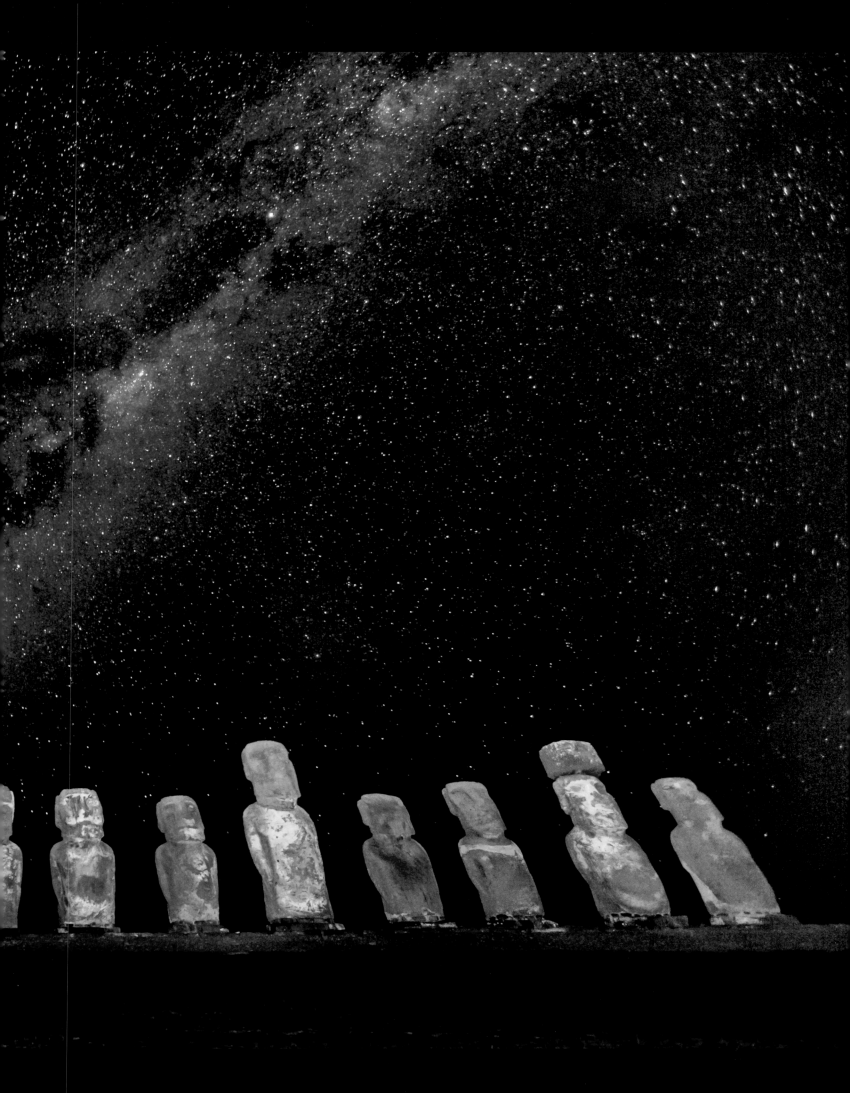

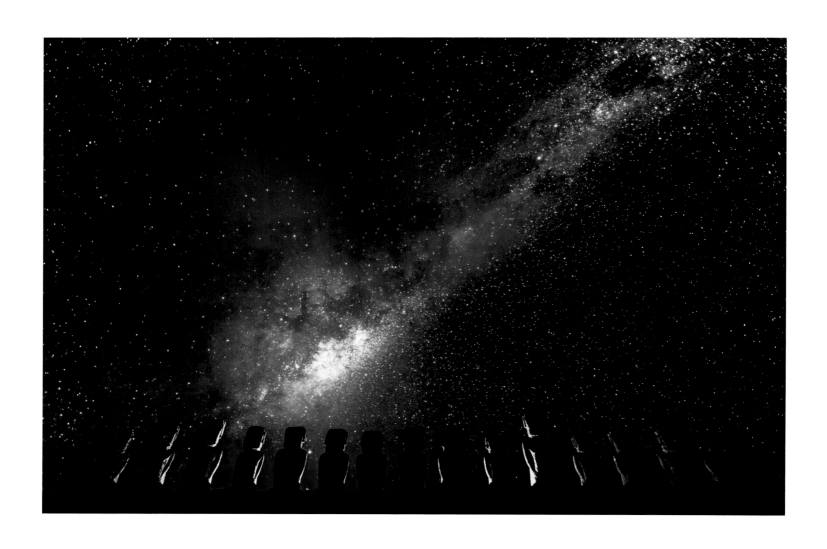

PREVIOUS PAGES AND ABOVE: Milky Way over moai, Ahu Tongariki, Rapa Nui (Easter Island), Chile
OPPOSITE: Comet NEOWISE, Washington, USA
FOLLOWING PAGES: El Tatio Geysers, Atacama Desert, Puna de Atacama, Chile

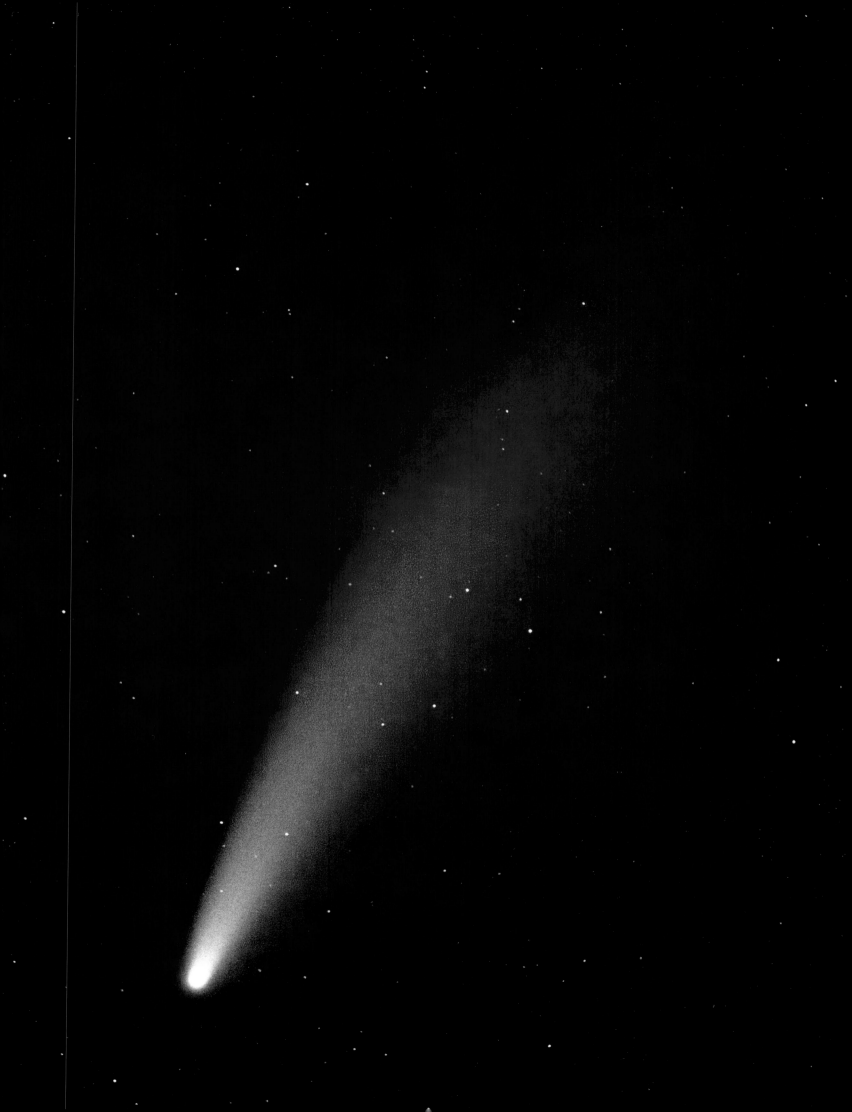

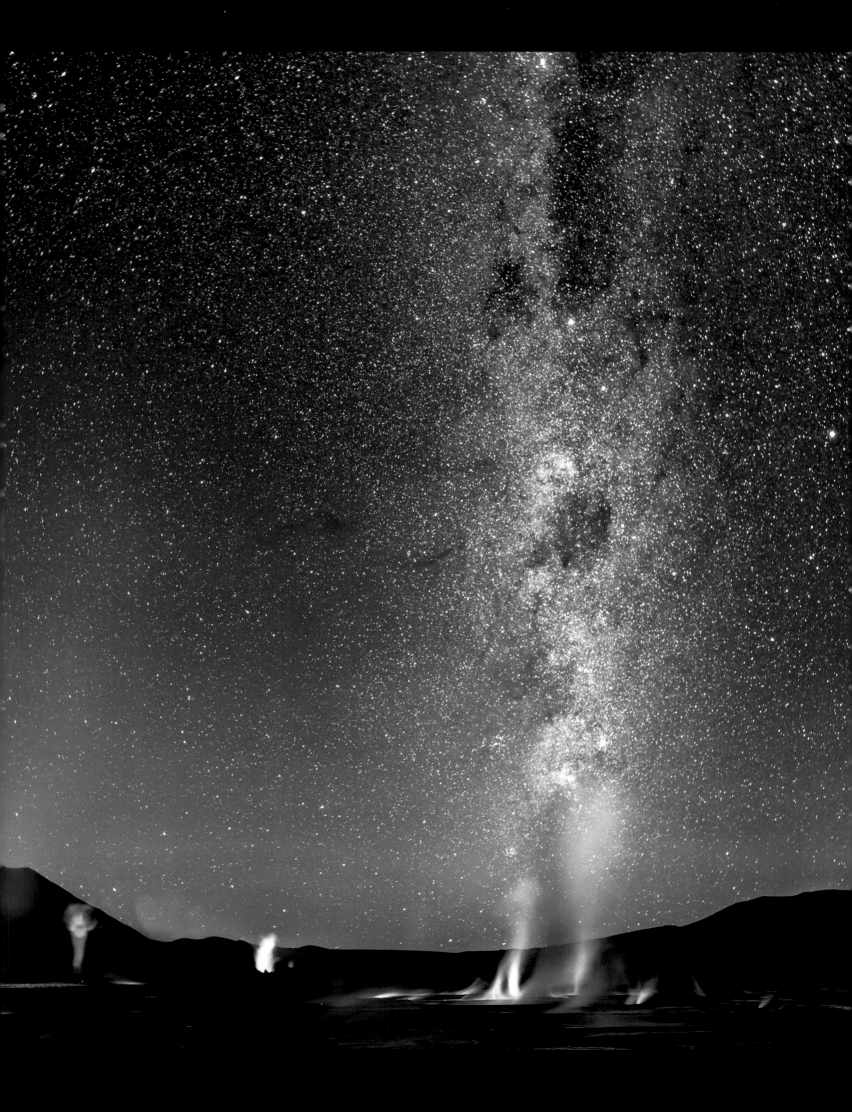

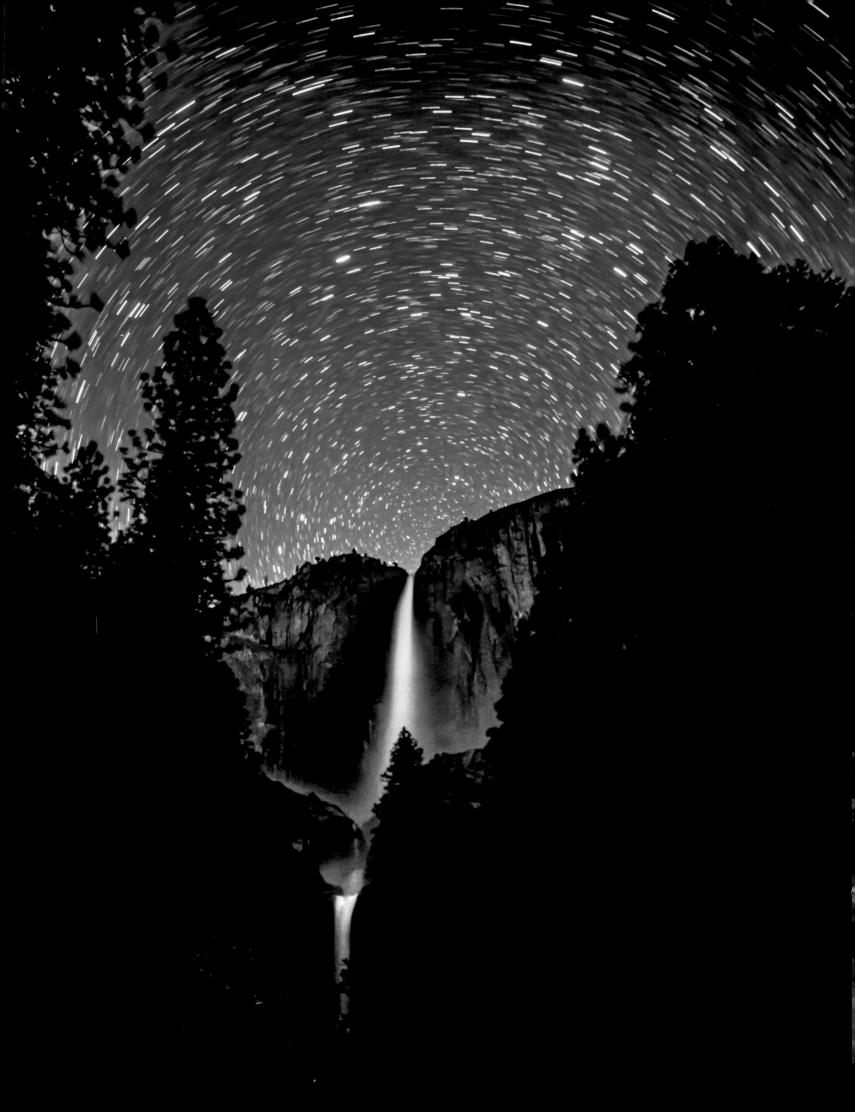

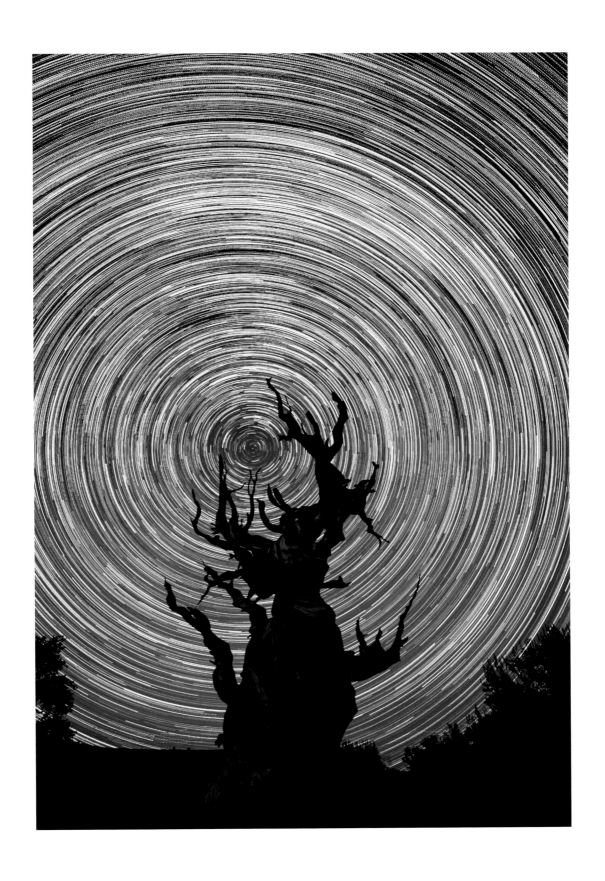

OPPOSITE: Yosemite Falls, Yosemite National Park, California, USA
ABOVE: Star trails, Ancient Bristlecone Pine Forest, White Mountains, California, USA

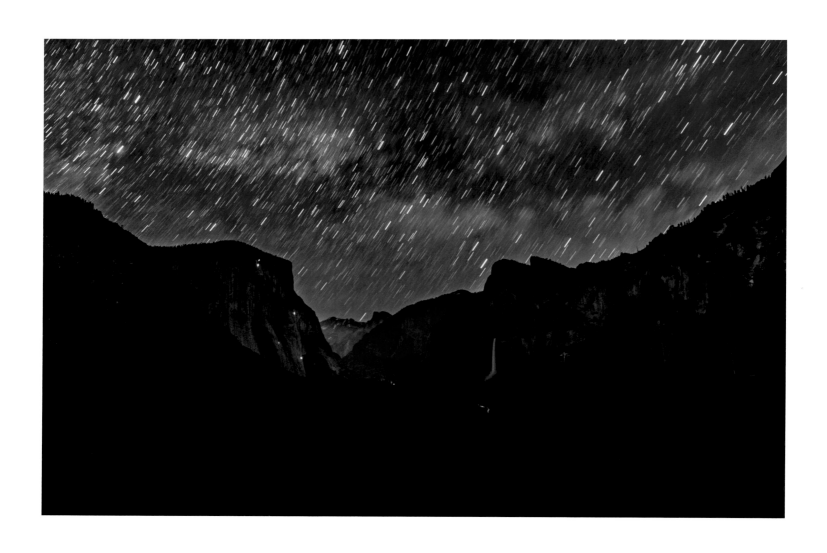

ABOVE: Yosemite National Park, California, USA
OPPOSITE: Rochester Rock Art Panel, Utah, USA

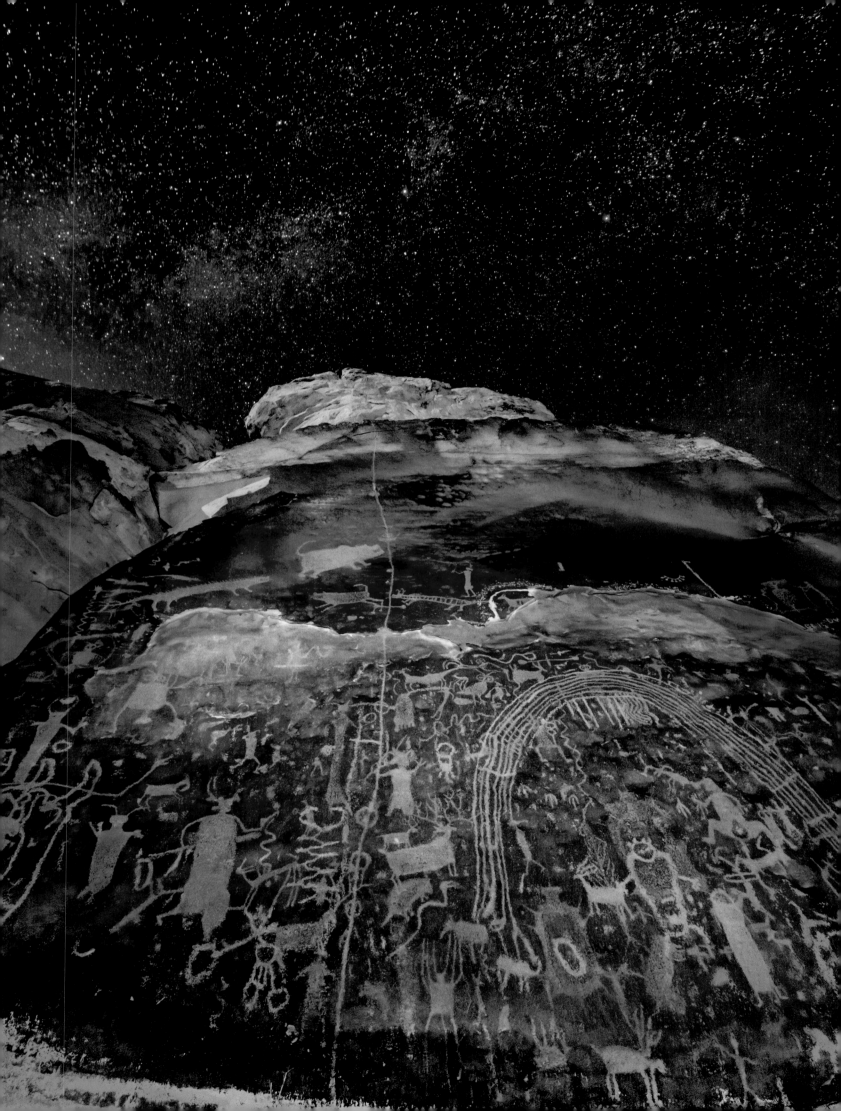

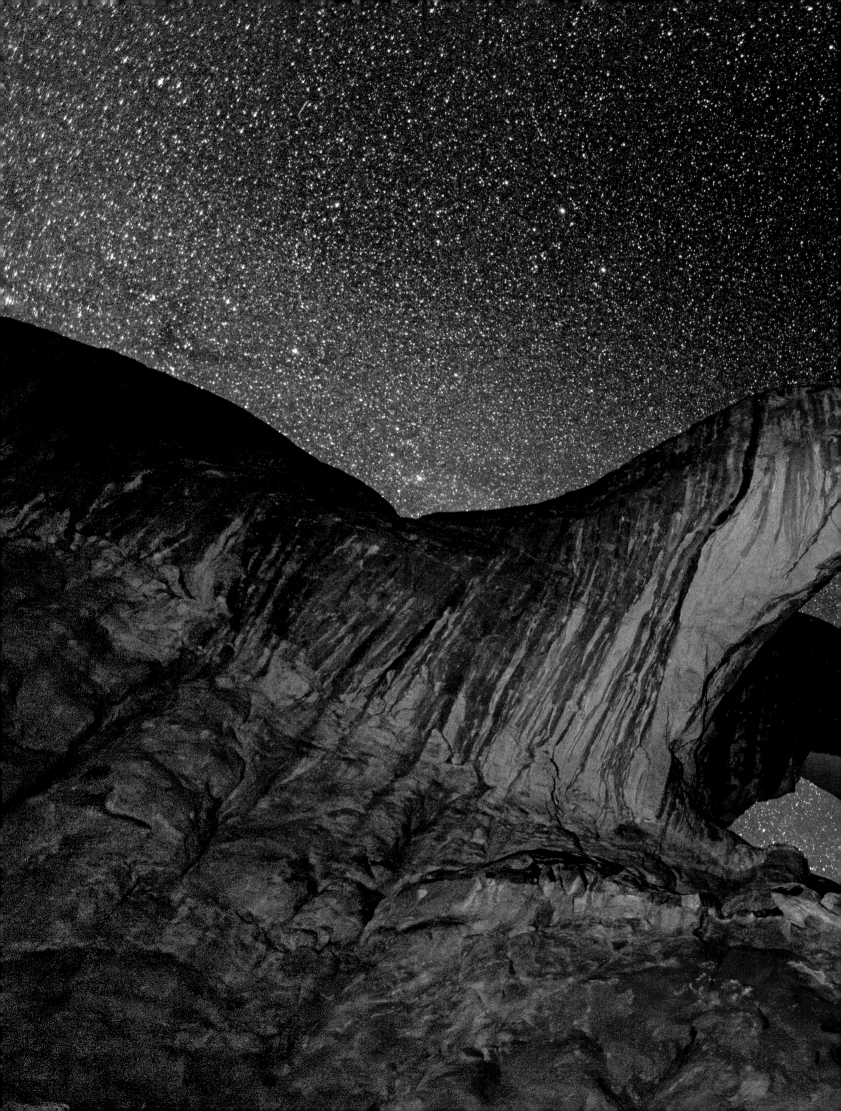

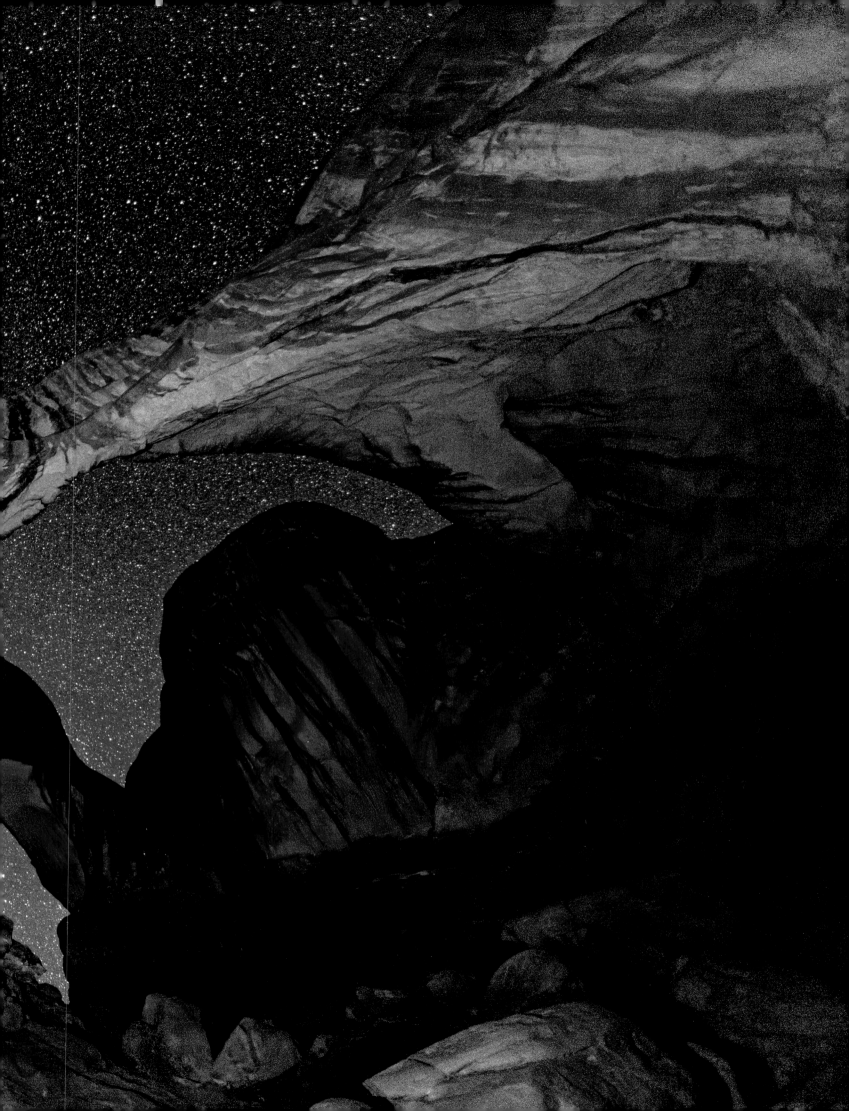

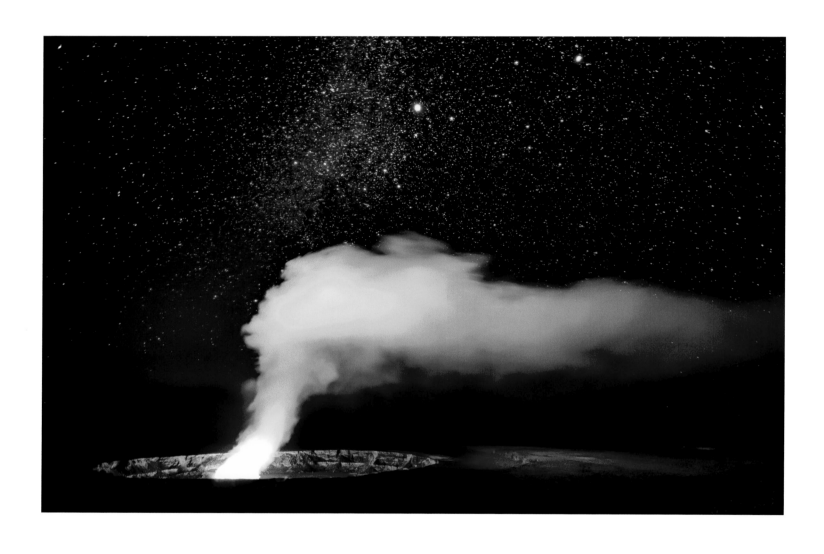

PREVIOUS PAGES: Double Arch, Arches National Park, Utah, USA
ABOVE: Milky Way over Halemaʻumaʻu Crater, Hawaiʻi Volcanoes National Park, Hawaii, USA
OPPOSITE: Halemaʻumaʻu, Hawaiʻi Volcanoes National Park, Hawaii, USA

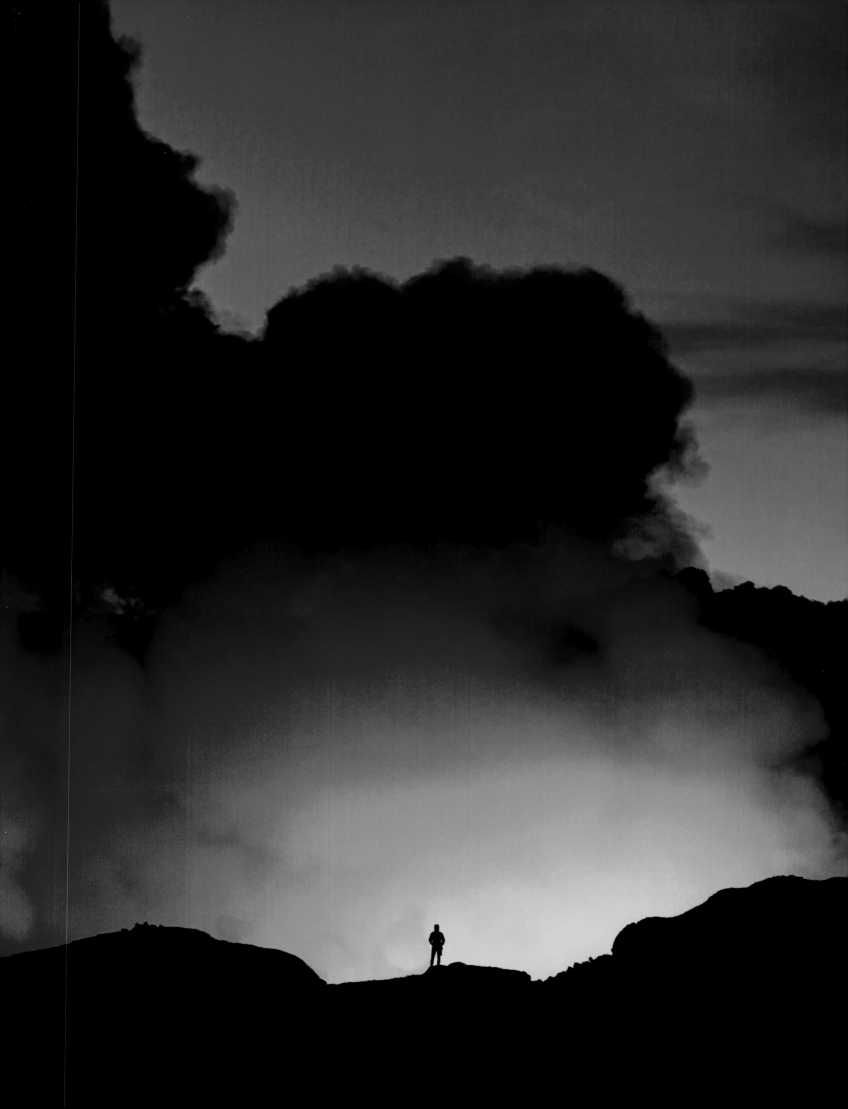

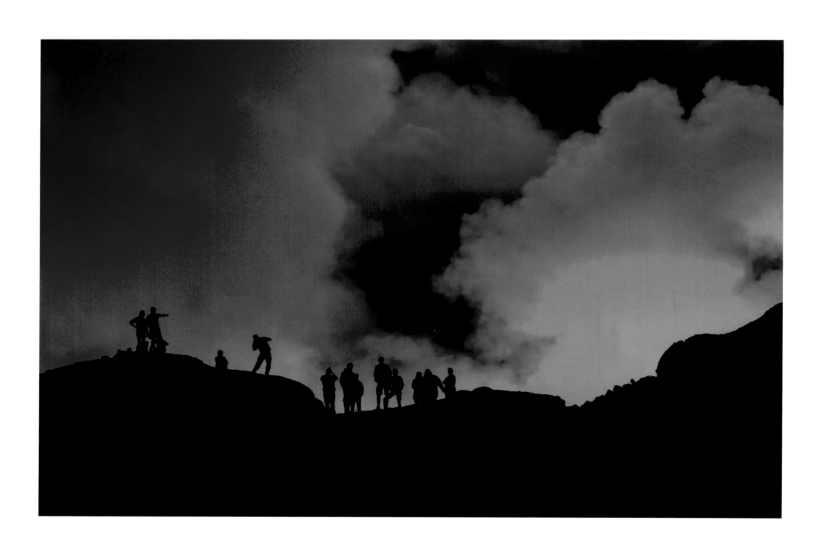

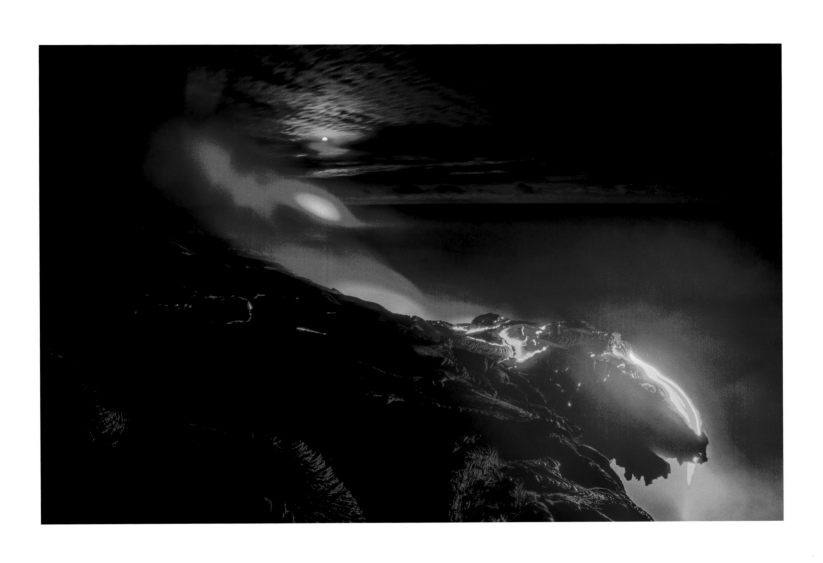

OPPOSITE: Halemaʻumaʻu eruption, Hawaiʻi Volcanoes National Park, Hawaii, USA
ABOVE: Lava flows enter the ocean, Hawaiʻi Volcanoes National Park, Hawaii, USA

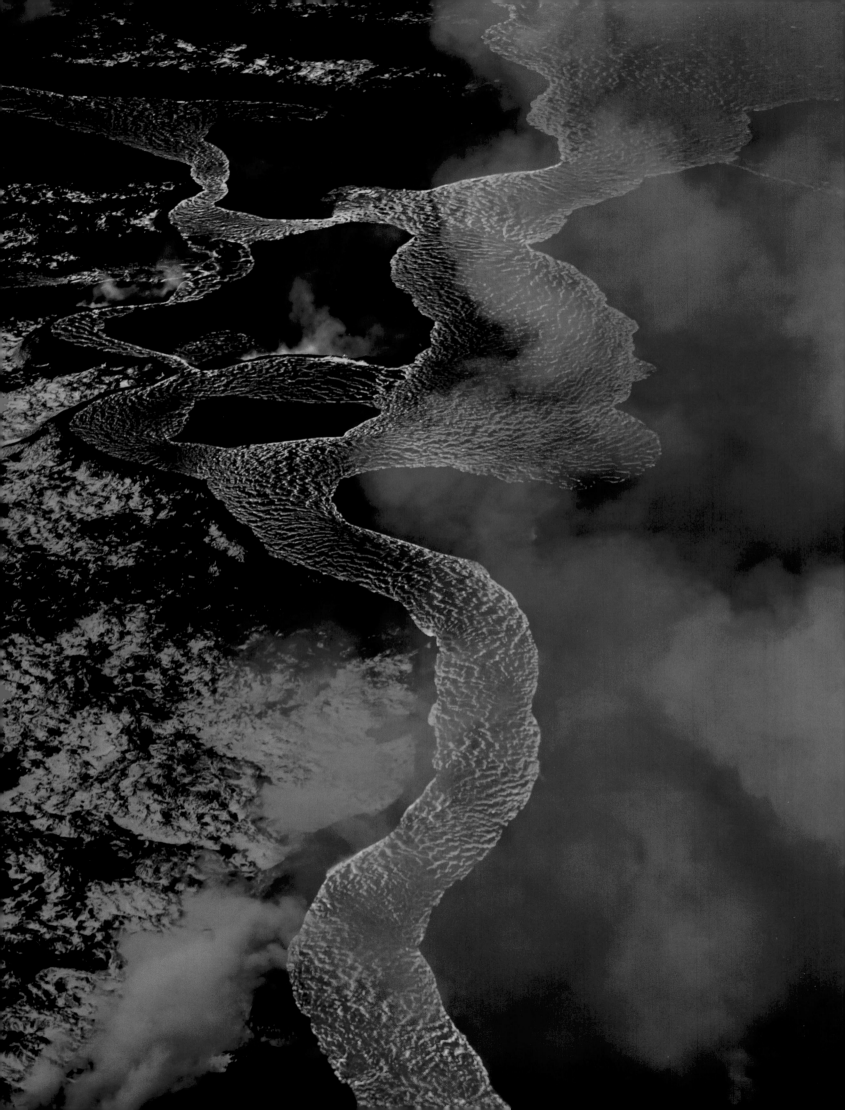

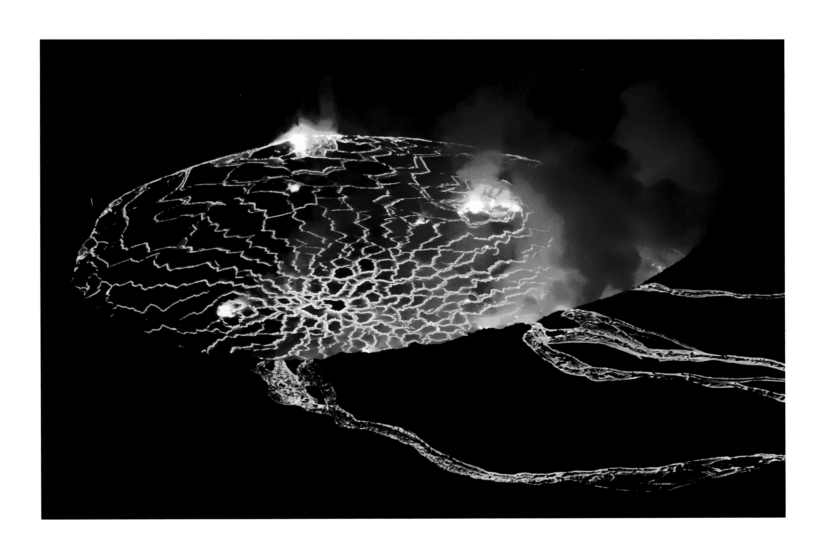

OPPOSITE: Volcanic eruption of Bárðarbunga, Vatnajökull National Park, Iceland
ABOVE: Lava lake, Mount Nyiragongo, Virunga National Park, North Kivu,
Democratic Republic of Congo

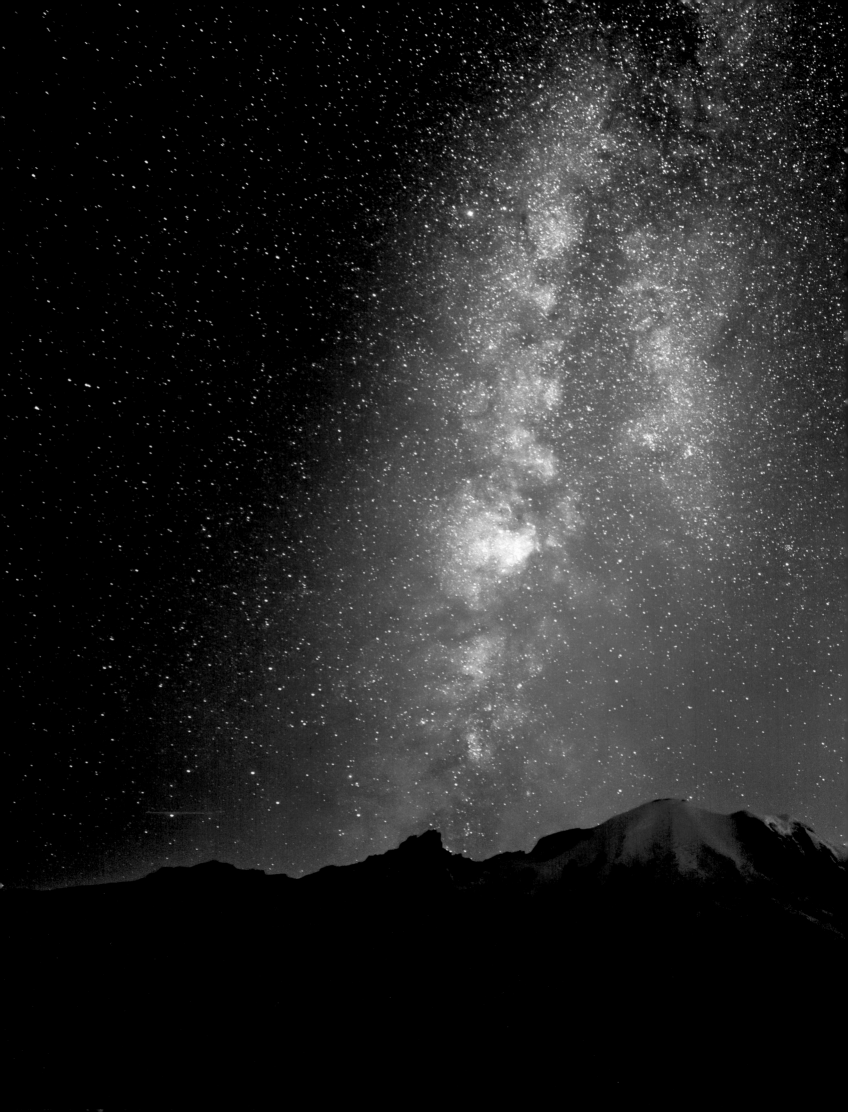

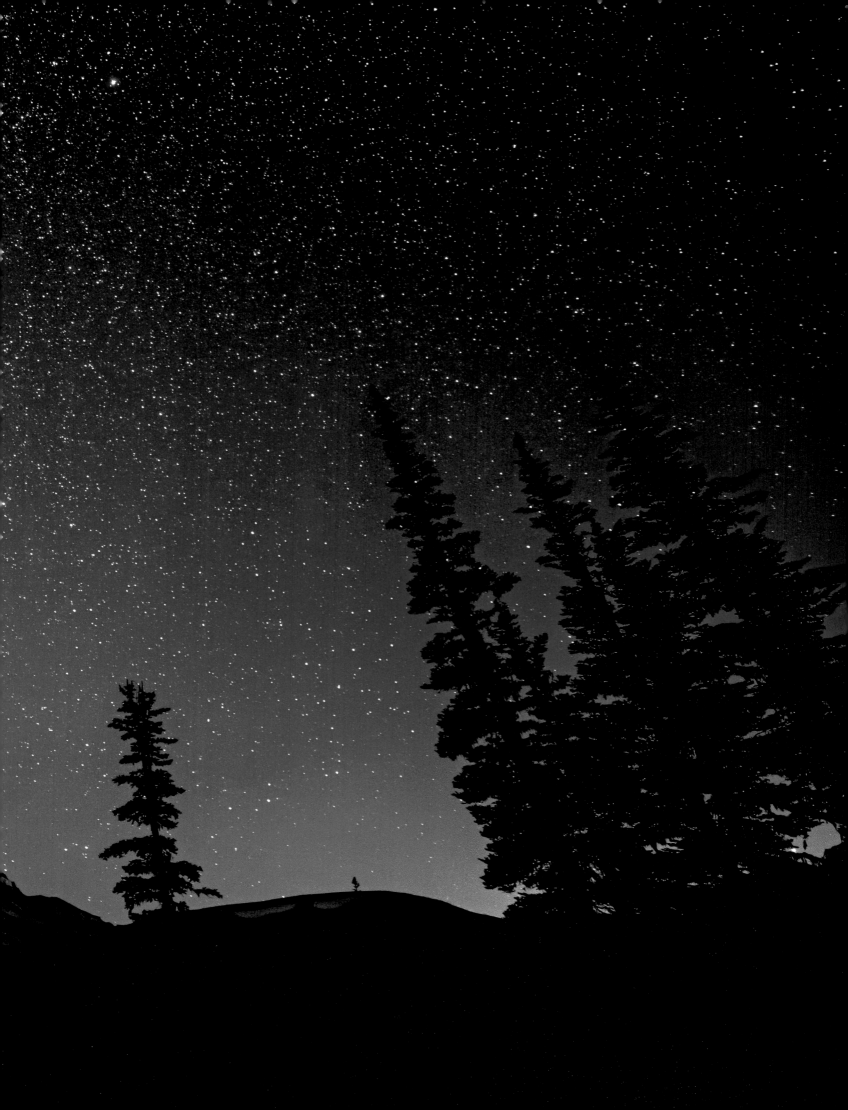

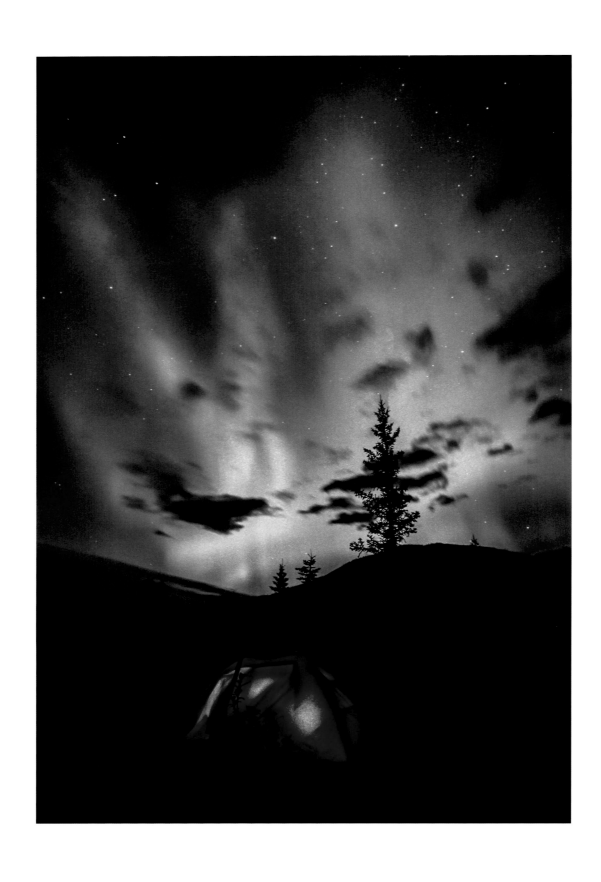

PREVIOUS PAGES: Milky Way over Mount Rainier, Mount Rainier National Park, Washington, USA
ABOVE: Mackenzie Mountains, Northwest Territories, Canada
OPPOSITE: Base Camp, Mount Everest, Tibet, China

50

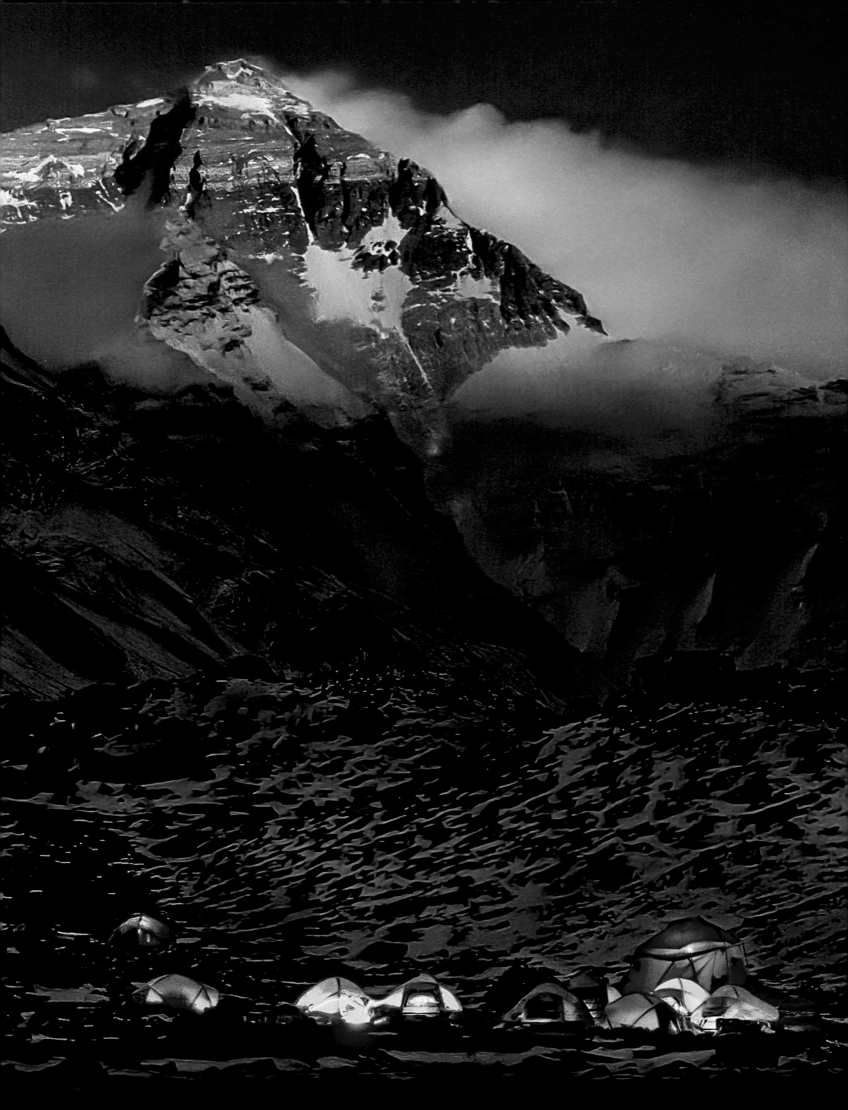

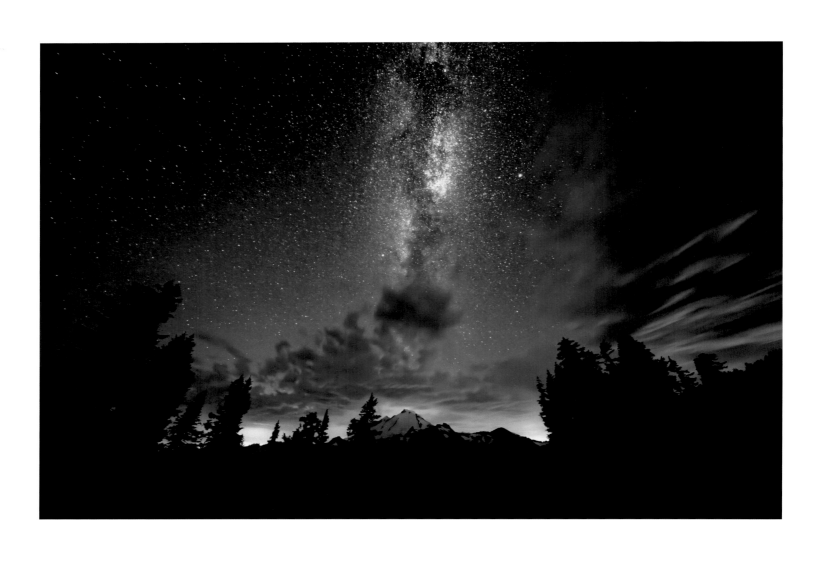

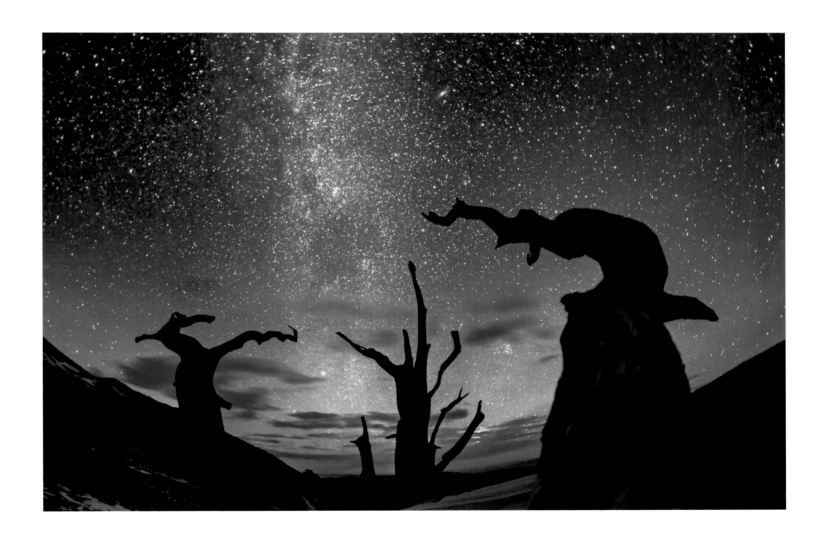

OPPOSITE: Milky Way over Mount Baker, Mount Baker Wilderness, Washington, USA
ABOVE: Great Basin bristlecone pines (*Pinus longaeva*) and Milky Way, Ancient Bristlecone Pine
Forest, White Mountains, California, USA

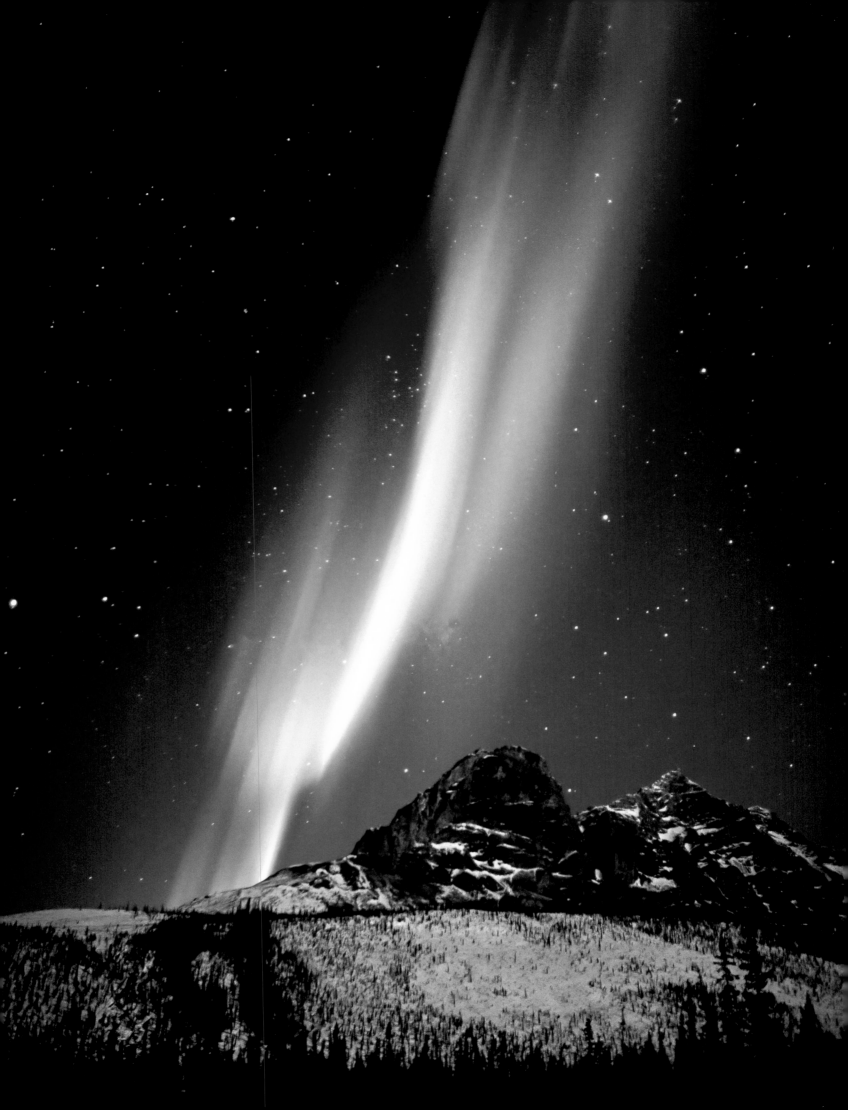

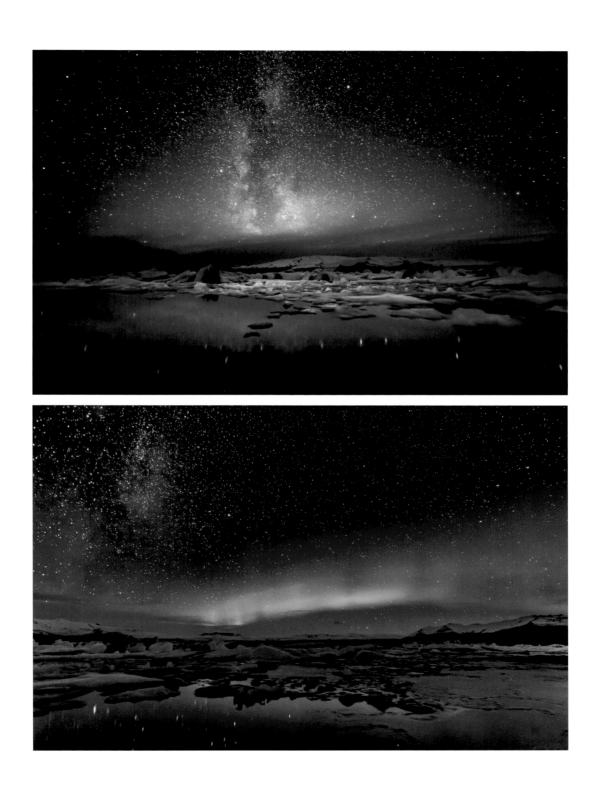

OPPOSITE: Aurora borealis, Brooks Range, Alaska, USA
ABOVE TOP AND BOTTOM: Milky Way and aurora borealis, Jökulsárlón, Iceland

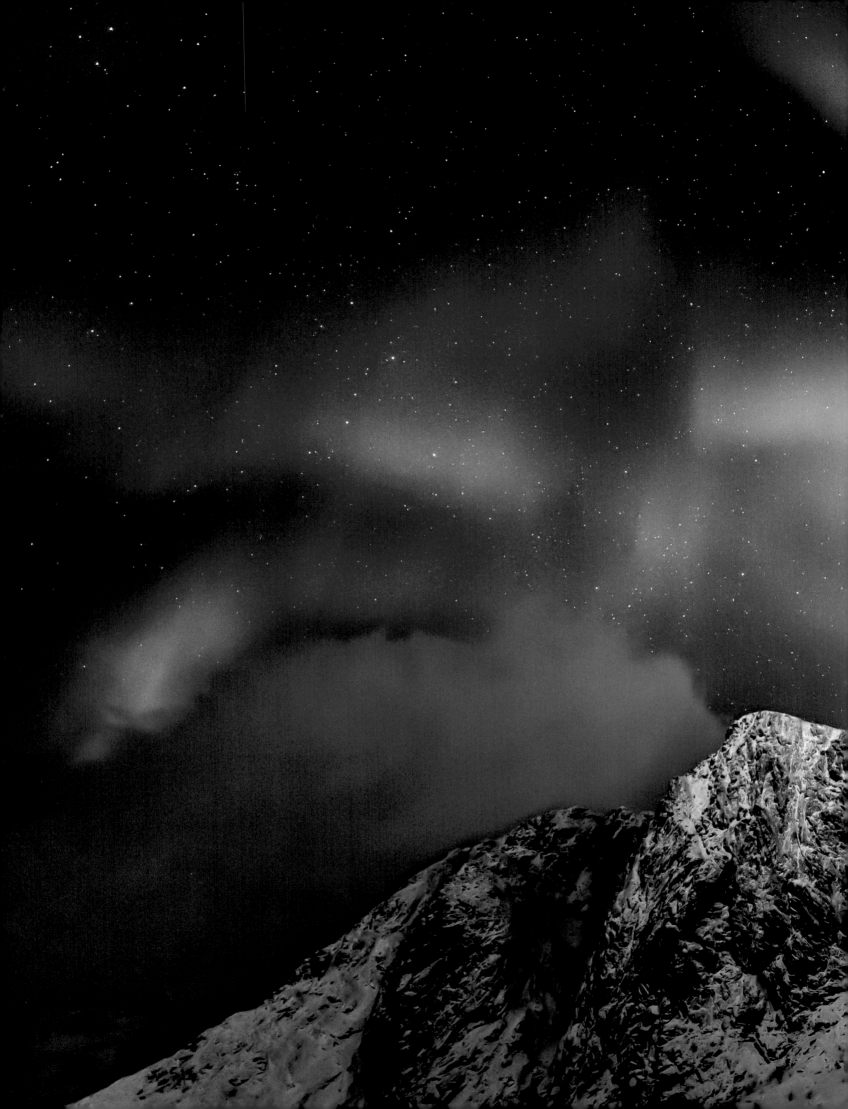

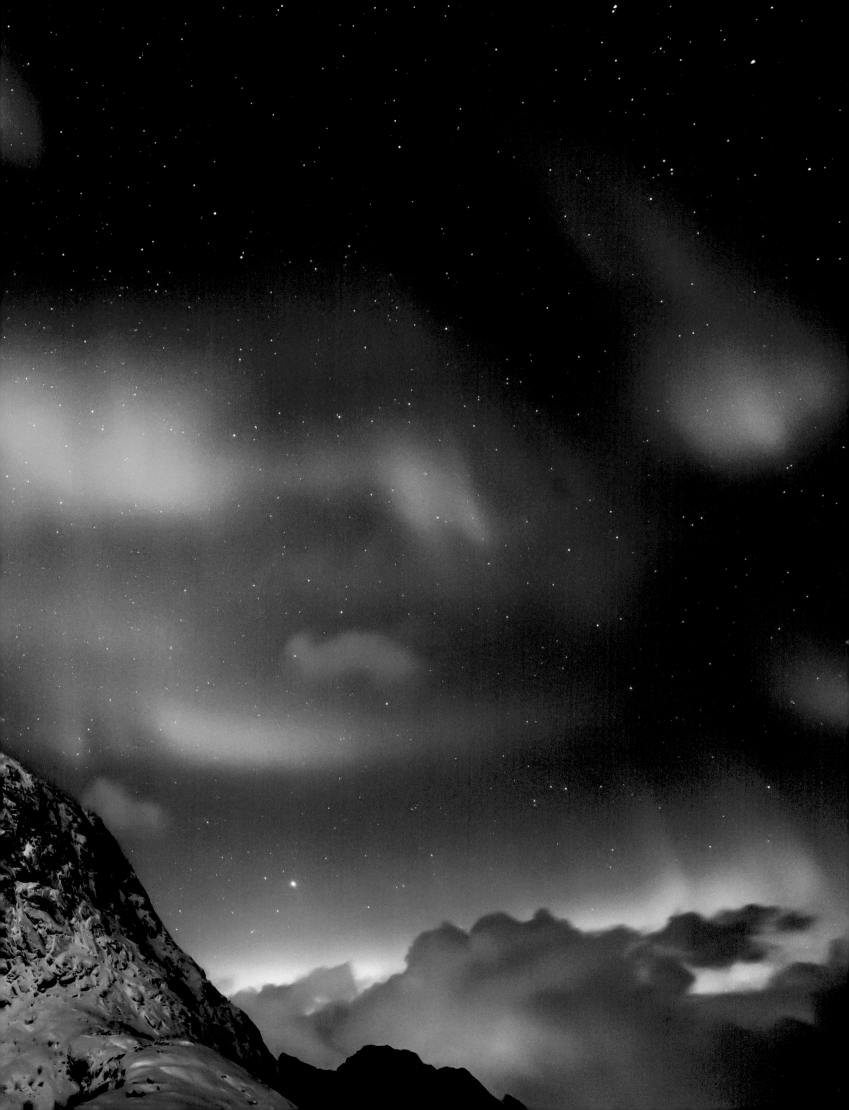

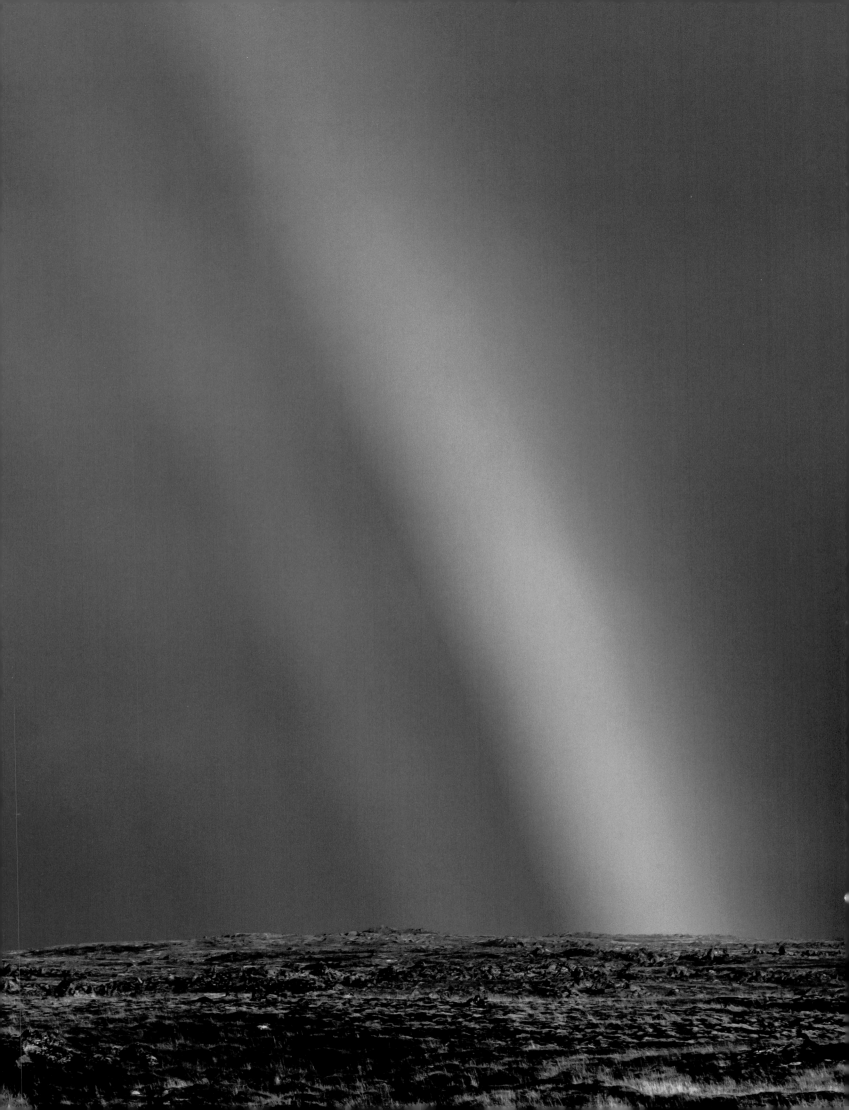

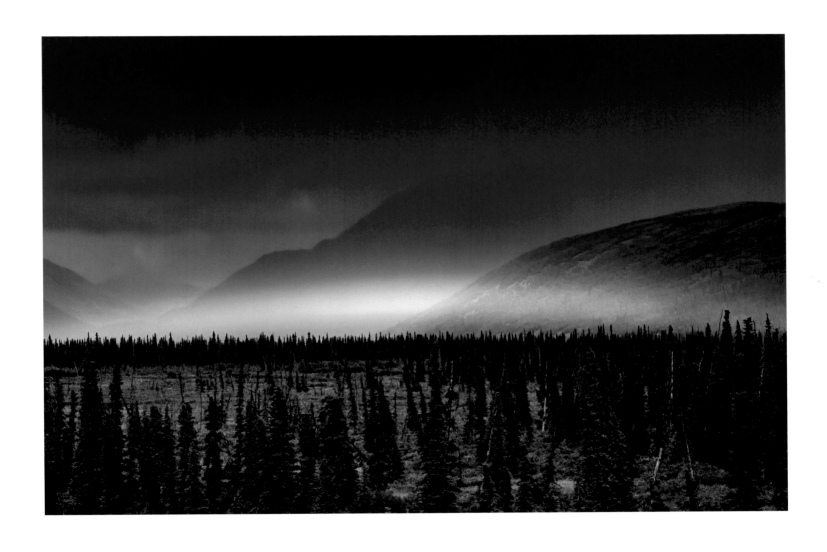

PREVIOUS PAGES: Aurora borealis, Nordland, Lofoten, Norway
OPPOSITE: Rainbow, Western Region, Iceland
ABOVE: Rainbow over boreal forest, Denali National Park and Preserve, Alaska, USA

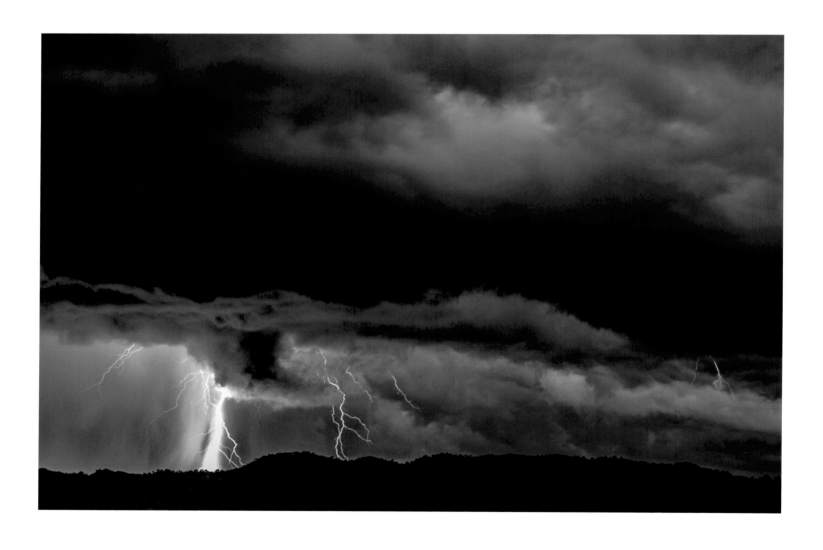

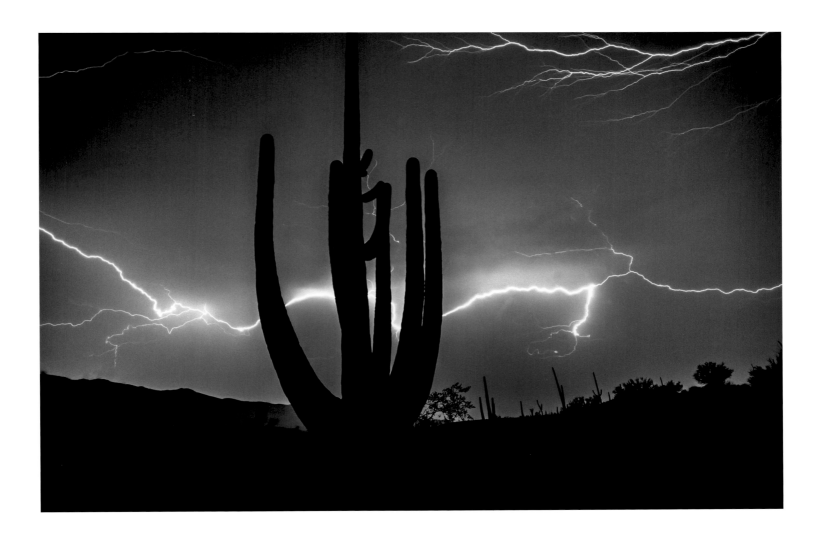

OPPOSITE: Lightning storm, Benin
ABOVE: Lightning and saguaros (*Carnegiea gigantea*), Saguaro National Park, Arizona, USA
FOLLOWING PAGES: Ariel, Washington, USA

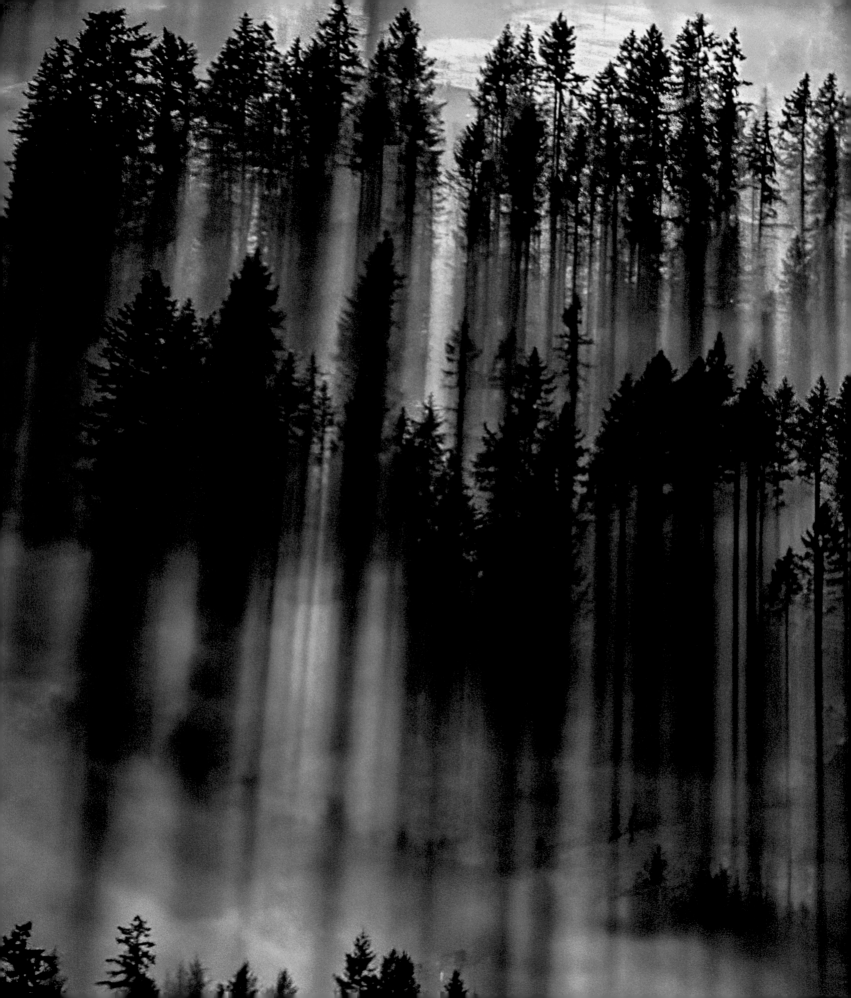

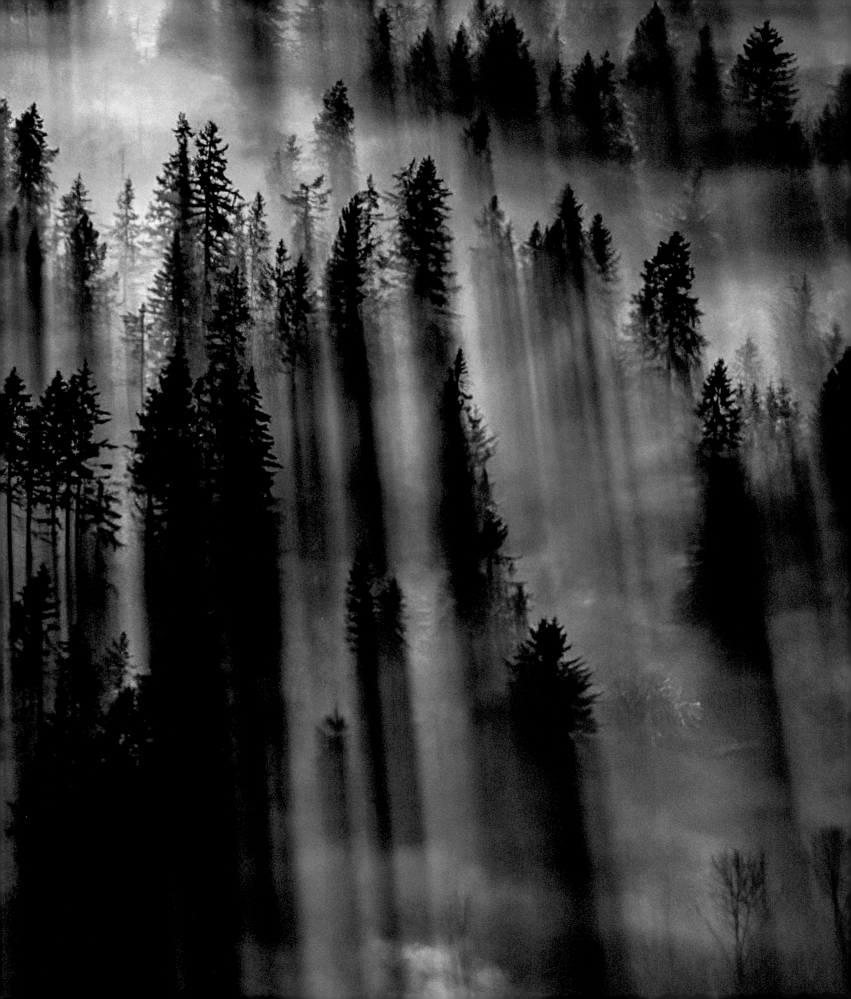

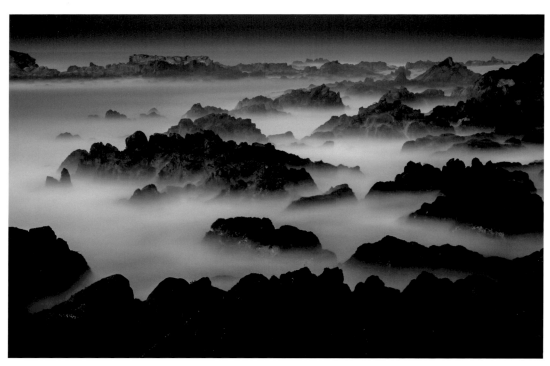

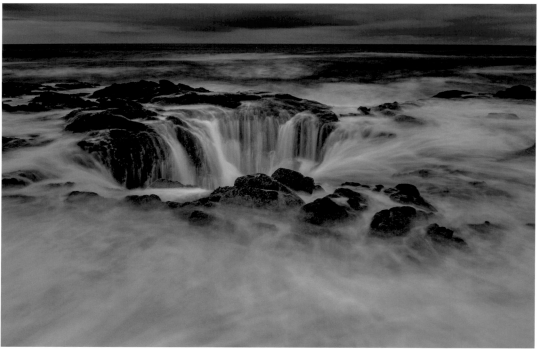

ABOVE TOP: Rocky coastline, Point Lobos, California, USA
ABOVE BOTTOM: Thor's Well, Cape Perpetua Scenic Area, Oregon, USA
OPPOSITE: Sea water surges over black volcanic rock, Southern Region, Iceland

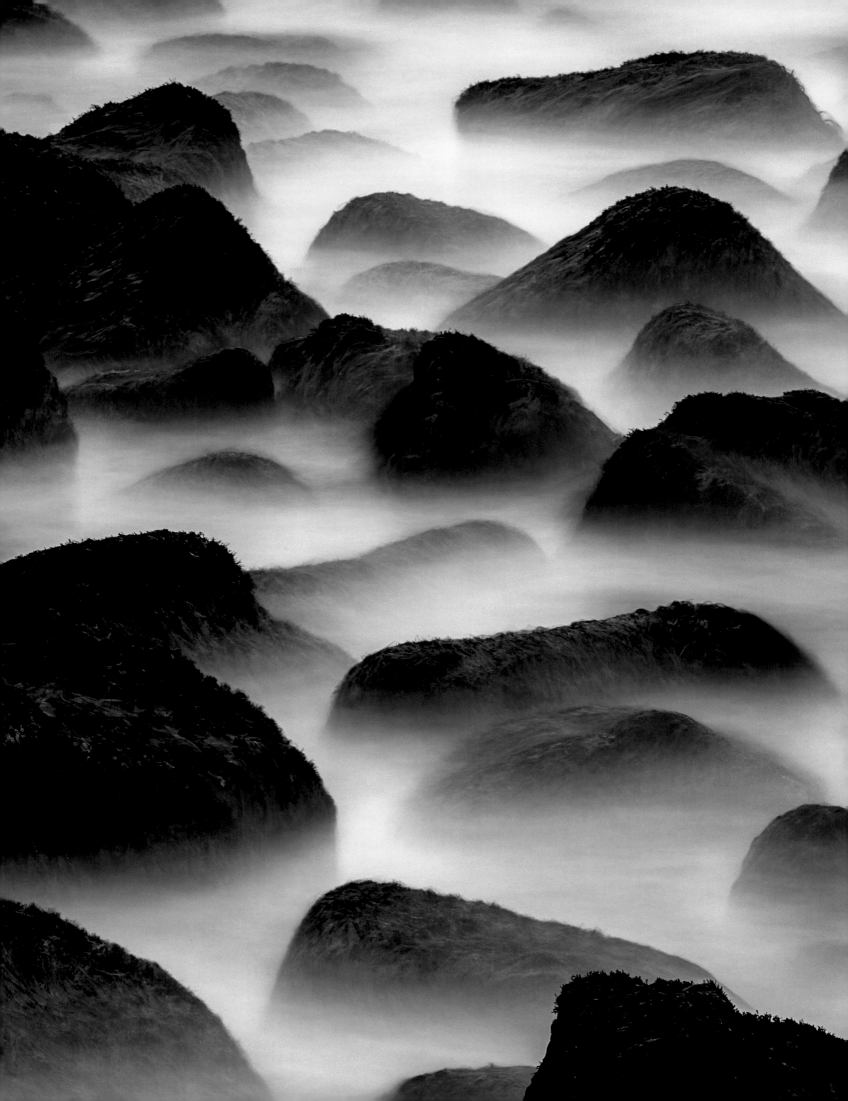

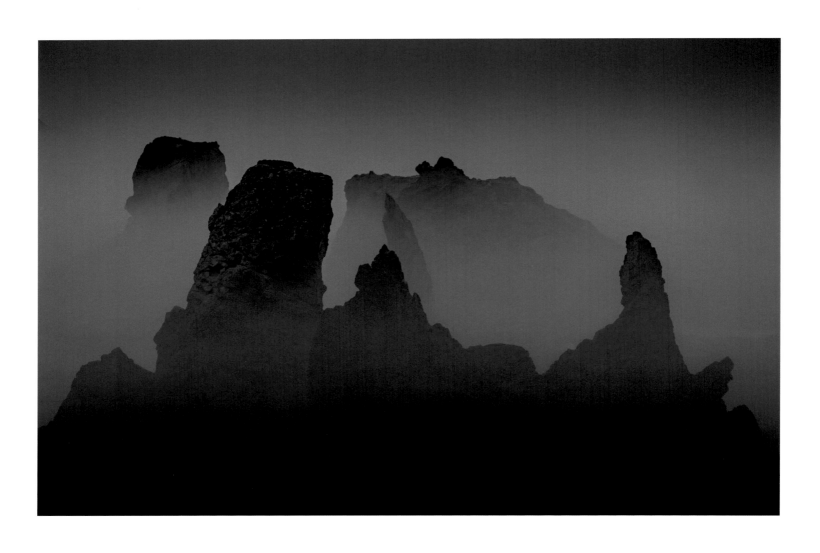

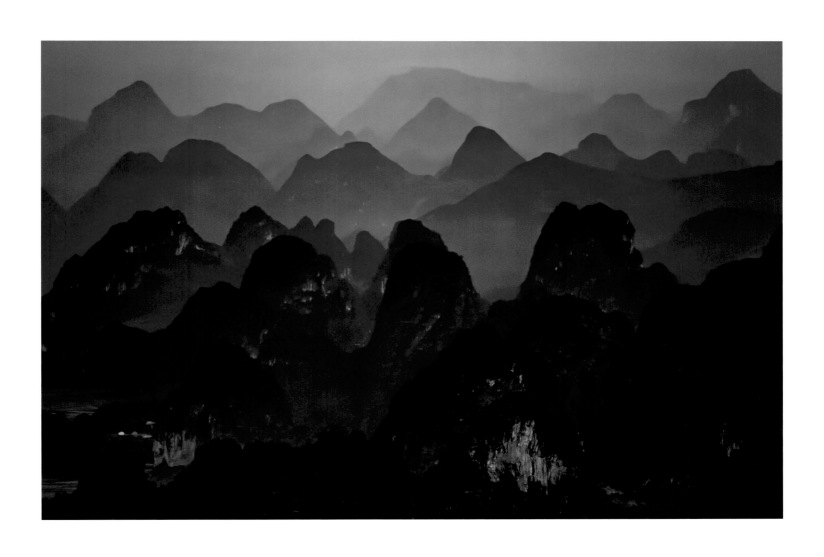

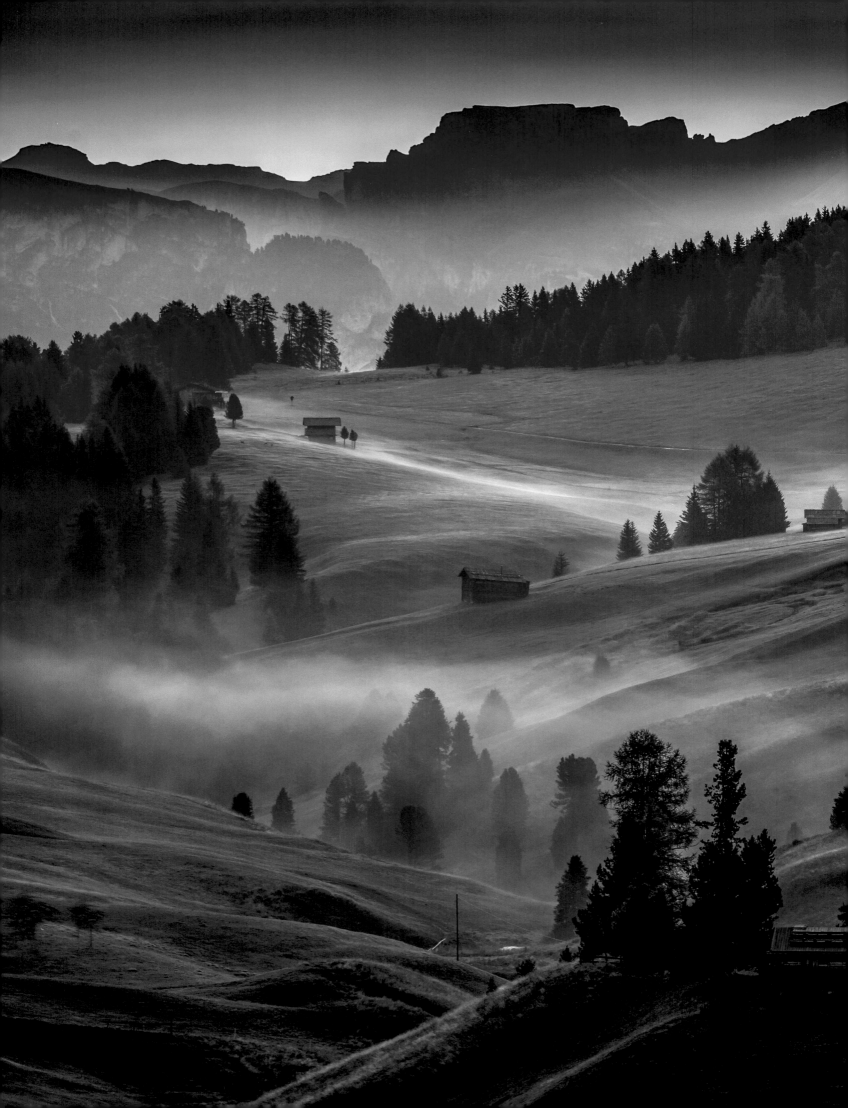

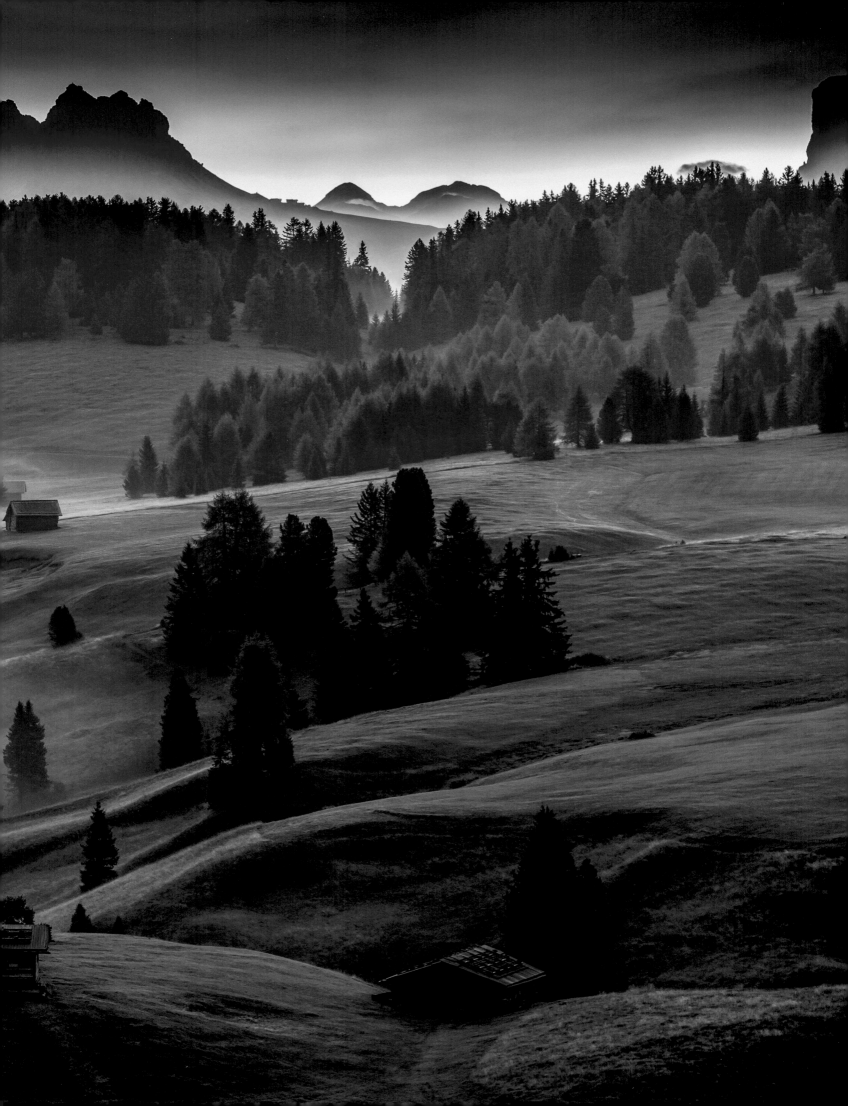

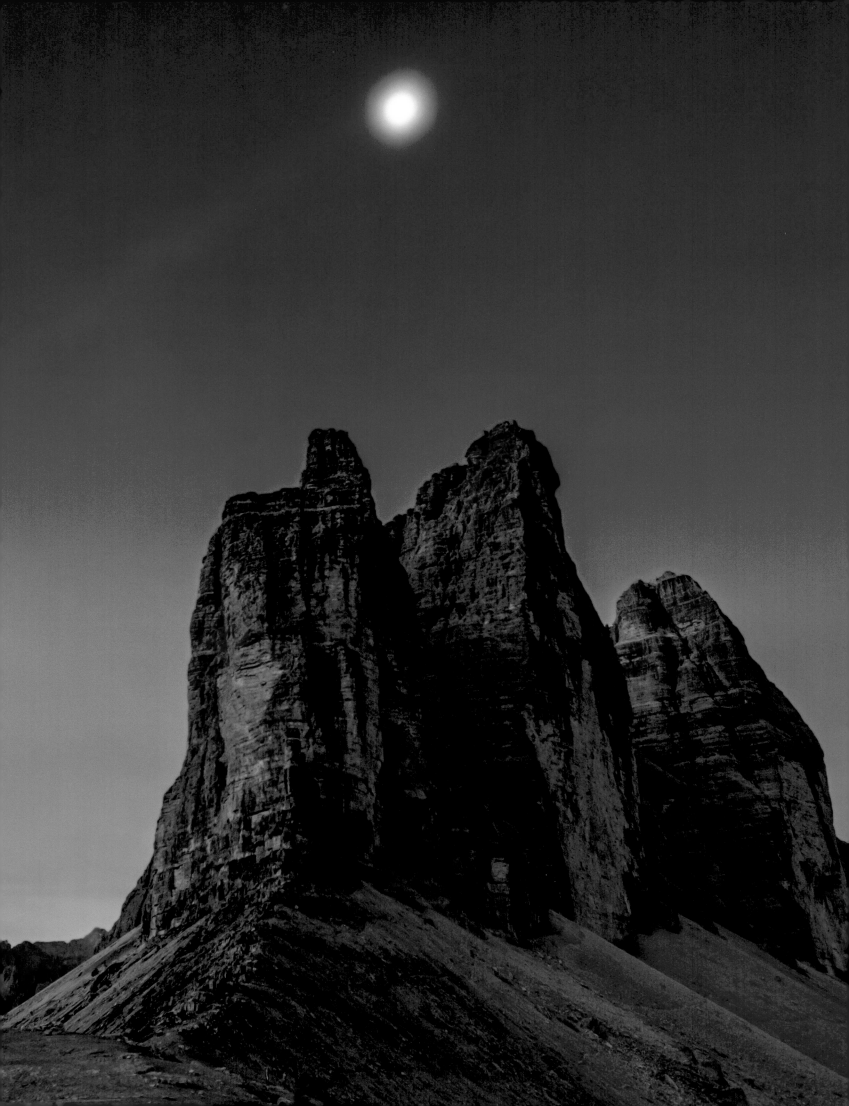

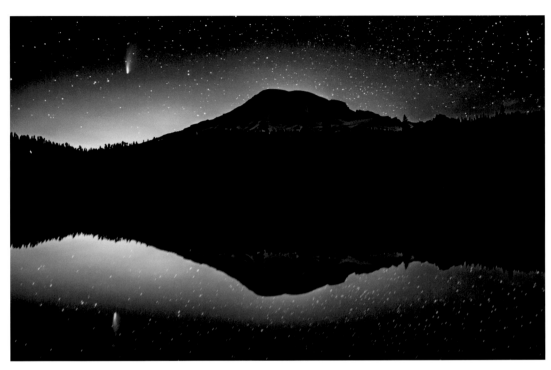

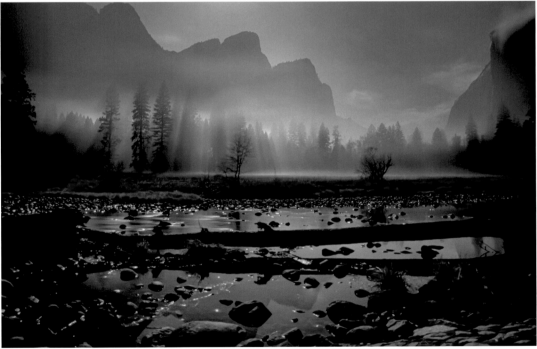

OPPOSITE: Moon over Tre Cime di Lavaredo, Sexten Dolomites, South Tyrol, Italy
ABOVE TOP: Comet NEOWISE shoots over Mount Rainier, Mount Rainier National Park, Washington, USA
ABOVE BOTTOM: Moonlight over Yosemite Valley, Yosemite National Park, California, USA
FOLLOWING PAGES: Lotus stems, Lake Biwa, Honshu, Japan

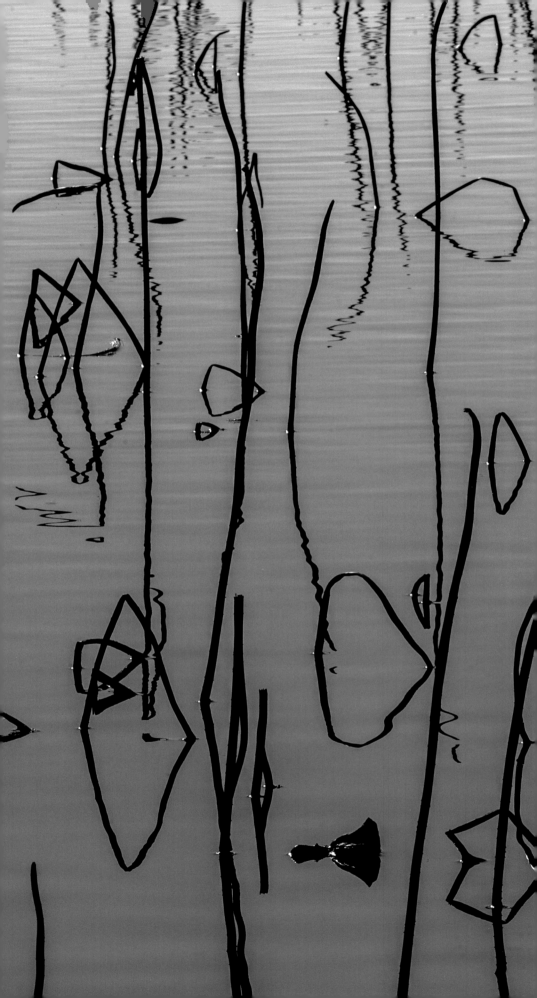

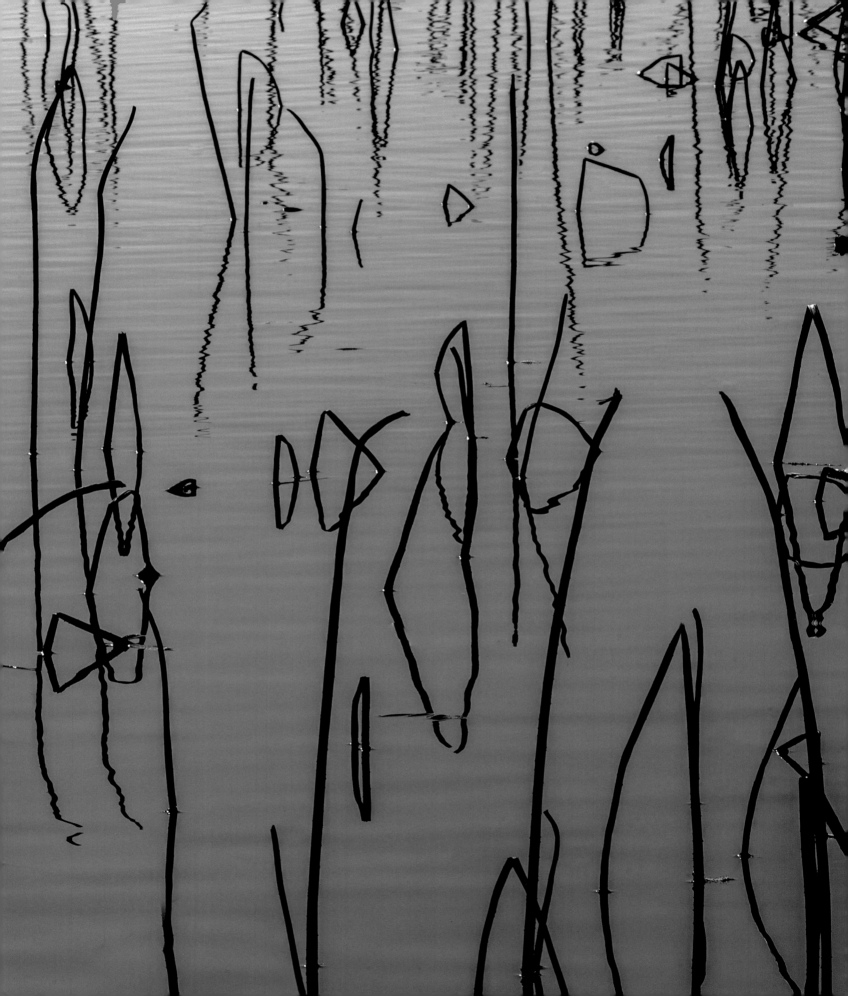

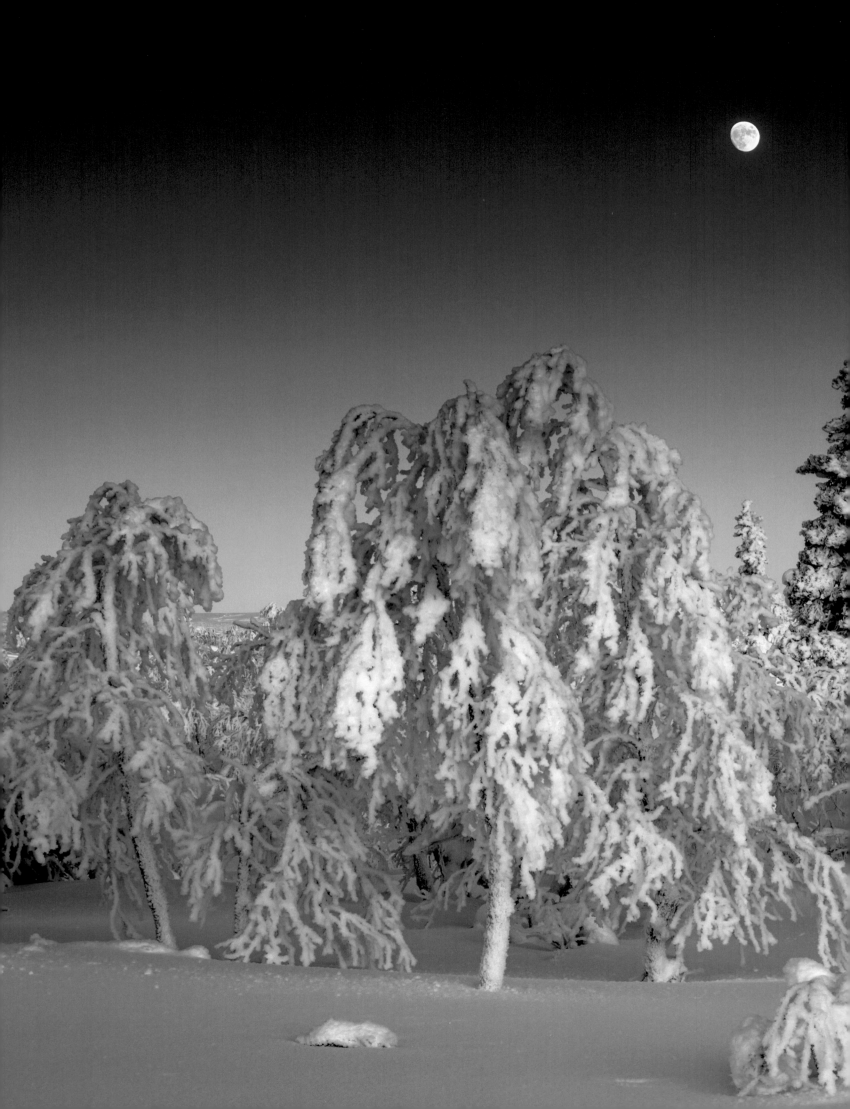

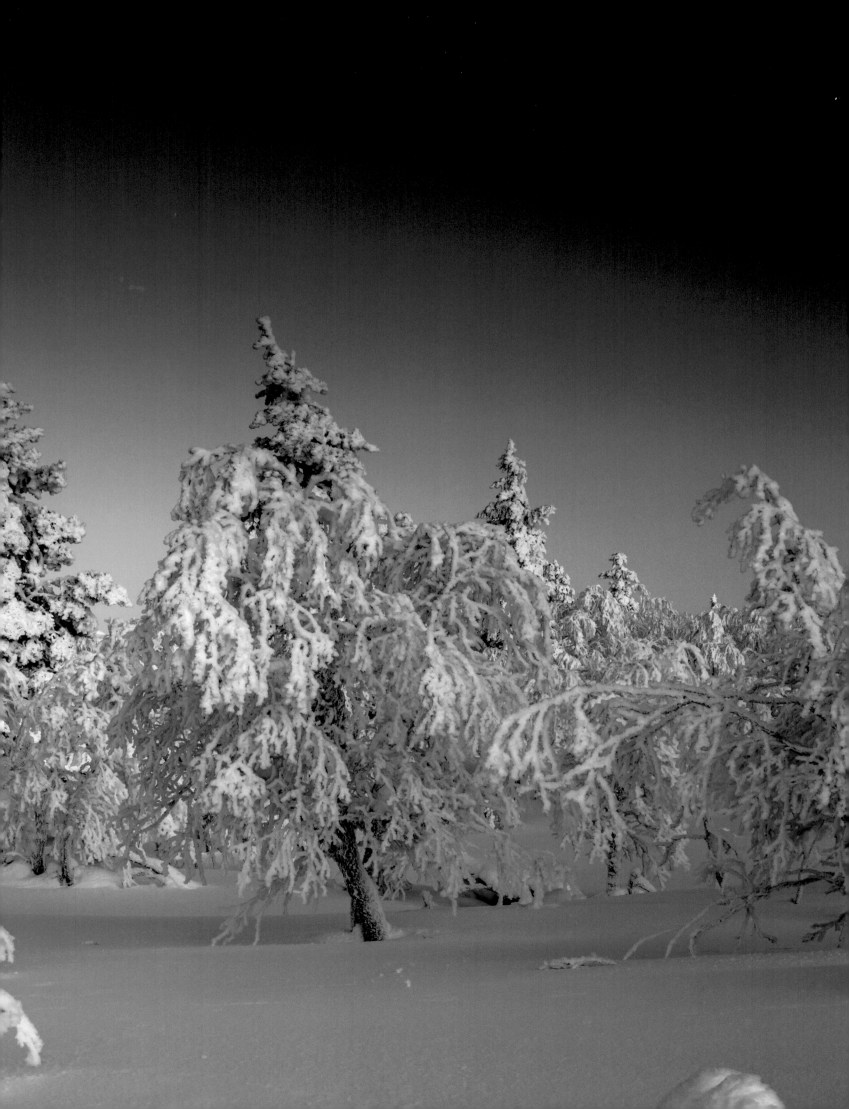

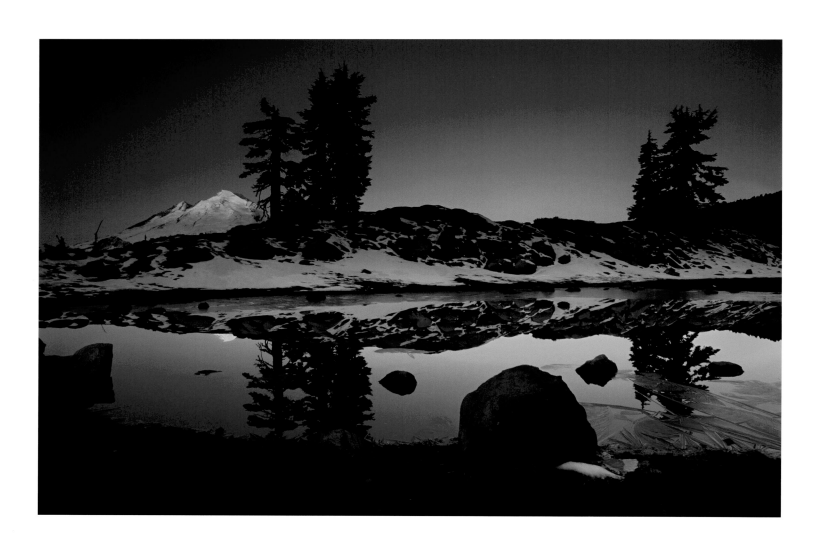

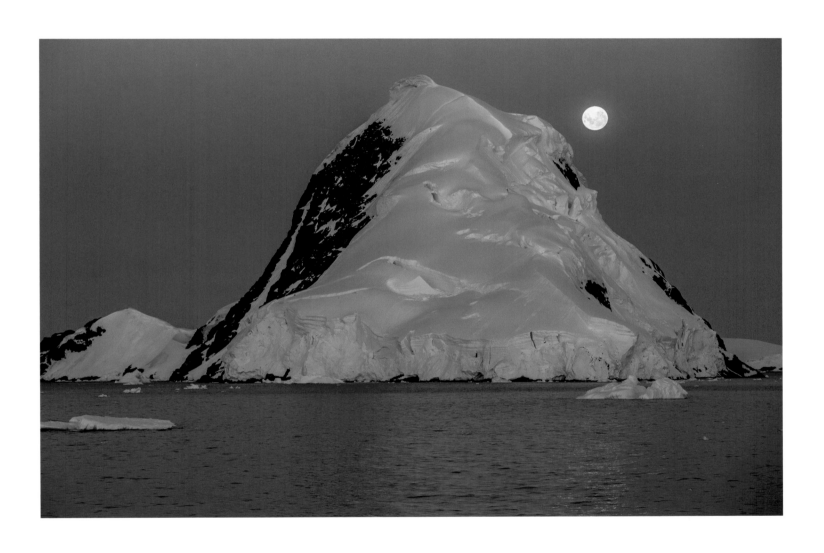

PREVIOUS PAGES: Moon over a snowbound northern forest. Lapland, Finland
OPPOSITE: Sunrise, Austin Pass, Mount Baker Wilderness, Washington, USA
ABOVE: Moonrise, Lemaire Channel, Antarctica

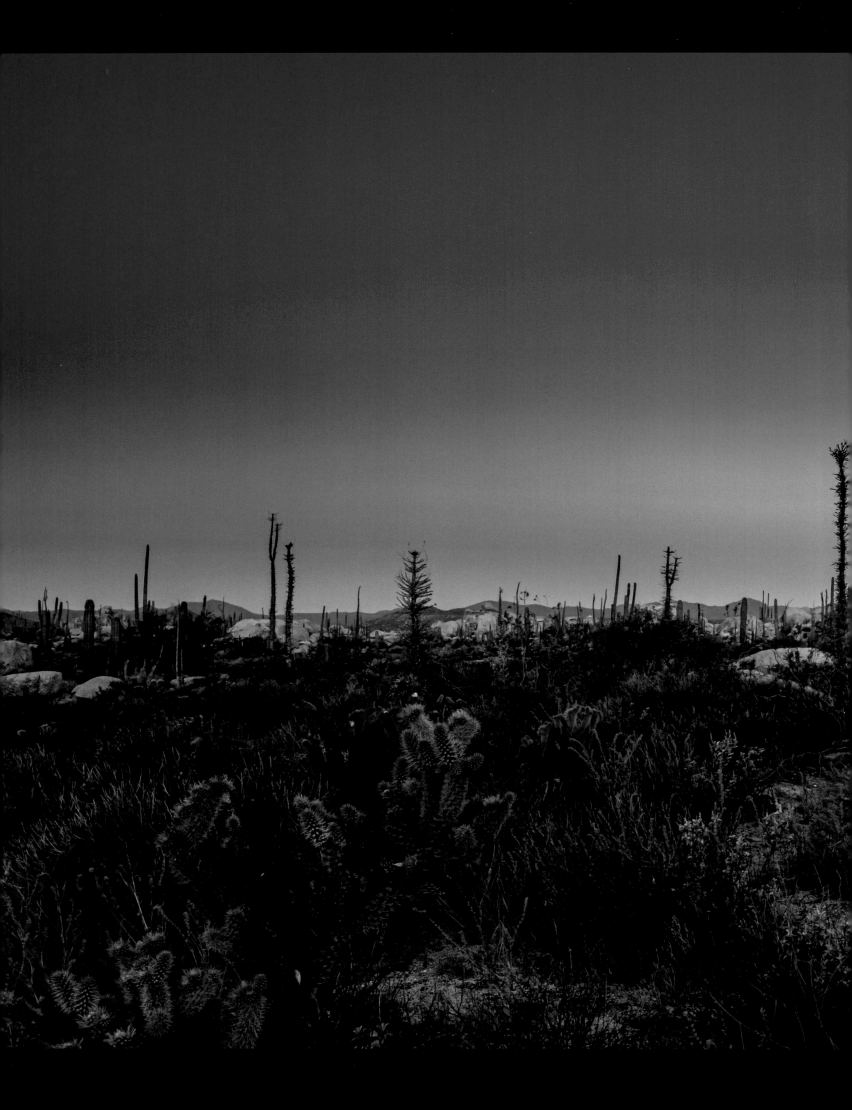

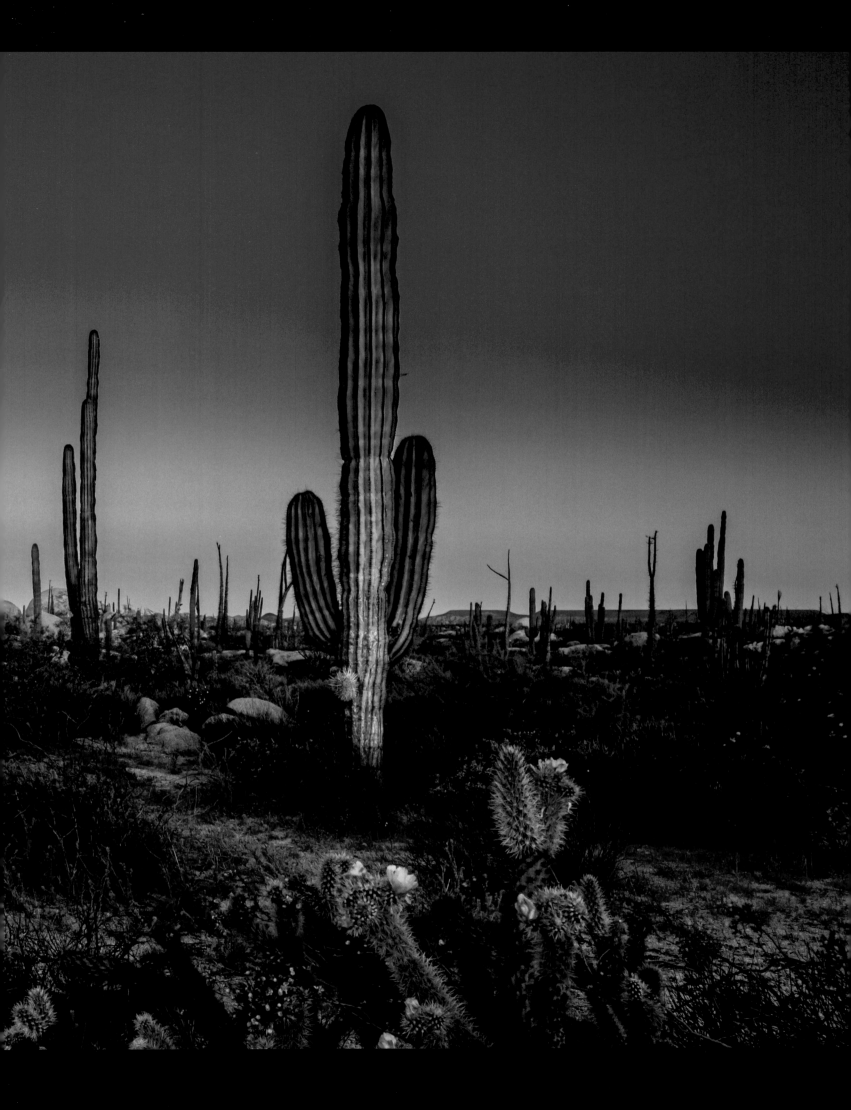

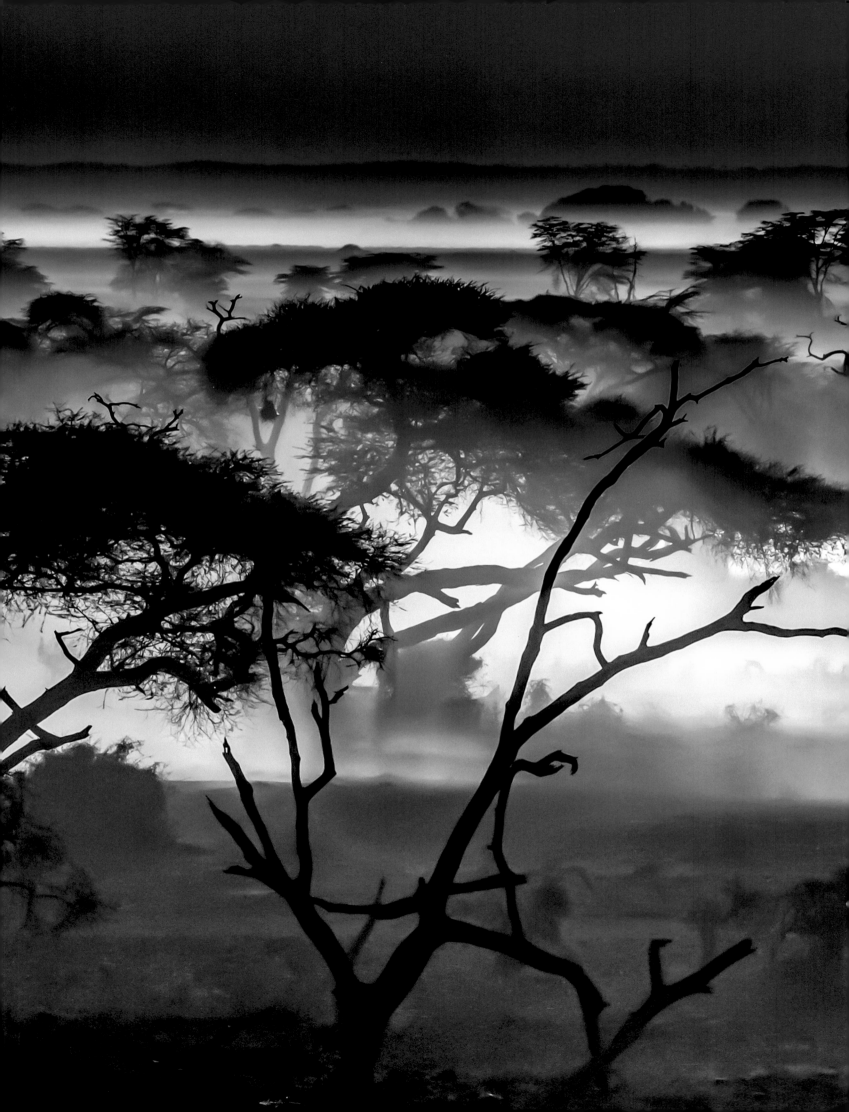

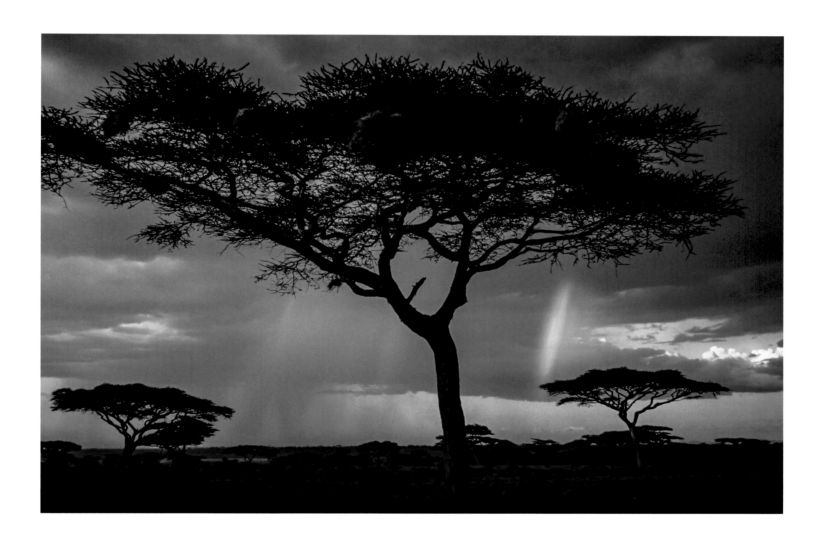

PREVIOUS PAGES: Cataviña Desert, Baja California, Mexico
OPPOSITE: Dust sifts through the acacia savanna of Amboseli National Park, Kajiado, Kenya
ABOVE: A storm rolls through Serengeti National Park, Mara, Tanzania

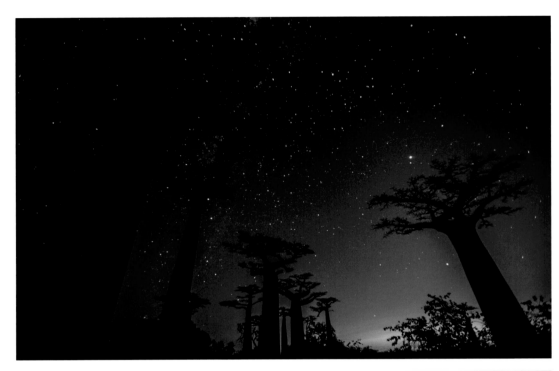

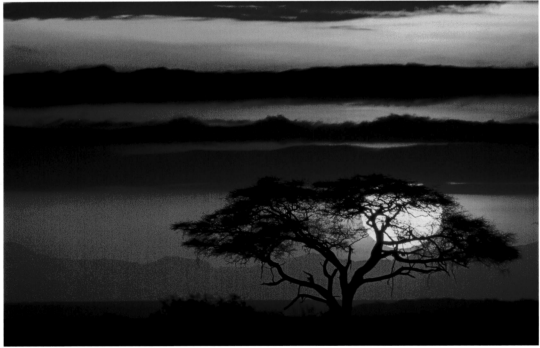

ABOVE TOP: Milky Way over Avenue of the Baobabs (*Adansonia grandidieri*), Menabe, Madagascar
ABOVE BOTTOM: Sunset and acacia, Amboseli National Park, Kajiado, Kenya
OPPOSITE: Joshua trees (*Yucca brevifolia*) at sunrise, Joshua Tree National Park, California, USA
FOLLOWING PAGES: Bushfire, Arnhem Land, Northern Territory, Australia

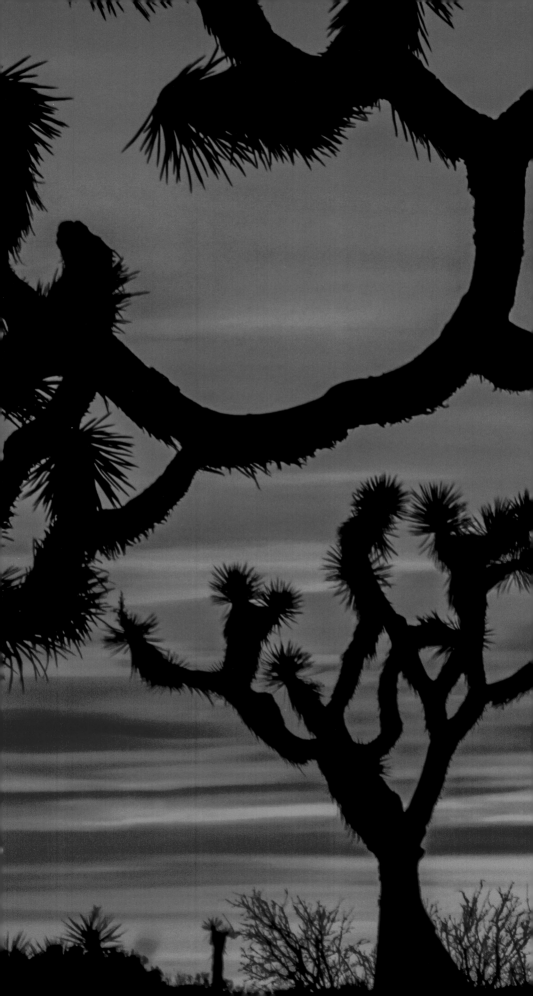

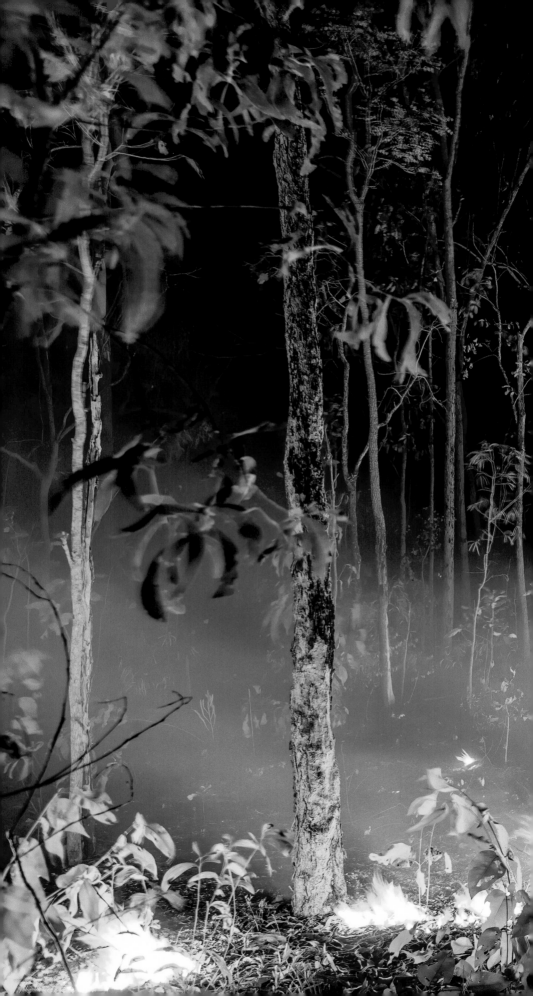

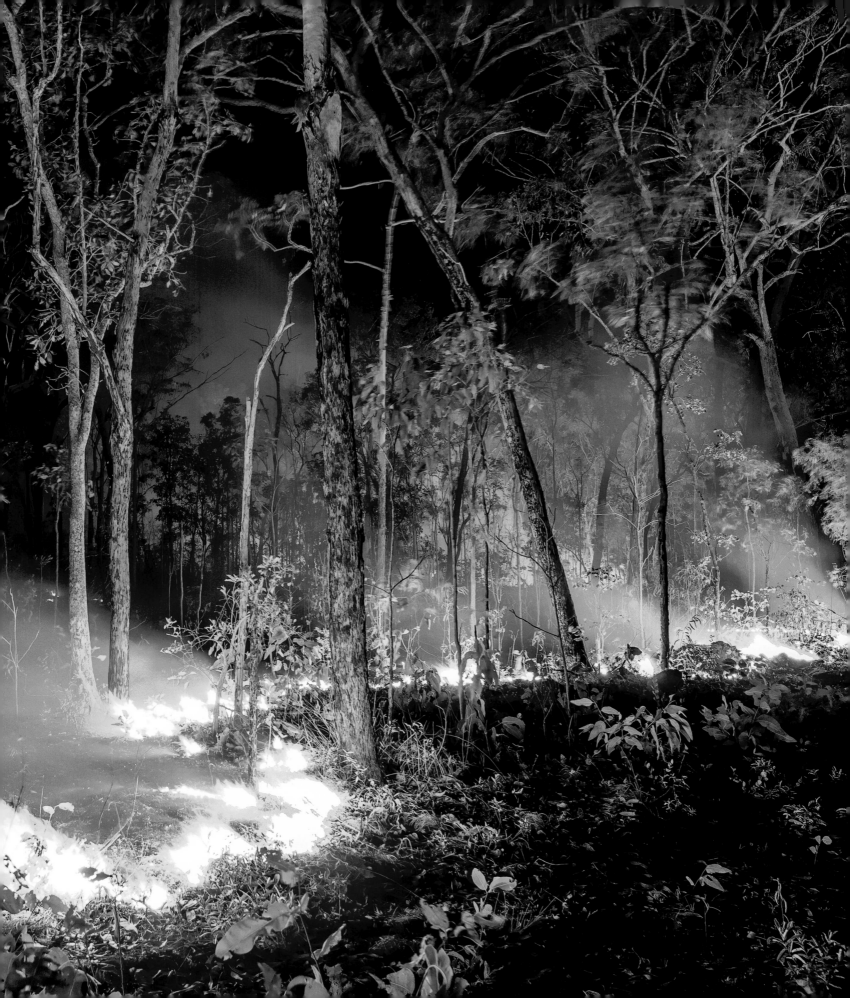

ABOVE: Stars over calcified camel thorns (*Vachellia erioloba*),
Namib-Naukluft National Park, Hardap, Namibia
OPPOSITE: Milky Way and alpine firs (*Abies lasiocarpa*),
Mount Rainier National Park, Washington, USA
FOLLOWING PAGES: Jedediah Smith Redwoods State Park, California, USA

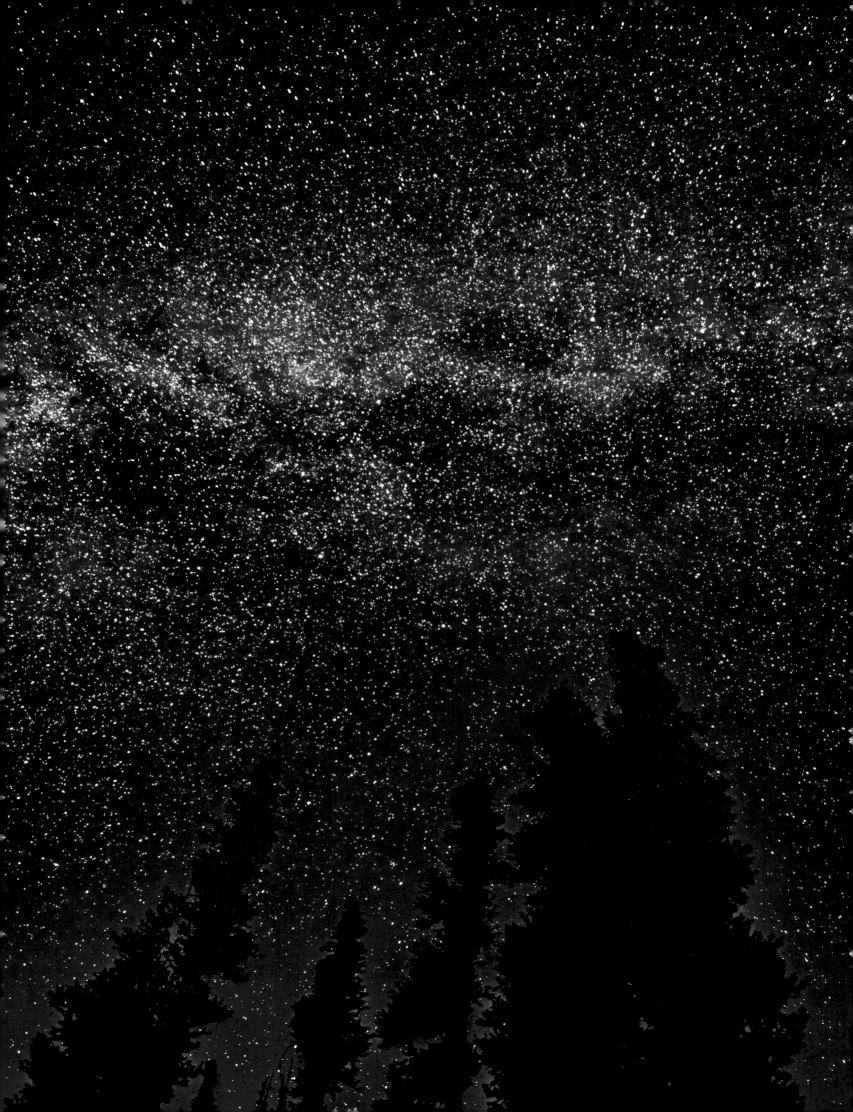

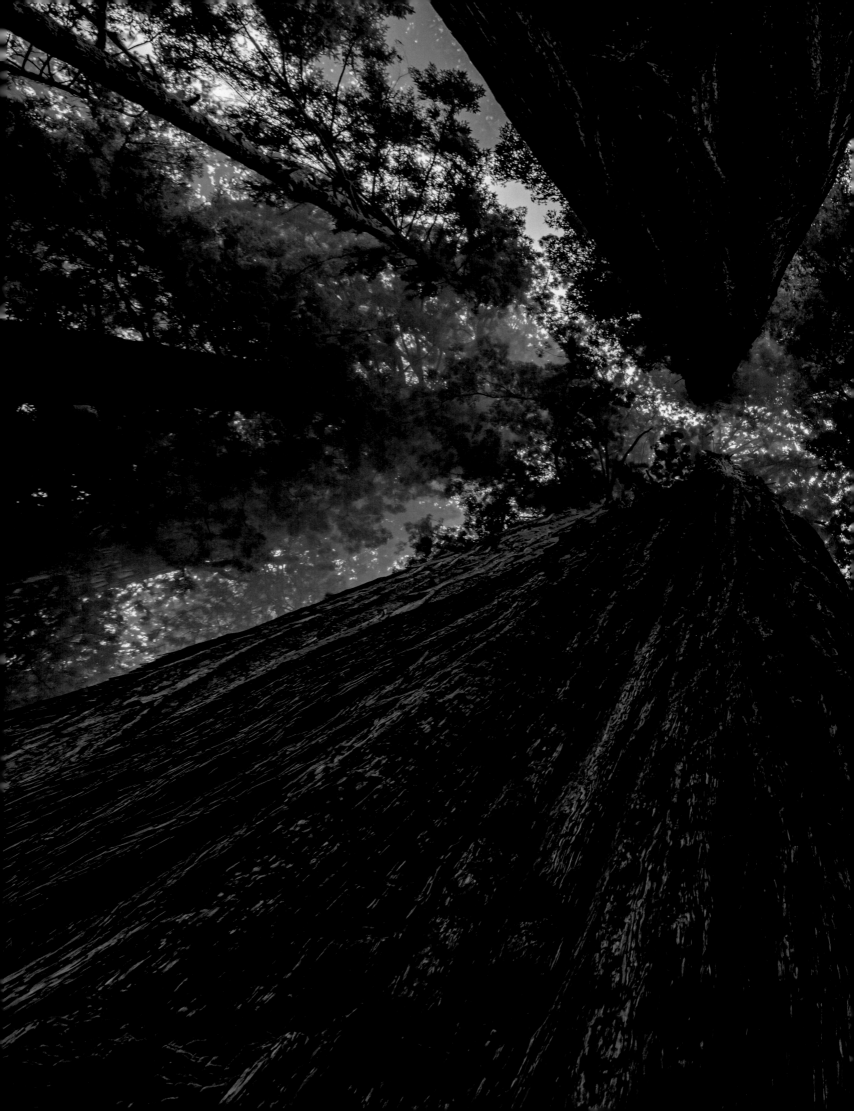

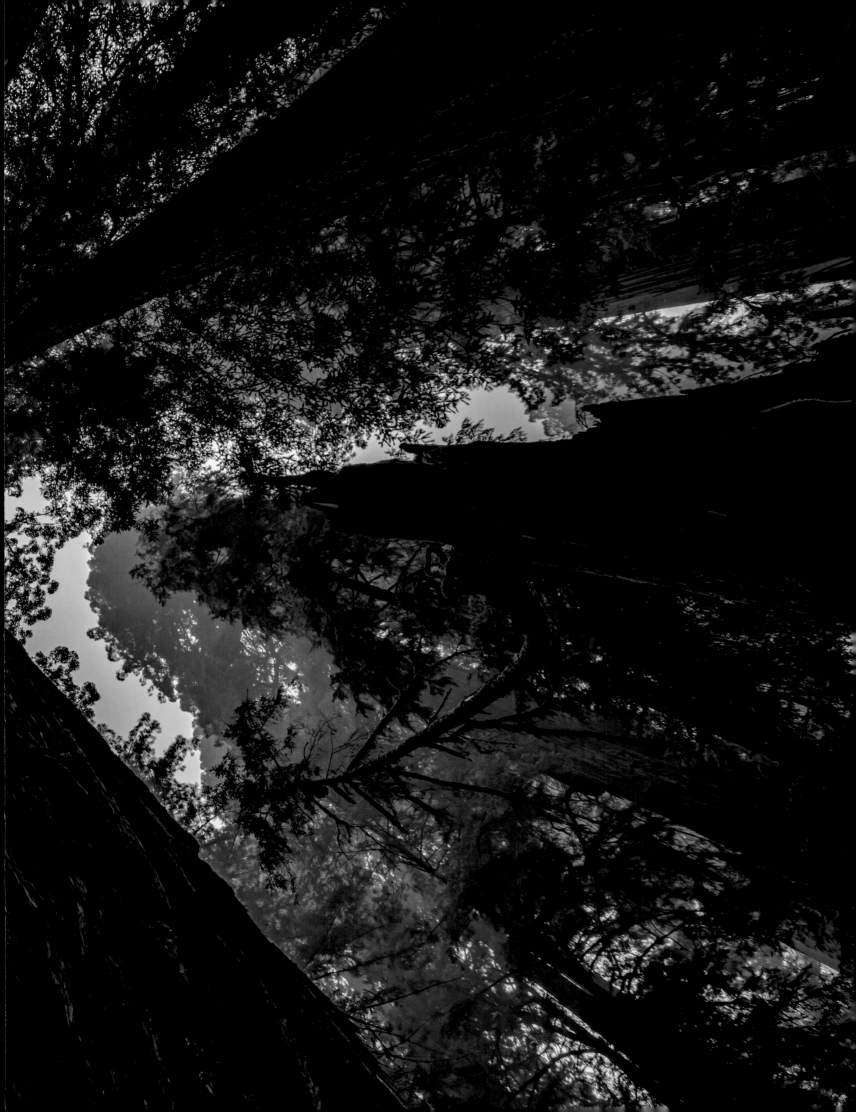

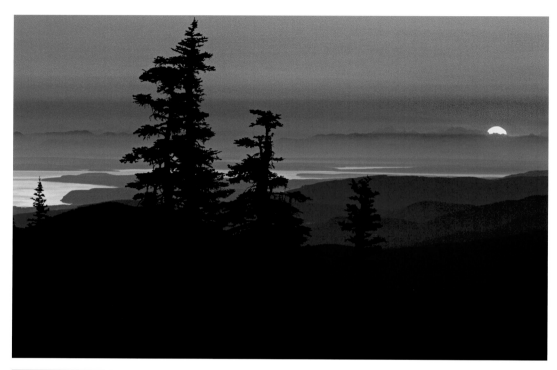

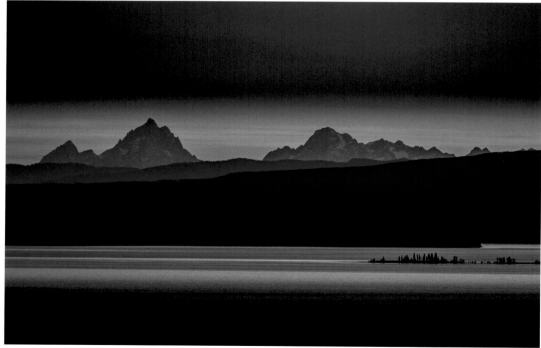

ABOVE TOP: Sunrise over Puget Sound, Olympic National Park, Washington, USA
ABOVE BOTTOM: Yellowstone Lake with Teton Range in distance,
Yellowstone National Park, Wyoming, USA

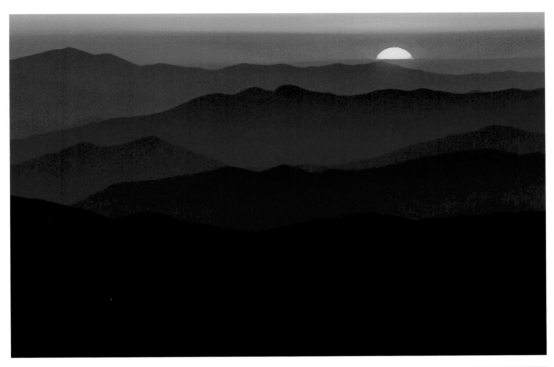

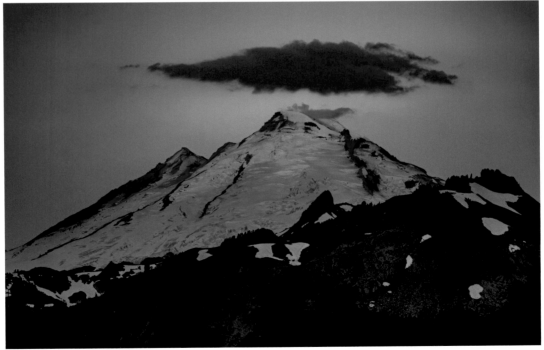

ABOVE TOP: Sunset over the Smoky Mountains, North Carolina, USA
ABOVE BOTTOM: Mount Baker, Mount Baker Wilderness, Washington, USA

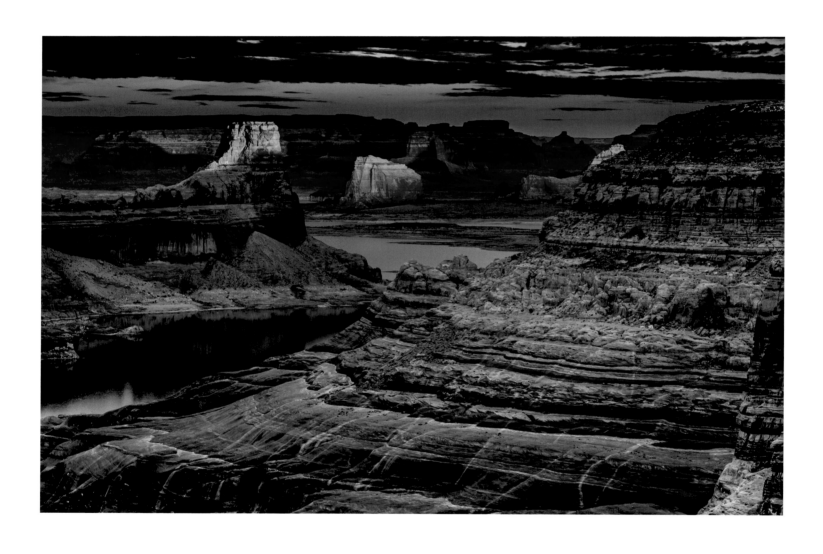

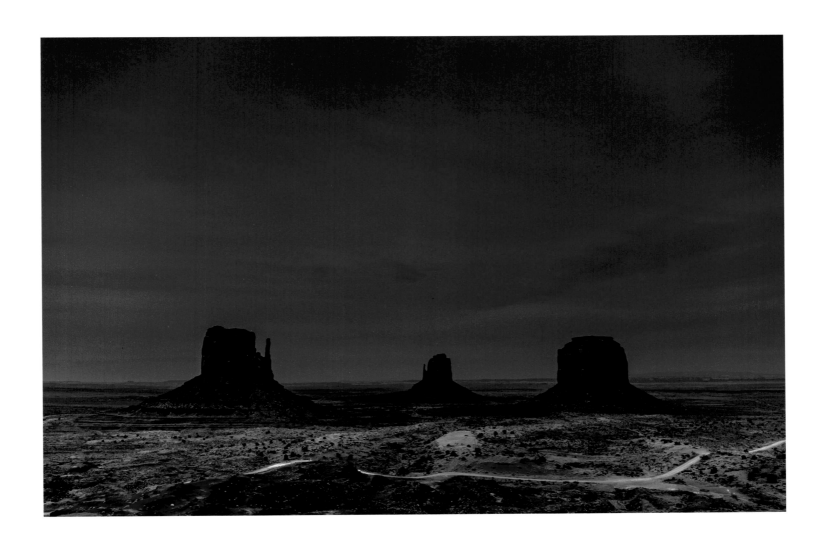

OPPOSITE: Lake Powell, Glen Canyon National Recreation Area, Utah, USA
ABOVE: Monument Valley, Utah and Arizona, USA
FOLLOWING PAGES: Half Dome, Yosemite National Park, California, USA

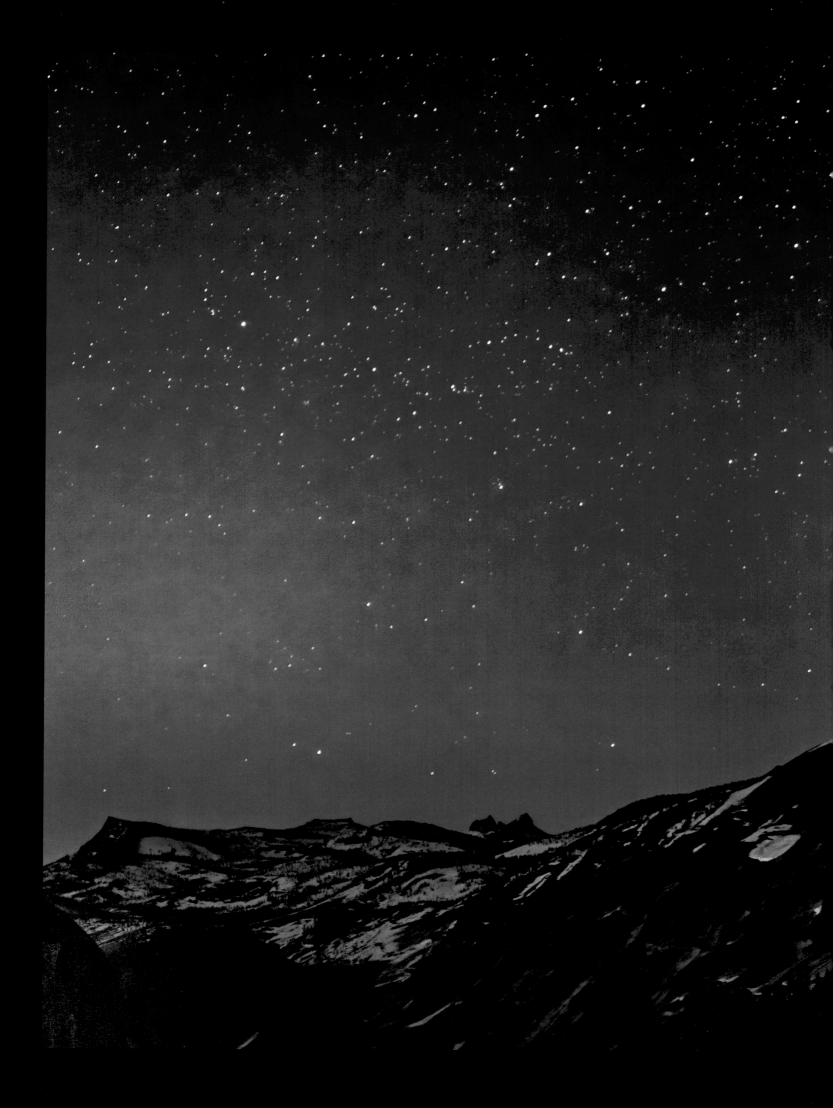

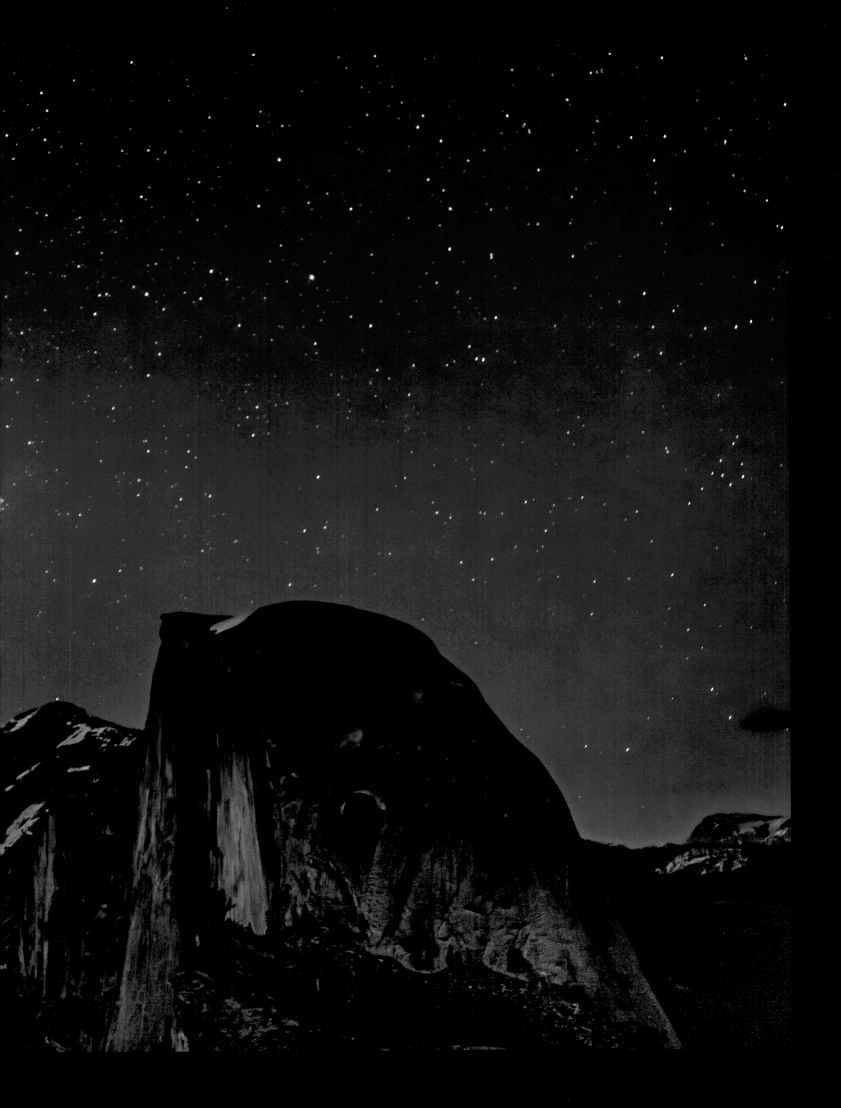

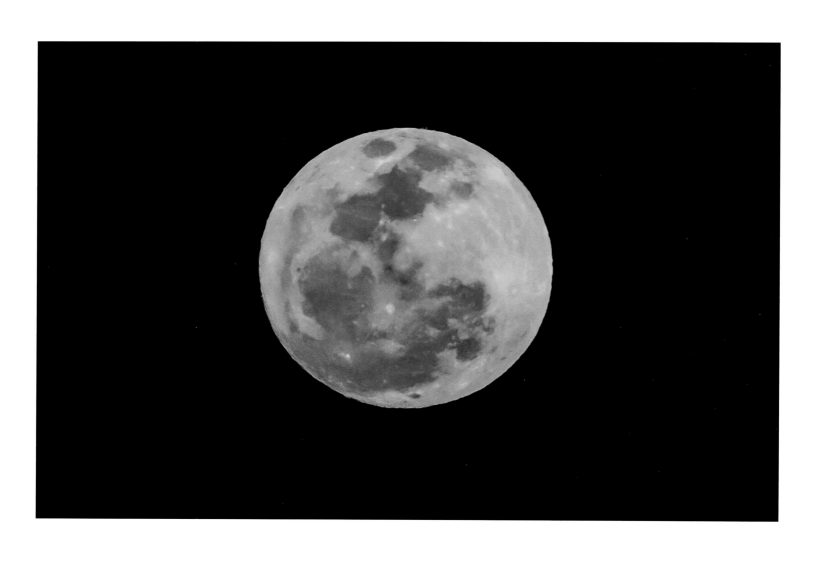

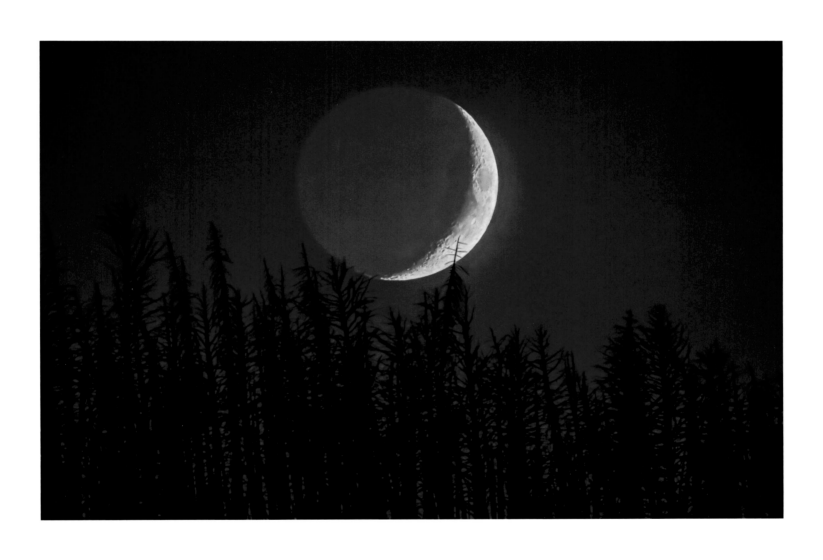

OPPOSITE: Full moon, Namib-Naukluft National Park, Hardap, Namibia
ABOVE: New moon, Yellowstone National Park, Wyoming, USA

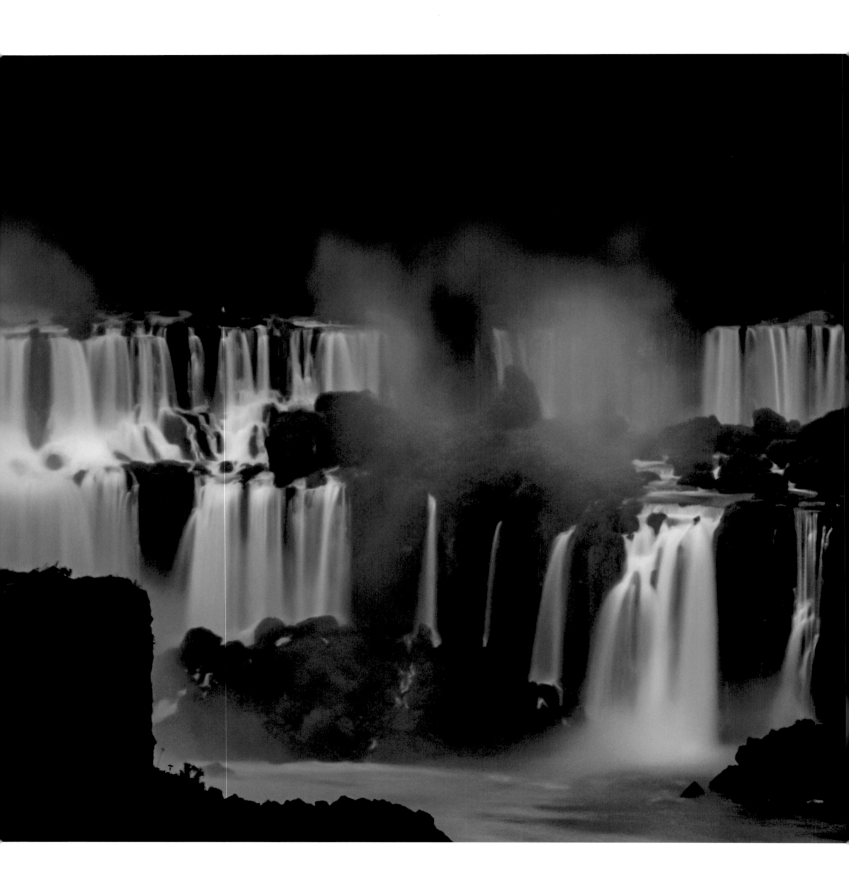

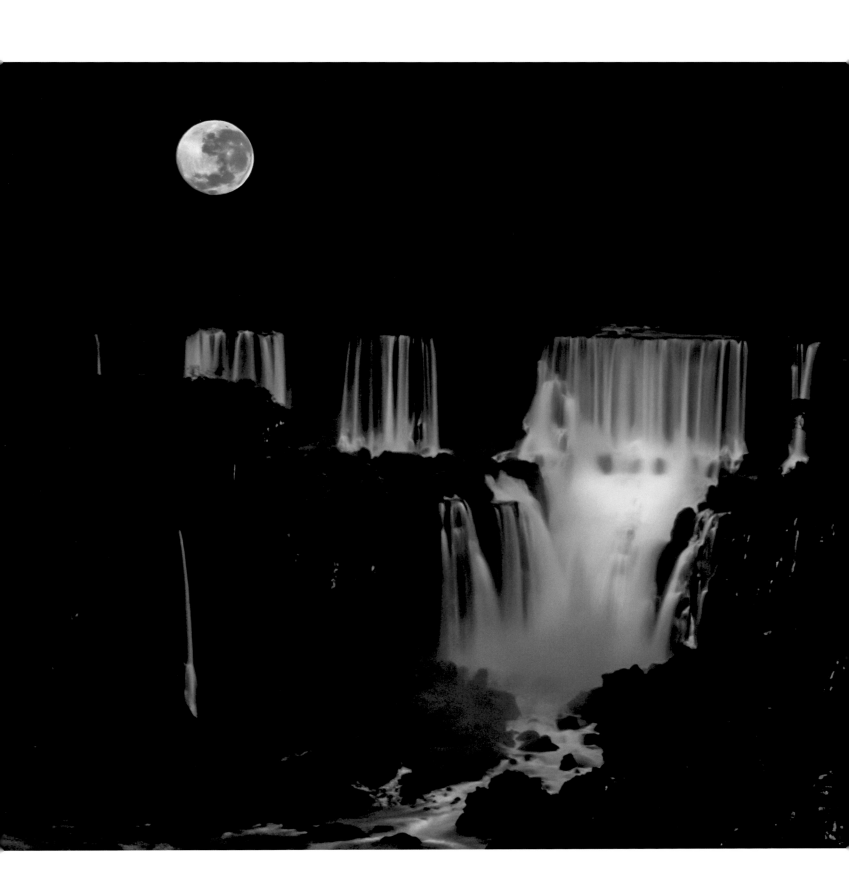

Moonset, Iguazú Falls, Iguazú National Park, Argentina

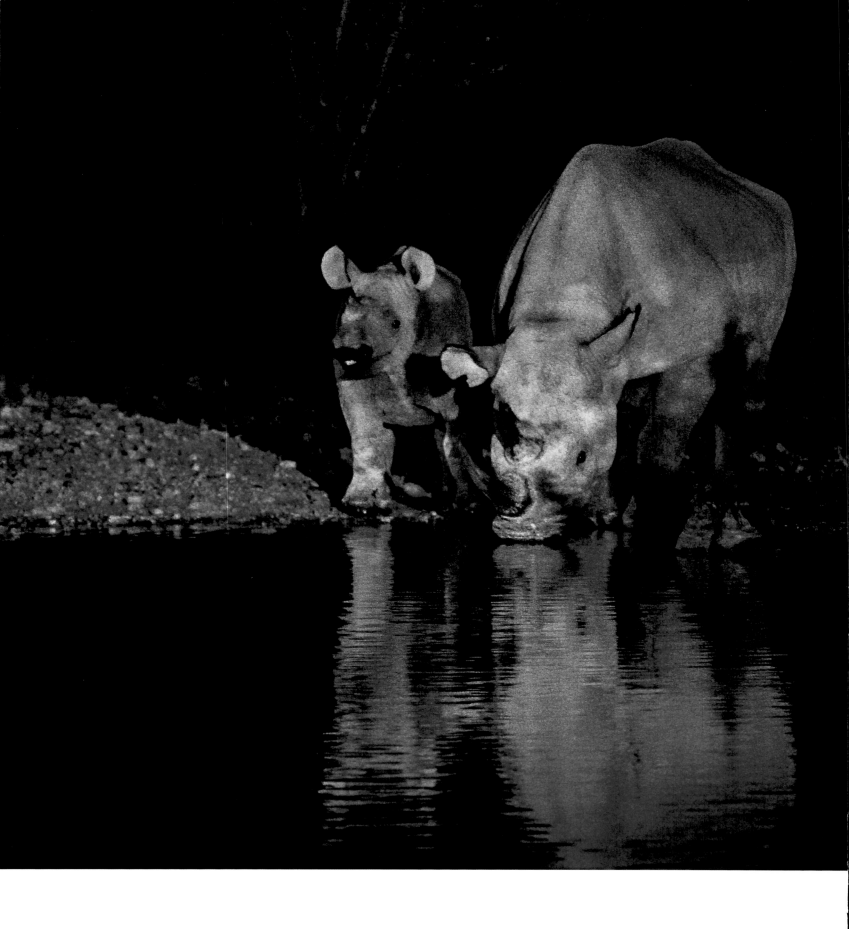

THE CREATURES OF THE NIGHT

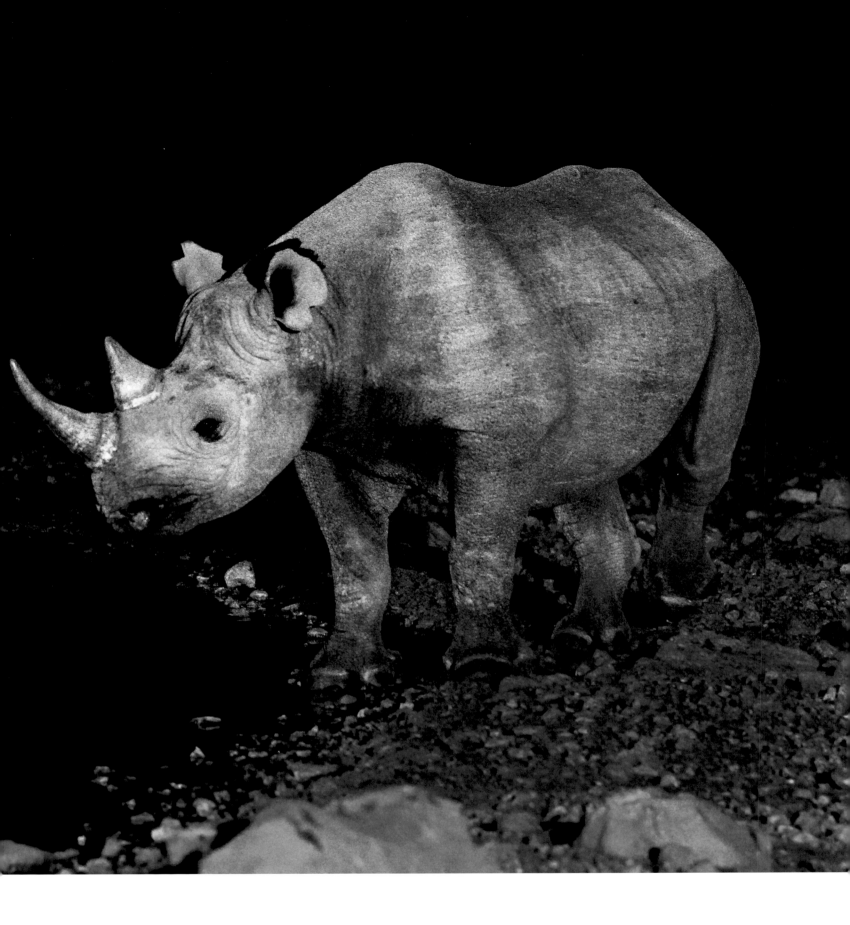

Some come alive in the dark and sacred hours. The whisper-soft flutter of an owl taking flight, the cackle of a hyena, and the hushed tread of a cougar—all carry through the evening quiet to spread the news that the world is asleep. Whether feathered or furred, predator or prey, creatures abandon the nest, leave the den, and explore the shadows during these magical nighttime hours. It's a different world in shade.

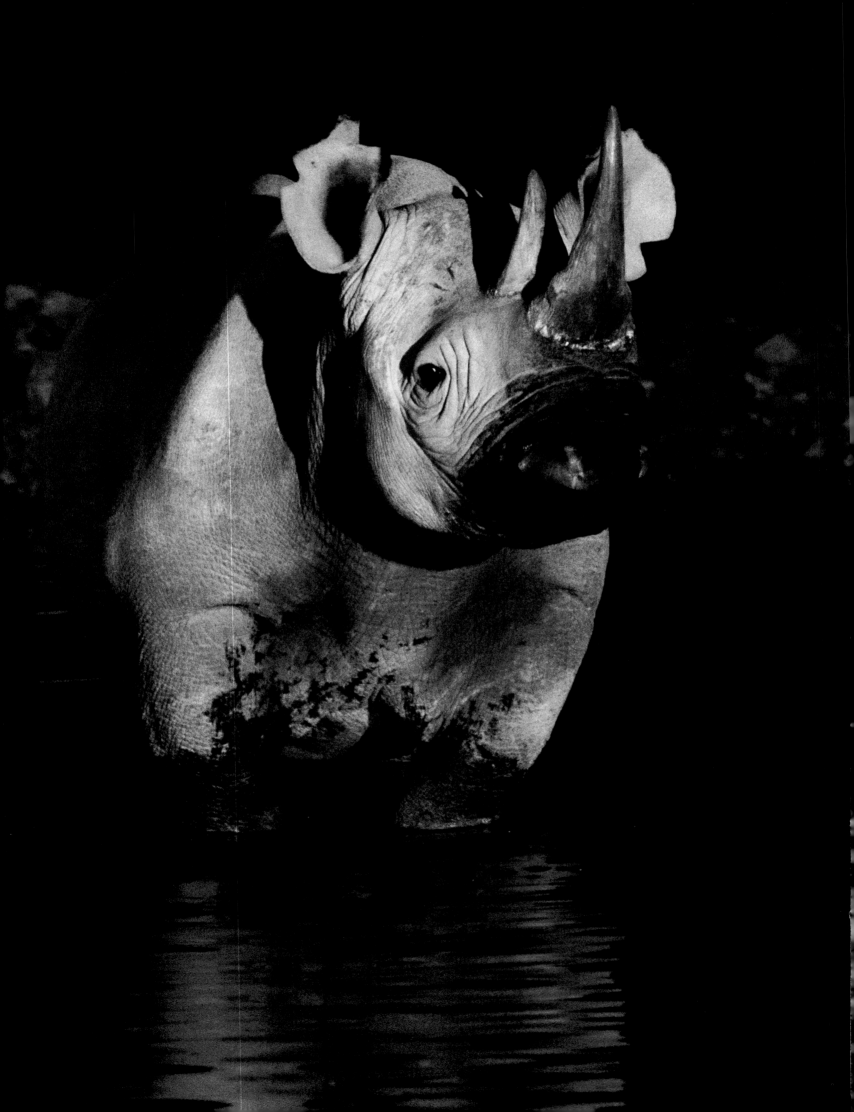

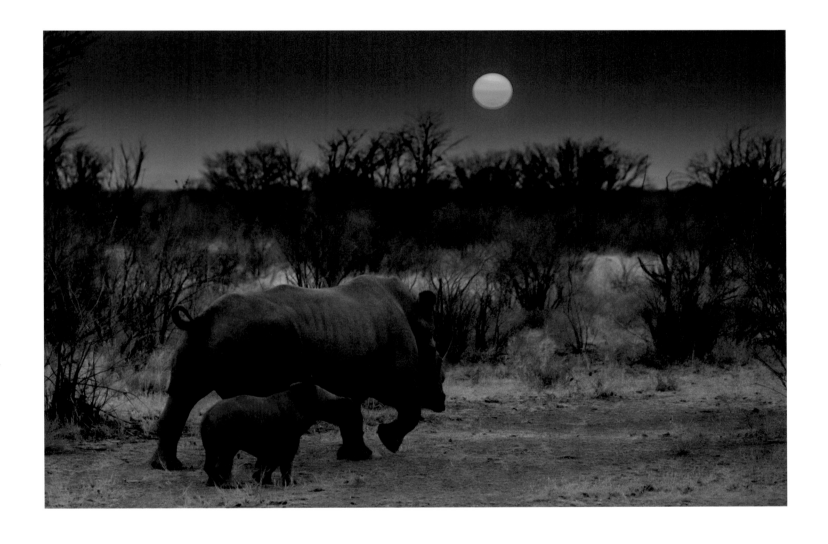

CHAPTER OPENER AND OPPOSITE: Black rhinoceros (*Diceros bicornis*),
Etosha National Park, Kunene, Namibia
ABOVE: White rhinoceros (*Ceratotherium simum*) and calf, Etosha National Park, Kunene, Namibia

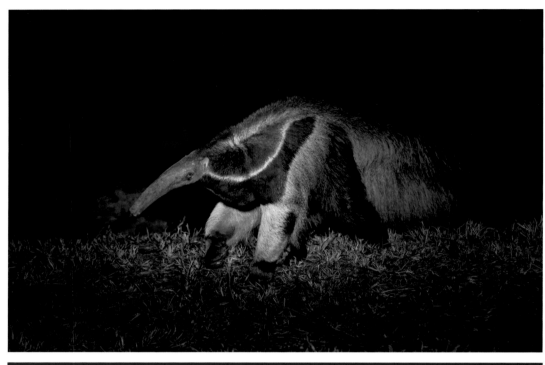

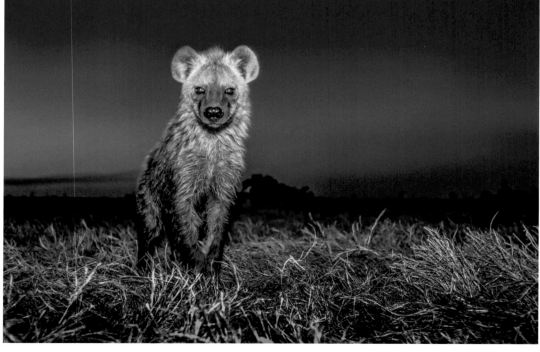

ABOVE TOP: Giant anteater (*Myrmecophaga tridactyla*), Pantanal, Mato Grosso, Brazil
ABOVE BOTTOM: Spotted hyenas (*Crocuta crocuta*) are active day and night,
Okavango Delta, Ngamiland, Botswana

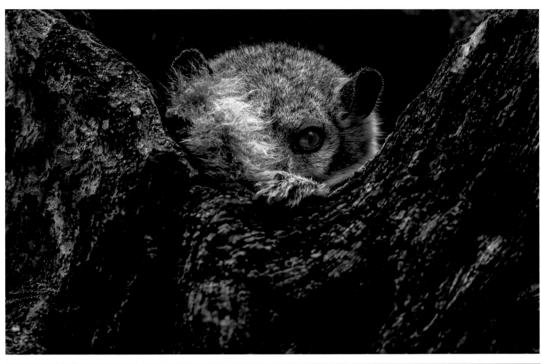

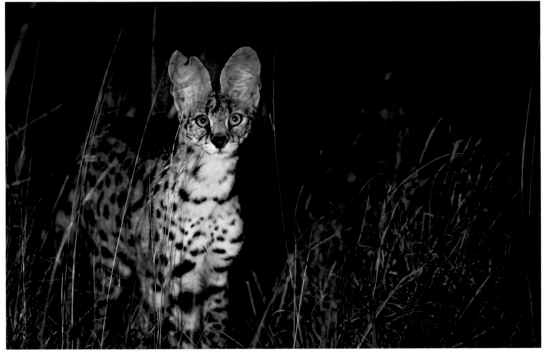

ABOVE TOP: White-footed sportive lemur (*Lepilemur leucopus*), Toamasina, Madagascar
ABOVE BOTTOM: Serval (*Leptailurus serval*), Chyulu Hills National Park, Makueni, Kenya

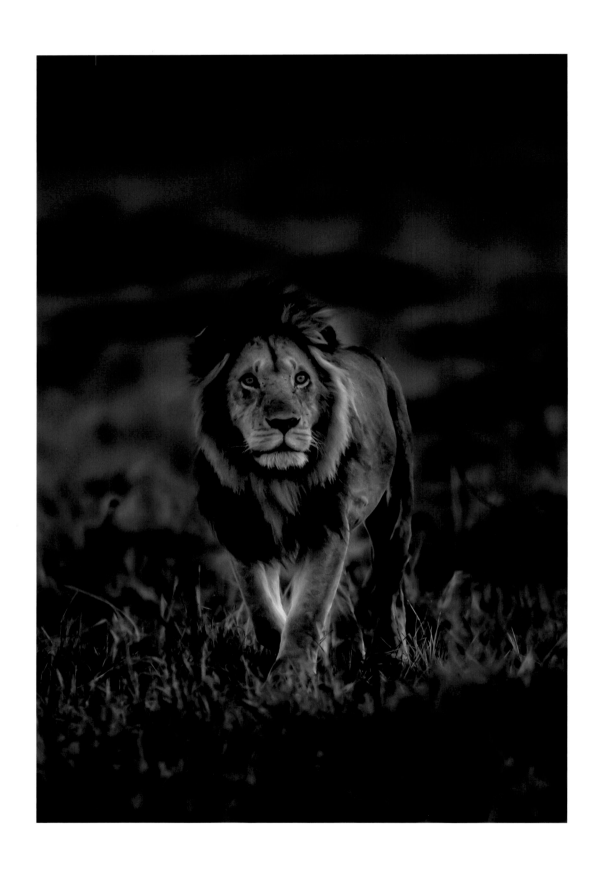

ABOVE: African lion (*Panthera leo*), Maasai Mara National Reserve, Narok, Kenya
OPPOSITE: African lions (*Panthera leo*), Okavango Delta, Ngamiland, Botswana

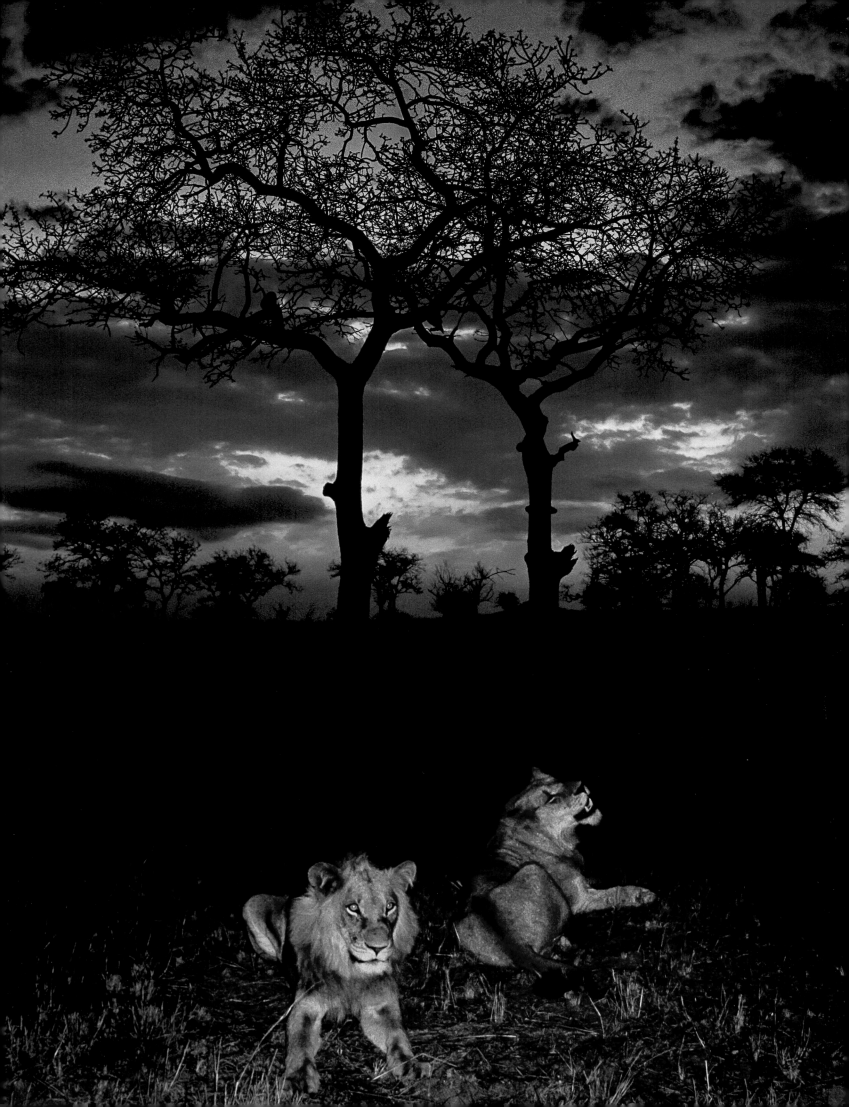

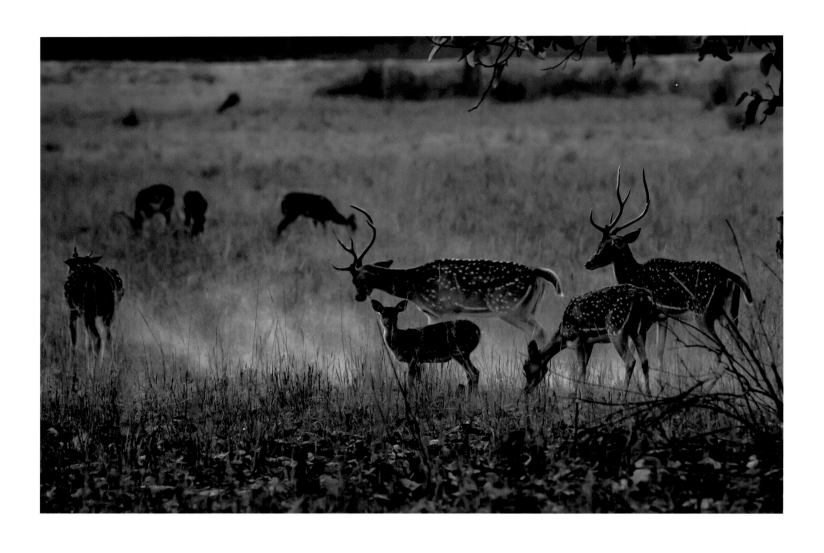

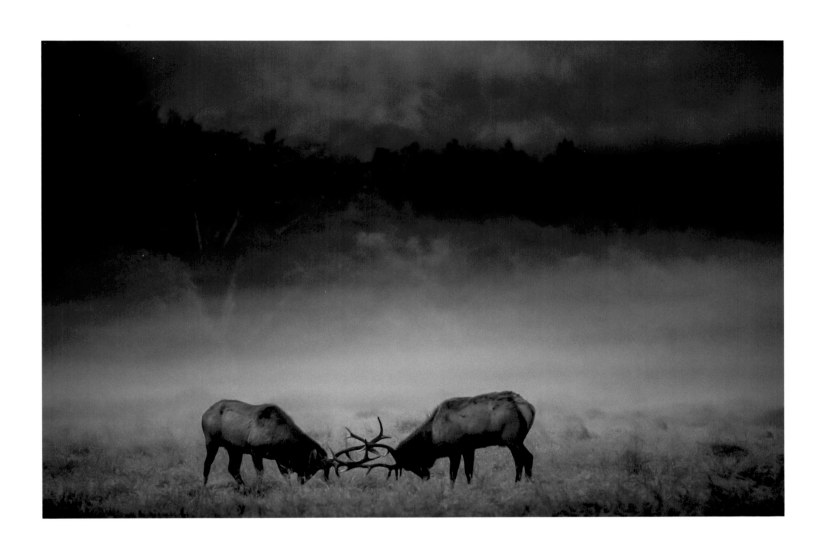

OPPOSITE: Alert for tigers, chital (*Axis axis*) graze at the margins of the day,
Bandhavgarh National Park, Madhya Pradesh, India
ABOVE: Roosevelt elk bulls (*Cervus canadensis roosevelti*) spar in fog at dawn,
Redwood National Park, California, USA
FOLLOWING PAGES: Common eland (*Taurotragus oryx*) and impala
(*Aepyceros melampus*), Central District, Botswana

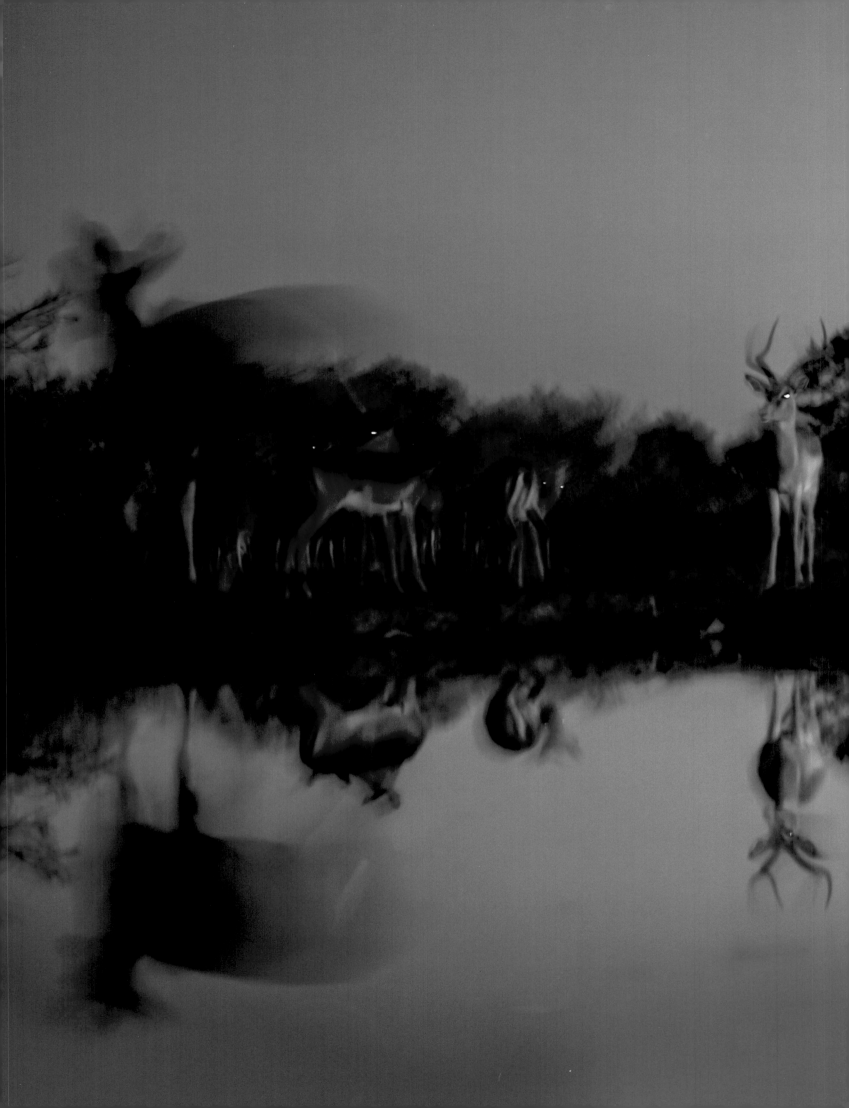

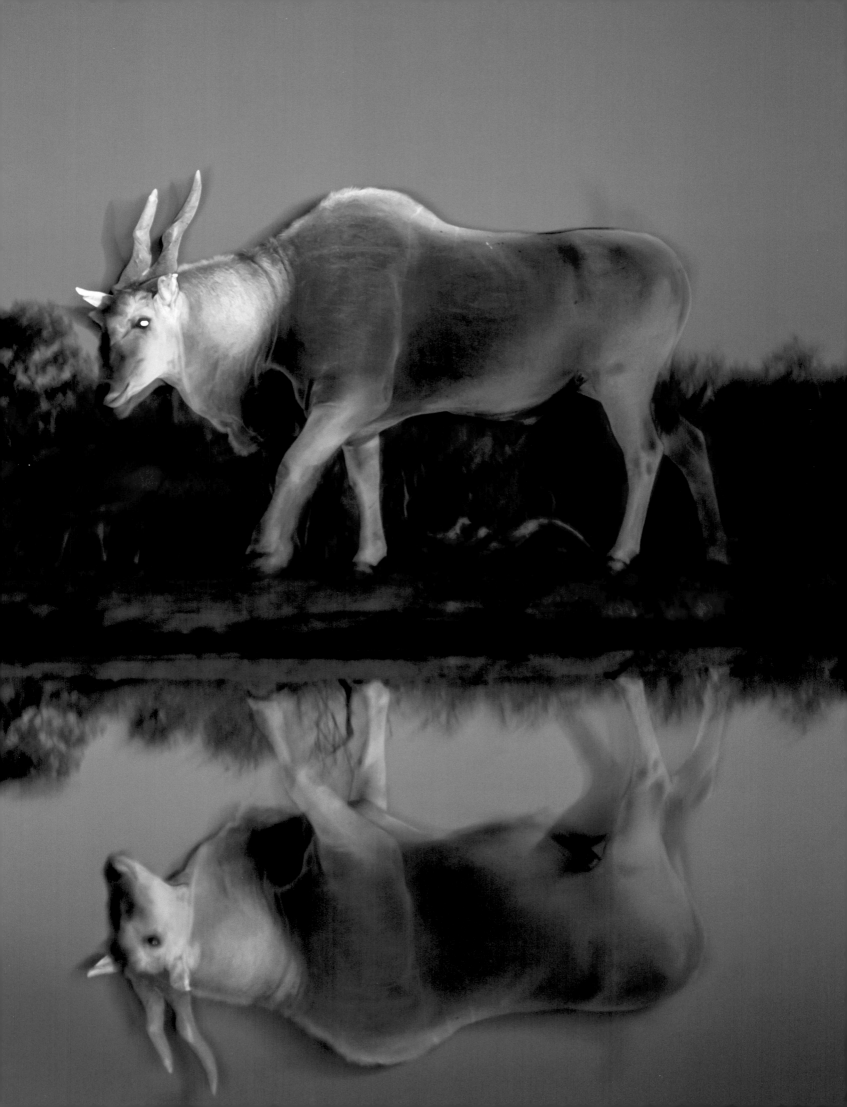

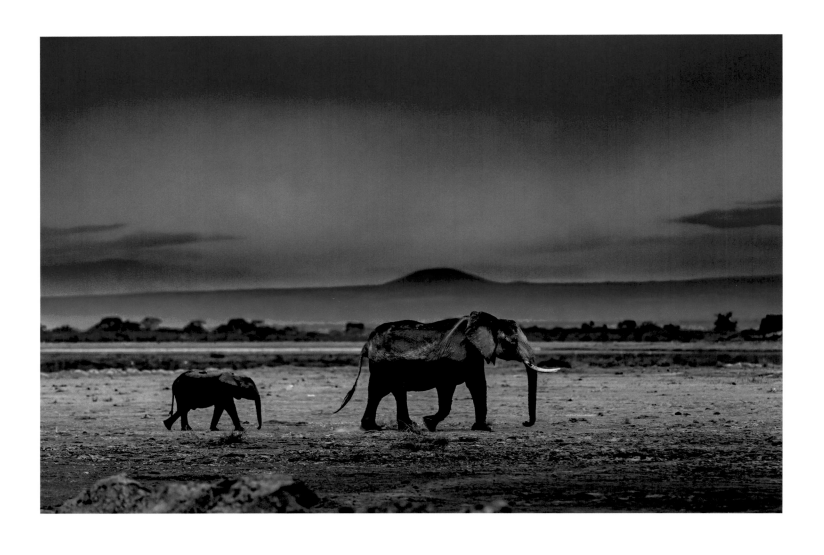

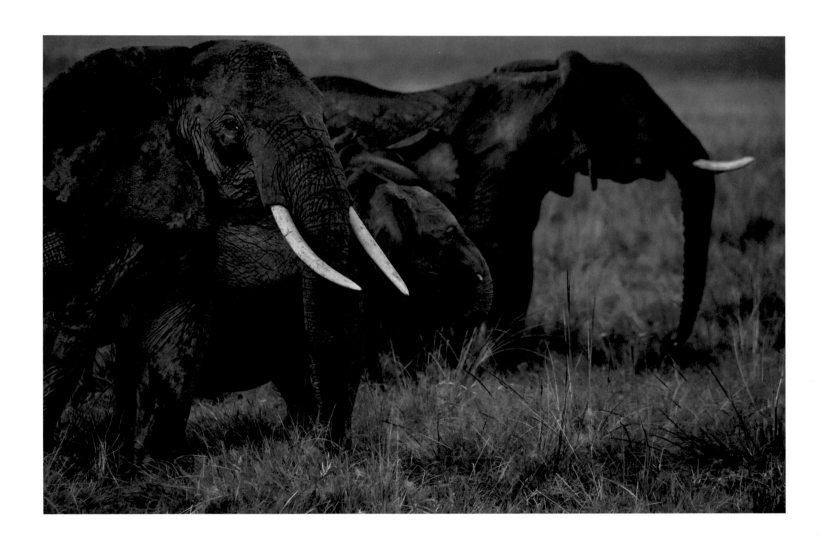

OPPOSITE: African bush elephant and calf (*Loxodonta africana*) on the move,
Amboseli National Park, Kajiado, Kenya
ABOVE: African bush elephants (*Loxodonta africana*), Olare Motorogi Conservancy, Narok, Kenya

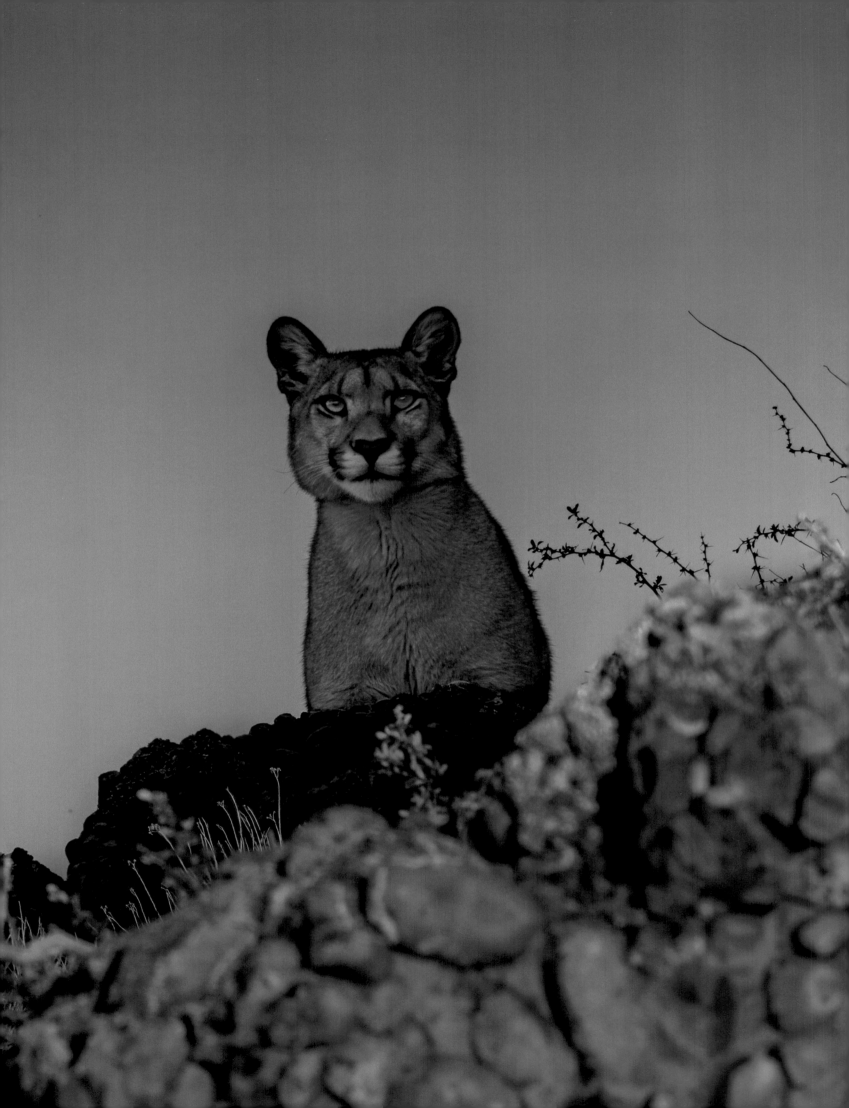

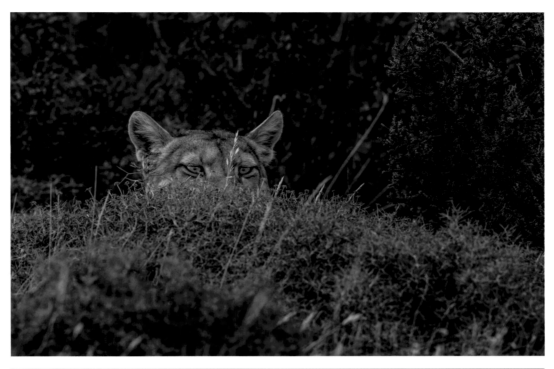

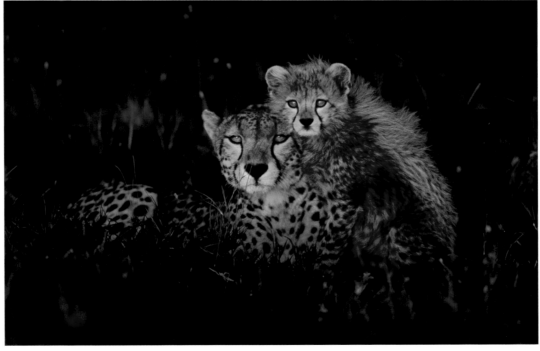

OPPOSITE AND ABOVE TOP: South American cougar or puma (*Puma concolor concolor*),
Torres del Paine National Park, Magallanes and Chilean Antarctica, Chile
ABOVE BOTTOM: Cheetah and cub (*Acinonyx jubatus*), Serengeti National Park, Mara, Tanzania

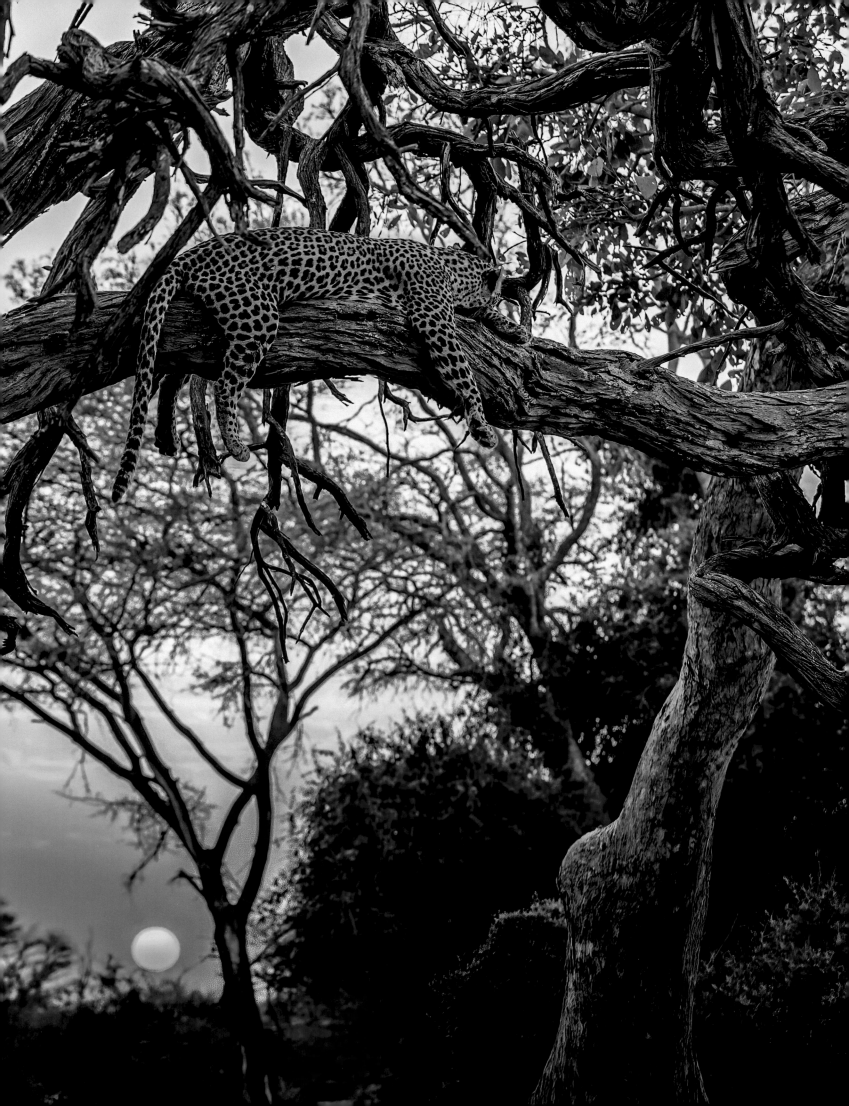

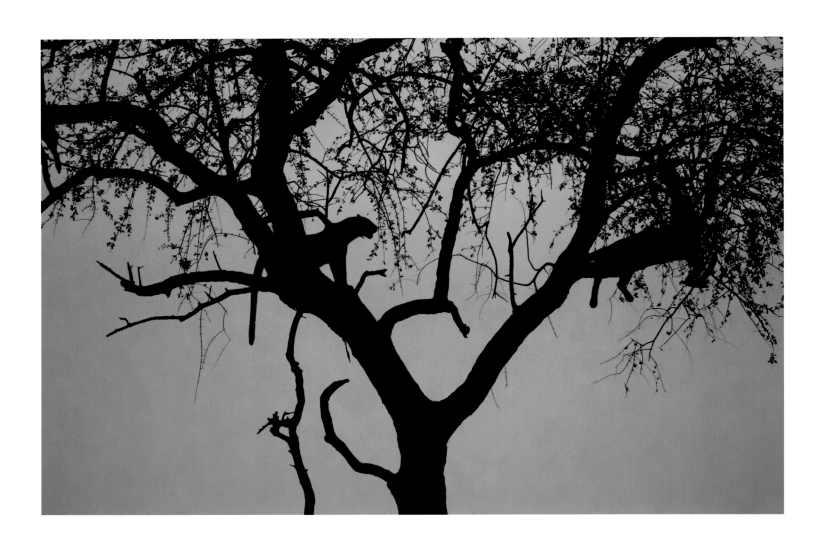

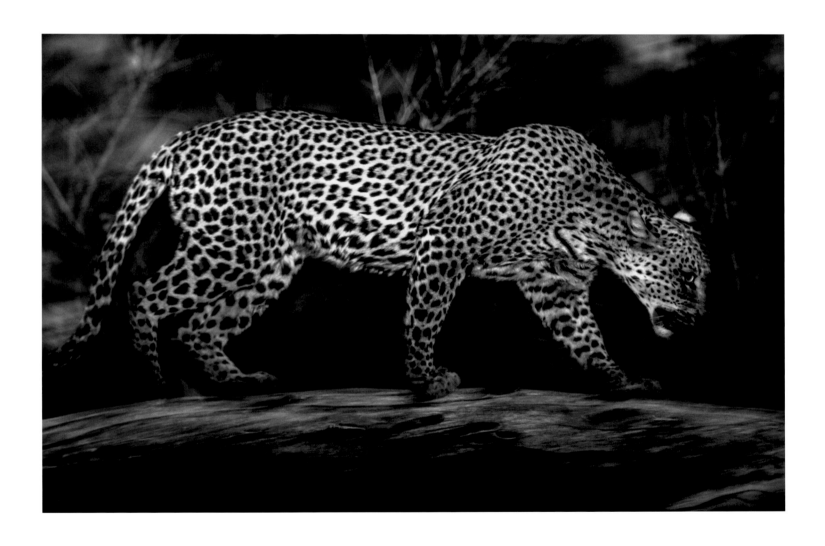

PREVIOUS PAGES: Leopard (*Panthera pardus*) in thorn tree (*Vachellia* sp.),
Chobe National Park, Ngamiland, Botswana
OPPOSITE: Leopards (*Panthera pardus*), Mashatu Reserve, Central District, Botswana
ABOVE: A leopard (*Panthera pardus*) heads out for a night of prowling, Okavango Delta, Botswana
FOLLOWING PAGES: Camels (*Camelus dromedarius*) on the Rann of Kutch, India

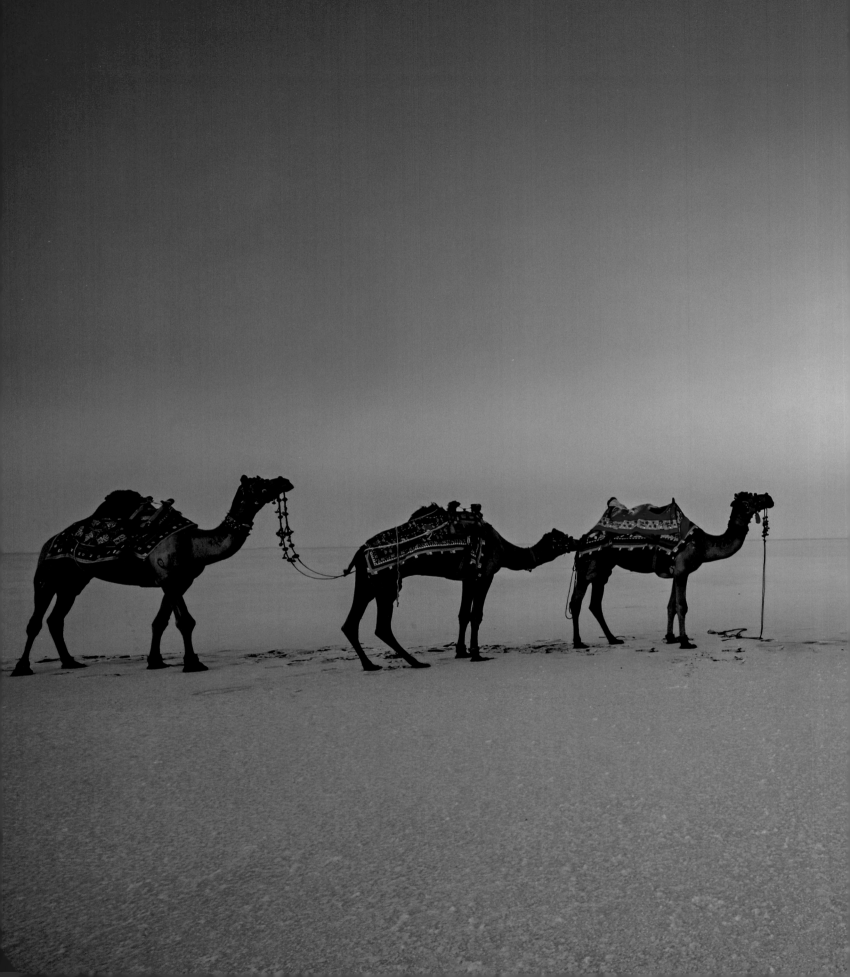

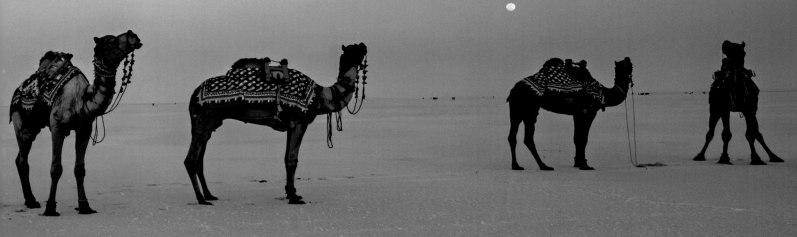

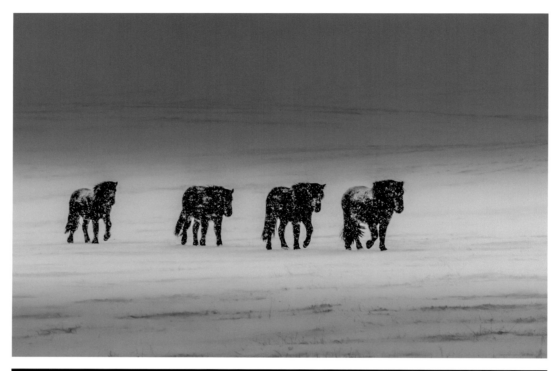

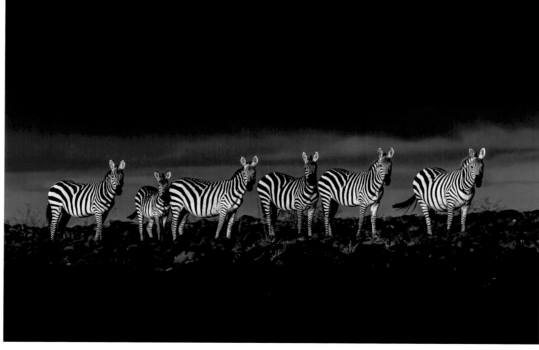

ABOVE TOP: Sturdy and weatherproof Icelandic horses, Southern Region, Iceland
ABOVE BOTTOM: Plains zebras (*Equus quagga*), Amboseli National Park, Kajiado, Kenya

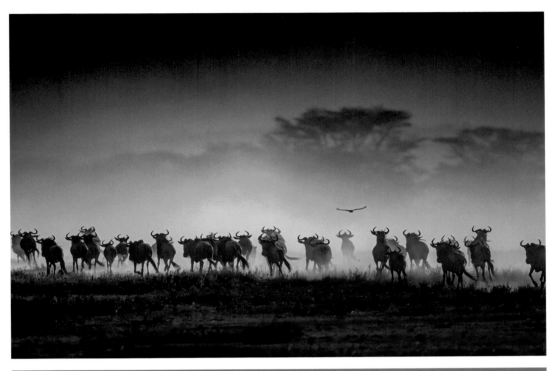

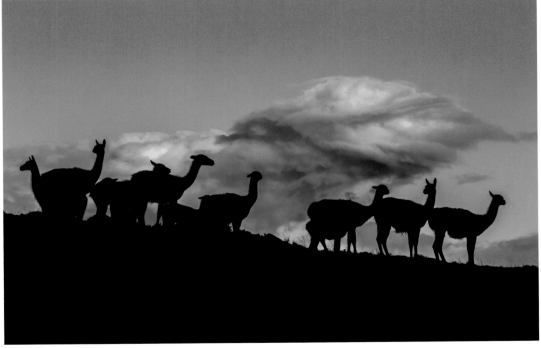

ABOVE TOP: Common wildebeest (*Connochaetes taurinus*), Lake Ndutu, Serengeti Plain, Arusha, Tanzania
ABOVE BOTTOM: Guanacos (*Lama guanicoe*) are silhouetted on a windswept ridge,
Torres del Paine National Park, Magallanes and Chilean Antarctica, Chile
FOLLOWING PAGES: Camargue horses, Camargue, Bouches-du-Rhône, France

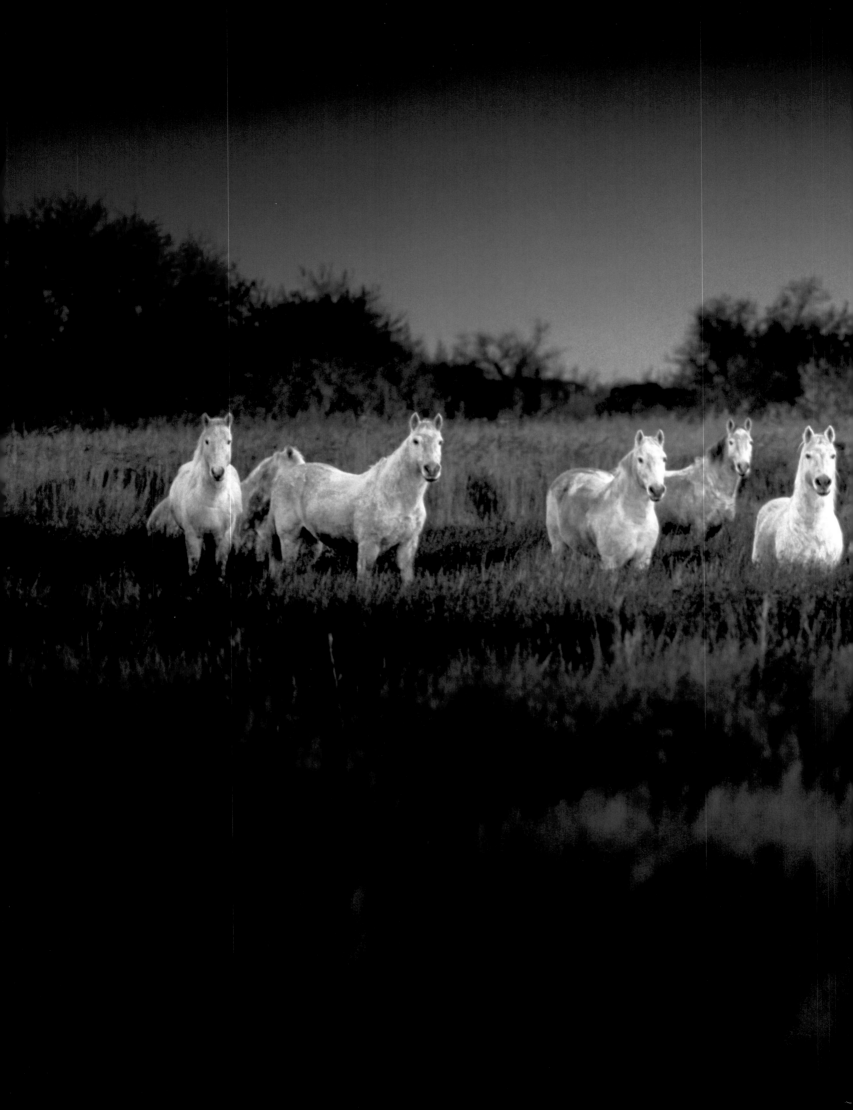

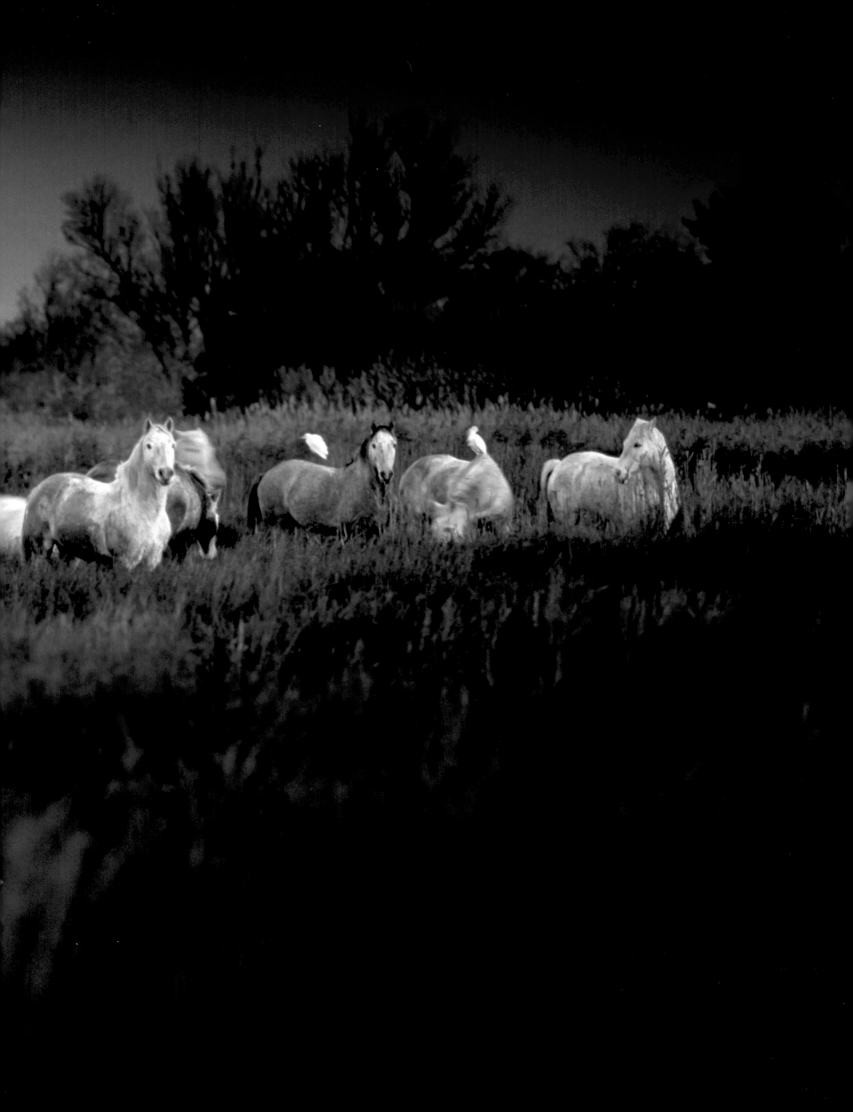

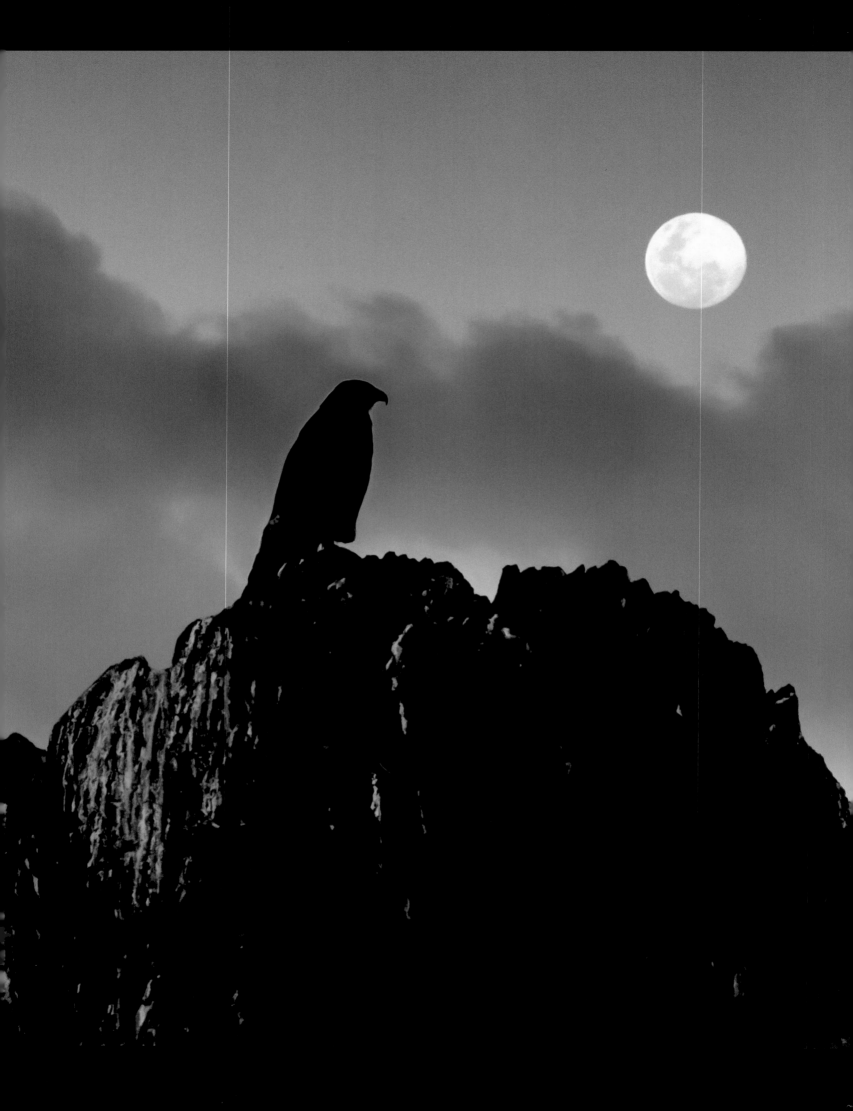

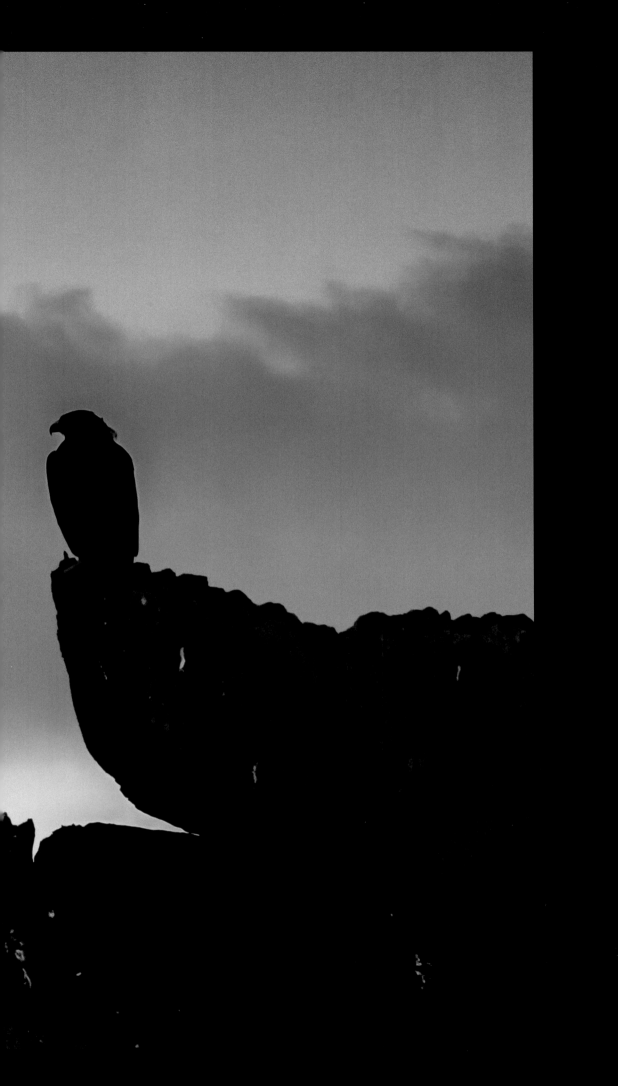

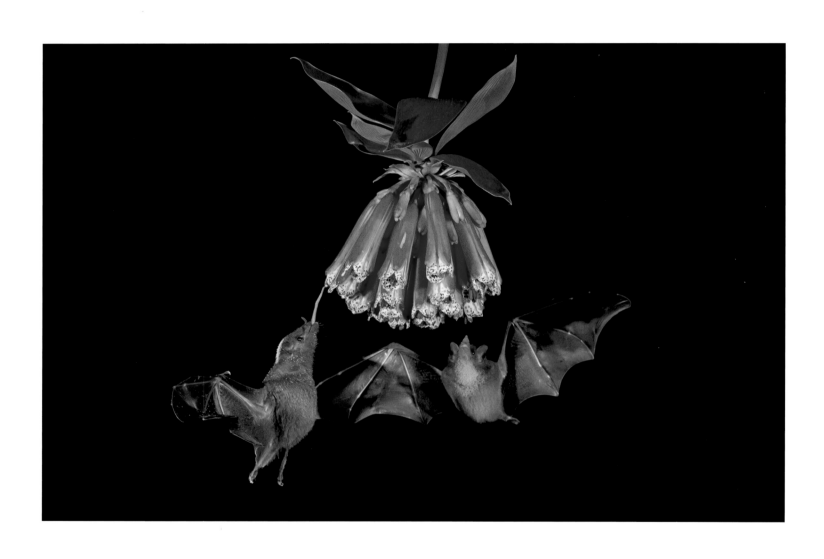

PREVIOUS PAGES: Endangered Galapagos hawks (Buteo galapagoensis), Galápagos Islands, Ecuador
ABOVE: Tube-lipped tailless bats (*Anoura fistulata*), Andean cloud forest, Ecuador
OPPOSITE: Bats issue from Tham Khang Khao cave, Phu Pha Man National Park, Khon Kaen, Thailand

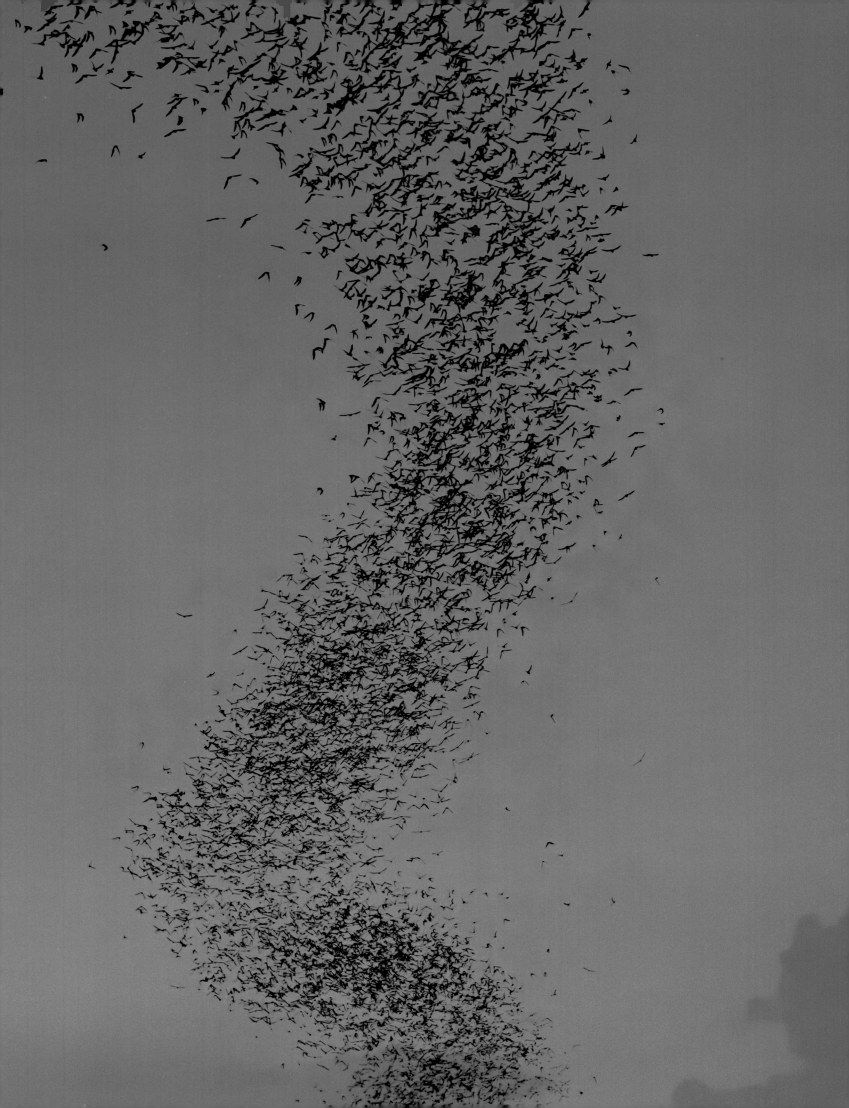

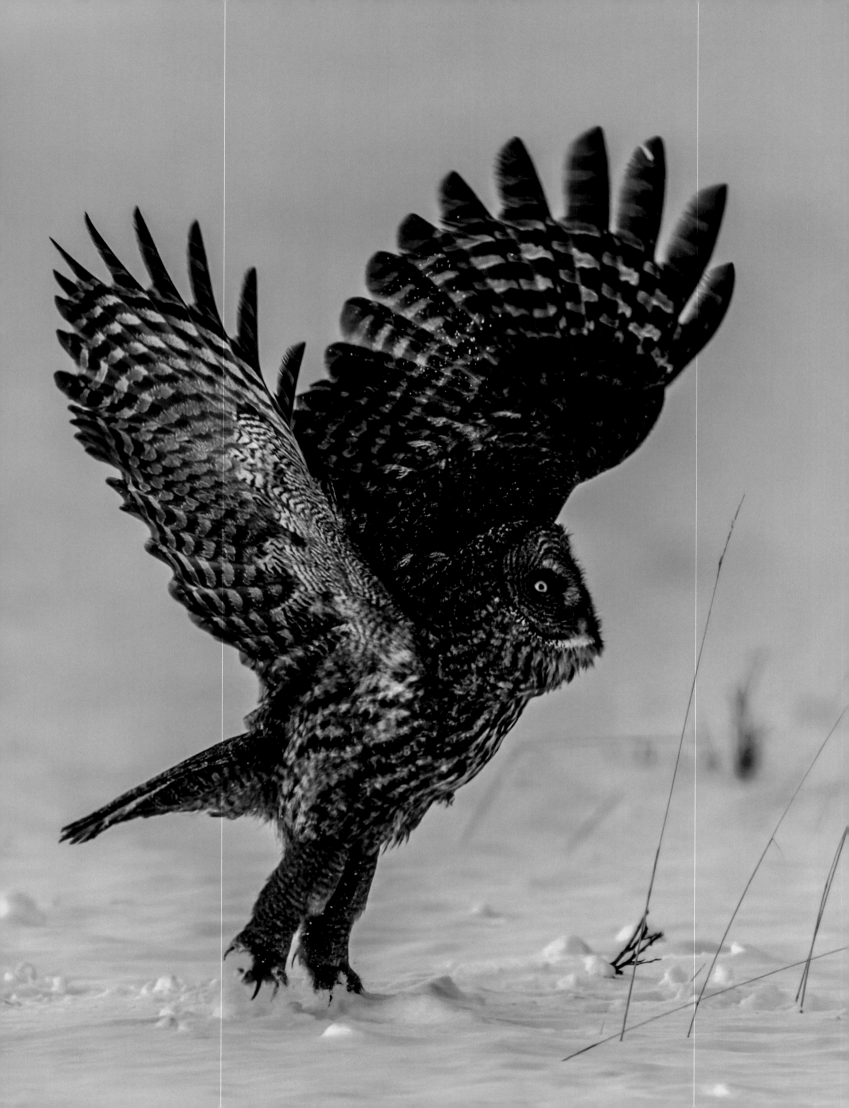

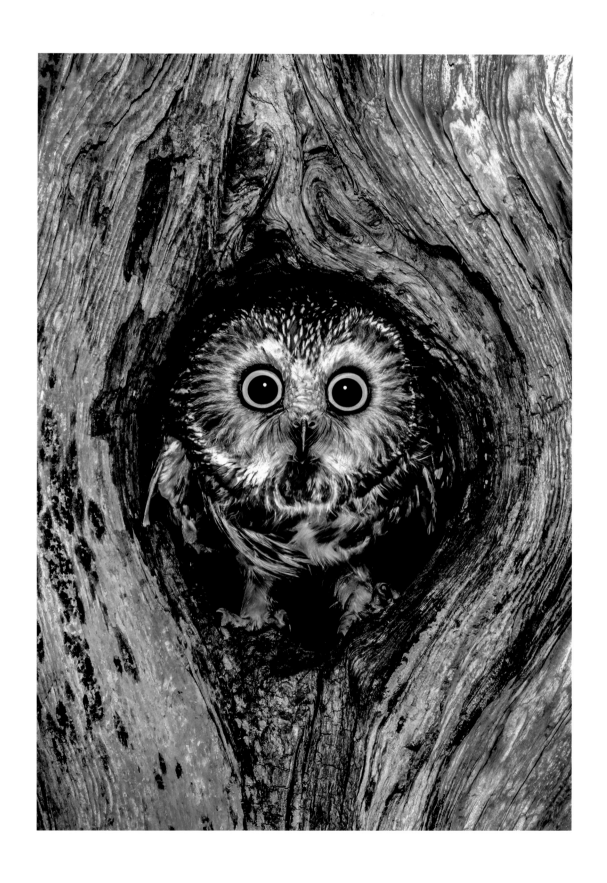

OPPOSITE: Great grey owl (*Strix nebulosa*), Alberta, Canada
ABOVE: Northern saw-whet owl (*Aegolius acadicus*), Washington, USA
FOLLOWING PAGES: King penguins (*Aptenodytes patagonicus*),
South Georgia Island, South Atlantic Ocean

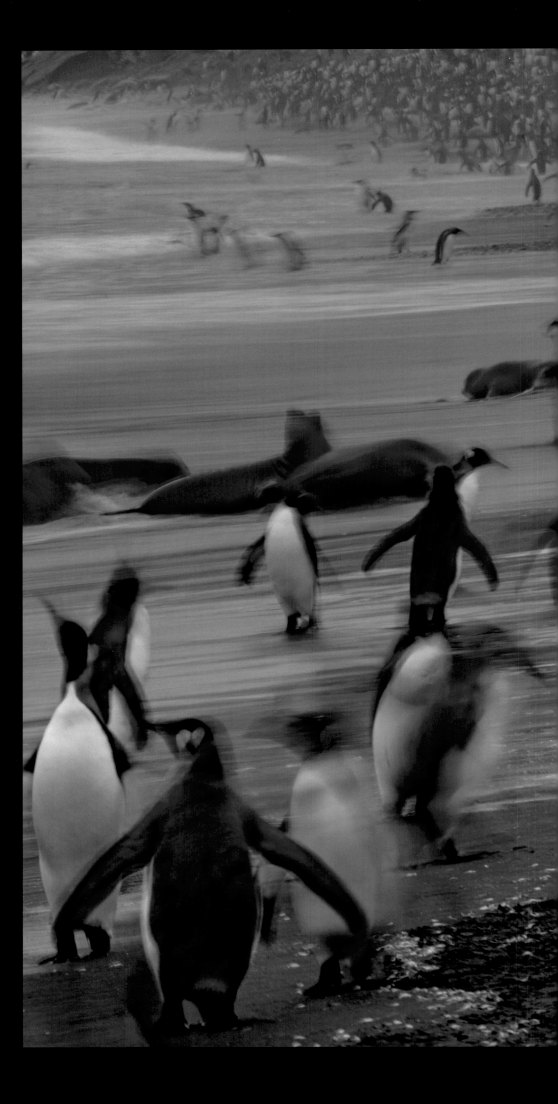

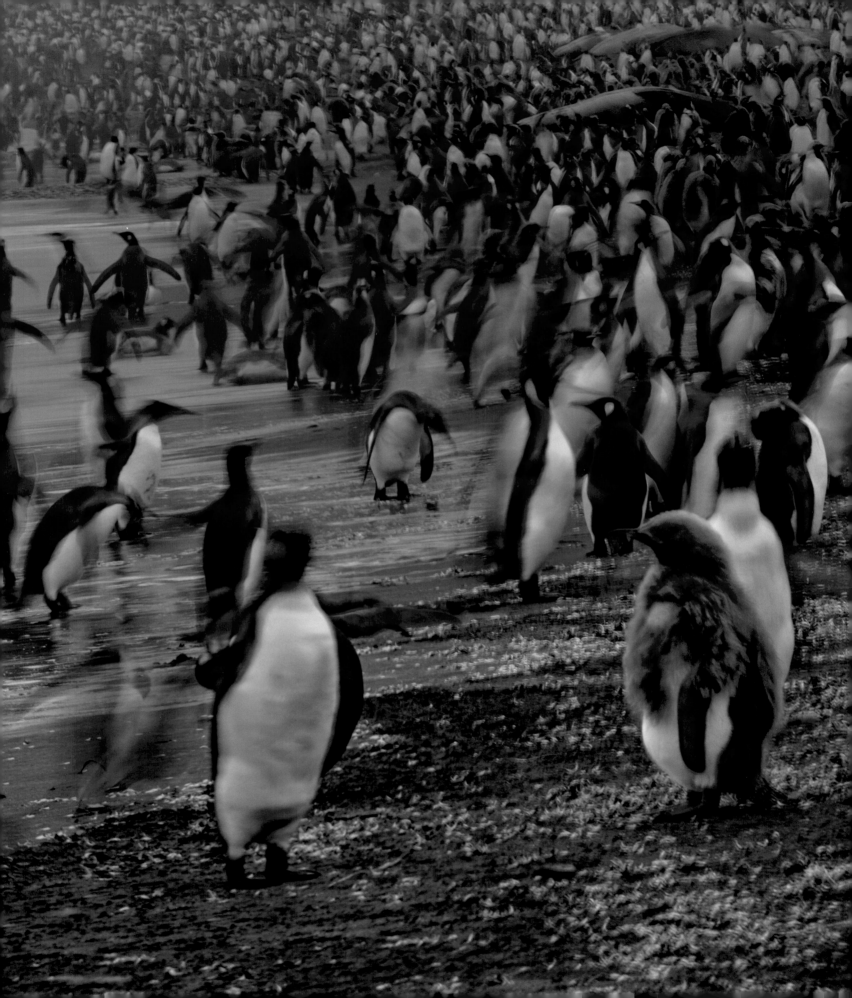

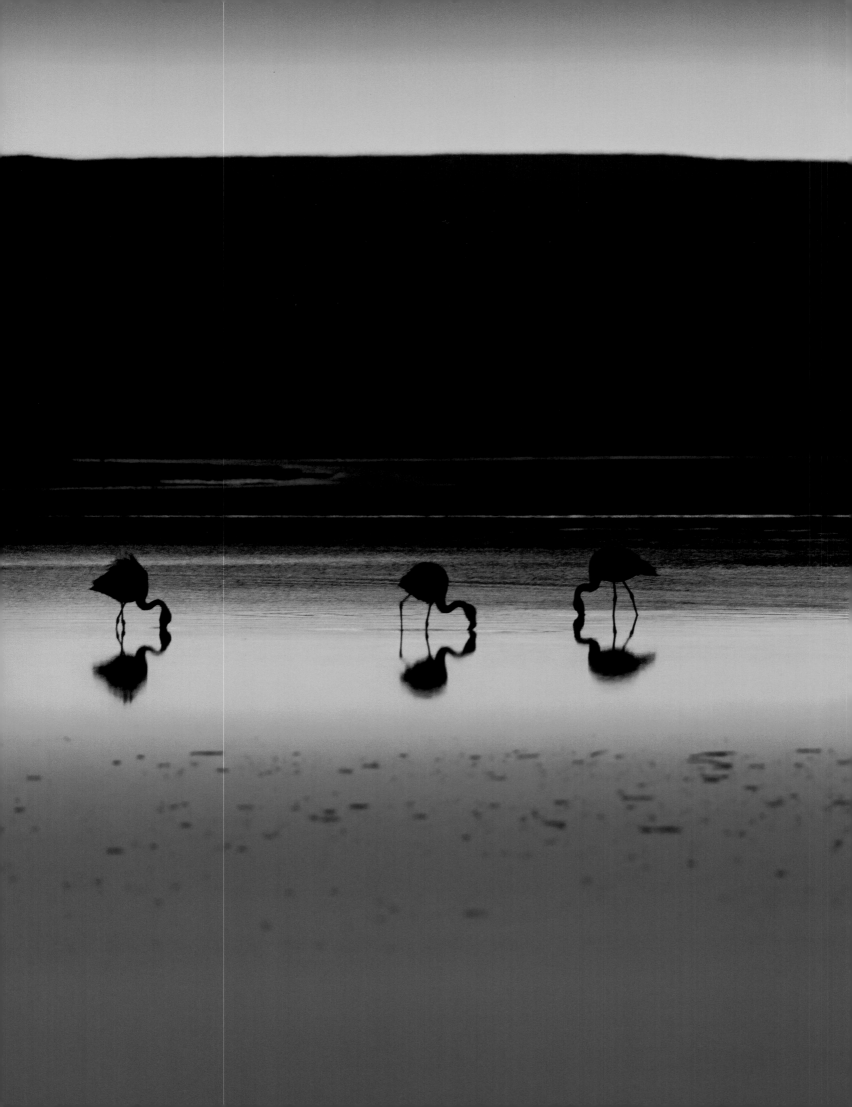

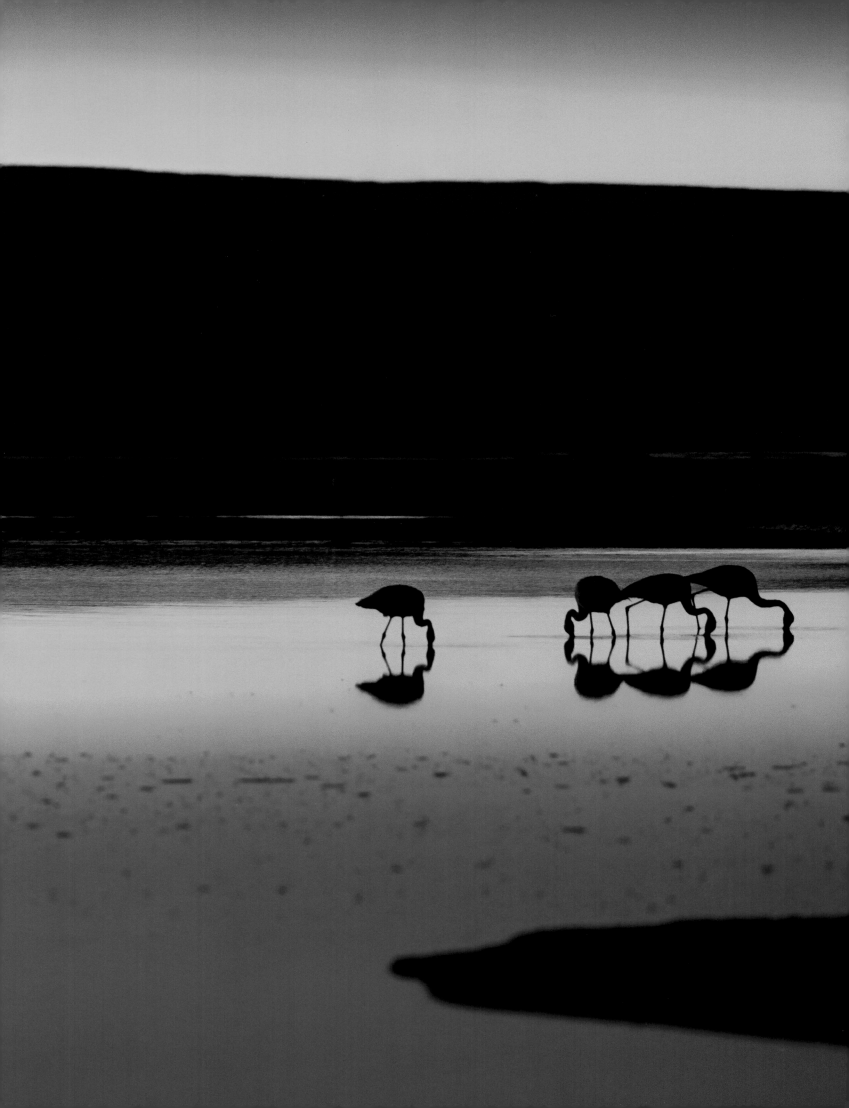

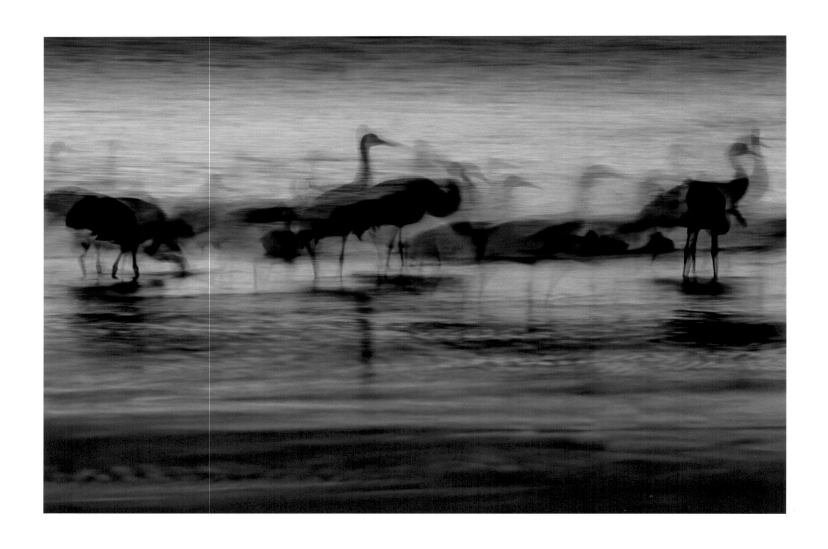

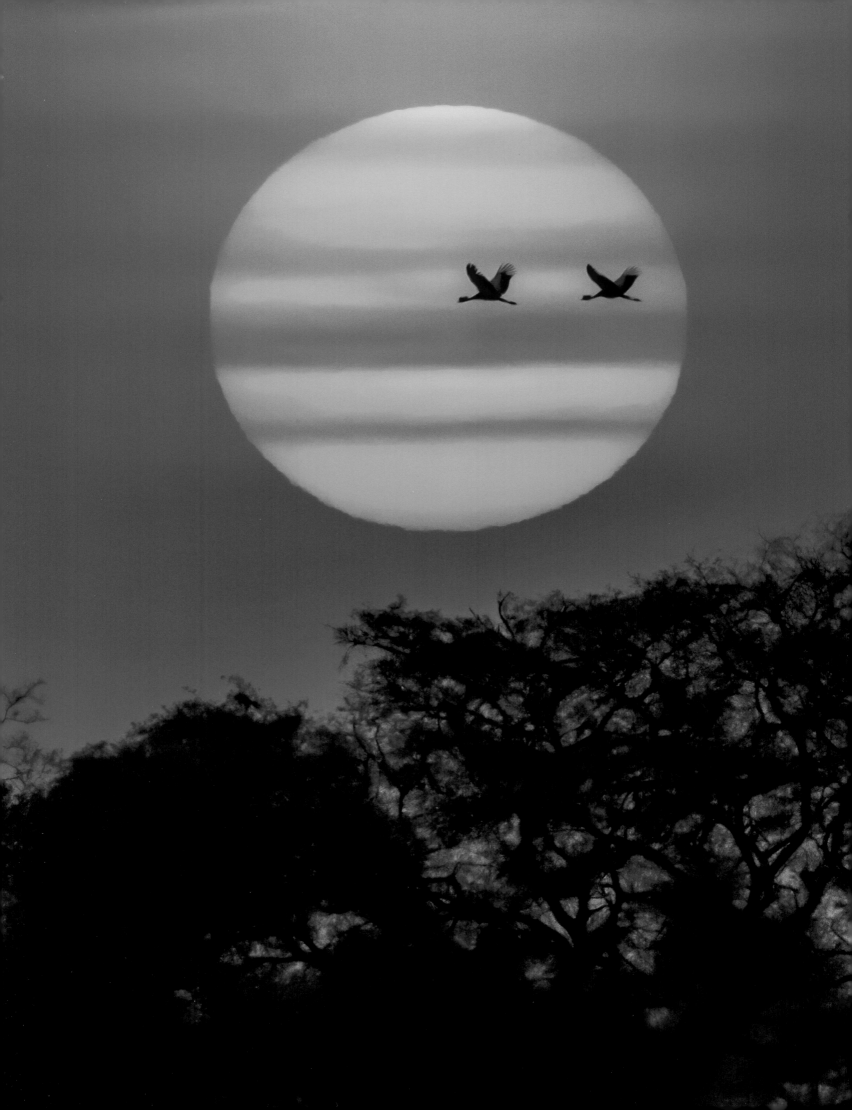

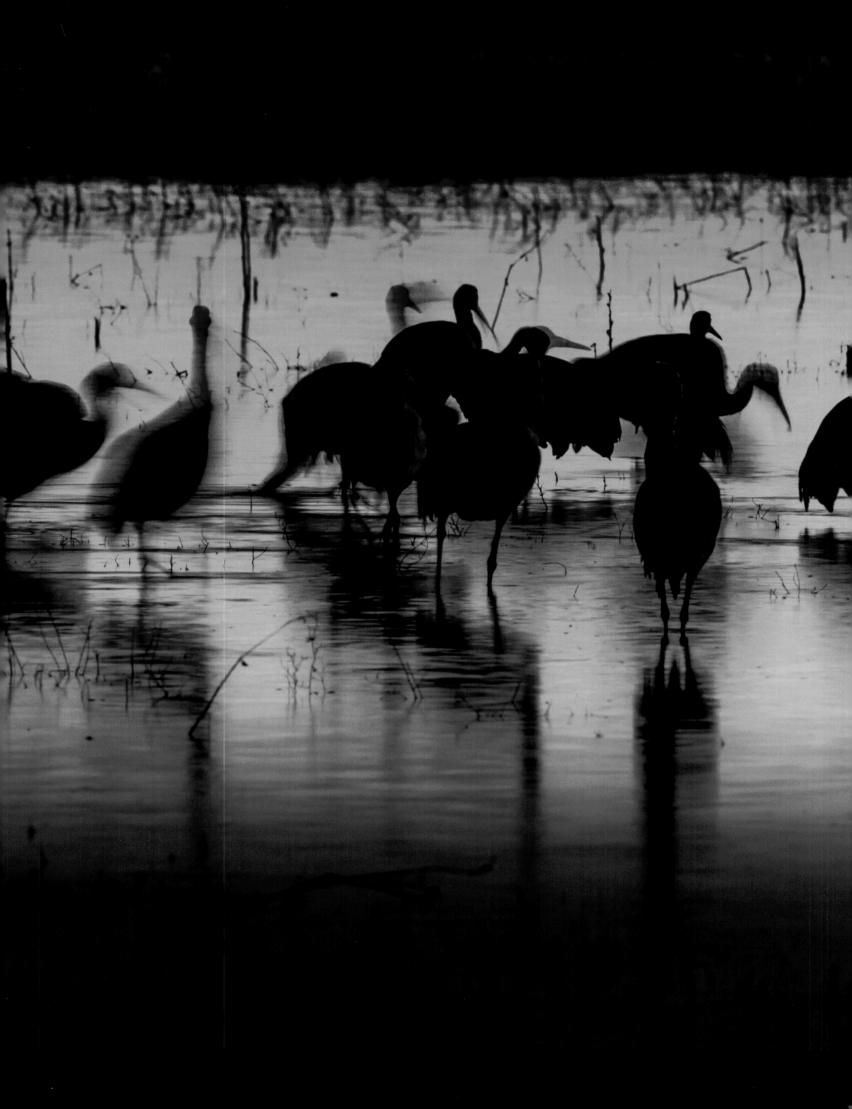

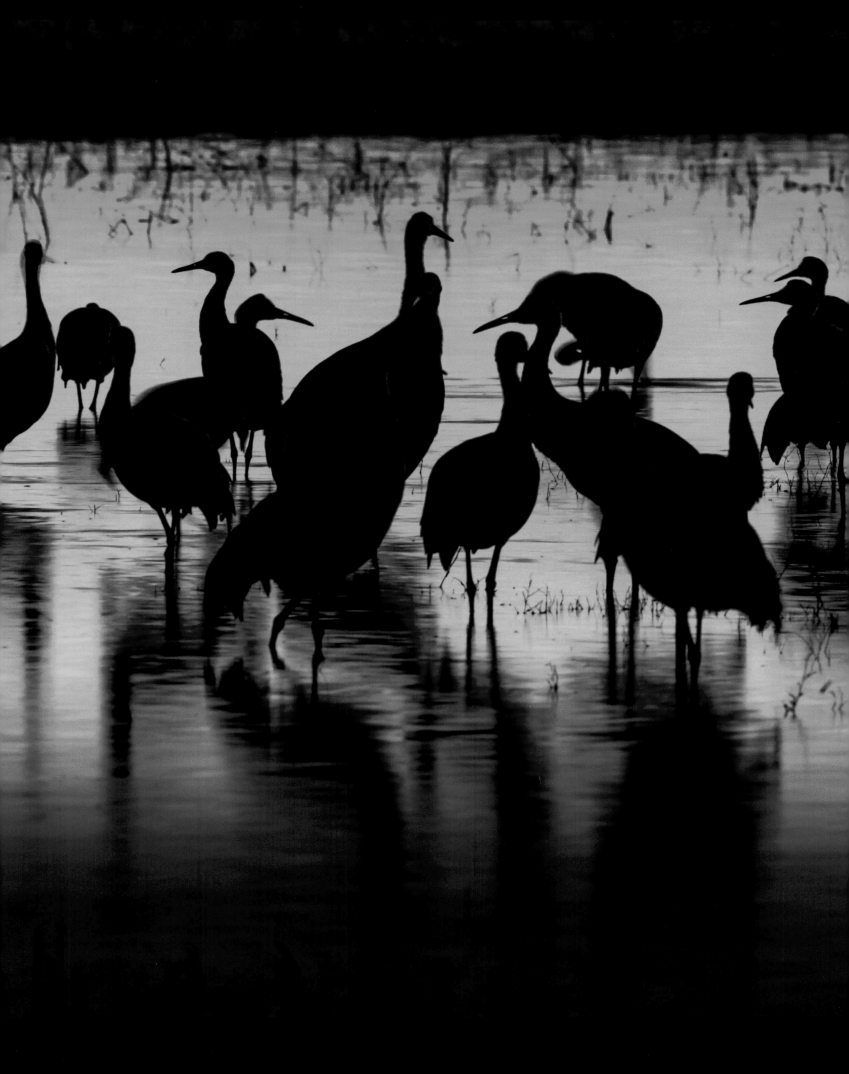

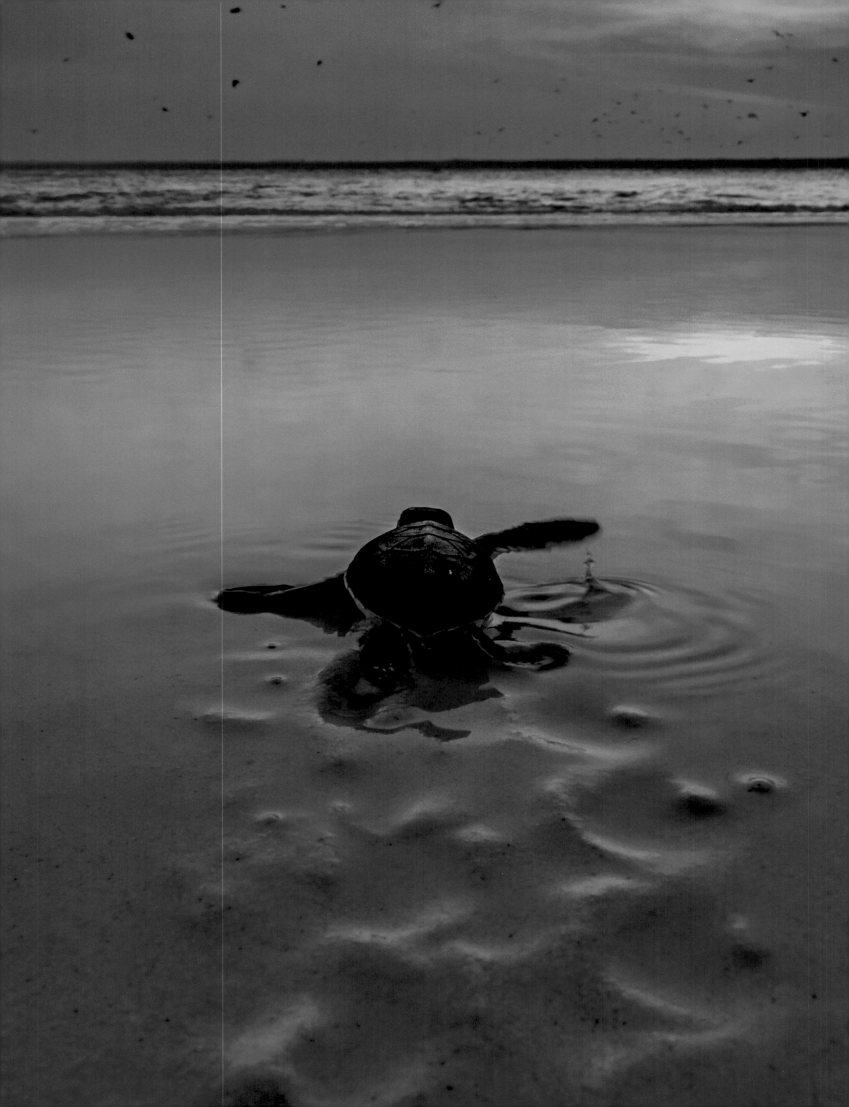

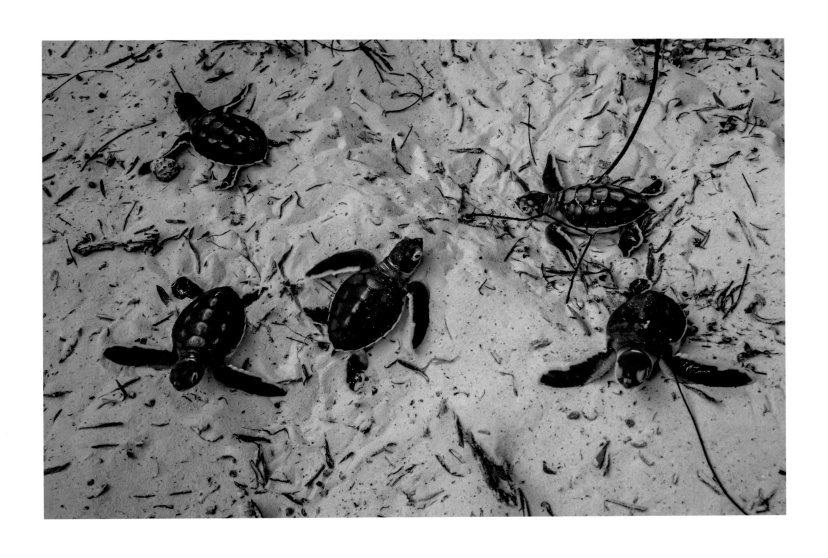

OPPOSITE AND ABOVE: Green sea turtle hatchlings (*Chelonia mydas*), Mnemba Island, Tanzania

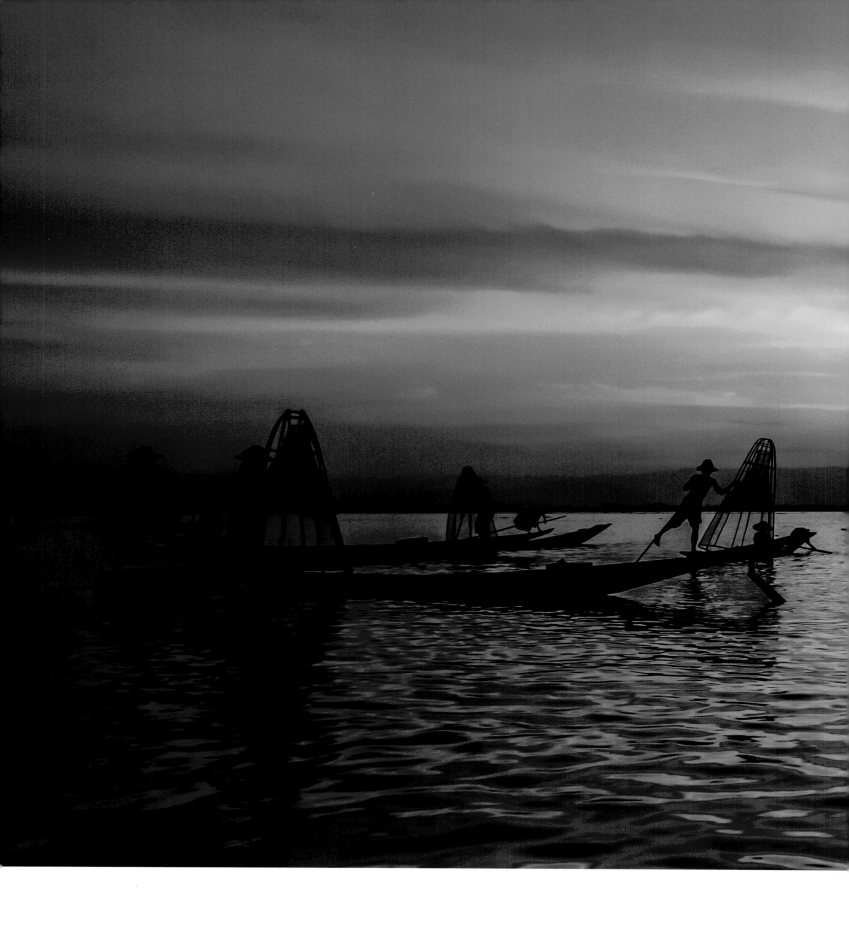

EMBRACING THE NIGHT

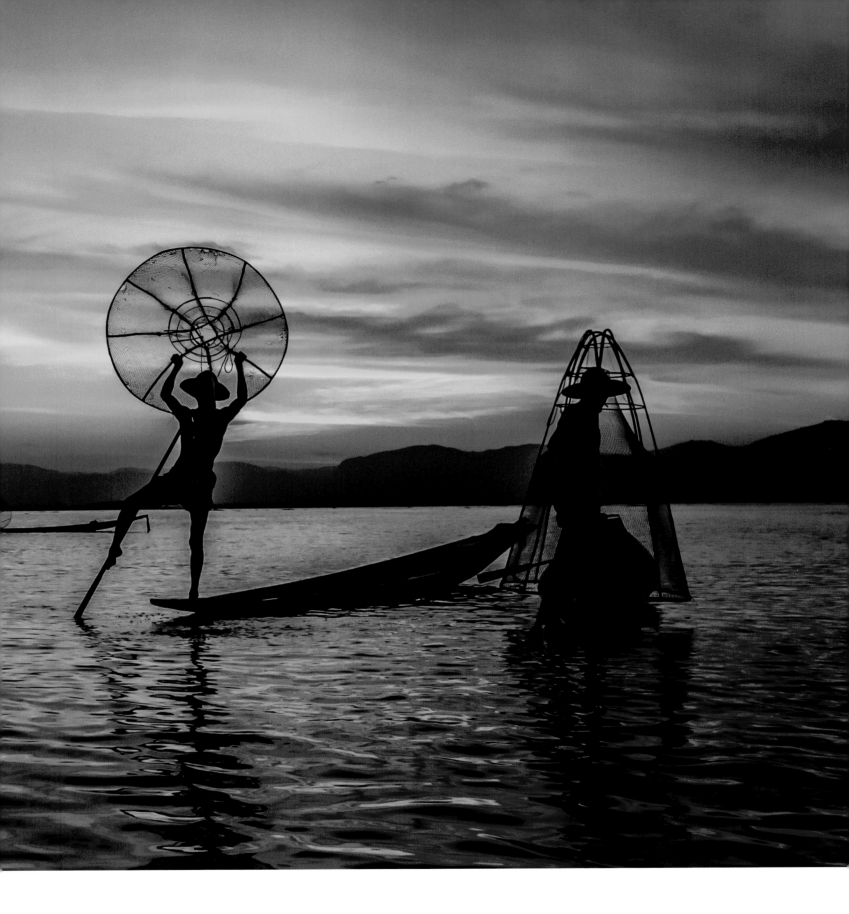

A small flame rises into the night, and the moon reflects on the surface of a still sea. Rituals of fire and water thrive in the dark, and in the quiet hours, our oldest stories are imagined and retold; oral histories built on the back of embers and twisting smoke.

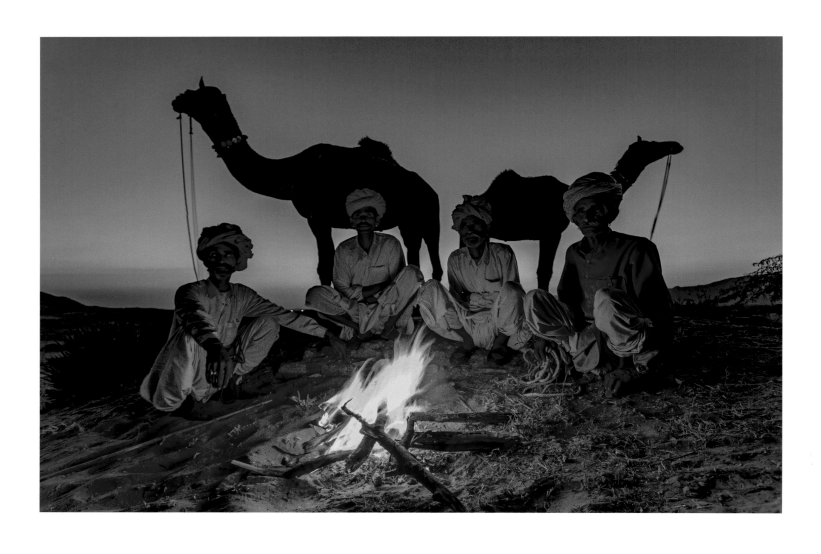

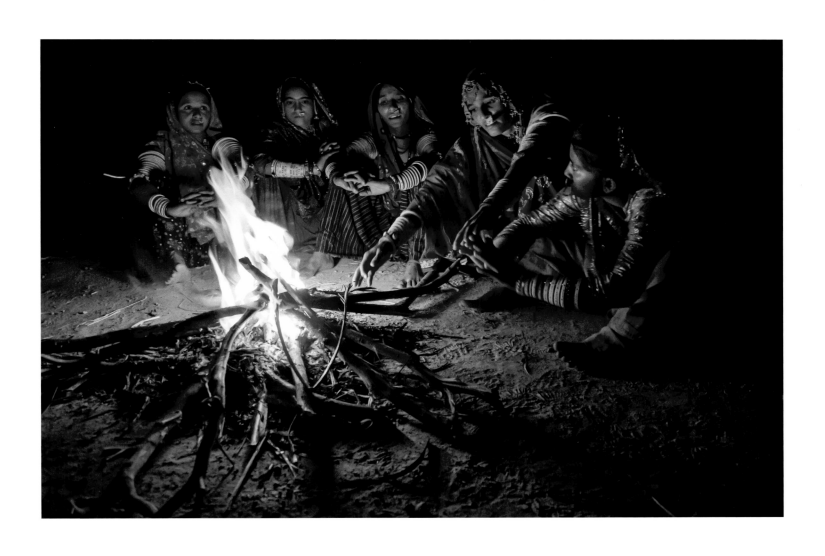

CHAPTER OPENER: Fishermen, Inle Lake, Shan, Myanmar
OPPOSITE: Evening fire, Pushkar Fair, Rajasthan, India
ABOVE: Meghwal women gathered around a fire, Gujarat, India

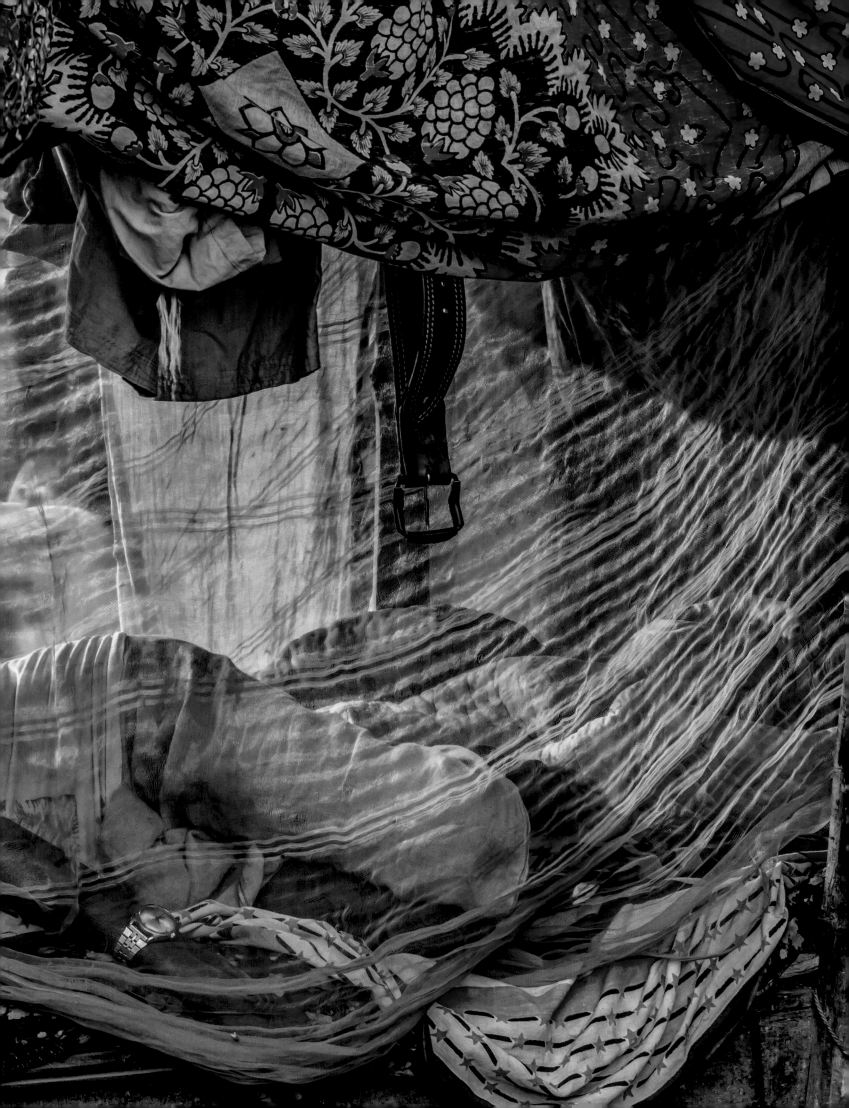

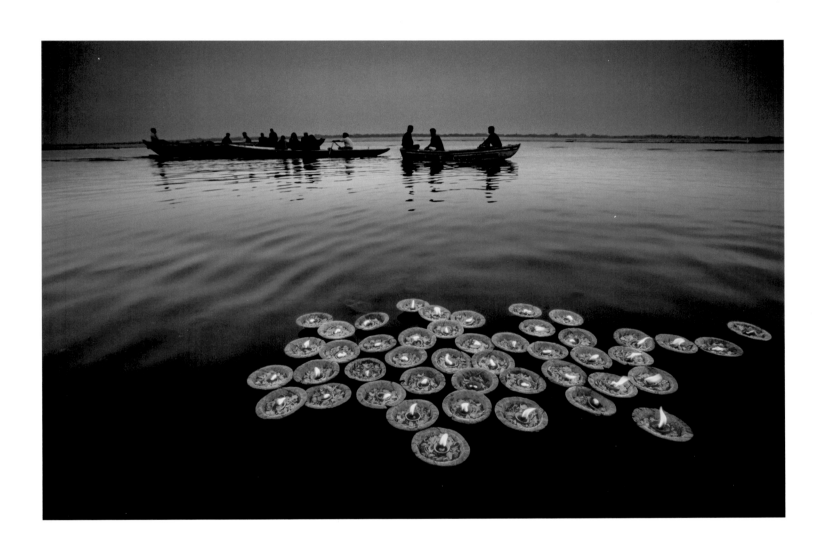

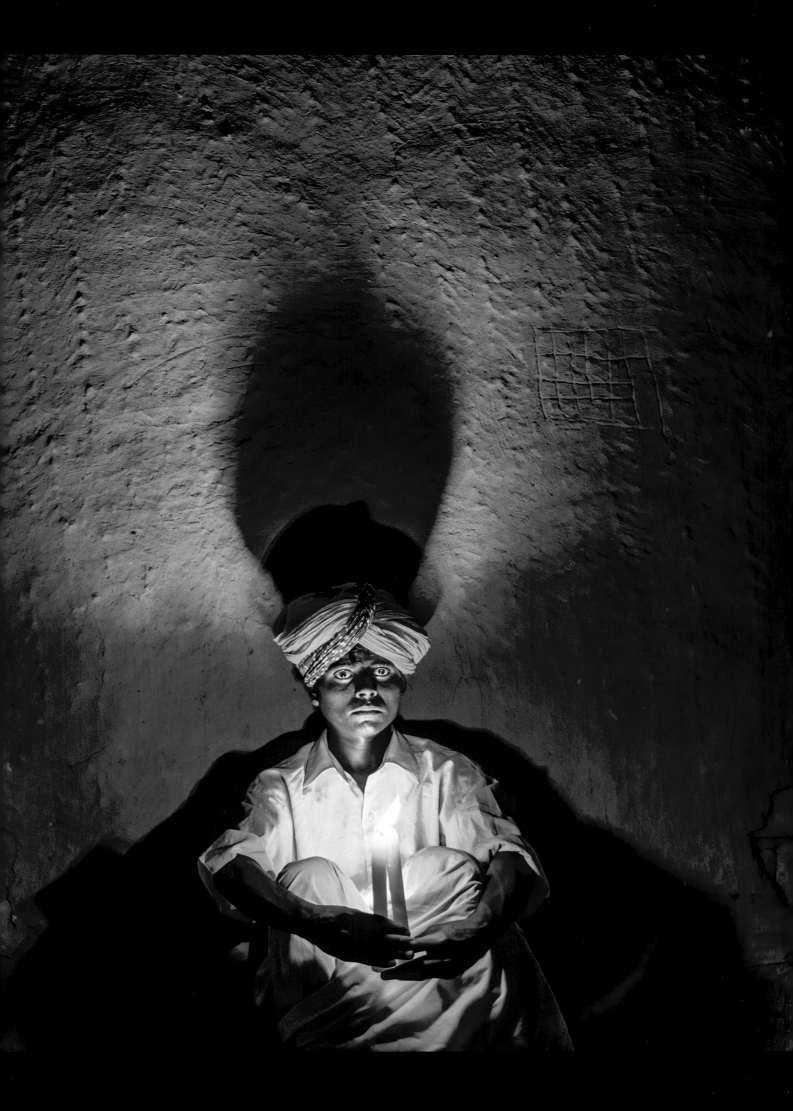

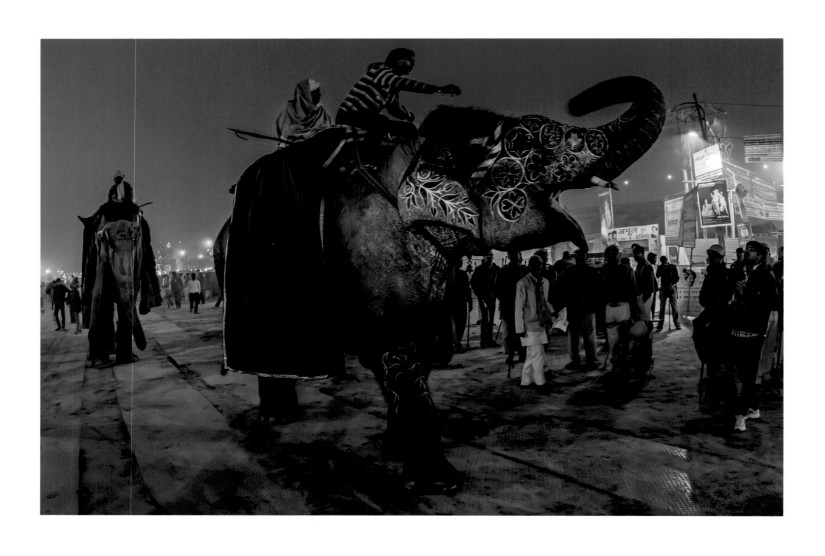

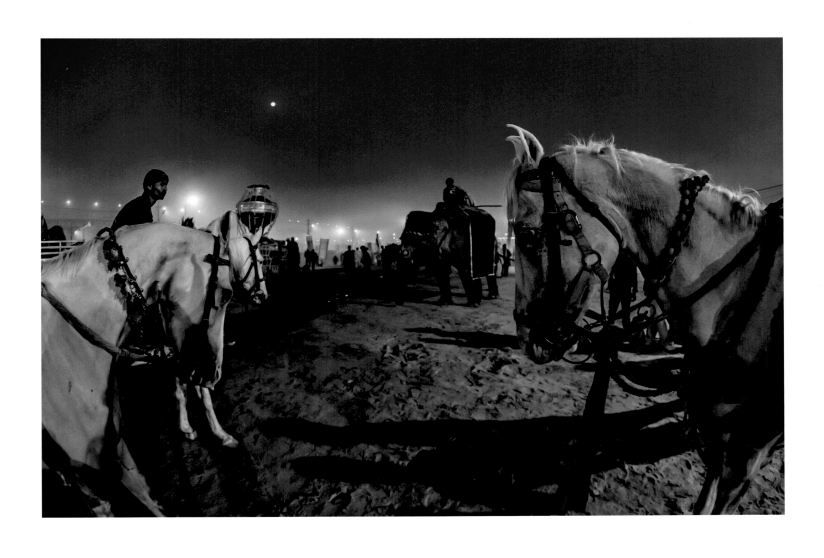

PREVIOUS PAGES: Portrait of a young man in candlelight, Jaisalmer, Rajasthan, India
OPPOSITE AND ABOVE: Entertainers at the Kumbh Mela, Allahabad, Uttar Pradesh, India

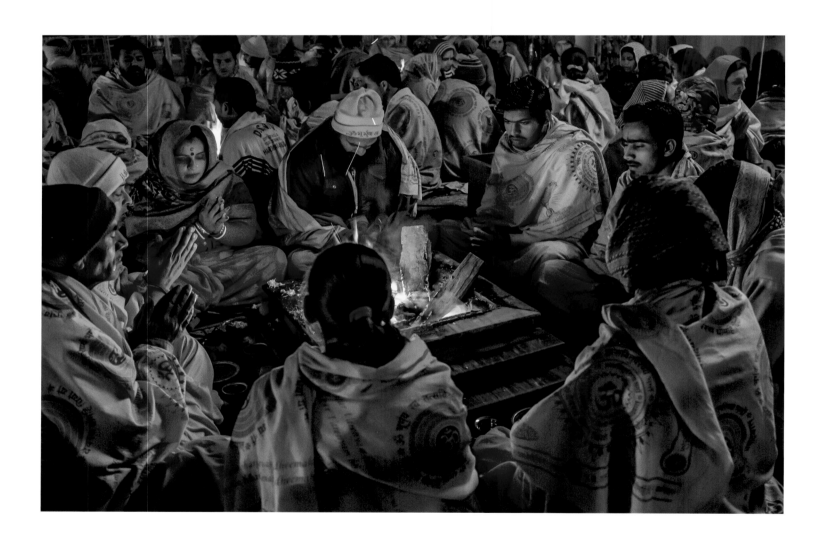

ABOVE: Saffron-robed pilgrims worship around a warming fire,
Kumbh Mela, Haridwar, Uttarakhand, India
OPPOSITE: A river of movement parts around a solitary figure in Bundi, Rajasthan, India

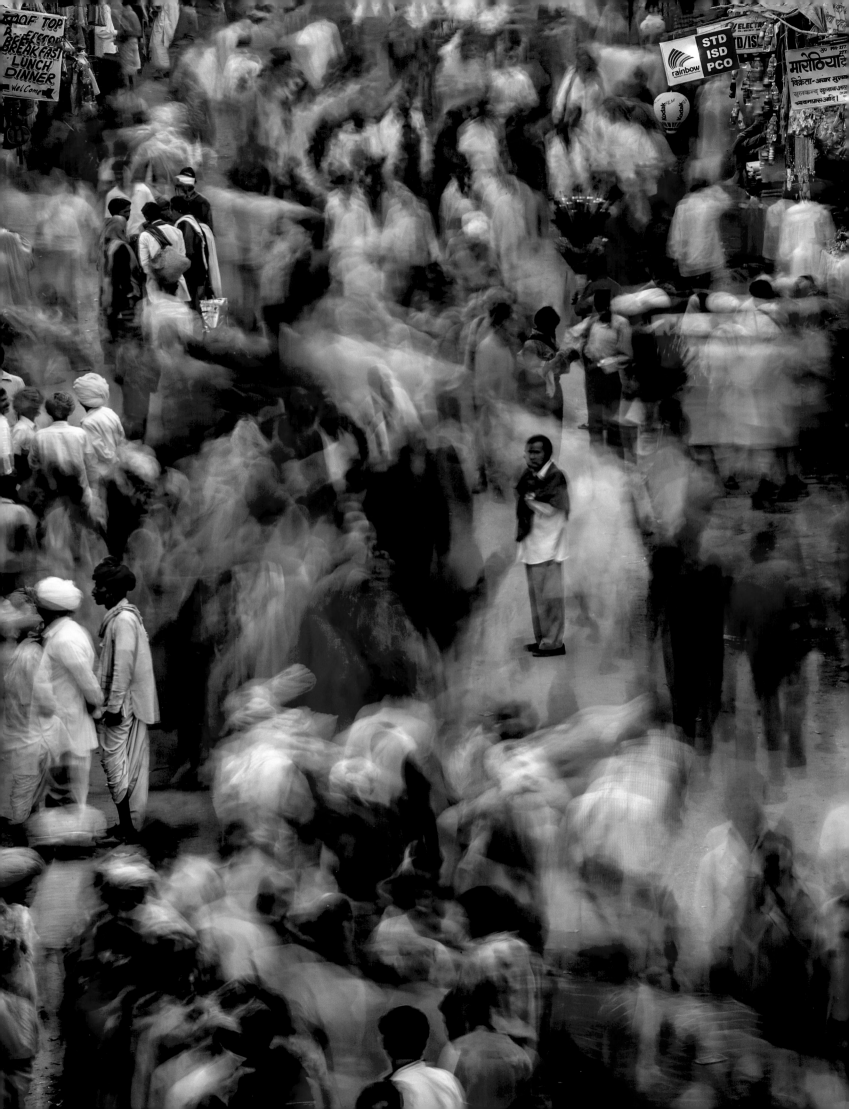

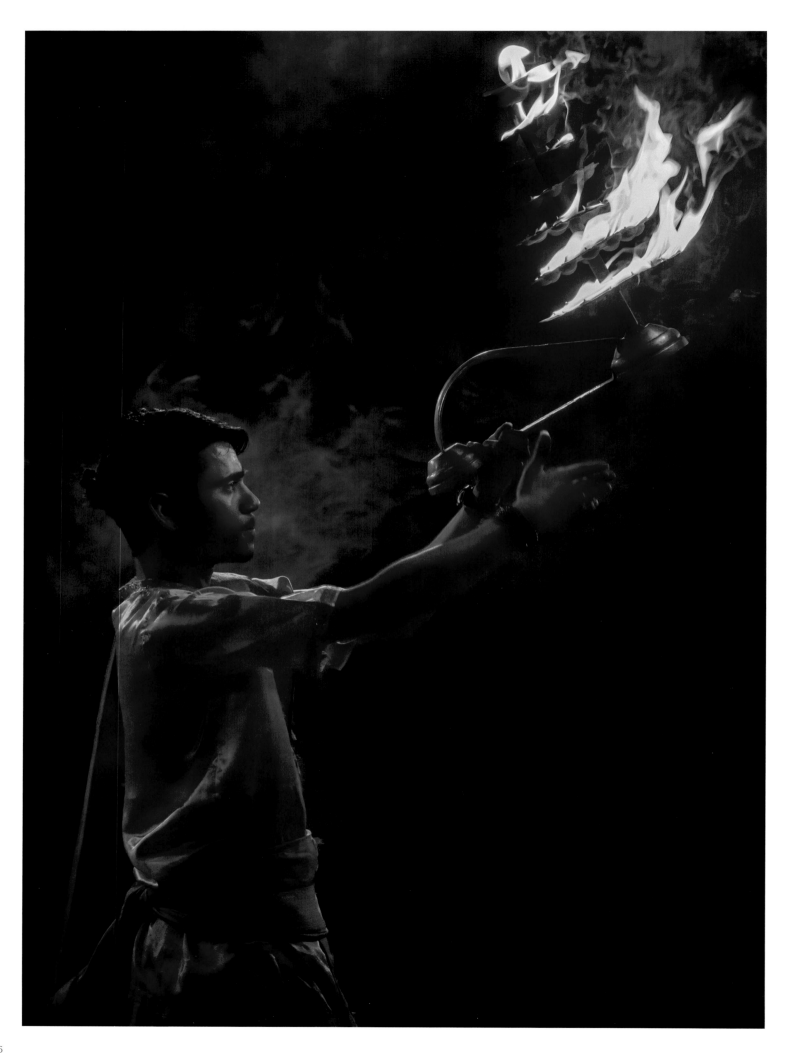

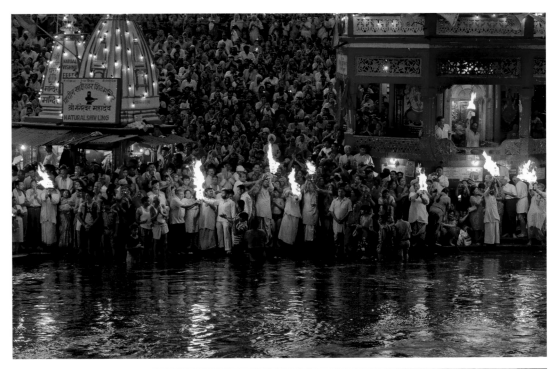

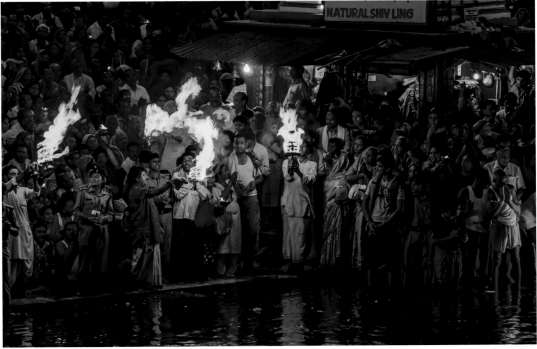

OPPOSITE: Ganga aarti, Varanasi, Uttar Pradesh, India
ABOVE TOP AND BOTTOM: Ganga aarti, a ritual prayer to the Ganges River,
on the sacred ghat of Har Ki Pauri, Haridwar, Uttarakhand, India

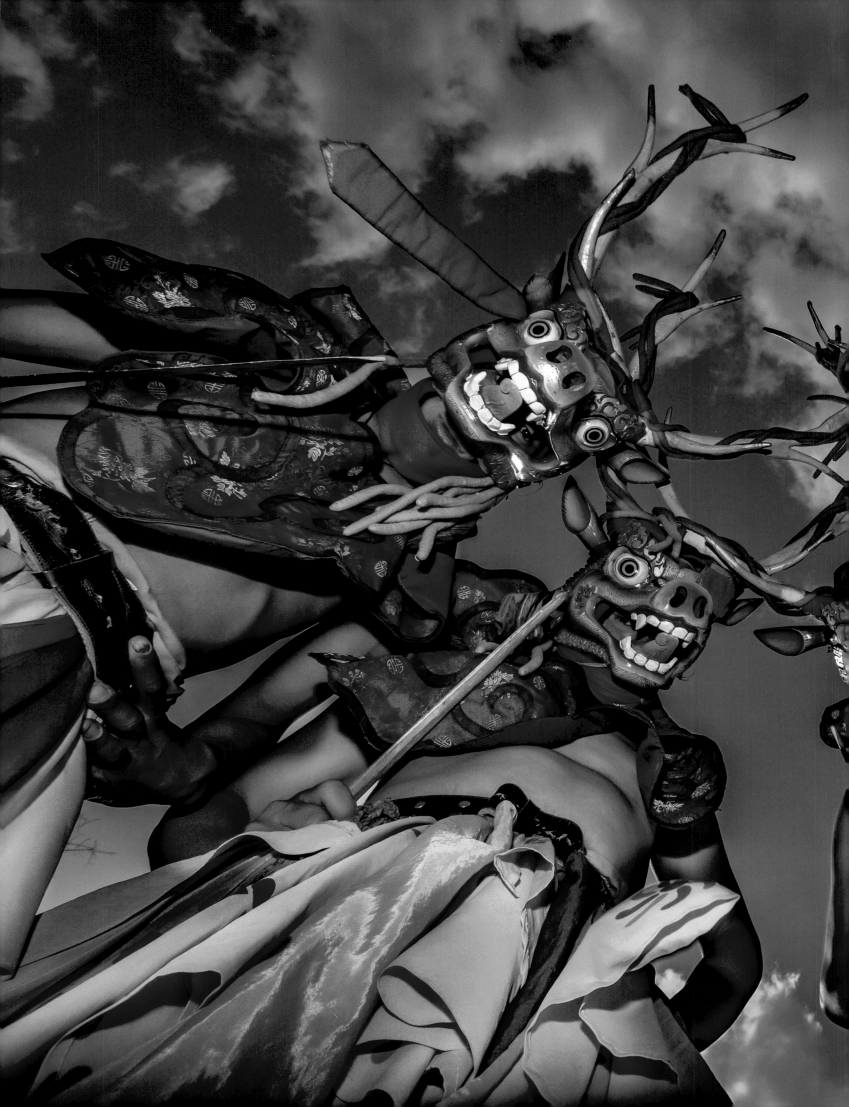

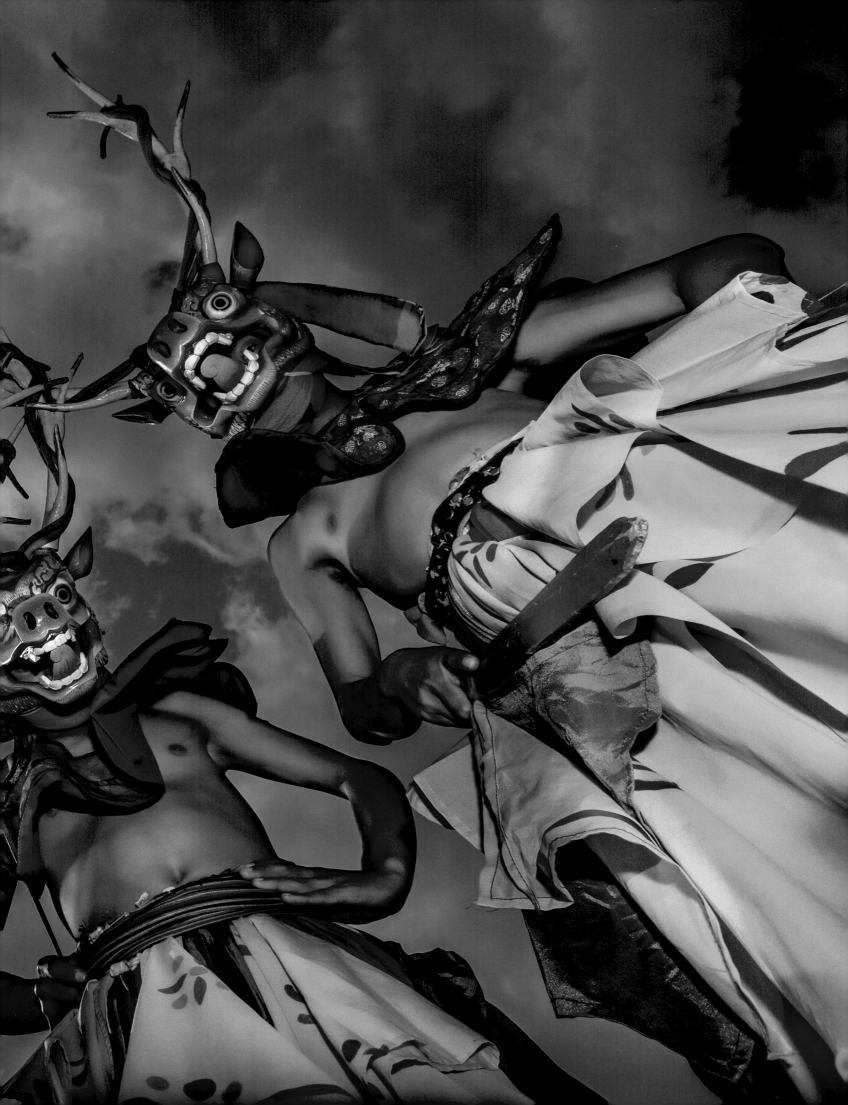

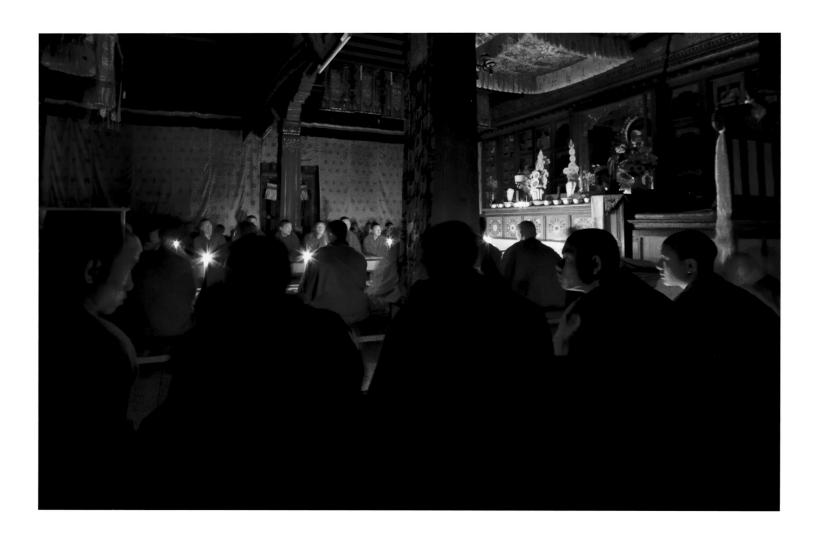

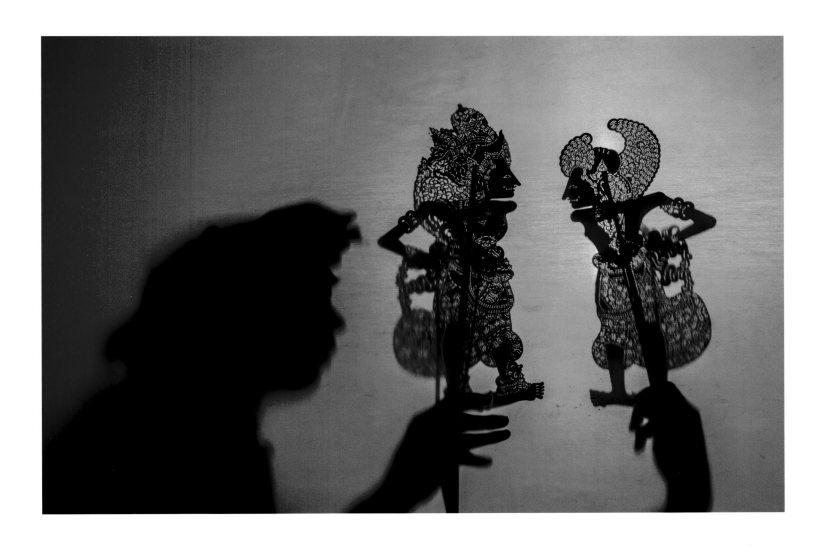

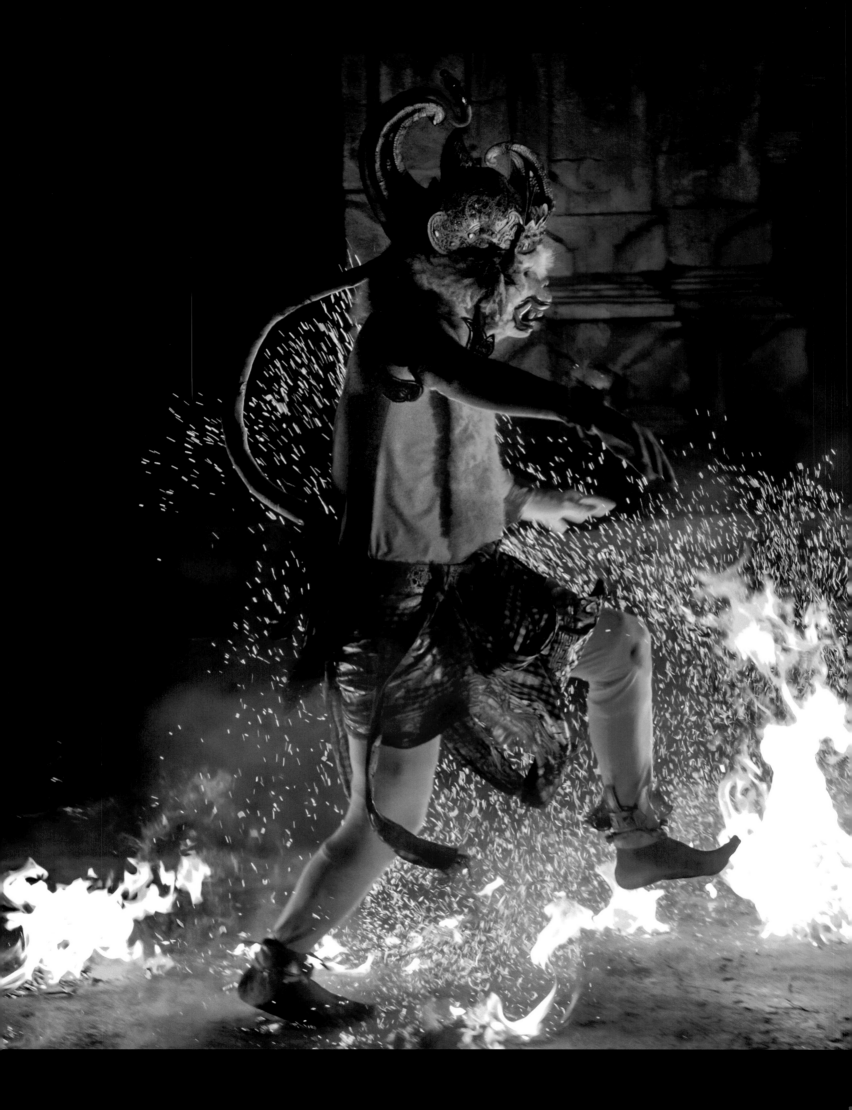

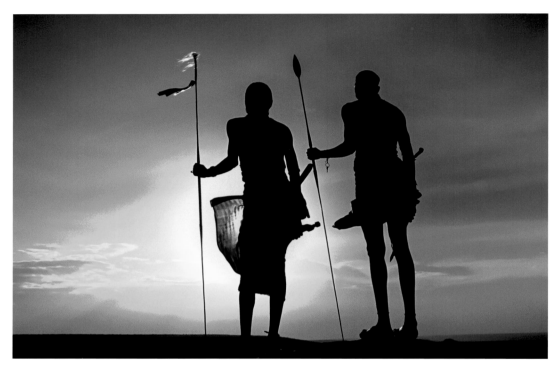

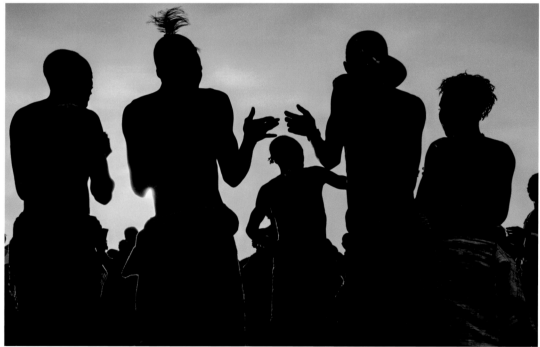

ABOVE TOP: Samburu herdsmen, Mpala, Nanyuki, Kenya
ABOVE BOTTOM: Karo tribesmen, South Omo, Ethiopia
OPPOSITE: San tribesmen at sunset, Makgadikgadi Pans National Park, Ngamiland, Botswana

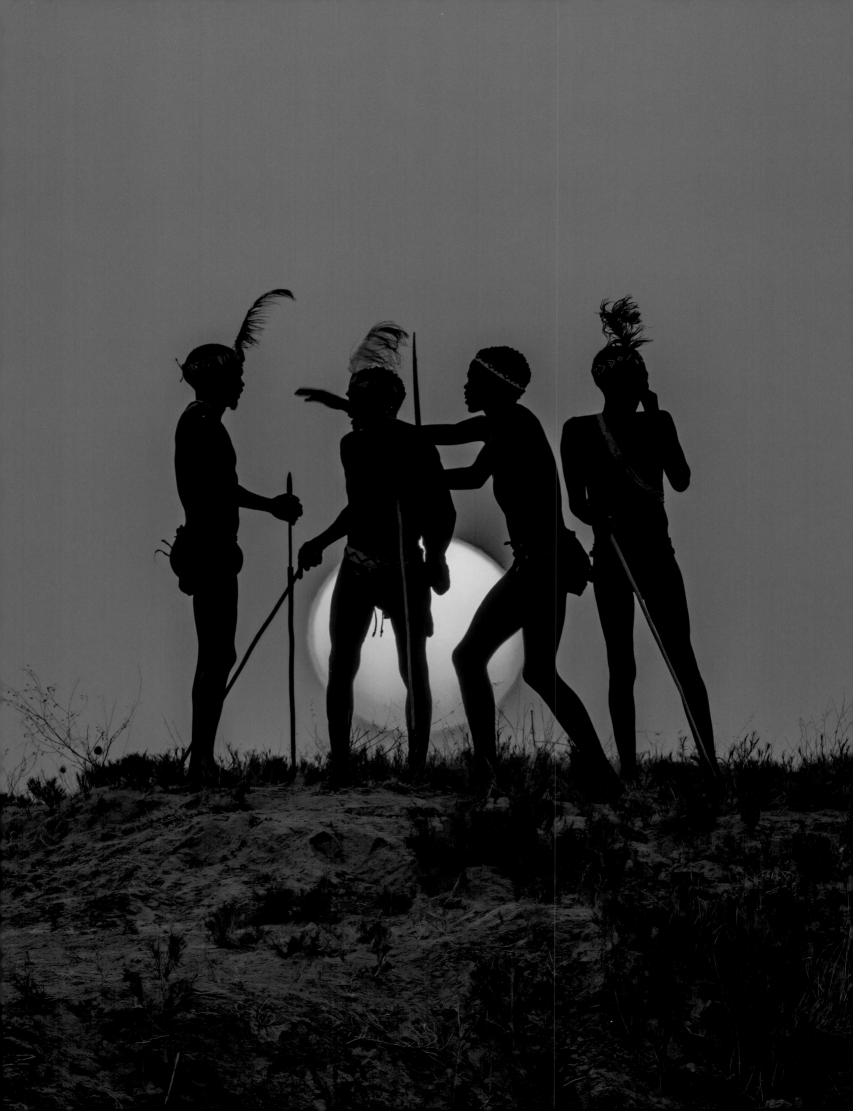

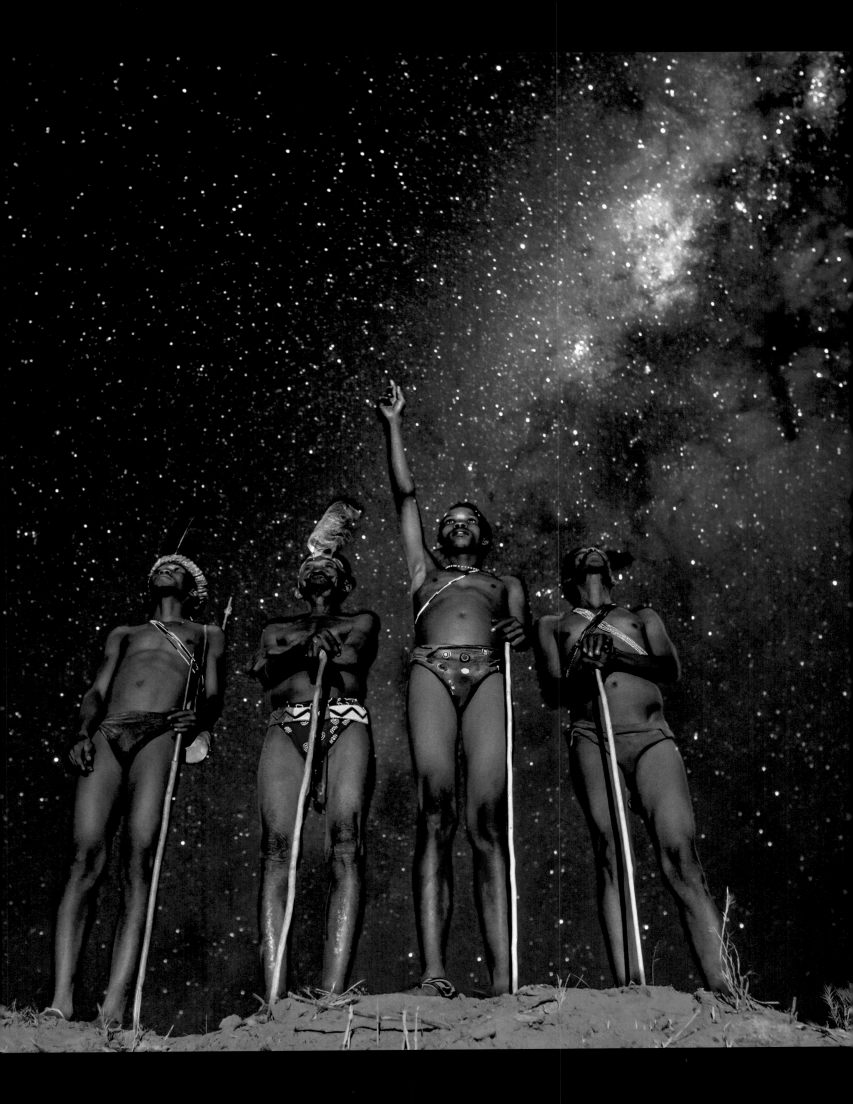

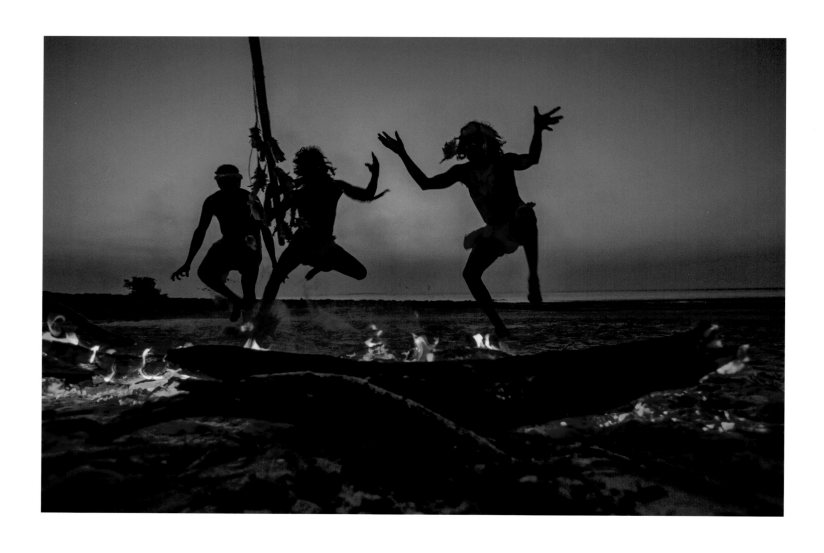

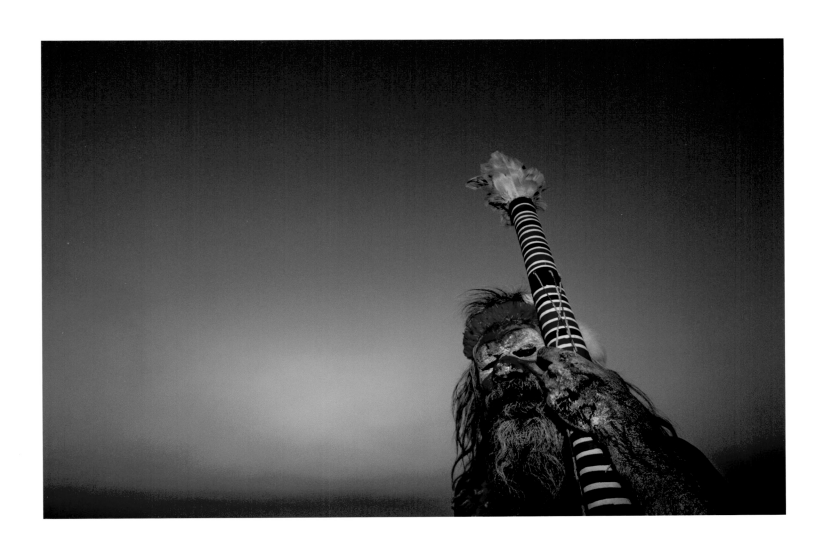

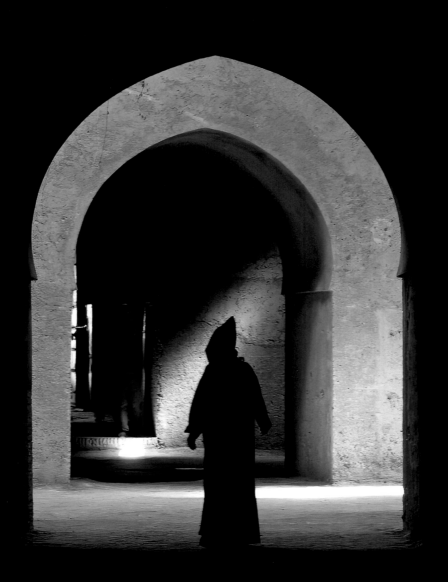

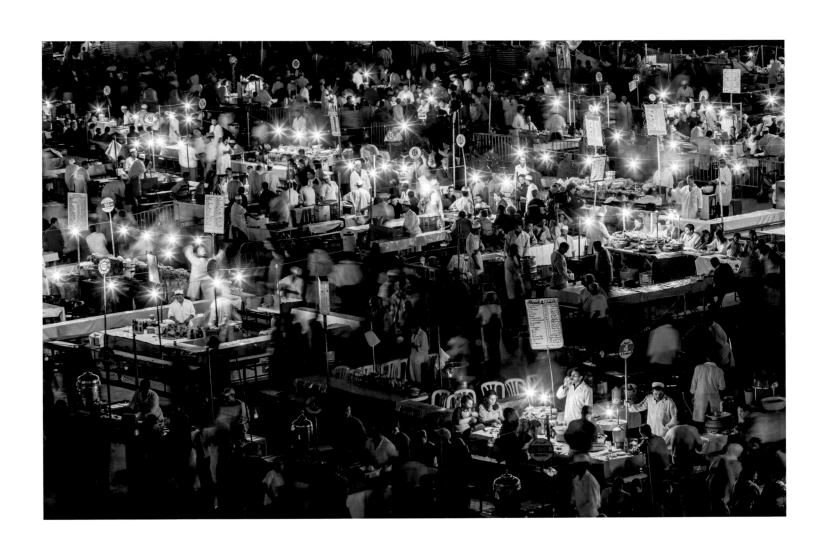

OPPOSITE: Djellaba-clad figure in one of the many arcades
of the old Medina of Fez, Fez-Meknes, Morocco
ABOVE: Marketplace in the old Medina of Fez, Fez-Meknes, Morocco

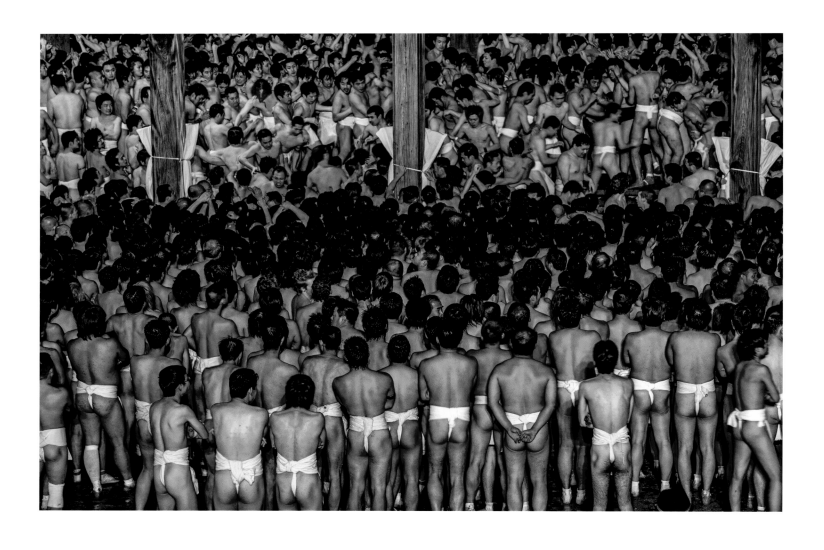

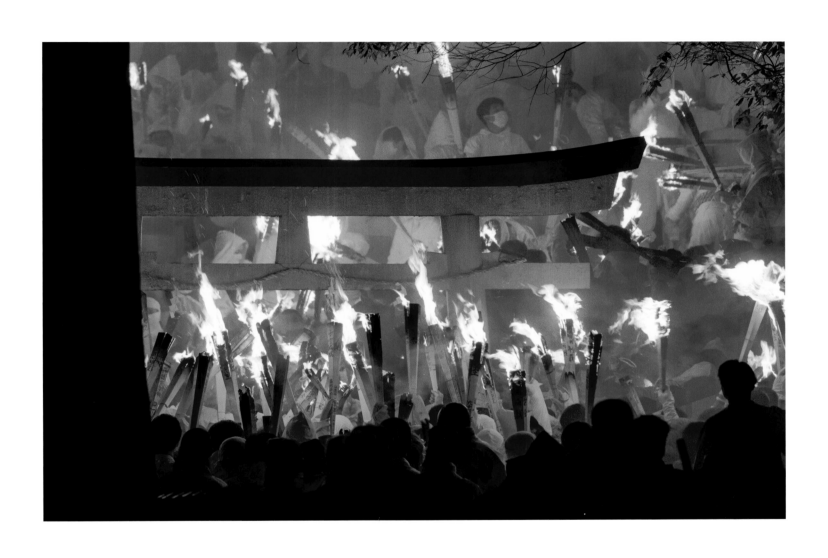

OPPOSITE: Saidai-ji Eyo Hadaka Matsuri, Okayama, Honshu, Japan
ABOVE: Oto Matsuri, Wakayama, Honshu, Japan
FOLLOWING PAGES: Day of the Dead, Pátzcuaro, Michoacán, Mexico

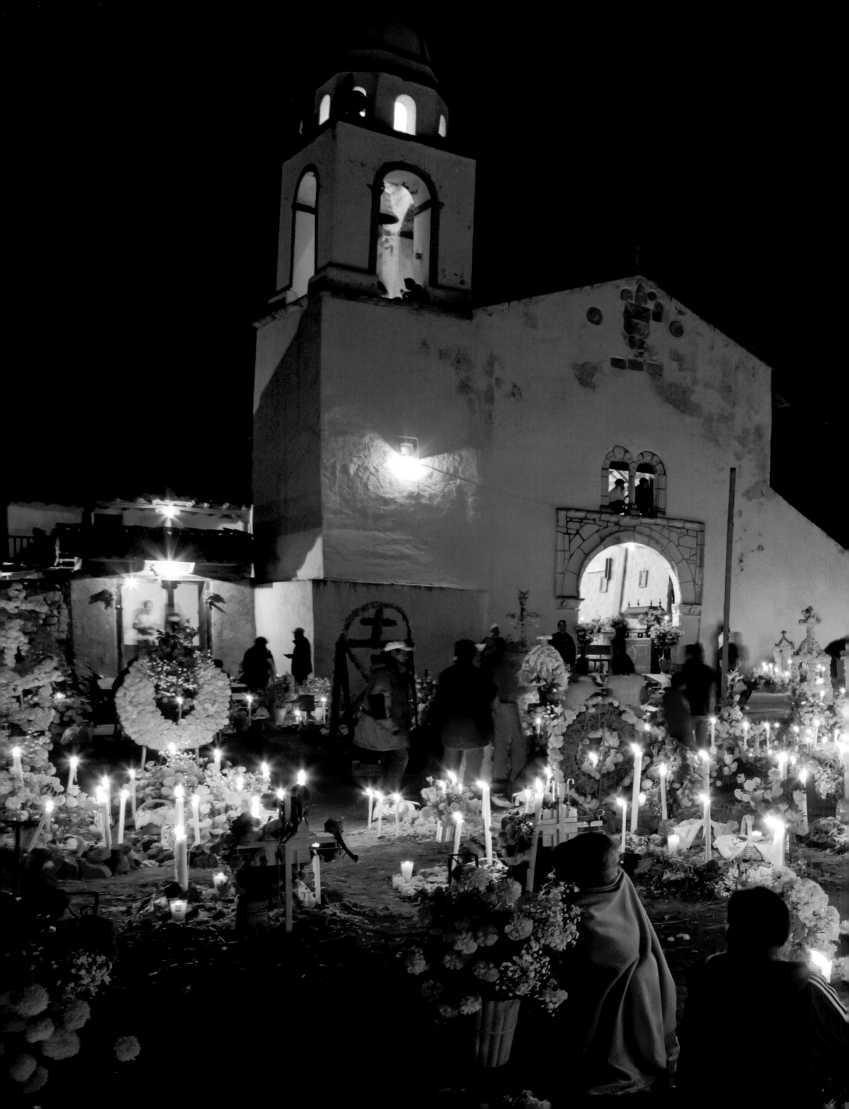

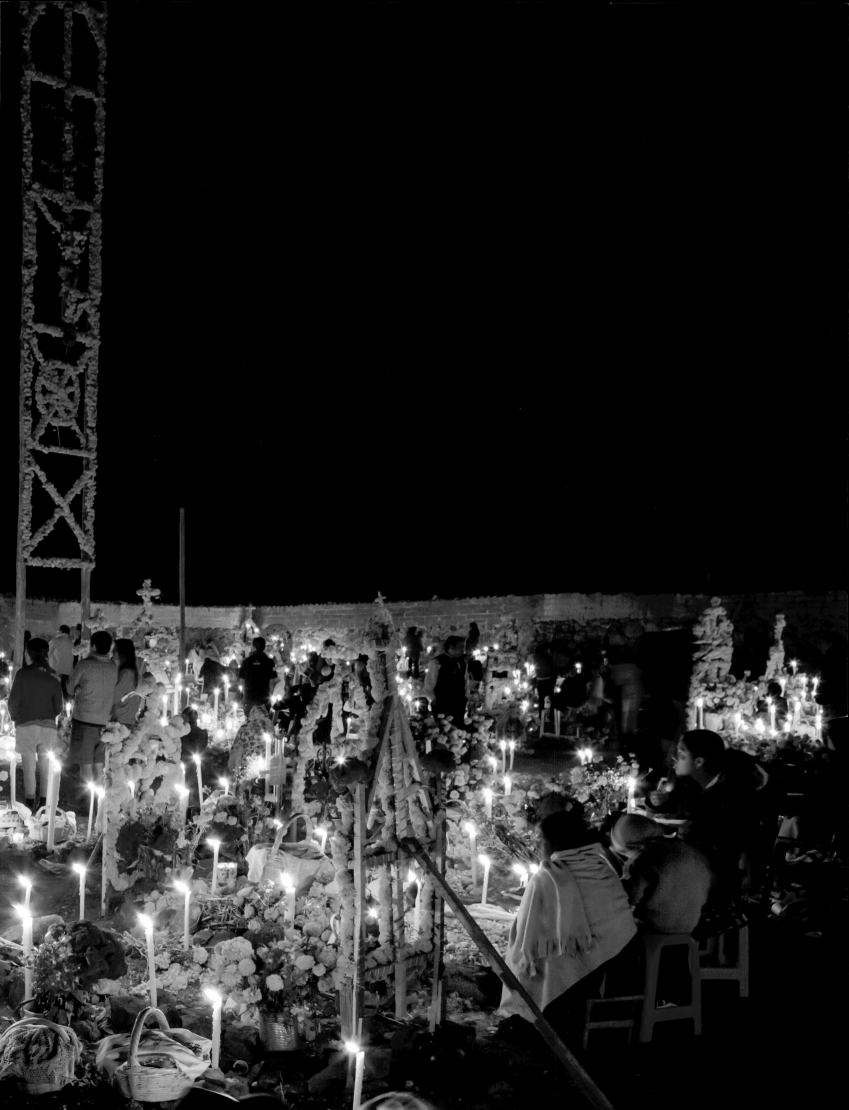

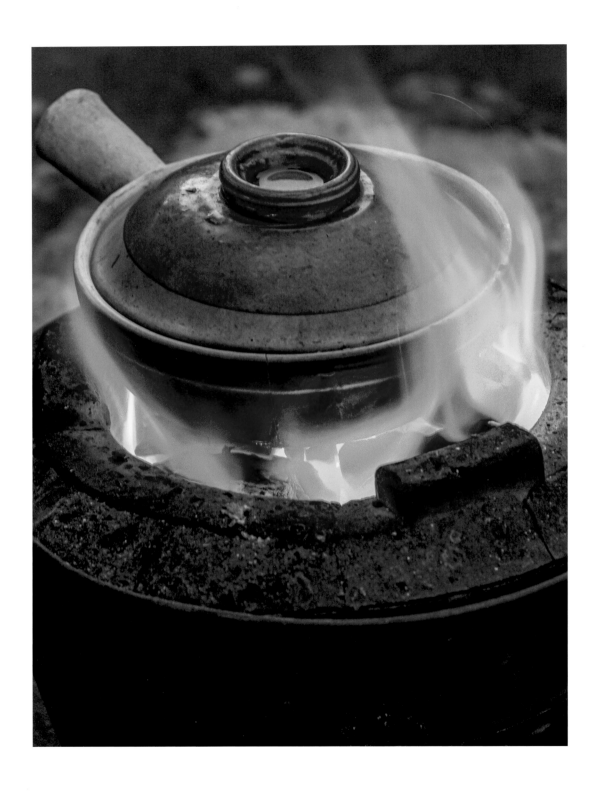

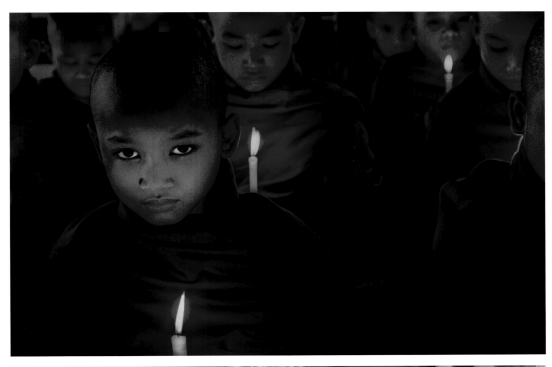

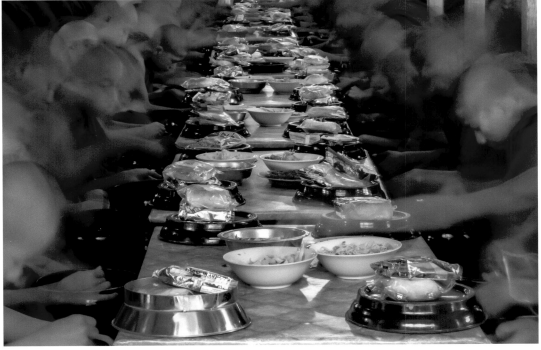

OPPOSITE: A clay pot simmers on a small barbeque, Yangon, Myanmar
ABOVE TOP: Mahagandayon Monastery, Mandalay, Myanmar
ABOVE BOTTOM: Monks at mealtime, Mandalay, Myanmar

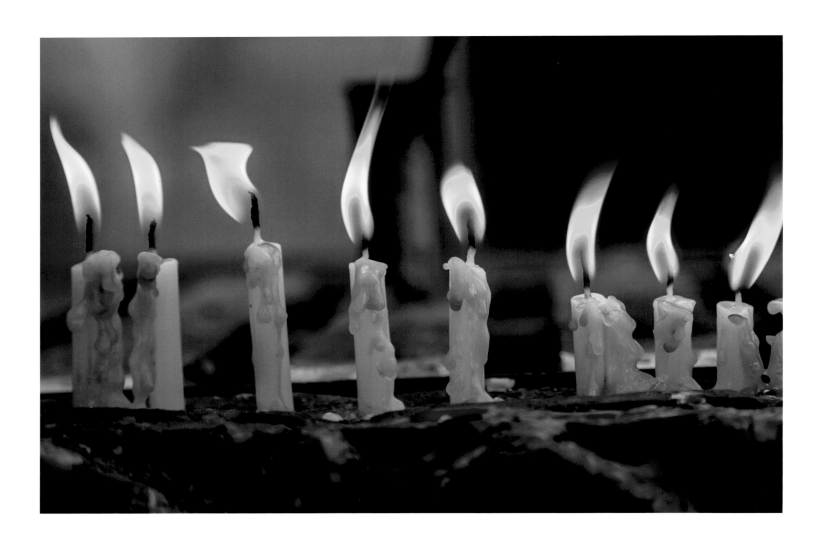

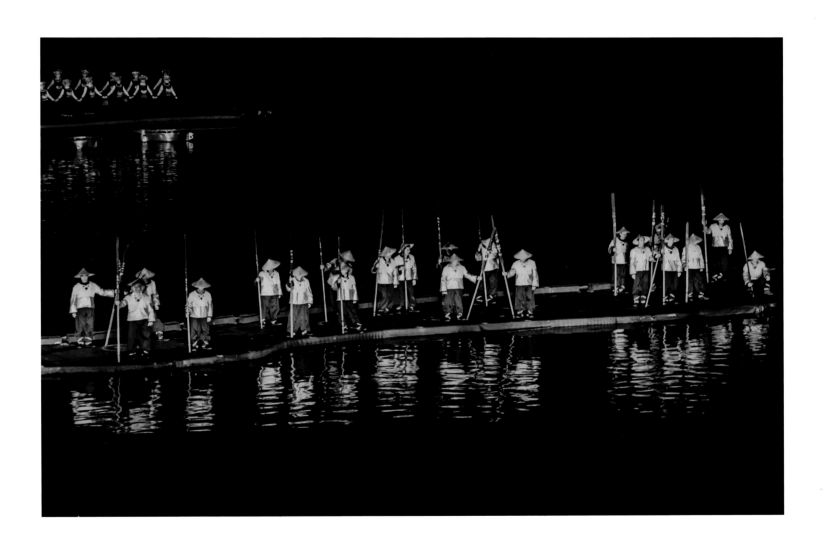

OPPOSITE: Candles symbolizing the enlightenment of the Buddha burn at a temple, Yangon, Myanmar
ABOVE: Cultural performance for visitors on the Li River, Yangshuo, Guangxi, China
FOLLOWING PAGES: Fishermen casts nets on the Irrawaddy River, Mandalay, Myanmar

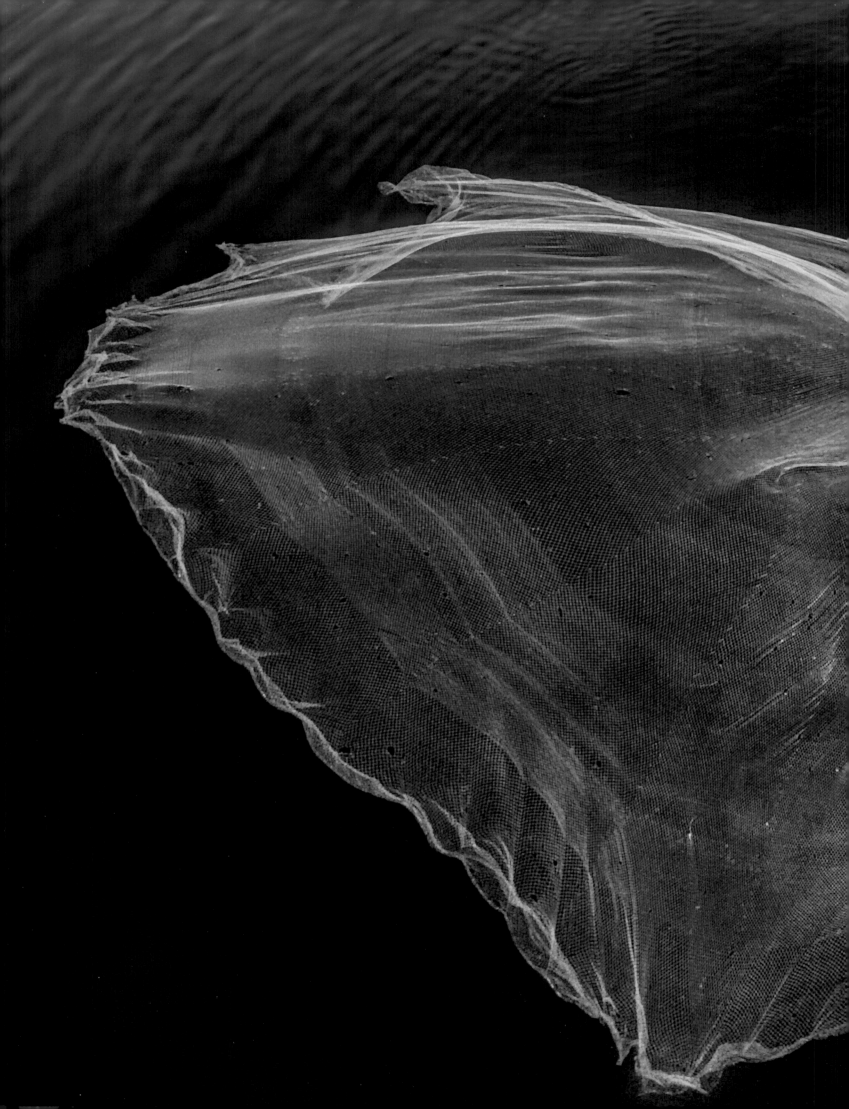

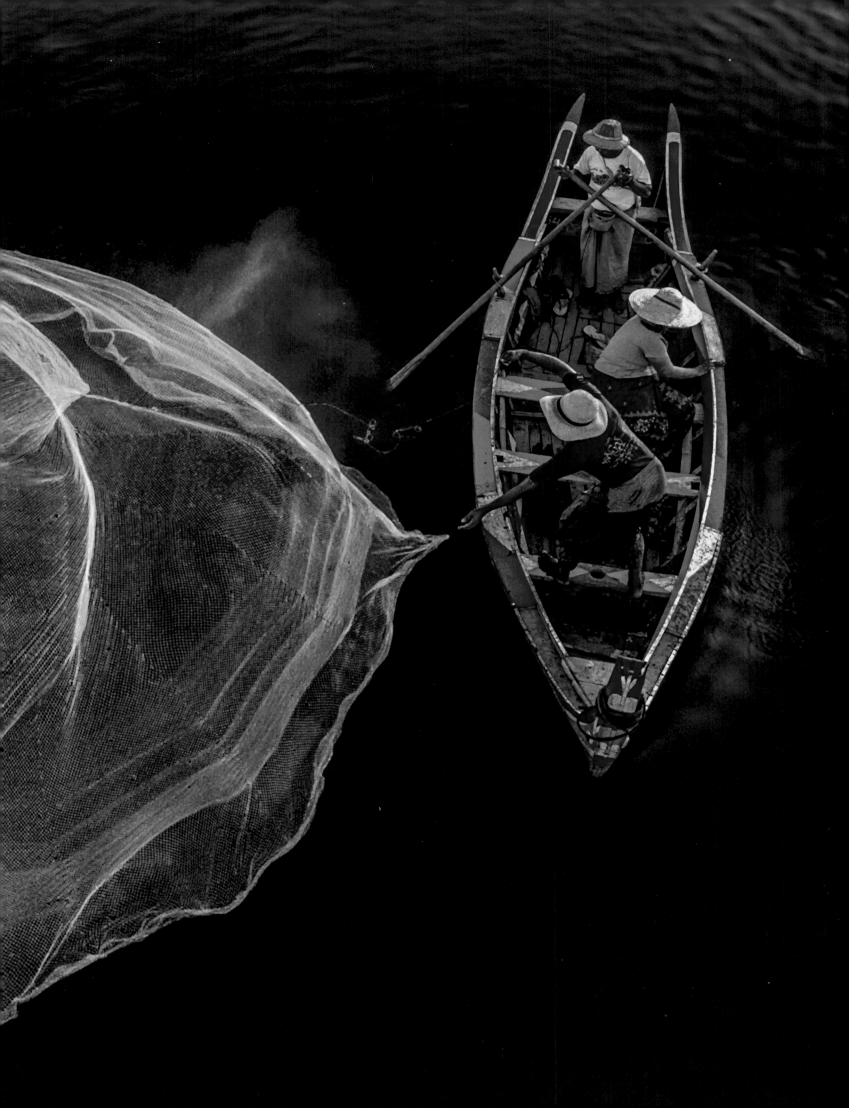

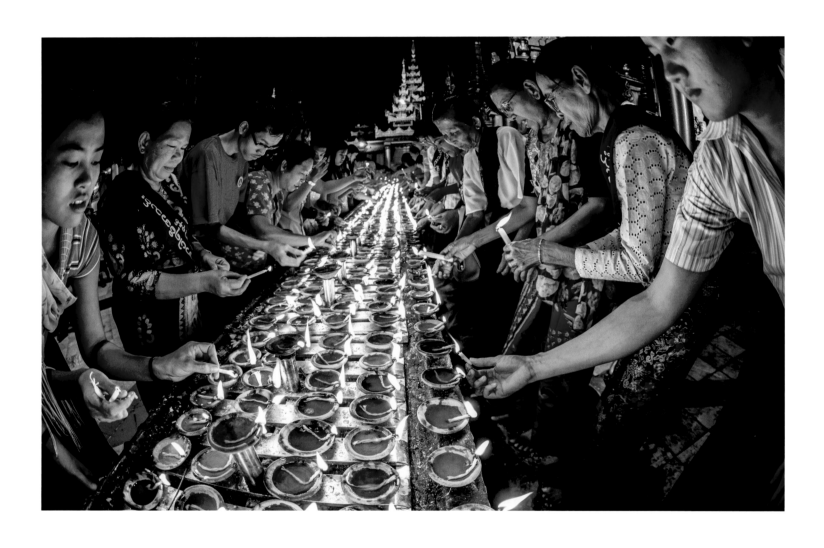

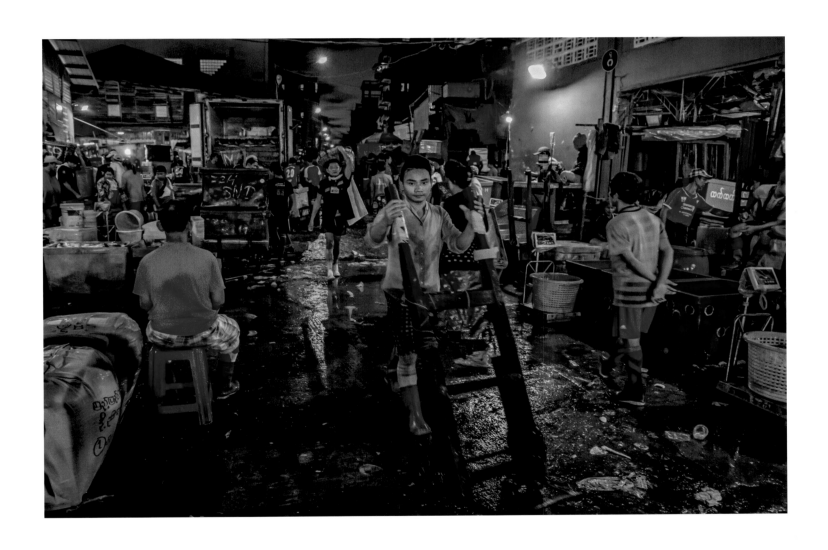

OPPOSITE: Buddhists at prayer, Mandalay, Myanmar
ABOVE: Night market, Yangon, Myanmar
FOLLOWING PAGES: Bagan, Mandalay, Myanmar

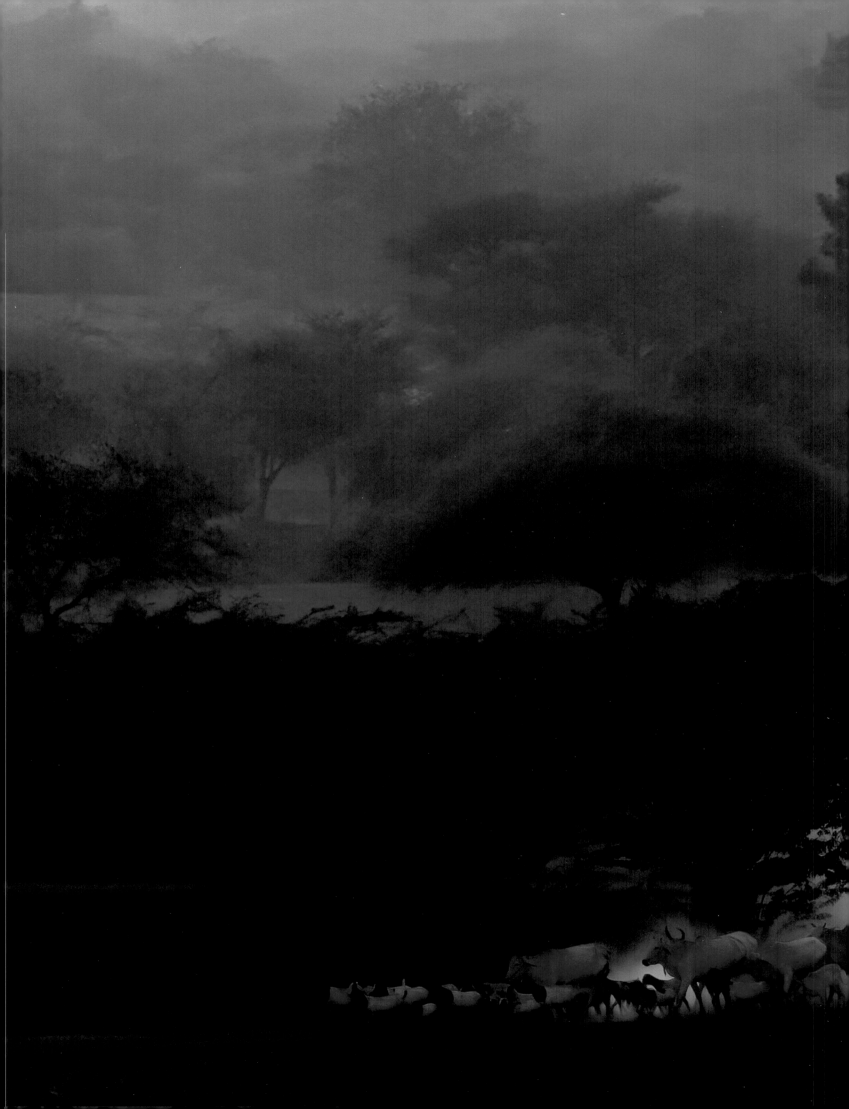

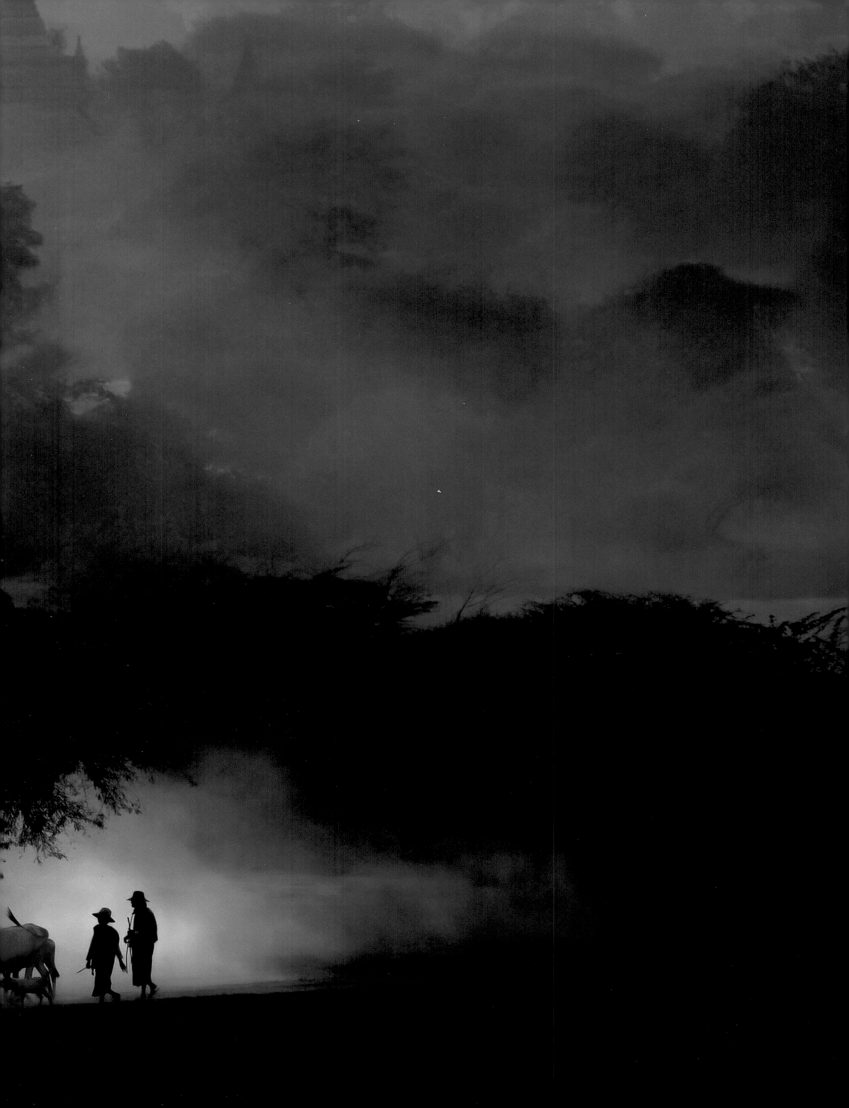

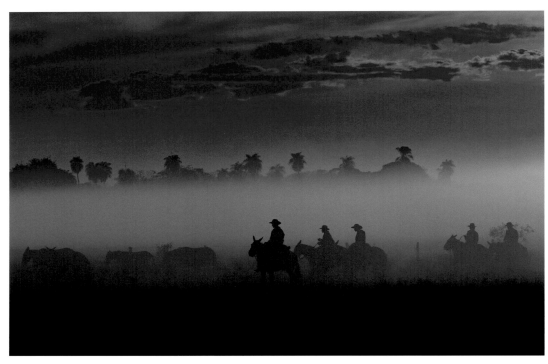

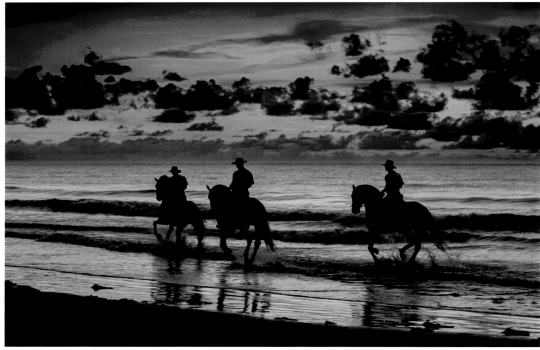

ABOVE TOP: Cowboys, Fazenda Rio Negro, Pantanal, Mato Grosso, Brazil
ABOVE BOTTOM: Bahia, Brazil

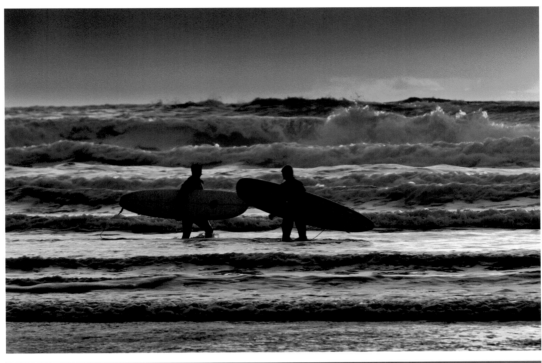

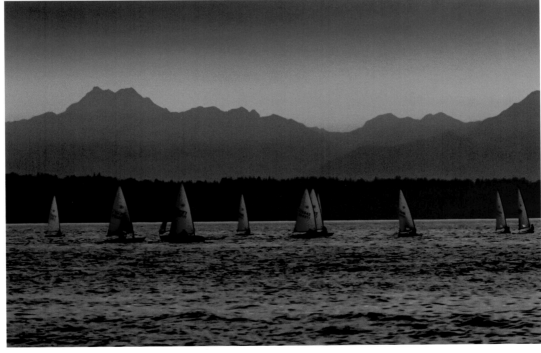

ABOVE TOP: Surfers, Cannon Beach, Oregon, USA
ABOVE BOTTOM: Sailboats off Golden Gardens Park, Seattle, Washington, USA

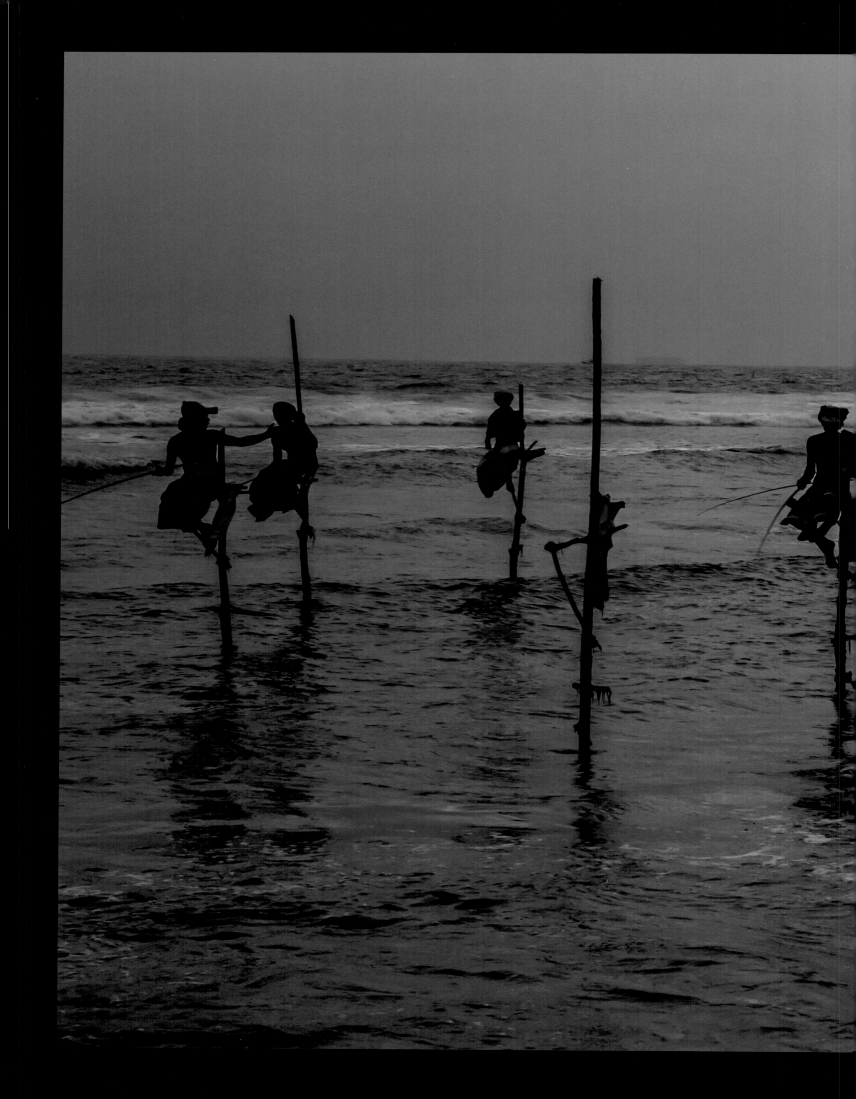

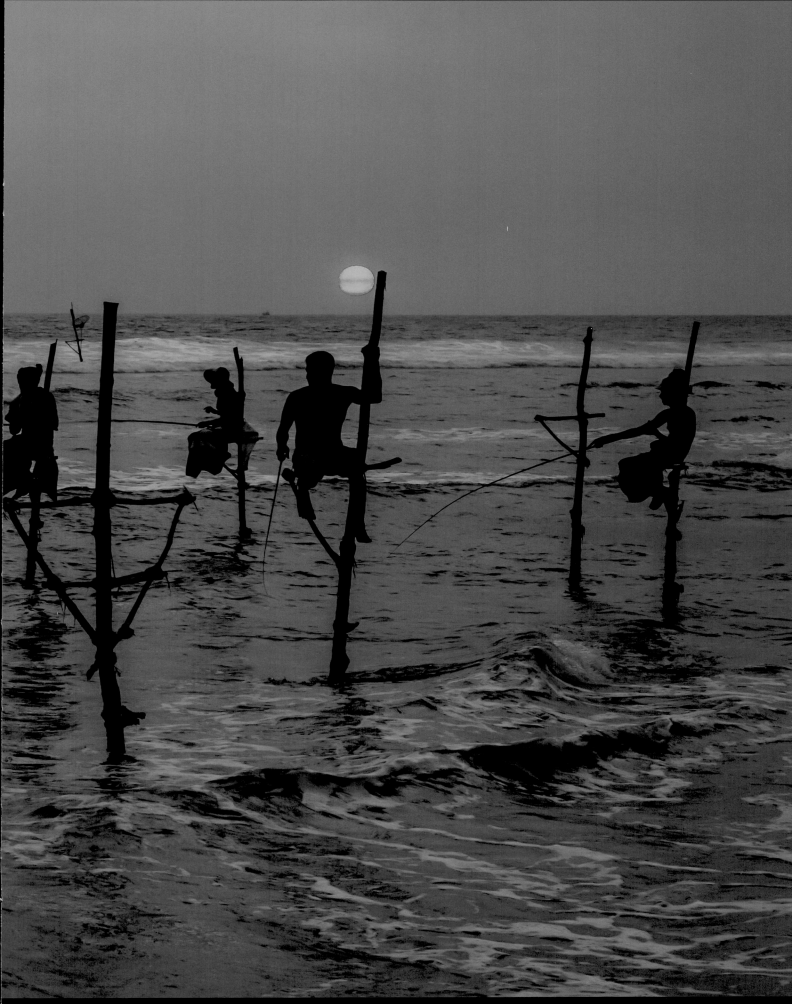

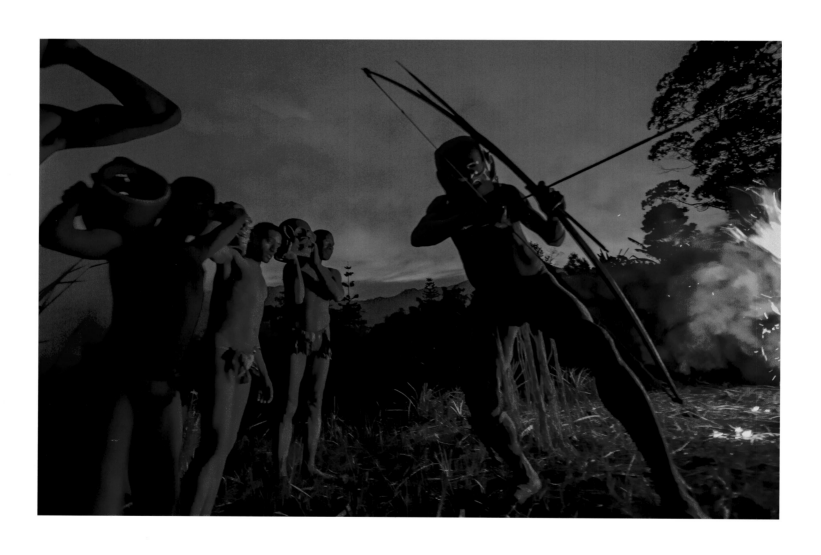

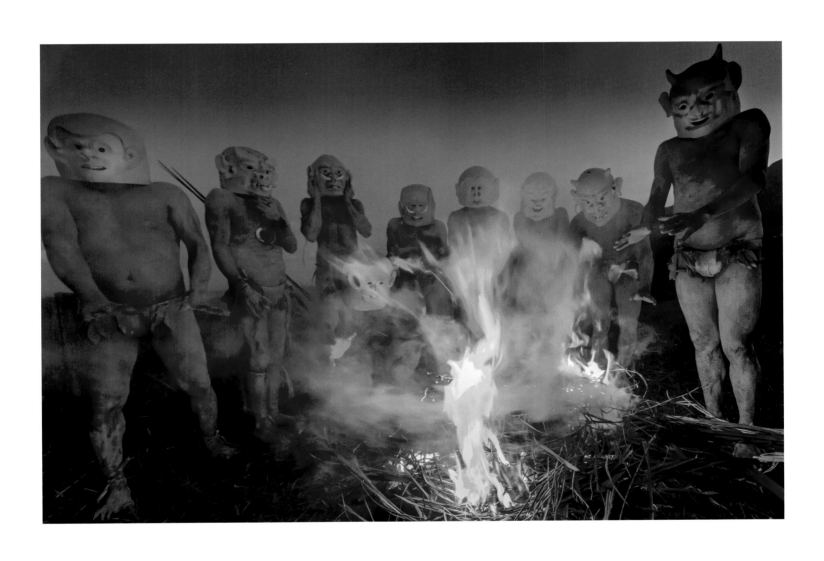

PREVIOUS PAGES: Stilt fishermen, Southern Province, Sri Lanka
OPPOSITE: Asaro mudmen, Eastern Highlands Province, Papua New Guinea
ABOVE: Asaro mudmen gather around a fire, Eastern Highlands Province, Papua New Guinea

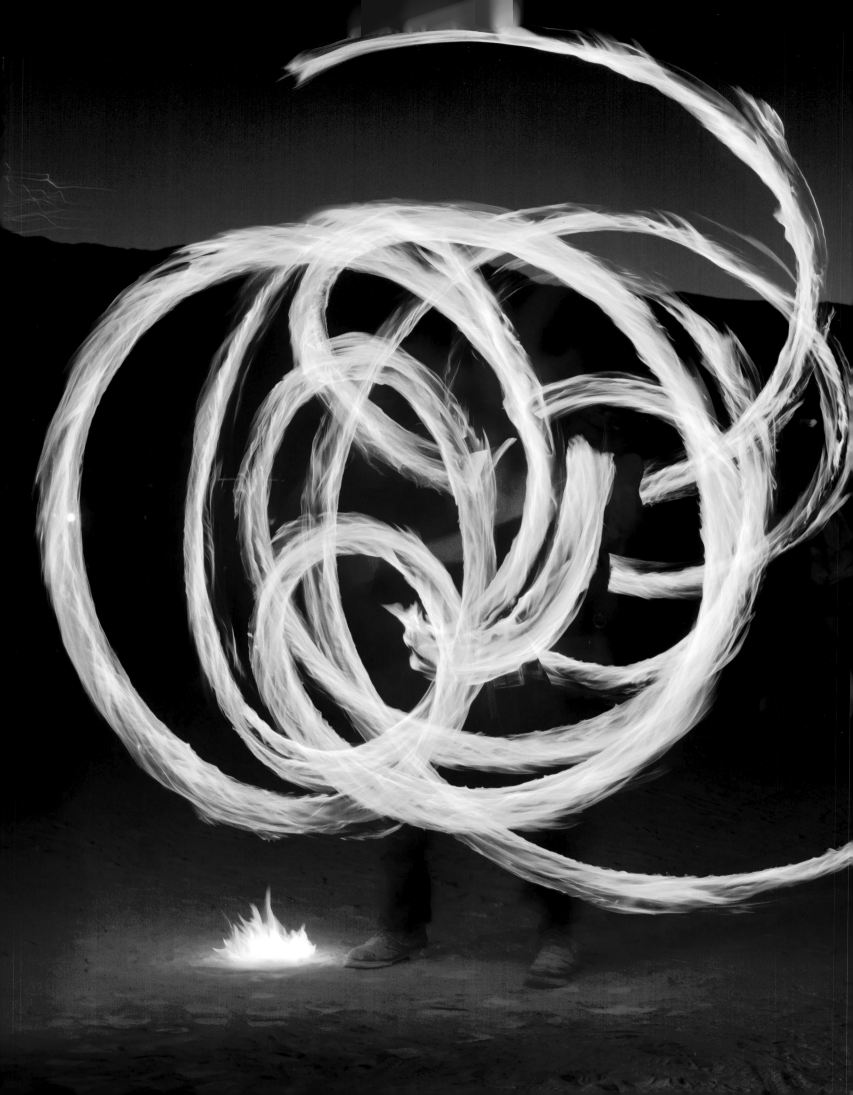

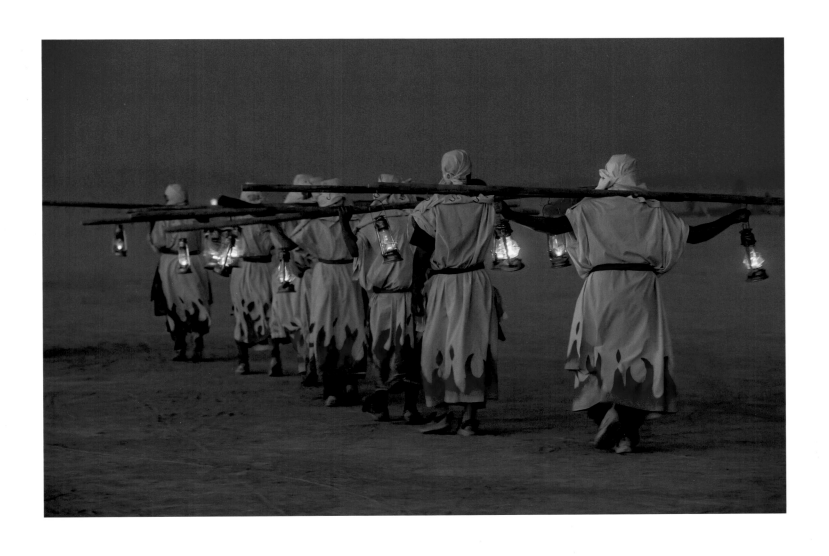

OPPOSITE: Fire performer, Burning Man, Nevada, USA
ABOVE: Lamplighters, Burning Man, Nevada, USA

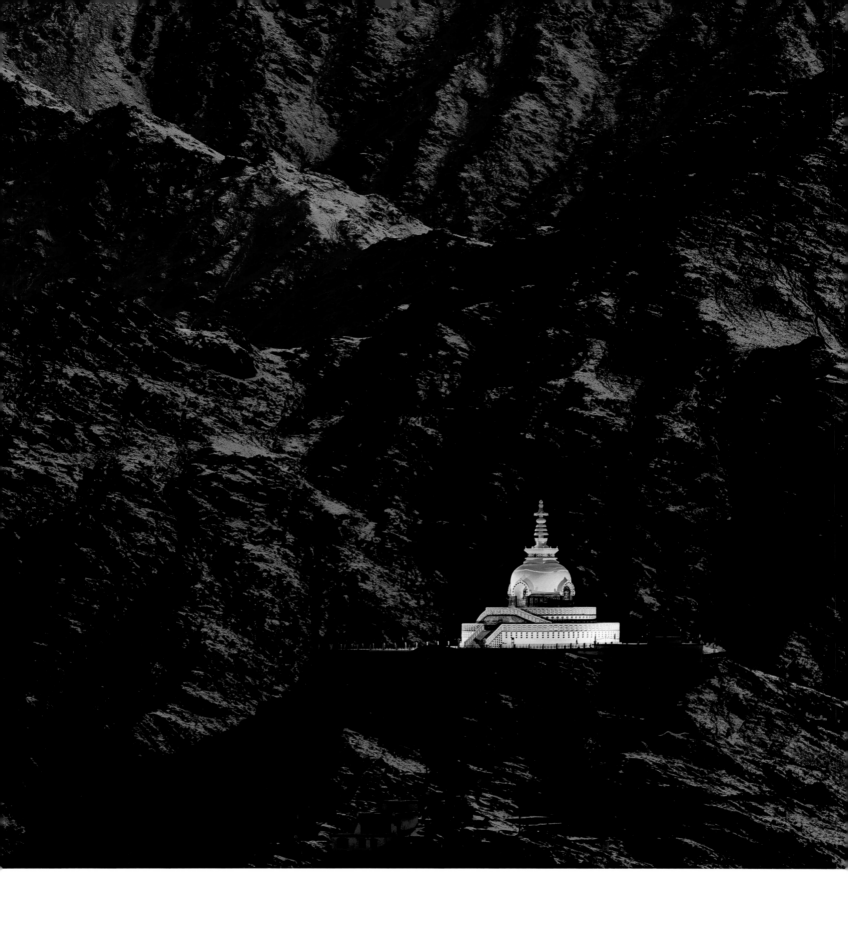

THE INTUITION OF LIGHT

Reflections careen off of well-polished steel and glass. A tower rises toward the sky, and a low electrical hum fills the avenues. Neon traffic lights and bar signs explode into the dark like fireworks. Beyond the wild displays of light, you can still see shadow and feel the lure of an alley and a streetlamp.

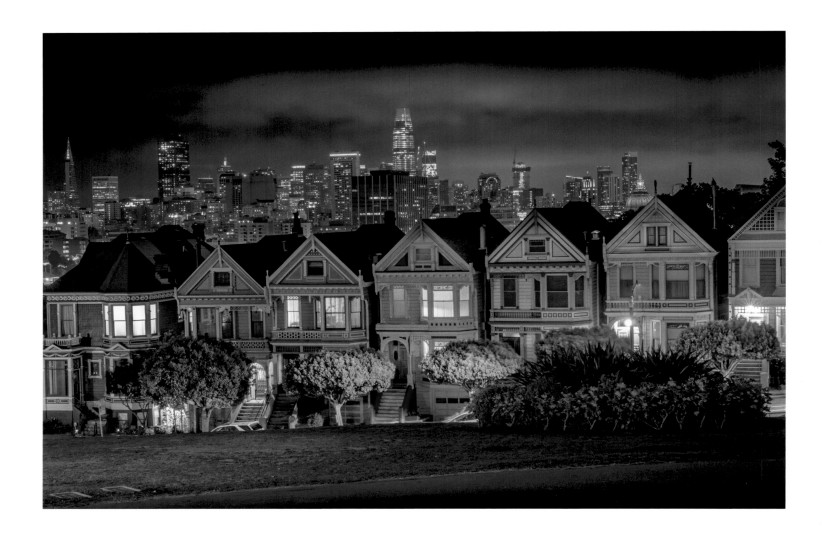

CHAPTER OPENER: Shanti Stupa, Leh, Ladakh, India
ABOVE: The famous Victorian homes, the Painted Ladies,
Alamo Square, San Francisco, California, USA
OPPOSITE: Eastern span of the San Francisco-Oakland Bay Bridge, California, USA

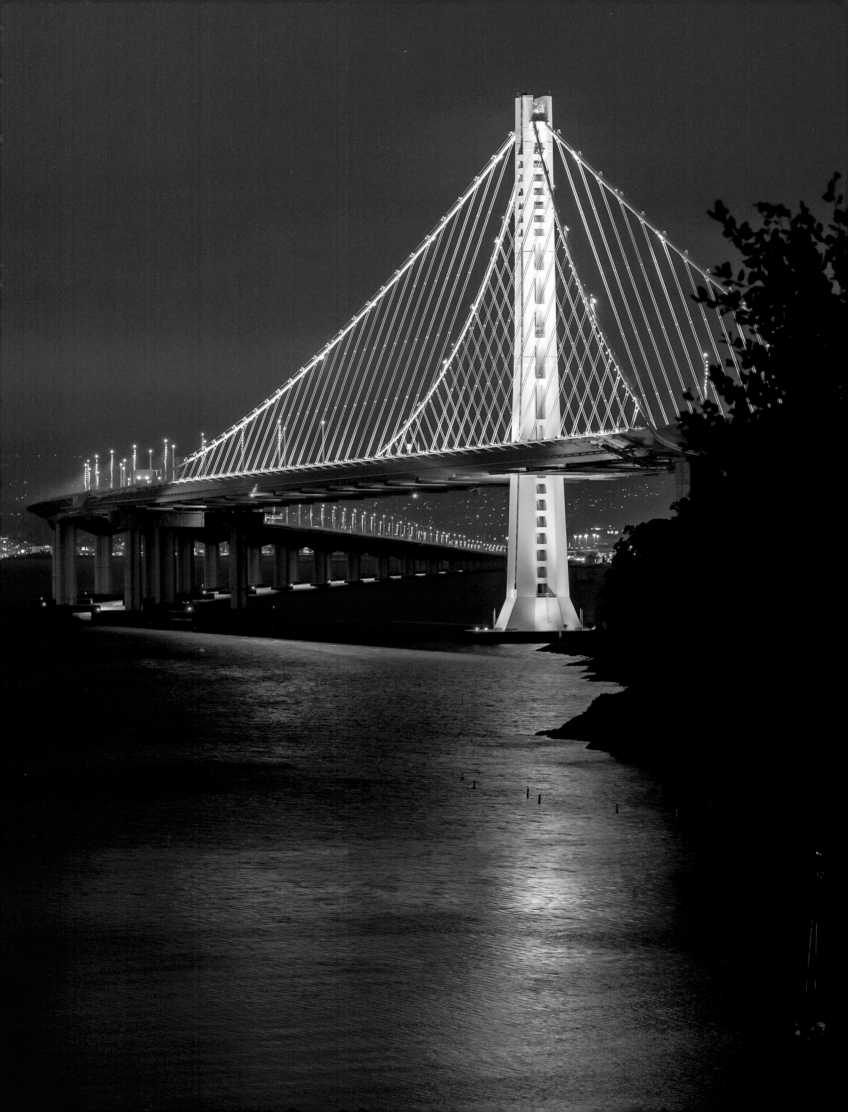

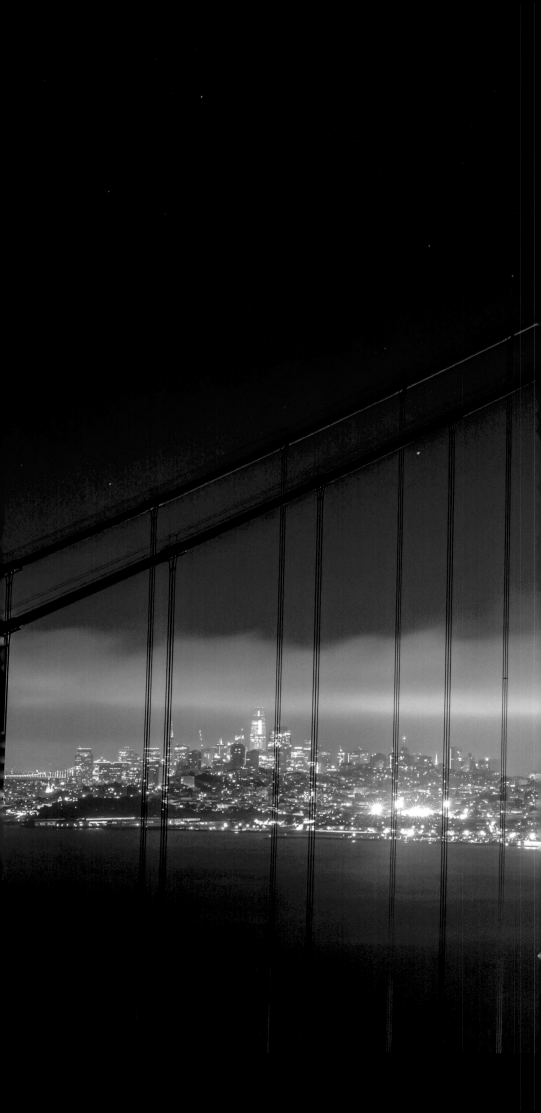

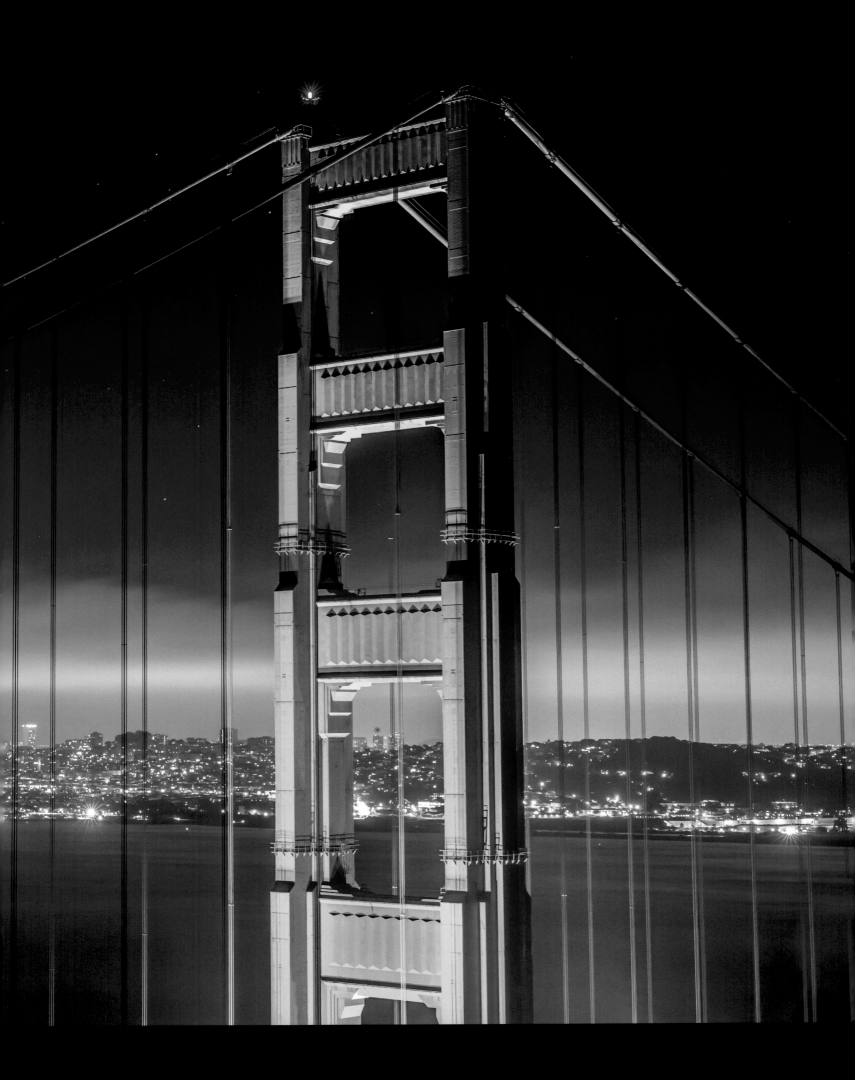

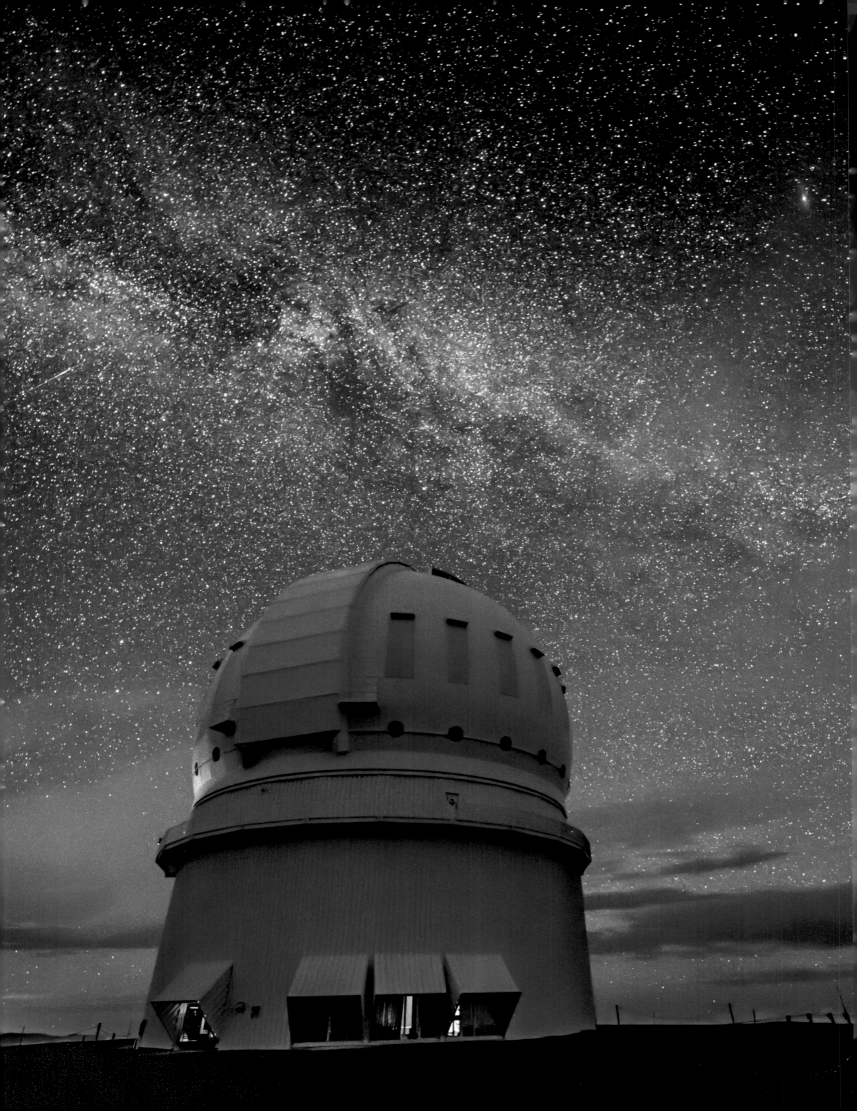

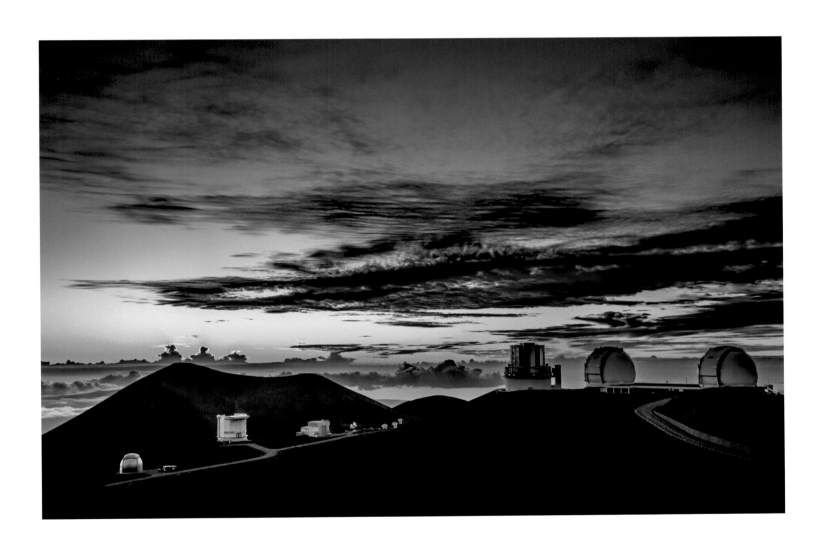

PREVIOUS PAGES: Golden Gate Bridge photographed from Marin Headlands
looking south to San Francisco, California, USA
OPPOSITE, ABOVE, AND FOLLOWING PAGES: Mauna Kea Observatories, Hawaii, USA

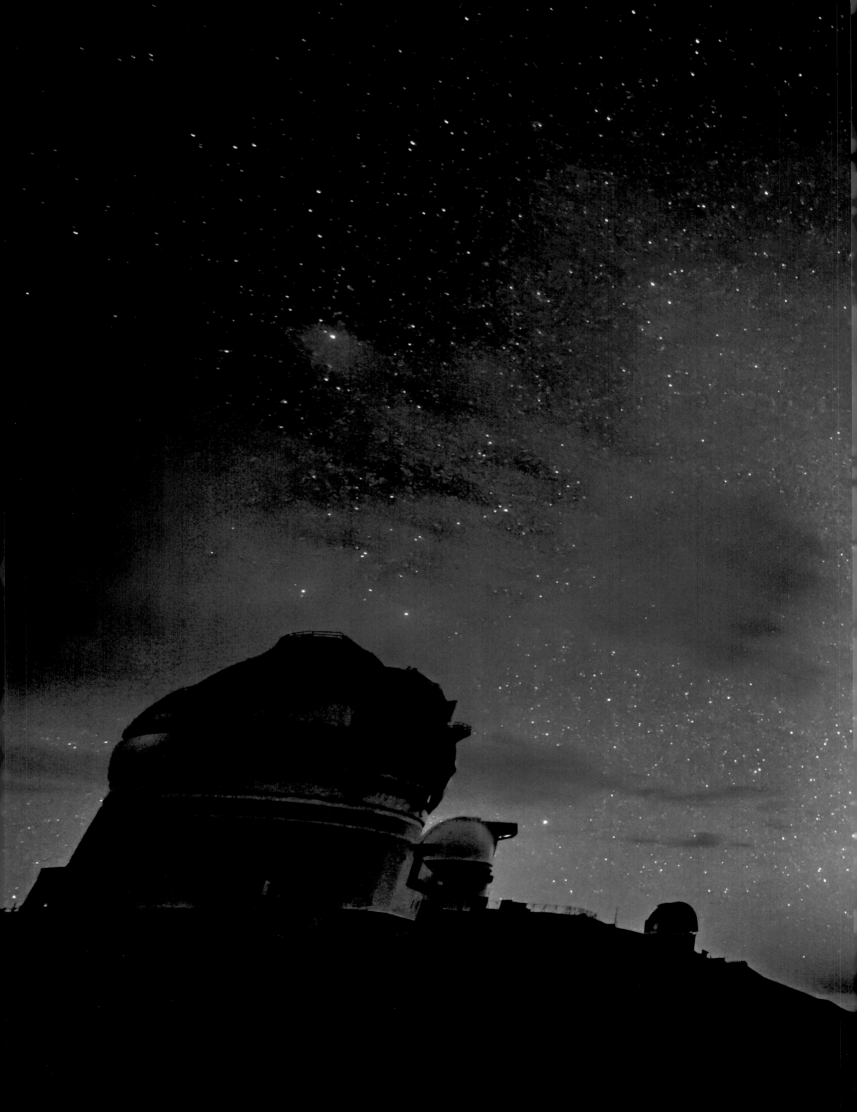

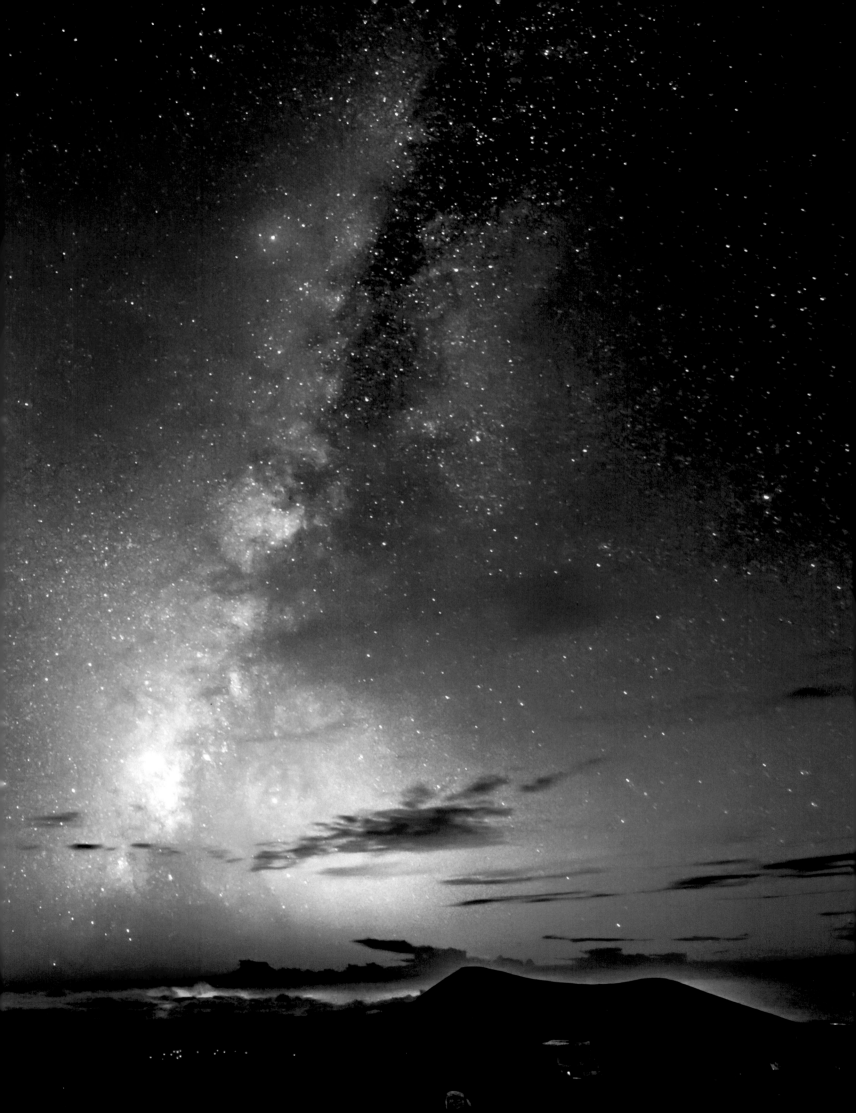

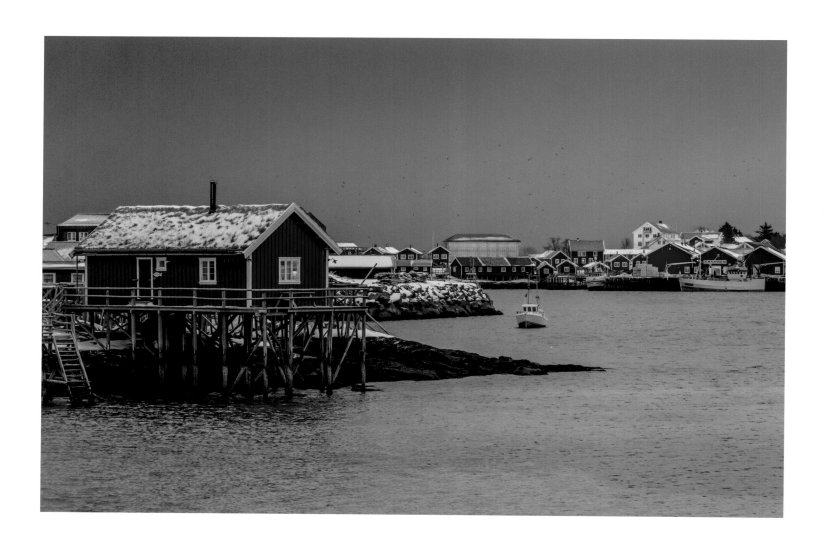

ABOVE: Reine, Lofoten, Nordland, Norway
OPPOSITE: Peggy's Cove, Nova Scotia, Canada
FOLLOWING PAGES: Oxcarts, Bagan, Mandalay, Myanmar

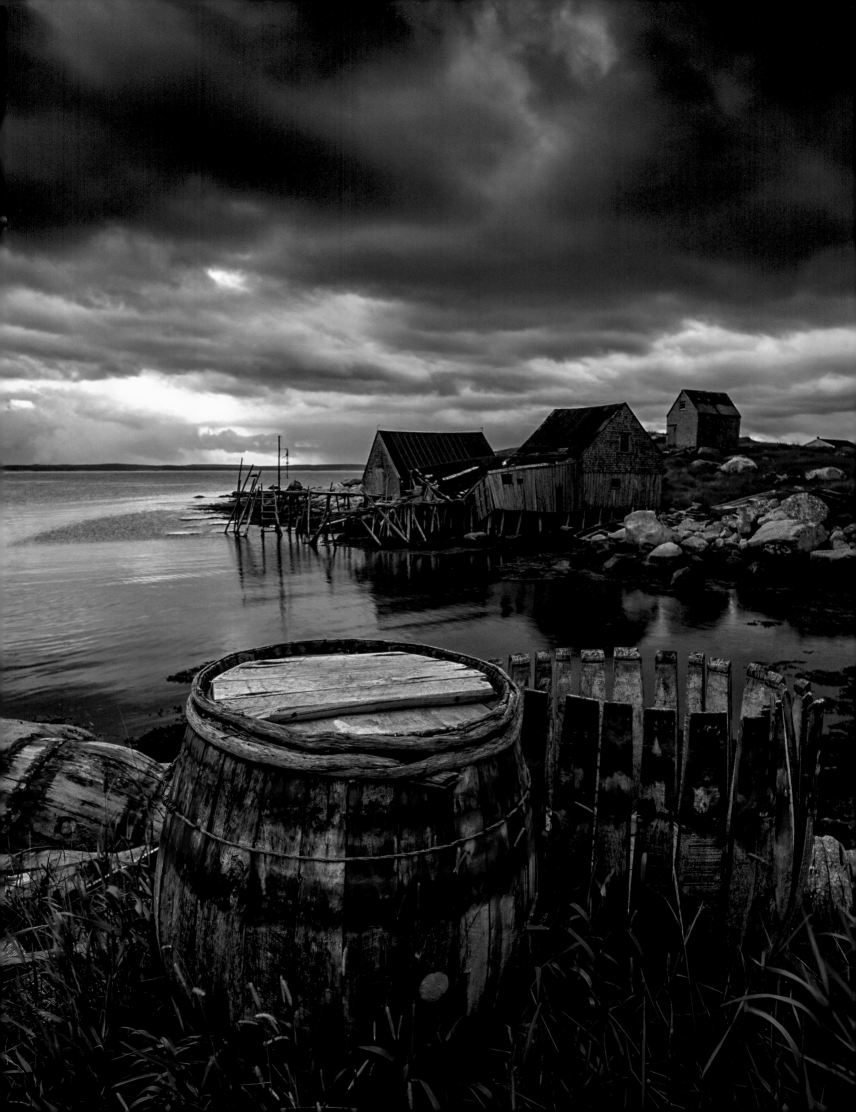

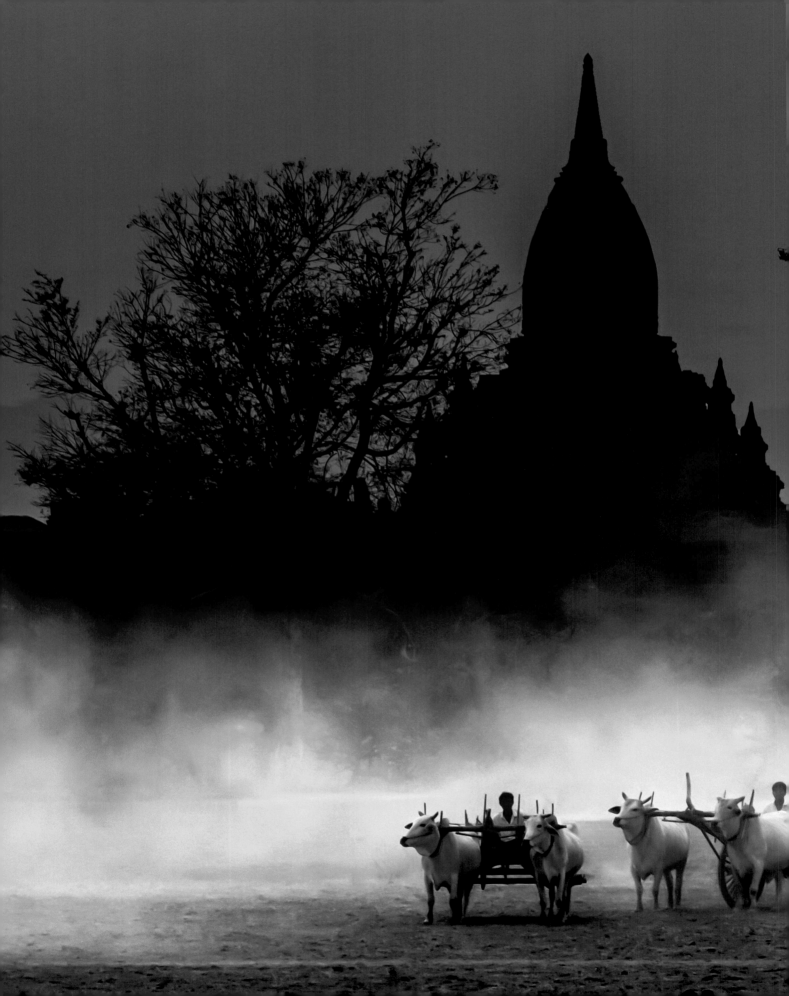

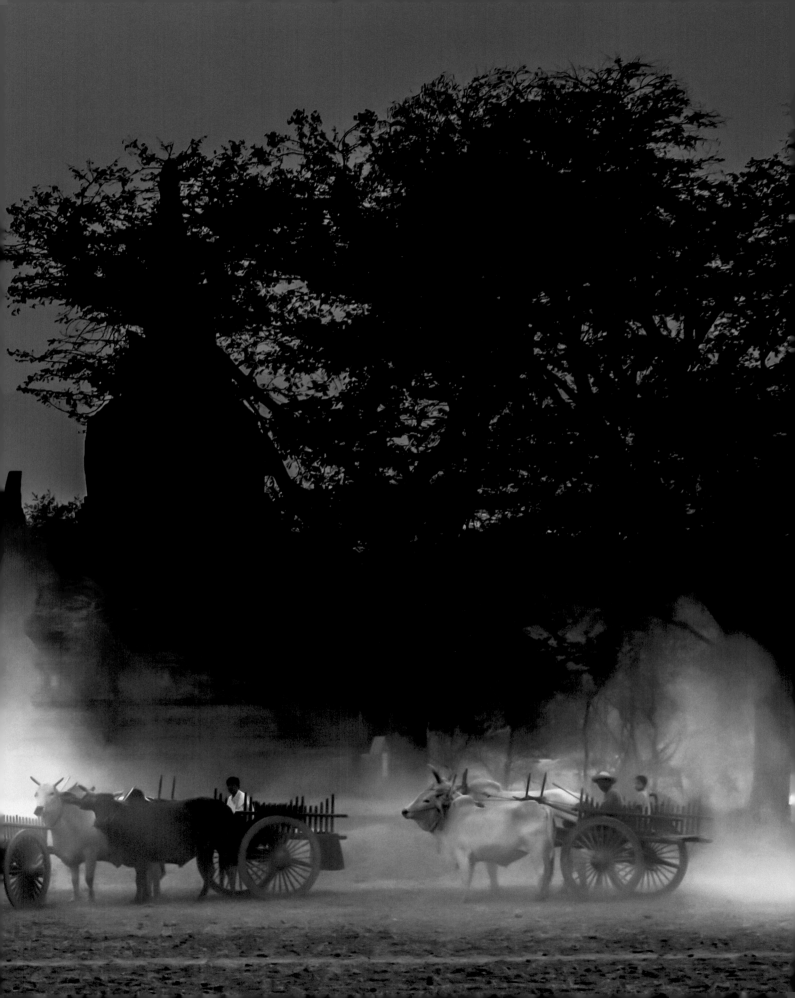

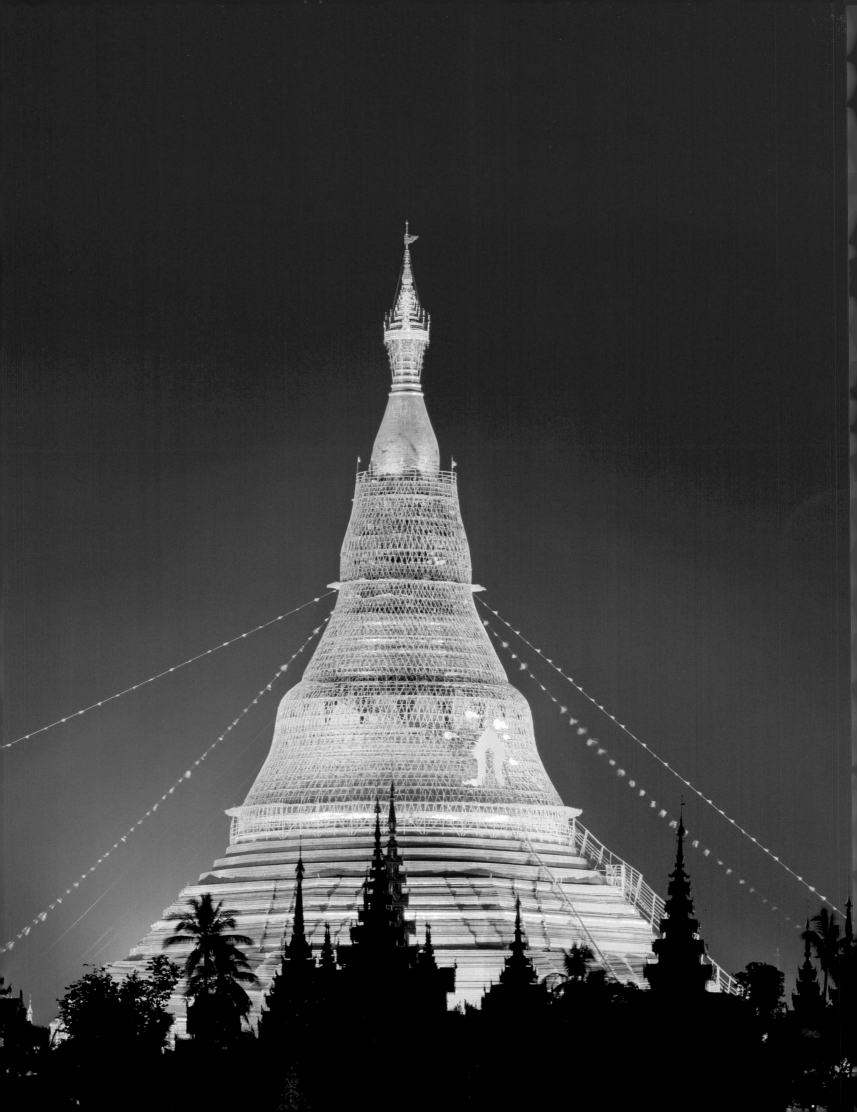

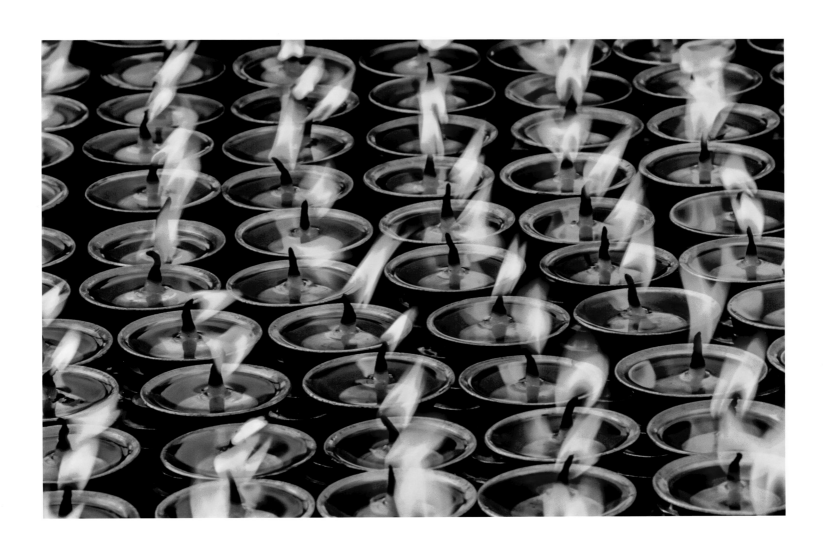

OPPOSITE: Shwedagon Pagoda, Yangon, Myanmar
ABOVE: Votives, Bouddhanath Stupa, Kathmandu, Nepal

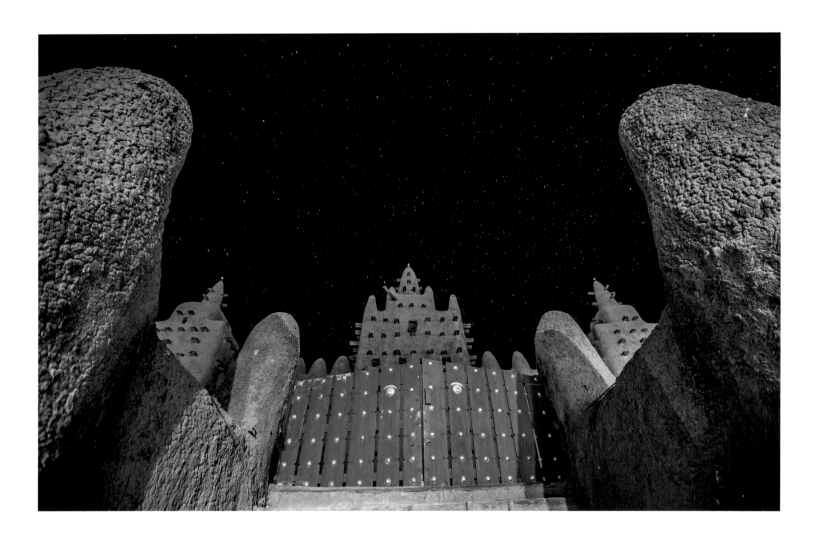

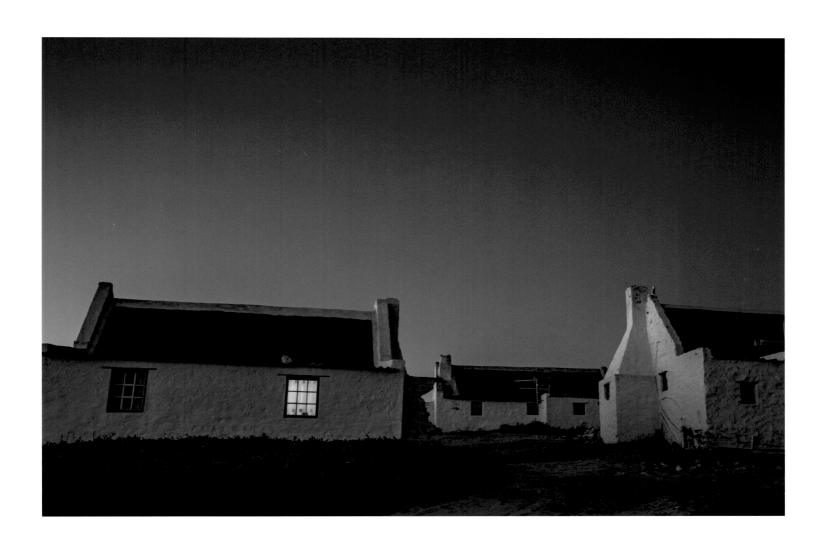

OPPOSITE: Grand Mosque of Djenné, Mopti, Mali
ABOVE: Light beckons from the window of a traditional fisherman's
cottage in Arniston, Western Cape, South Africa
FOLLOWING PAGES: Oia, Santorini, Southern Aegean, Greece

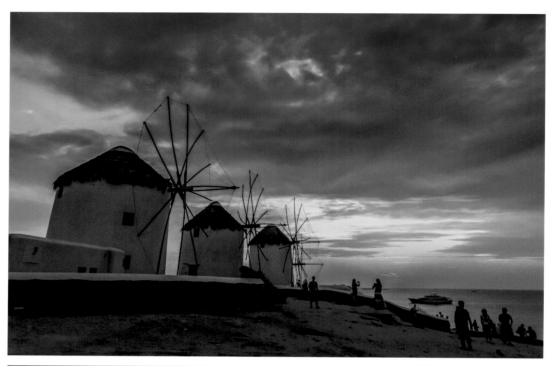

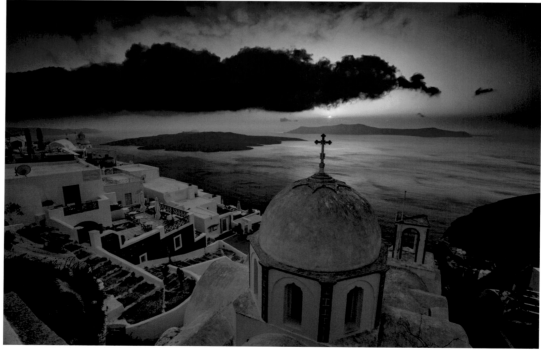

ABOVE TOP: Windmills, Chora, Mykonos, Southern Aegean, Greece
ABOVE BOTTOM: Orthodox church, Mykonos, Southern Aegean, Greece

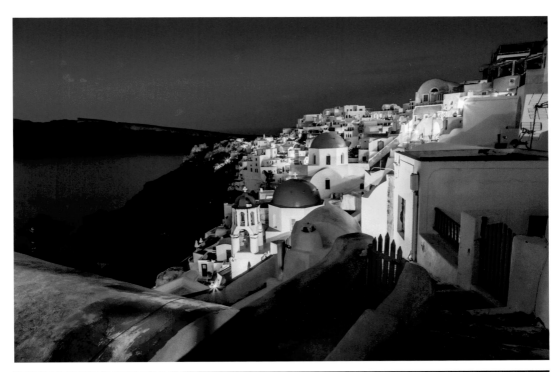

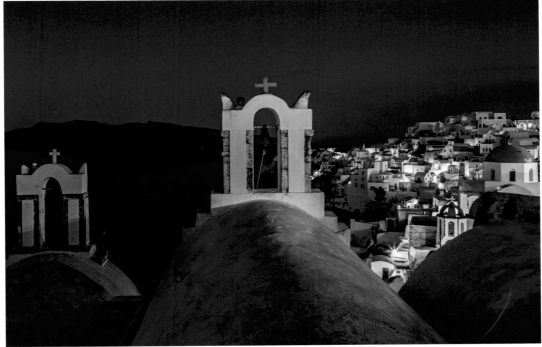

ABOVE TOP: Oia, Santorini, Southern Aegean, Greece
ABOVE BOTTOM: Bell towers, Oia, Santorini, Southern Aegean, Greece

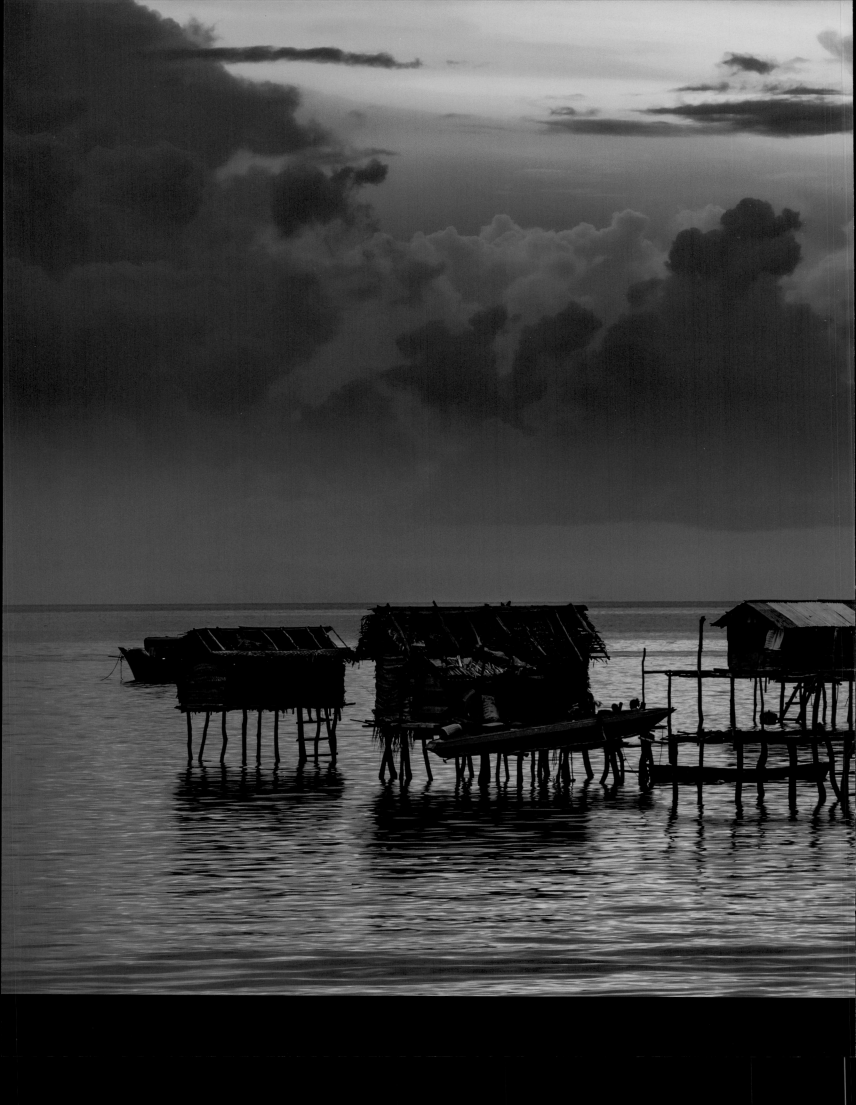

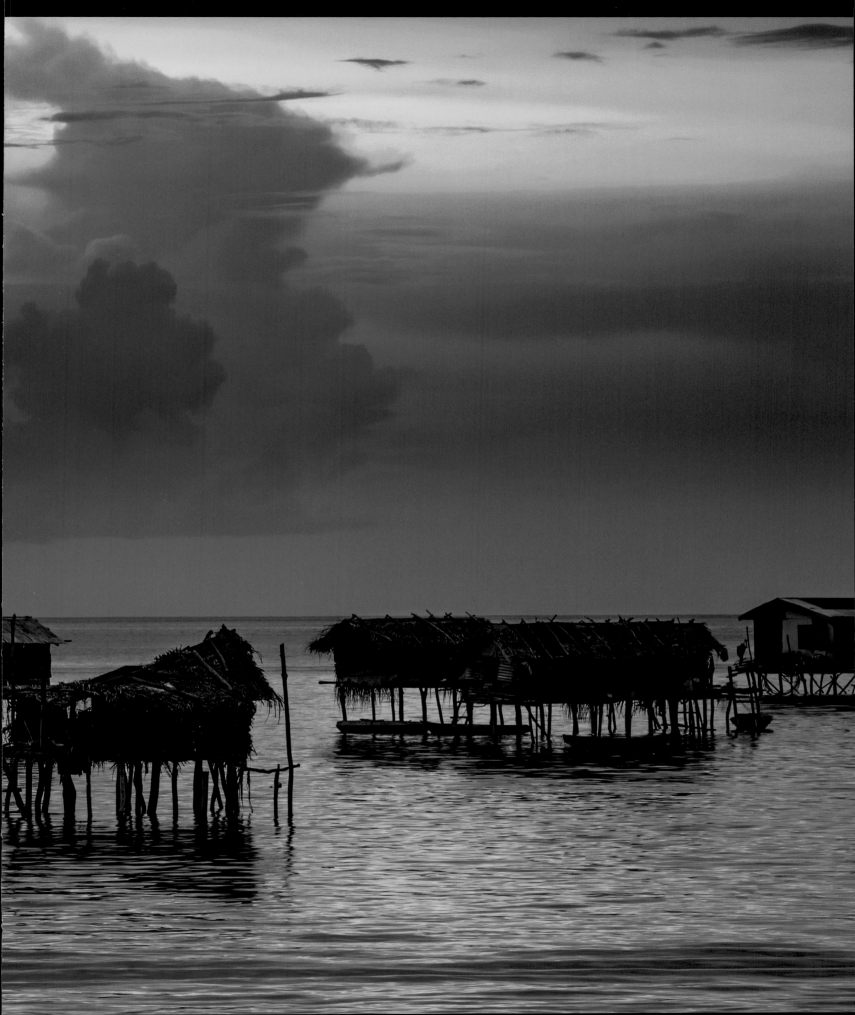

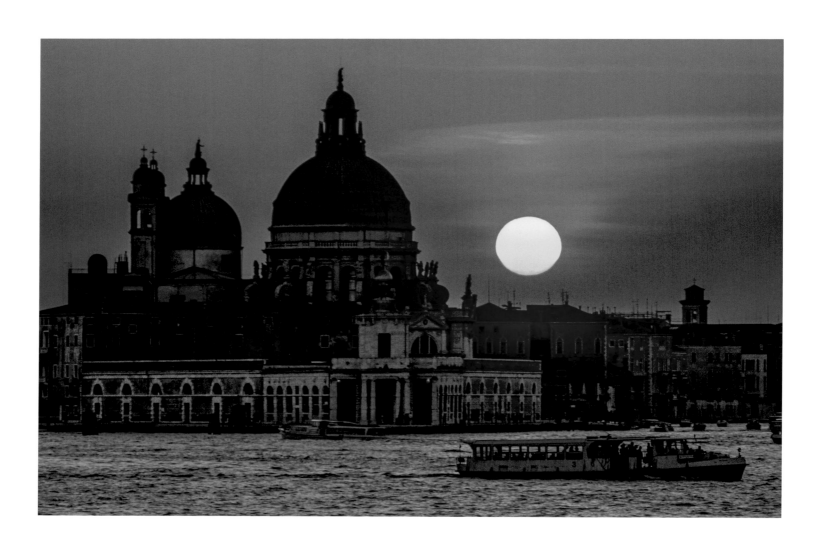

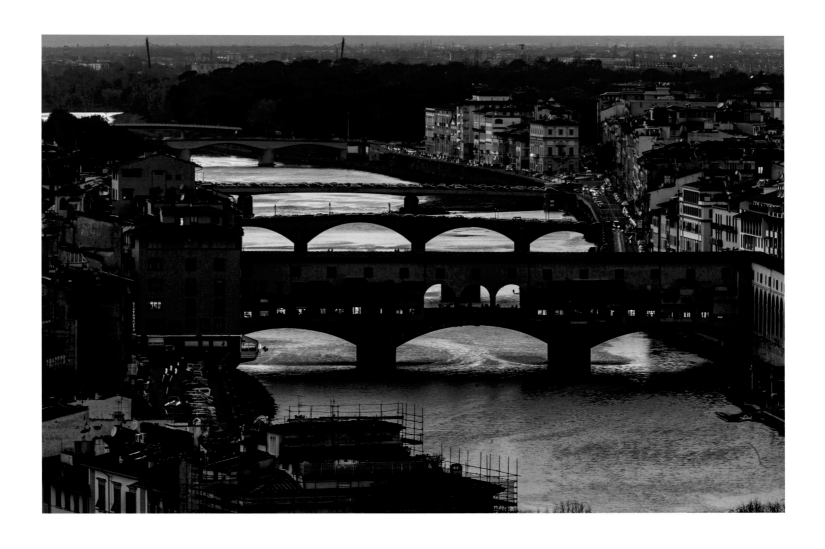

PREVIOUS PAGES: Bajau seaborne settlement, Semporna, Sabah, Malaysia
OPPOSITE: St. Mark's Basilica, Venice, Veneto, Italy
ABOVE: The medieval Ponte Vecchio spans the Arno River, Florence, Tuscany, Italy
FOLLOWING PAGES: Gondolas, Venice, Veneto, Italy

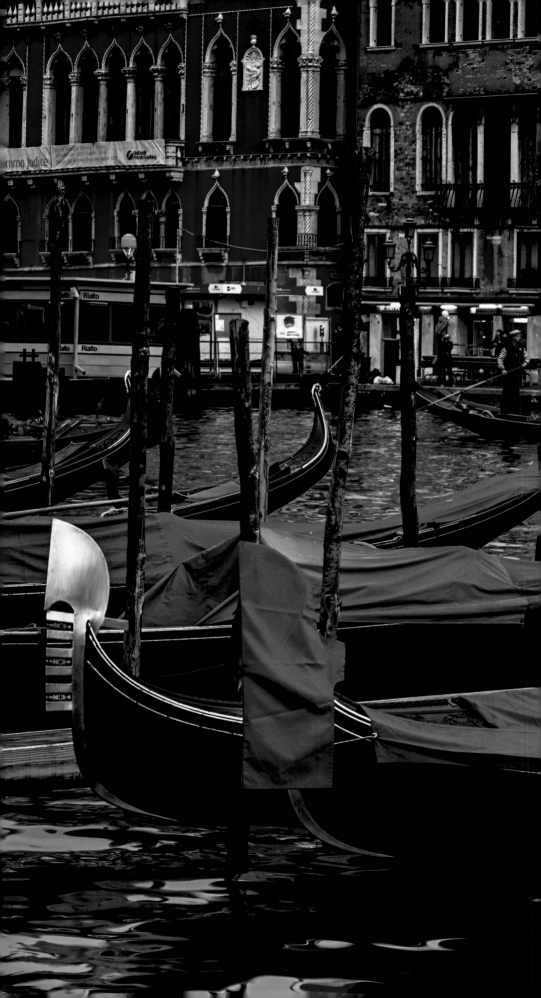

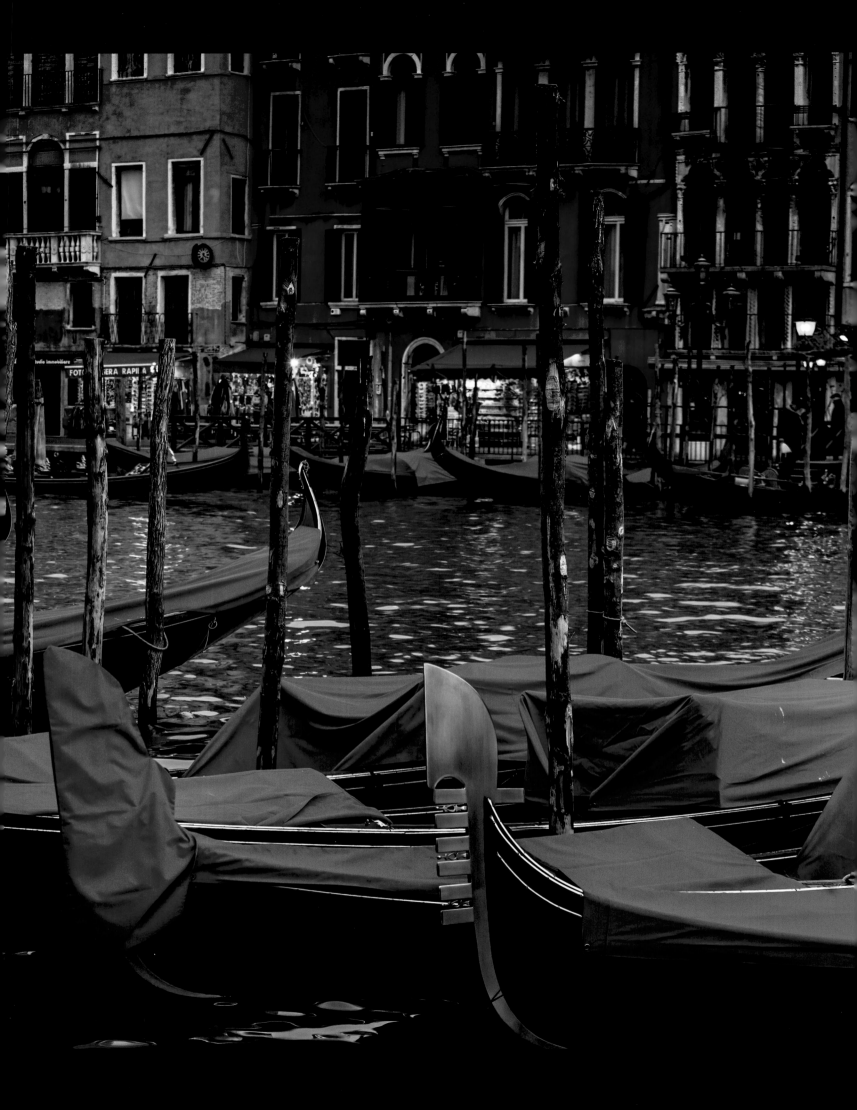

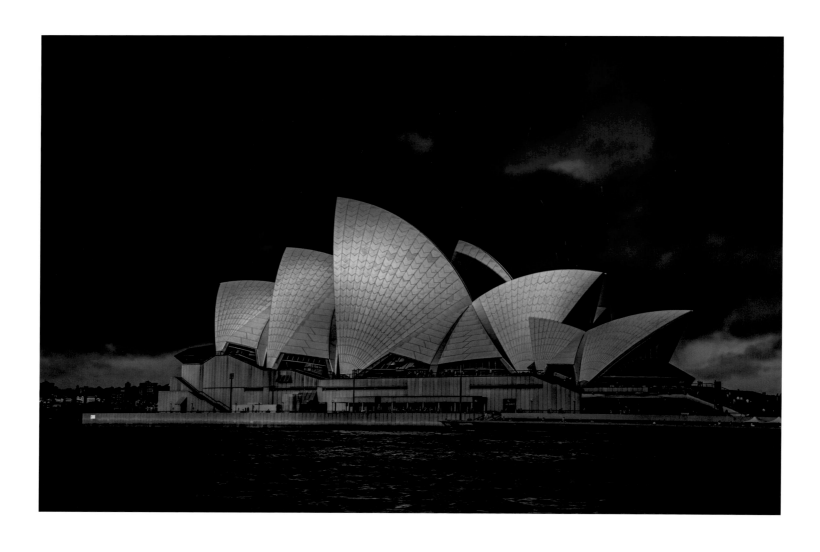

ABOVE: Sydney Opera House, Sydney, New South Wales, Australia
OPPOSITE: Heceta Head Lighthouse, Oregon, USA
FOLLOWING PAGES: Crescent moon and Woolworth Building, New York City, New York, USA

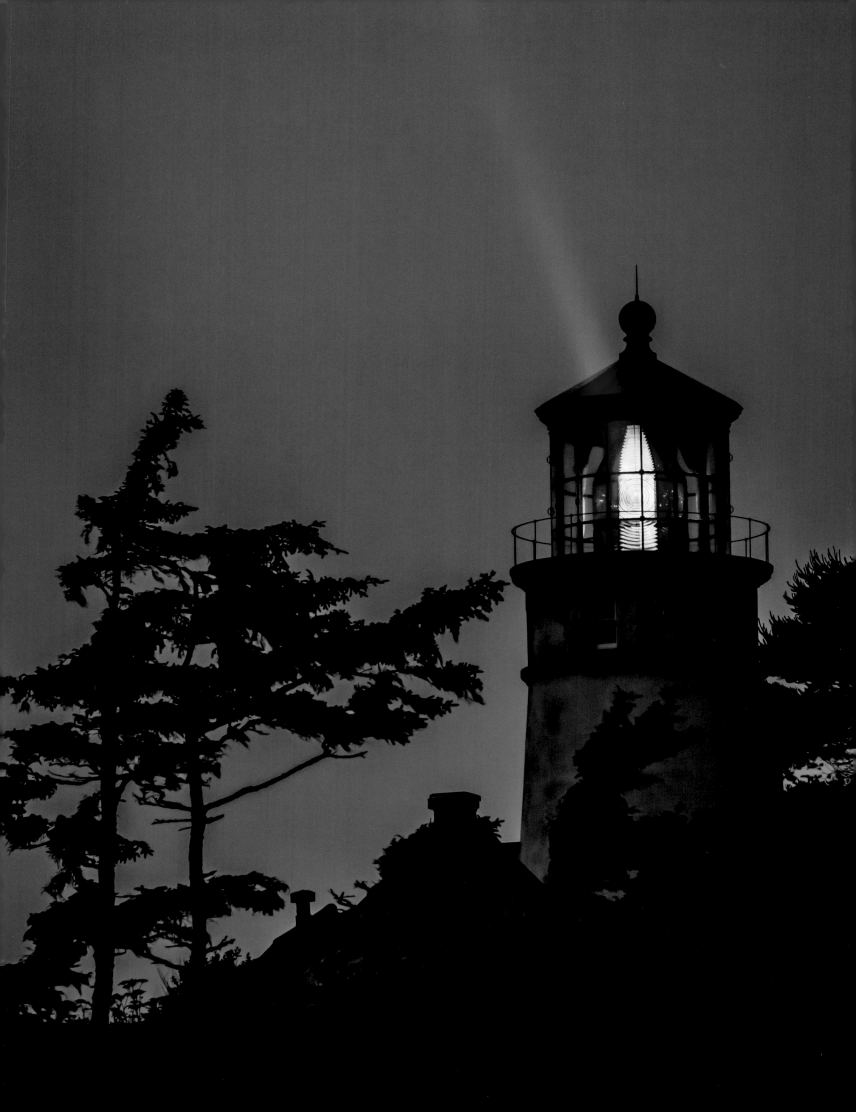

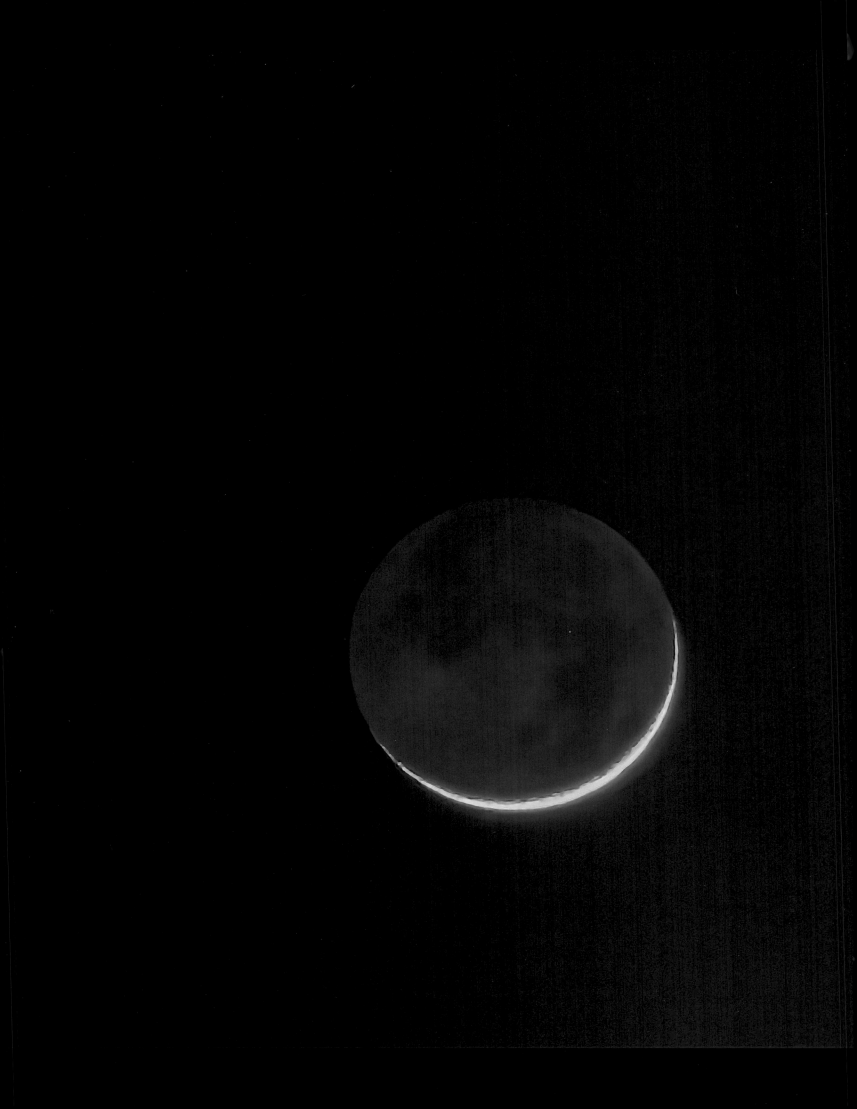

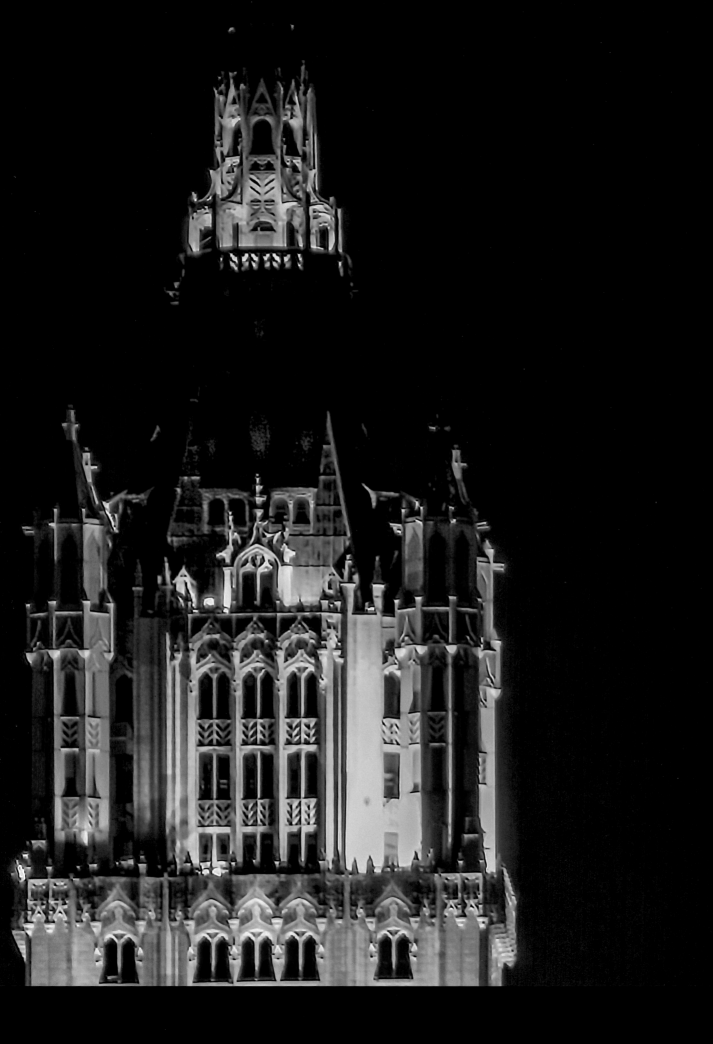

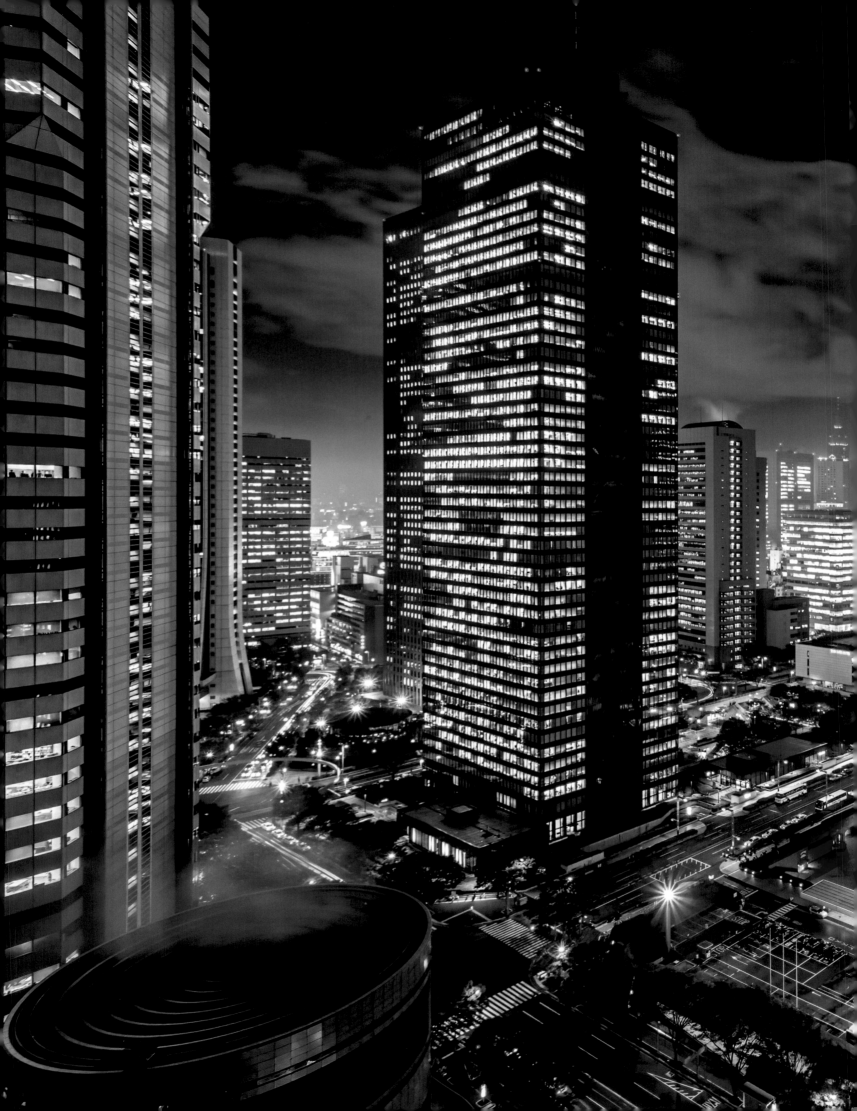

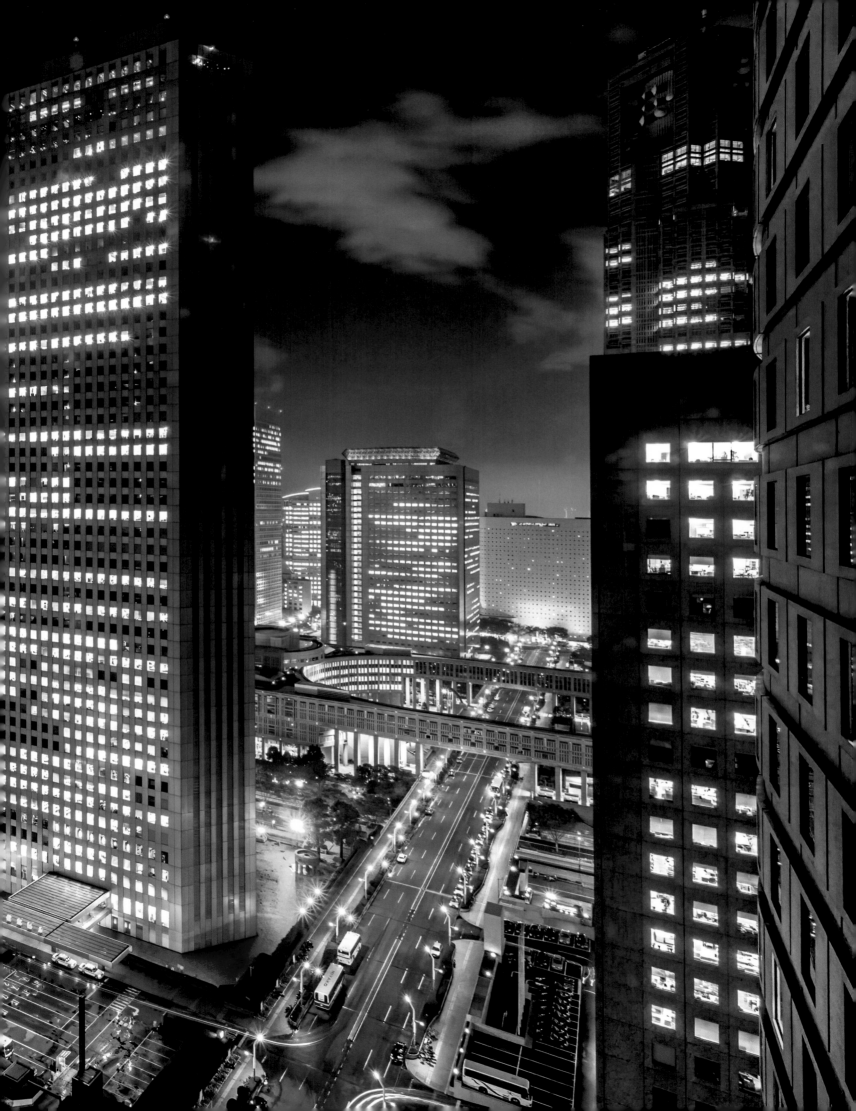

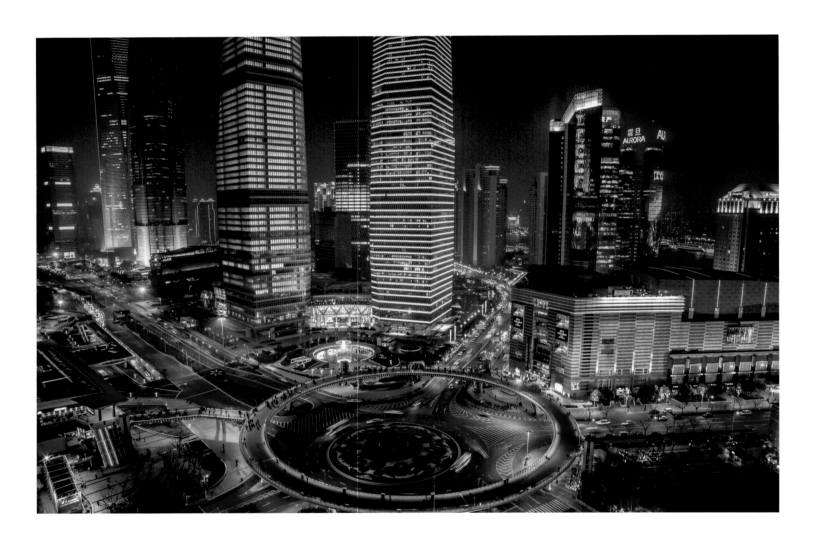

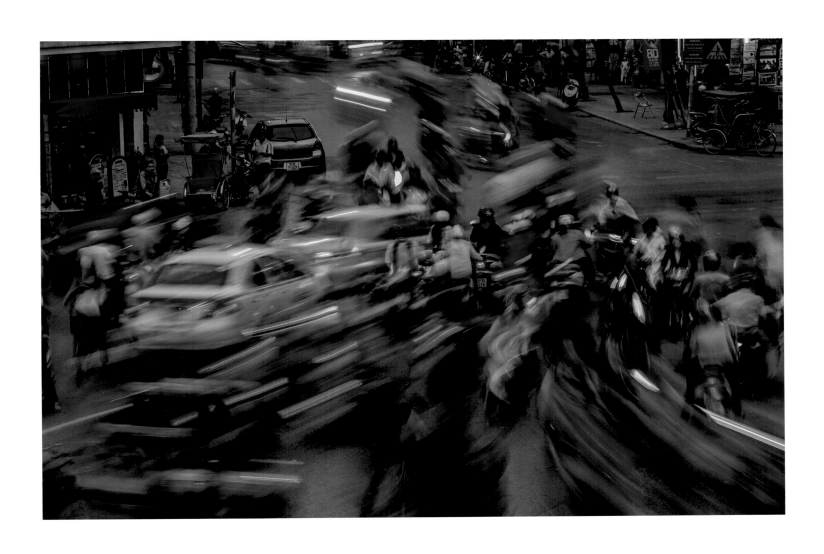

PREVIOUS PAGES: Shinjuku, Tokyo, Honshu, Japan
OPPOSITE: The Lujiazui Traffic Circle, Shanghai, East China, China
ABOVE: Teeming streets of Hanoi, Hong River Delta, Vietnam

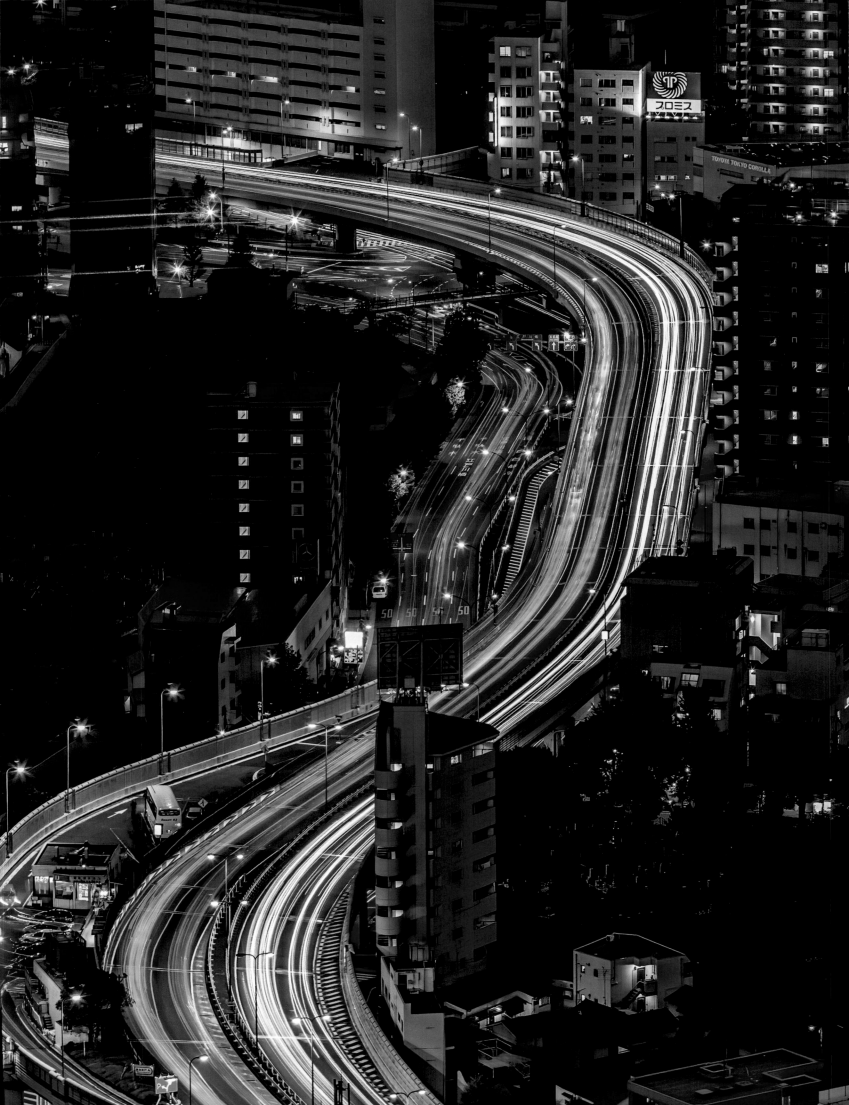

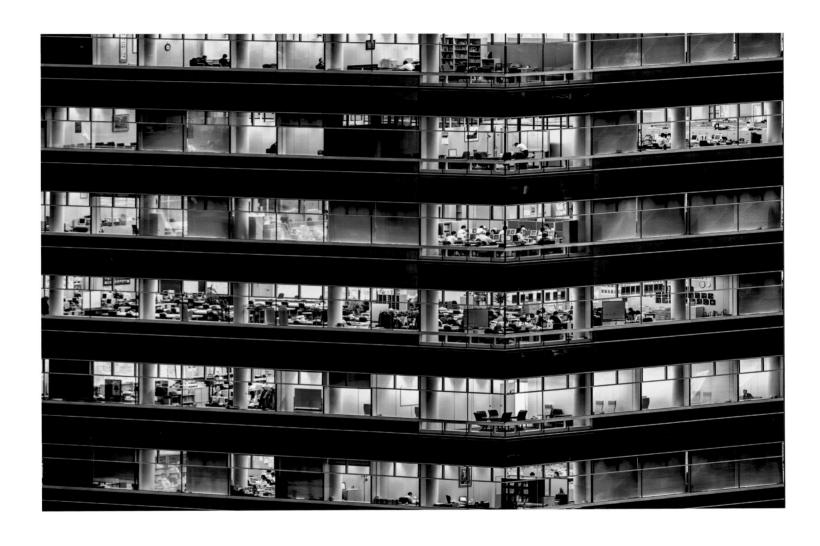

OPPOSITE: Shinjuku Route, Tokyo, Honshu, Japan
ABOVE: Shinjuku, Tokyo, Honshu, Japan
FOLLOWING PAGES: View of Manhattan down Sixth Avenue with
Empire State Building on right, New York City, New York, USA

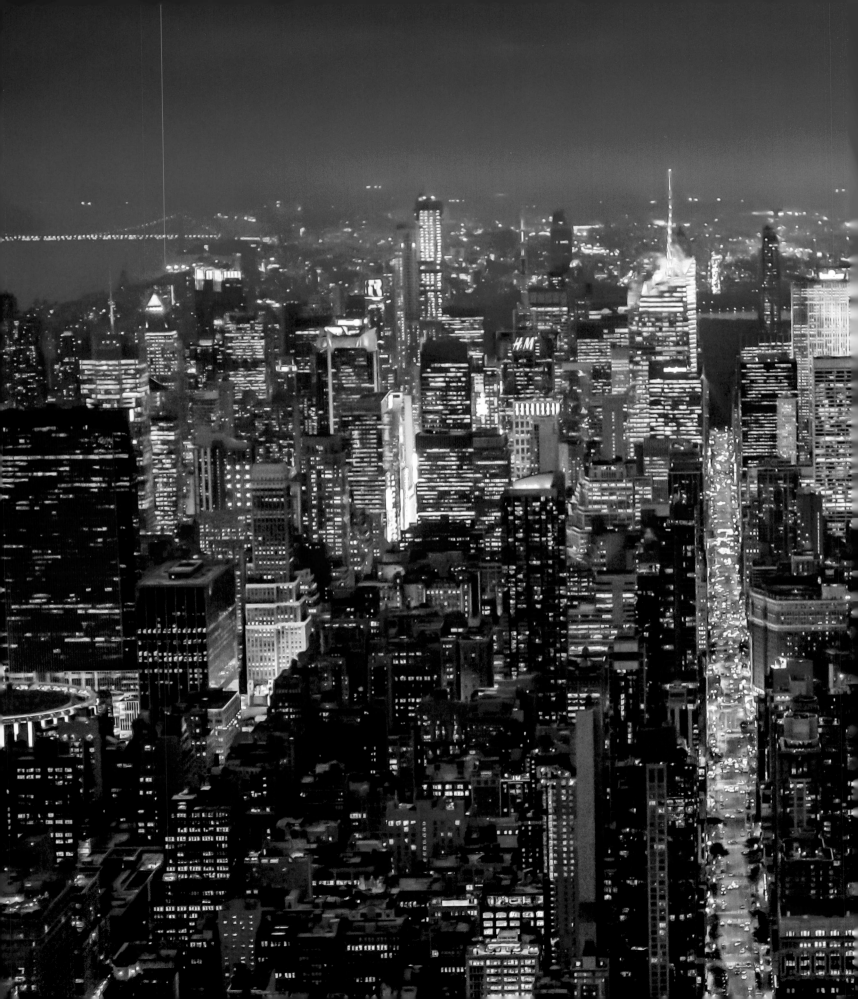

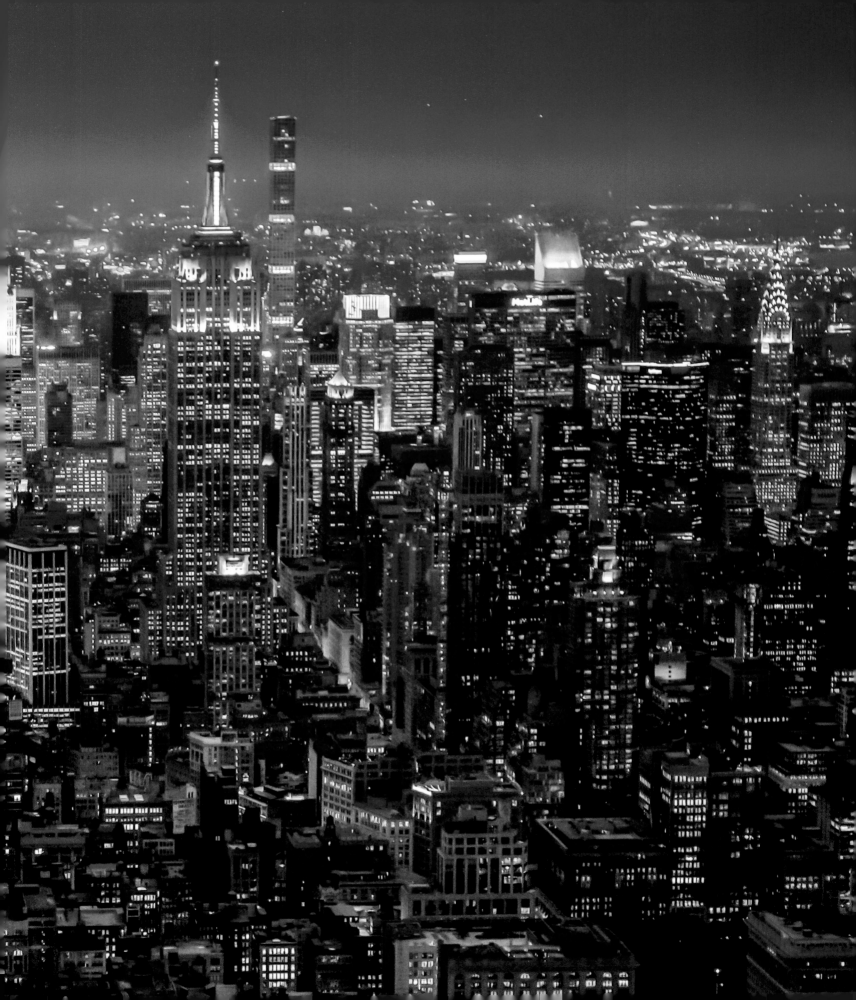

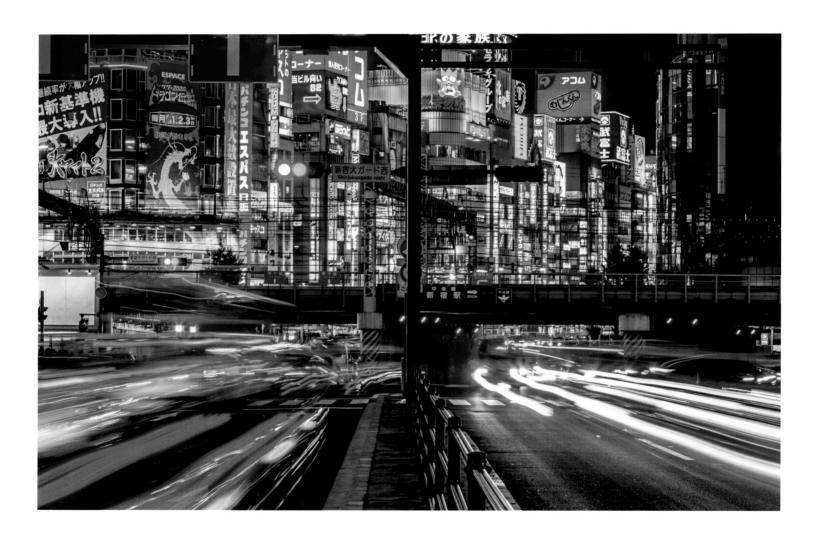

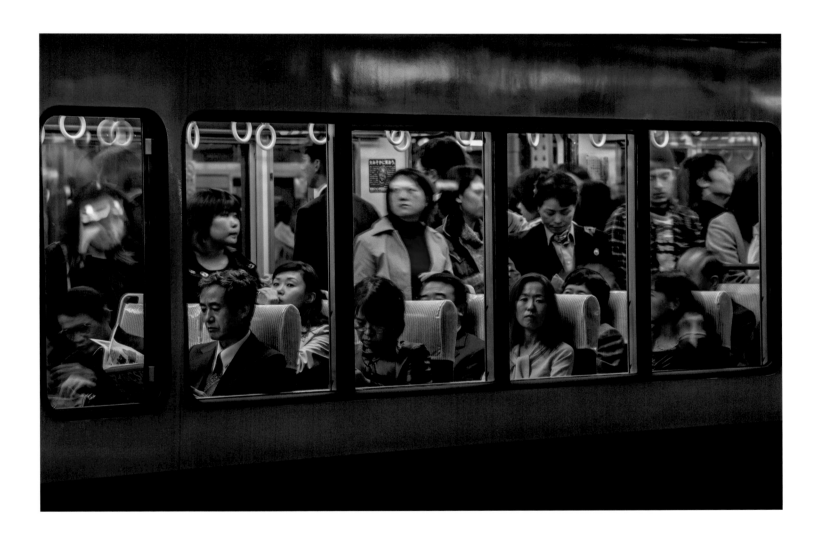

OPPOSITE: Ginza, Tokyo, Honshu, Japan
ABOVE: Tokyo Metro, Tokyo, Honshu, Japan

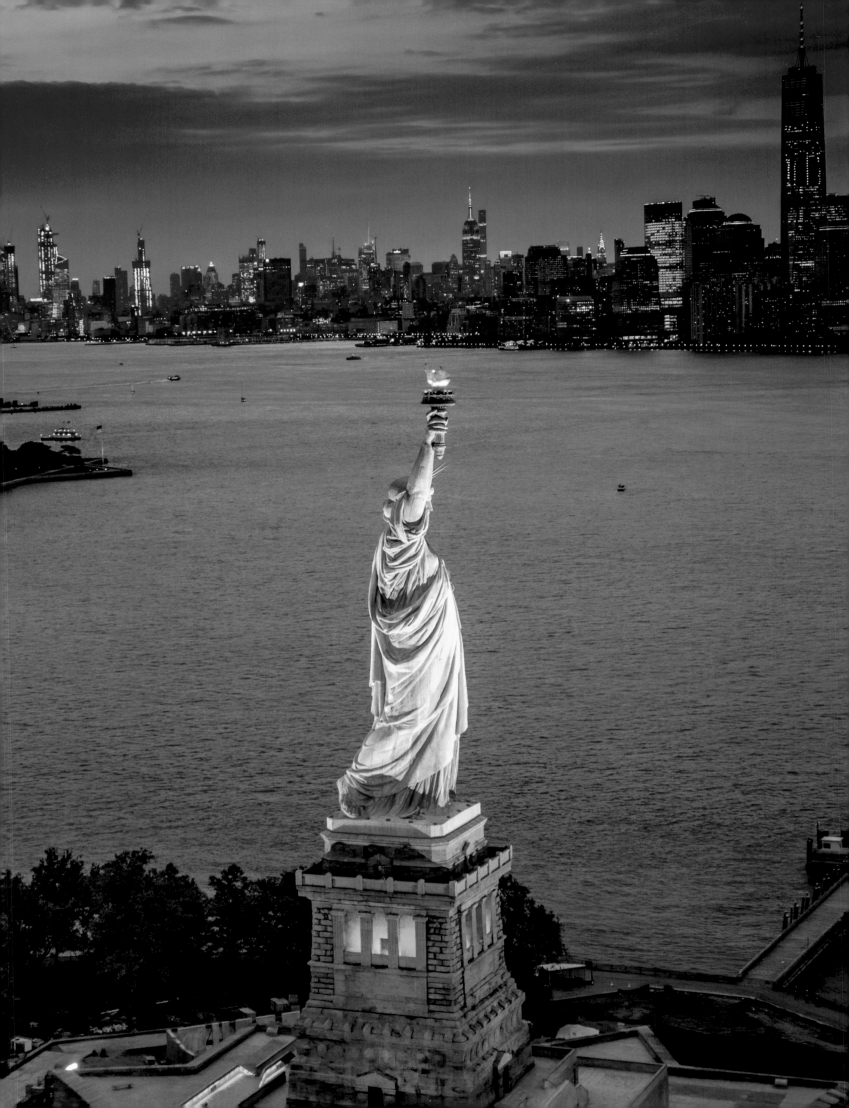

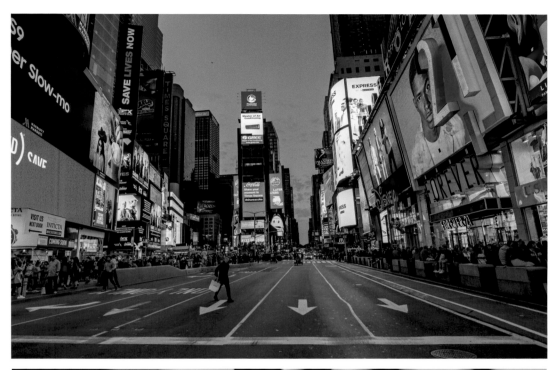

OPPOSITE: Statue of Liberty, Liberty Island, New York City, New York, USA
ABOVE TOP: Times Square, New York City, New York, USA
ABOVE BOTTOM: Pigeons (*Columba livia*) silhouetted against neon lights, New York City, New York, USA

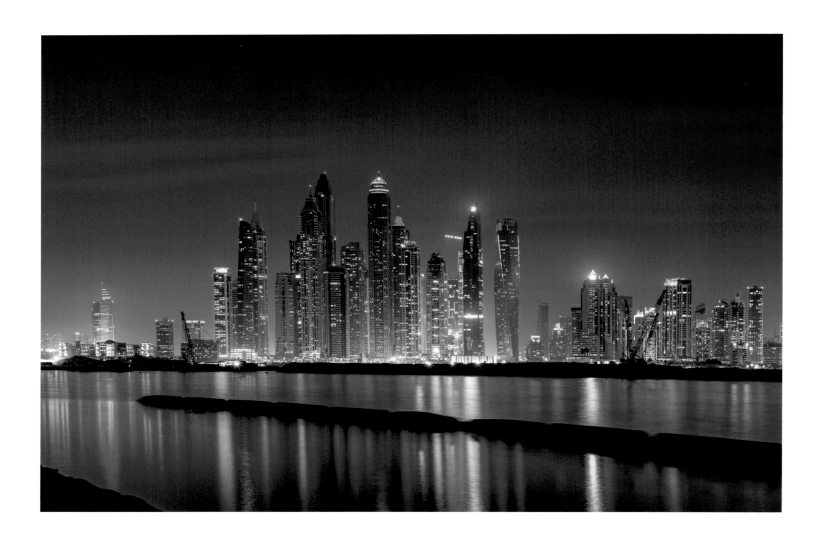

ABOVE: Dubai cityscape, United Arab Emirates
OPPOSITE: British Columbia Day fireworks, Vancouver, British Columbia, Canada
FOLLOWING PAGES: Seattle skyline with Space Needle and Mount Rainier, Washington, USA

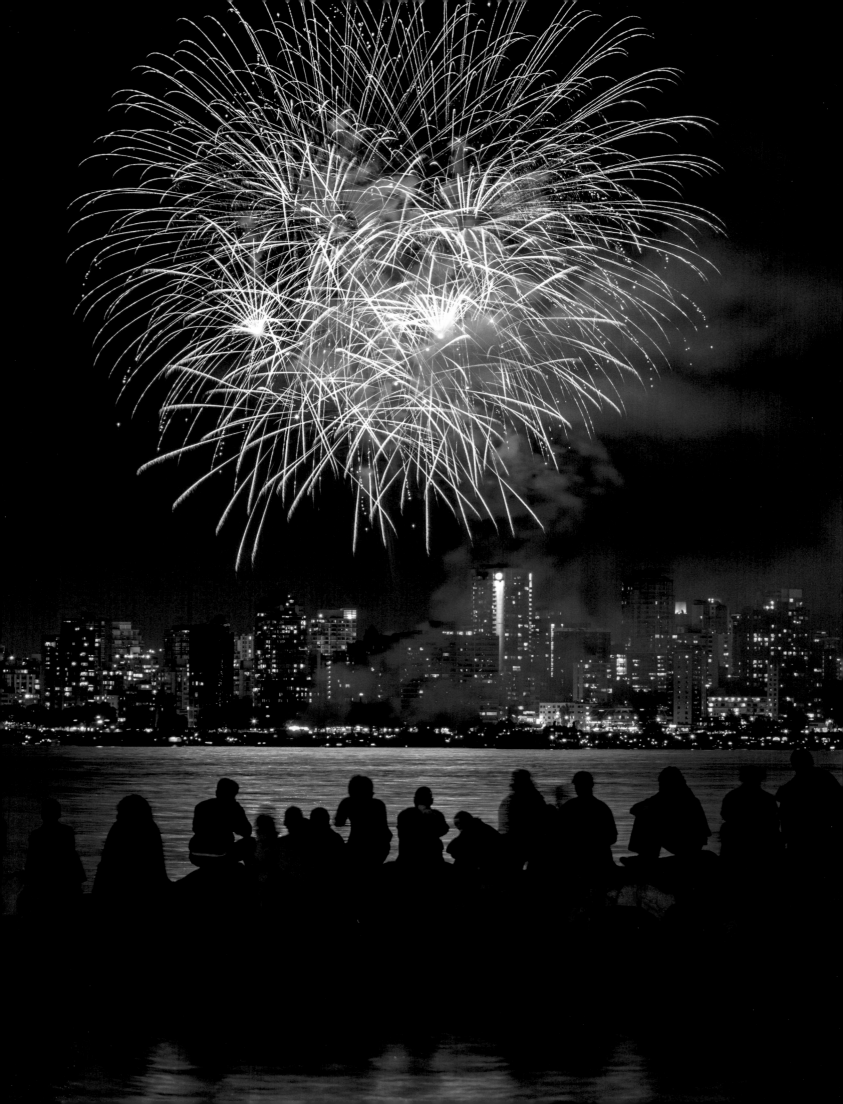

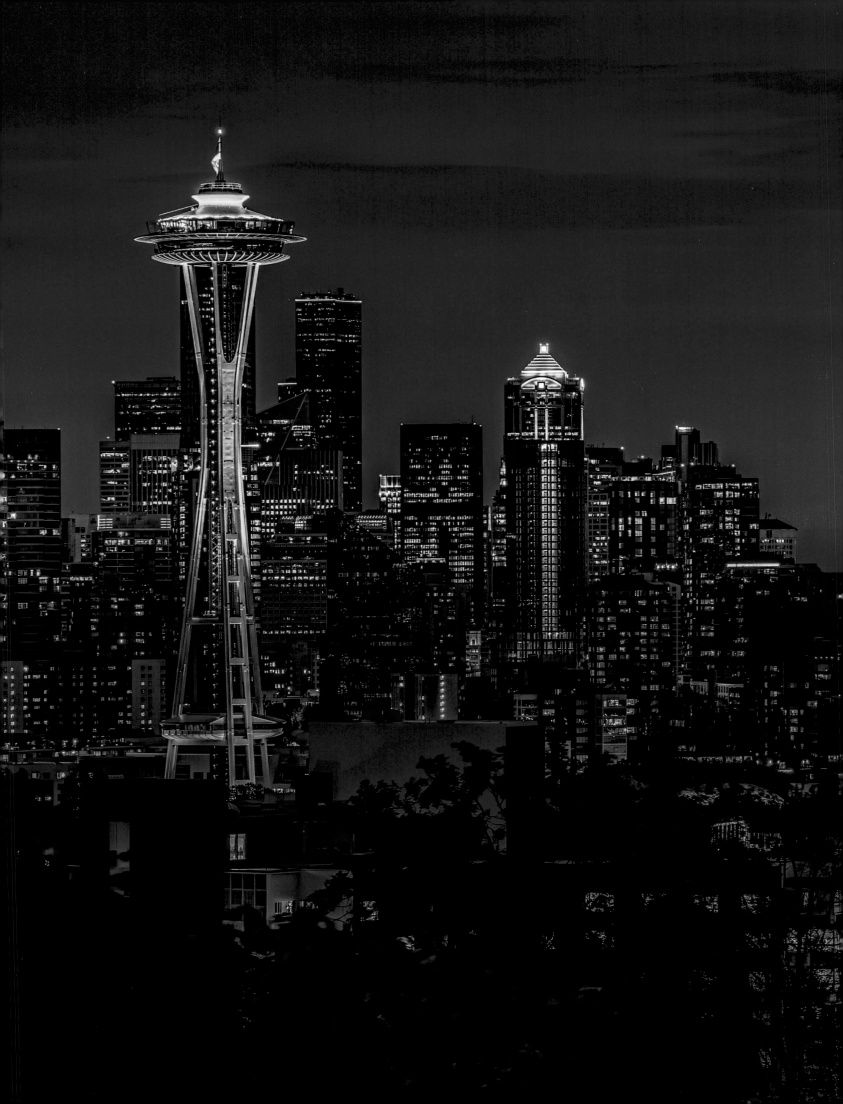

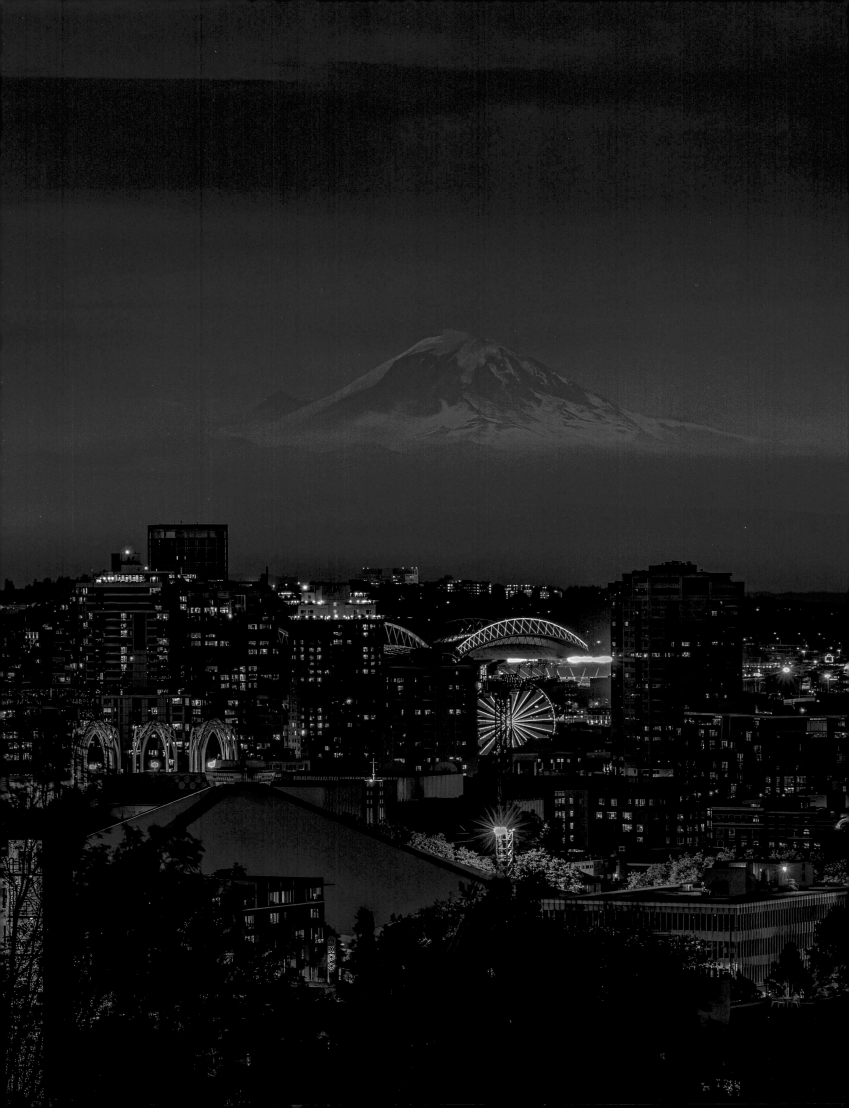

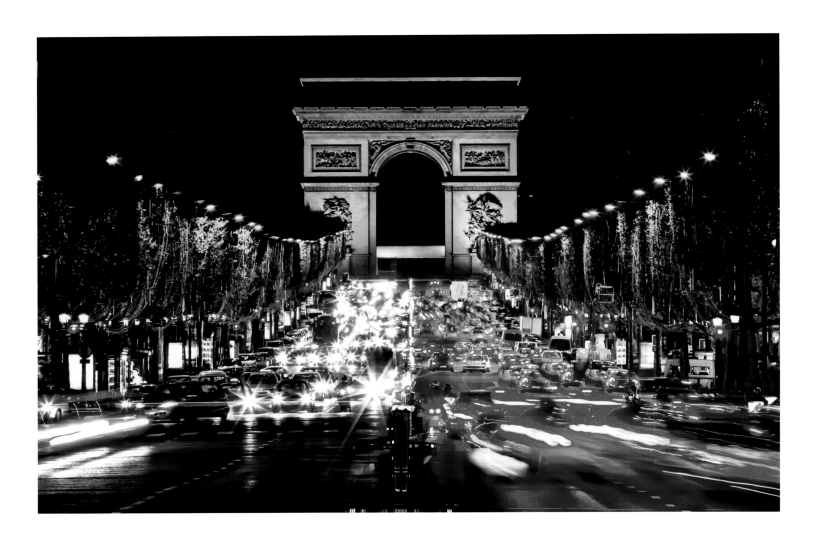

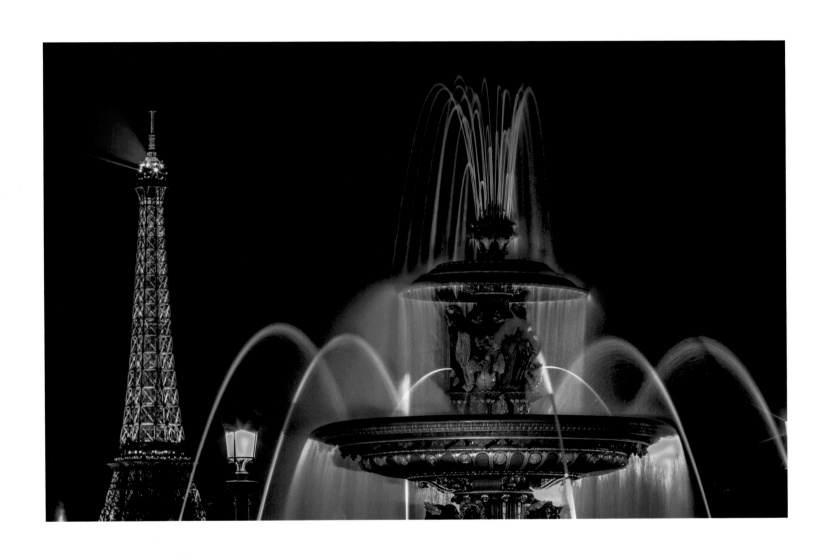

OPPOSITE: Champs-Élysées and Arc de Triomphe, Paris, Île-de-France, France
ABOVE: The Maritime Fountain and Eiffel Tower, Paris, Île-de-France, France

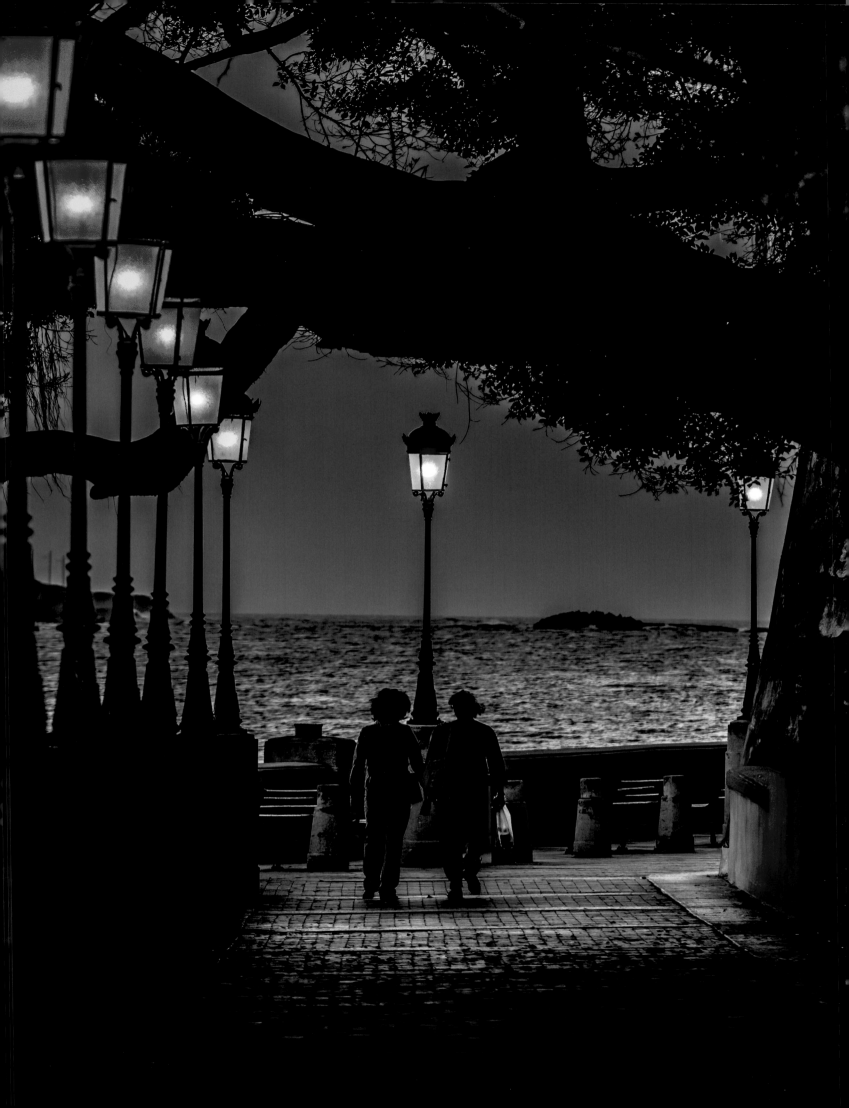

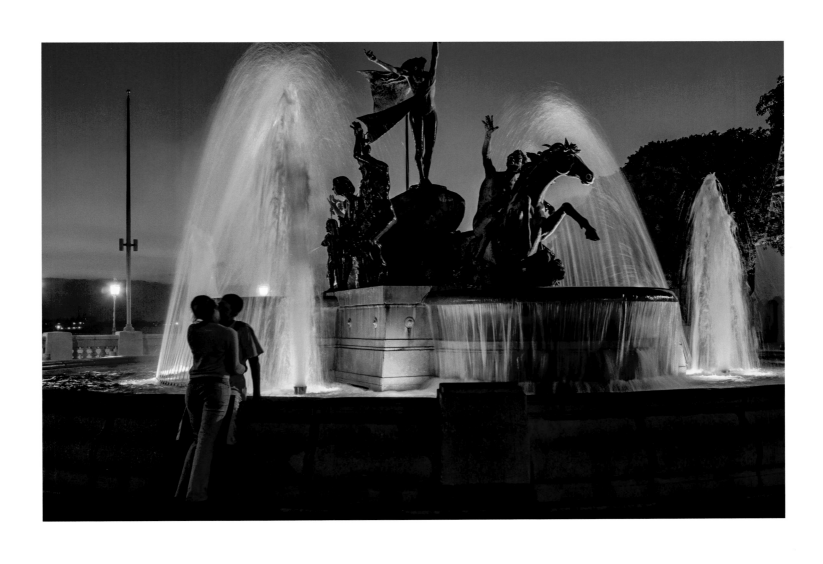

OPPOSITE: Paseo de la Princesa, Old San Juan Historic District, San Juan, Puerto Rico
ABOVE: Raices Fountain, Old San Juan Historic District, San Juan, Puerto Rico

PHOTO NOTES

COVER: Quiver tree or kokerboom (*Aloe dichotoma*) and Milky Way, Karas, Namibia
Quiver trees, members of the succulent aloe family, are particularly well adapted to surviving in the harsh conditions of Namibia's southern desert. The plant stores water in its trunk and has spongy wood.
Canon EOS-1D X, EF16-35mm f/2.8L II USM lens, f/2.8 for 30 seconds, ISO 2500

PAGE 2: Milky Way over Mount Baker, Mount Baker Wilderness, Washington, USA
Canon EOS 5D Mark IV, EF11-24mm f/4L USM lens, f/4 for 30 seconds, ISO 4000

PAGE 4 TOP: Moonrise over boreal forest, Mackenzie Mountains, Northwest Territories, Canada
Canon EOS-1N, EF lens, Fujichrome Provia 400 film

PAGE 4 BOTTOM: Star trails over Mt Fitzroy, Los Glaciares National Park, Santa Cruz, Argentina
SLR camera, 200-400mm lens, f/4.5 for 6 hours, Kodachrome 64 film

PAGE 6: Saguaro National Park, Arizona, USA
Slow growing and long-lived, this saguaro (*Carnegiea gigantea*) is probably around one hundred years old as evidenced by its large side arms.
Canon EOS-1D X Mark II, EF11-24mm f/4L USM lens, f/4 for 30 seconds, ISO 1600

PAGE 9: The moon peeks out from behind an eruption of ash, Etna, Sicily, Italy
Canon EOS-1N, EF17-35mm f/2.8 lens, f/5.6 for 1 second, Fujichrome Velvia film

PAGE 10: Old Faithful geyser under the Milky Way, Yellowstone National Park, Wyoming, USA
Canon EOS-1D X, Zeiss Distagon T 2.8/15 ZE lens, f/2.8 for 25 seconds, ISO 3200*

PAGE 13: Cataviña Desert, Baja California, Mexico
Stars punctuate the evening sky above a landscape dominated by cardon cactus (*Pachycereus pringlei*), boojum tree (*Fouquieria columnaris*). This beautiful desert is one of my favorite areas, affording the blessings of striking imagery and solitude.
Canon EOS 5D, EF24mm f/1.4L lens, f/2 for 15 seconds, ISO 400

PAGE 14: Karlu Karlu / Devils Marbles Conservation Reserve, Northern Territory, Australia
Milky Way over round granitic boulders, named Karlu Karlu by the local Aboriginal people.
Canon EOS-1D Mark IV, EF16-35mm f/2.8L II USM lens, f/2.8 for 30 seconds, ISO 1600

PAGES 16-17: Nieves penitentes, Paso de Agua Negra, Andes, Chile
These ice formations are called penitents because they resemble a parade of white-robed monks.
Canon EOS-IV, EF70-200mm lens, f/16 for 1 second, Fujichrome Velvia film

PAGES 18-19: Full moon at dawn over tufa fairy chimneys, Cappadocia, Turkey
Canon EOS-3, EF17-35mm lens, f/11 for 1/30 second, Fujichrome Provia film

PAGE 20: Glacier Bay National Park and Preserve, Alaska, USA
Afternoon light illuminates mist and clouds clinging to the jagged Fairweather Range, which are formed by the subduction of tectonic plates. Despite the name, these mountains experience harsh weather conditions.
Canon EOS-1D X Mark II, EF100-400mm f/4.5-5.6L IS II USM lens, f/6.3 for 1/60 second, ISO 800

PAGE 21: Table Mountain as seen from Table Bay, Western Cape, South Africa
Canon EOS 5D Mark II, EF24-105mm f/4L IS USM lens, f/16 for 0.8 second, ISO 100

PAGE 22: Cerro Torre, Los Glaciares National Park, Santa Cruz, Argentina
Canon EOS 5D Mark III, EF70-200mm f/2.8L IS II USM lens, f/13 for 1/320 second, ISO 250

PAGE 23 TOP: Golden light over Los Glaciares National Park, Santa Cruz, Argentina
Canon EOS-1D X, EF100-400mm f/4.5-5.6L IS II USM lens, f/13 for 1/4000 second, ISO 640

PAGE 23 BOTTOM: Los Glaciares National Park, Santa Cruz, Argentina
Canon EOS 5D Mark III, EF70-200mm f/2.8L IS II USM lens, f/16 for 0.6 second, ISO 100

PAGE 24 TOP: Baily's beads or diamond ring effect of a solar eclipse, Coquimbo, Chile
Canon EOS 5DS R, EF600mm f/4L IS USM +1.4x III lens, f/8 for 1/4000 second, ISO 400

PAGE 24 BOTTOM: Cloudscape Torres del Paine National Park, Magallanes and Chilean Antarctica, Chile
The strong westerly winds between 40 and 50 degrees south latitude, called the Roaring Forties, create magnificent cloud formations.
Canon EOS-1D X, EF100-400mm f/4.5-5.6L IS II USM lens, f/15 for 1/6400 second, ISO 4000

PAGE 25: A solar eclipse turns day into night, Coquimbo, Chile
Canon EOS 5D Mark IV, EF24-70mm f/4

PAGES 26-27: Moon over Lake Pehoé, Cordillera del Paine, Torres del Paine National Park, Magallanes and Chilean Antarctica, Chile
Canon EOS 5DS R, EF24-70mm f/4L IS USM lens, f/4 for 4 seconds, ISO 500

PAGE 28: Lago Nordenskjold, Cuernos del Paine, Torres del Paine National Park, Chile
These rugged pinnacles are a testament to the forces of nature: volcanic rock carved by ancient glaciers, layered with sediment, then eroded by the elements.
Canon EOS 5D Mark III, EF24-105mm f/4L IS USM lens, f/22 for 4 seconds, ISO 500

PAGE 29: Moonrise, North Cascades National Park, Washington, USA
Film capture

PAGES 30-31: Milky Way over moai, Ahu Tongariki, Rapa Nui, Easter Island, Chile
Canon EOS 5D Mark IV, EF14mm f/2.8L II USM lens, f/2.8 for 30 seconds, ISO 3200

PAGE 32: Milky Way over moai, Ahu Tongariki, Rapa Nui, Easter Island, Chile
Canon EOS 5D Mark IV, EF14mm f/2.8L II USM lens, f/2.8 for 30 seconds, ISO 3200

PAGE 33: Comet NEOWISE, Washington, USA
Canon EOS R5, EF600mm f/4L IS III USM lens, f/4 for 1/2 second, ISO 25600

PAGES 34-35: El Tatio Geysers, Atacama Desert, Puna de Atacama, Chile
El Tatio is the third largest geyser field in the world after Yellowstone National Park and Kamchatka's Valley of Geysers.
Canon EOS-1D X, 20mm F1.4 DG HSM | Art 015 lens, f/1.4 for 30 seconds, ISO 2500

PAGE 36: Yosemite Falls, Yosemite National Park, California, USA
Canon EOS 5D Mark IV, EF24-70mm f/4L IS USM lens, f/4 for 565 seconds, ISO 800

PAGE 37: Star trails, Ancient Bristlecone Pine Forest, California, USA
A vertiginous spiral of stars circles over an ancient bristlecone pine (*Pinus longaeva*), considered the longest continuously living life-form on Earth. These trees are unbelievably hardy, growing in exceedingly dry conditions at altitude. At 11,000 feet the sky is clear, cold, and dark, perfect for night photography.
Canon EOS-1D X Mark II, EF11-24mm f/4L USM lens, StarStaX software

PAGE 38: Yosemite National Park, California, USA
The sheer granite face of El Capitan is decorated with the lights of rock climbers bivouacked for the night in their portaledges.
Canon EOS 5D Mark IV, EF24-70mm f/4L IS USM lens, f/4 for 263 seconds, ISO 800

PAGE 39: Rochester Rock Art Panel, Utah, USA
Canon EOS 5D Mark IV, Sigma 14mm F1.8 DG HSM | Art 017 lens, f/8 for 30 seconds, ISO 3200

PAGES 40-41: Double Arch, Arches National Park, Utah, USA
Canon EOS 5D Mark IV, EF14mm f/2.8L II USM lens, f/2.8 for 20 seconds, ISO 3200

PAGE 42: Milky Way over Halemaumau Crater, Hawai'i Volcanoes National Park, Hawaii, USA
This is the most primordial of images, a vision of earth at its very infancy in the universe.
Canon EOS-1D X, EF14mm f/2.8L II USM lens, f/2.8 for 30 seconds, ISO 2500

PAGE 43: Halema'uma'u, Hawai'i Volcanoes National Park, Hawaii, USA
Canon EOS R5, EF24-70mm f/4L IS USM lens, f/4.5 for 1/30 second, ISO 2000

PAGE 44: Halema'uma'u eruption, Hawai'i Volcanoes National Park, Hawaii, USA
Canon EOS R5, EF100-400mm f/4.5-5.6L IS II USM lens, f/9 for 1/10 second, ISO 1600

PAGE 45: Lava flows enter the ocean, Hawai'i Volcanoes National Park, Hawaii, USA
Canon EOS-1N, EF70-200mm lens, f/22 for 3 seconds, Fujichrome Velvia film

PAGE 46: Volcanic eruption of Bárðarbunga, Vatnajökull National Park, Iceland
At 6591 feet, Bárðarbunga stratovolcano is the second highest point in Iceland. It is located under the icecap of Vatnajökull Glacier. Its last large eruption was in 2014-15 after a swarm of 1600 earthquakes in a forty-eight-hour period.
Canon EOS-1D X, EF70-200mm f/2.8L IS II USM lens, f/2.8 for 1/2000 second, ISO 1000

PAGE 47: Lava lake, Mount Nyiragongo, Virunga National Park, North Kivu, Democratic Republic of Congo
Canon EOS-1D X Mark II, EF100-400mm f/4.5-5.6L IS II USM lens, f/4.5 for 1/160 second, ISO 4000

PAGES 48-49: Milky Way over Mount Rainier, Mount Rainier National Park, Washington
Canon EOS-1D X, Zeiss Distagon T 2.8/15 ZE lens, f/2.8 for 20 seconds, ISO 4000*

PAGE 50: MacKenzie Mountains, Northwest Territories, Canada
In an idyllic bivouac on the Ravens Throat River, the aurora borealis shines above a tent.
Canon EOS-1N, EF17-35mm lens, f/2.8 for 30 seconds, Fujichrome Provia film

PAGE 51: Base Camp, Mount Everest, Tibet, China
Climbers' tents in the Rongbuk Valley base camp are illuminated by lantern light, while Everest looms above, illuminated by the moon.
Nikon F3, Nikkor 80-200mm lens, f/2.8 for 10 minutes, Kodachrome 64 film

PAGE 52: Milky Way over Mount Baker, Mount Baker Wilderness, Washington, USA
Canon EOS 5D Mark IV, EF11-24mm f/4L USM lens, f/4 for 30 seconds, ISO 4000

PAGE 53: Great Basin bristlecone pines (*Pinus longaeva*) and Milky Way, Ancient Bristlecone Pine Forest, White Mountains, California, USA
Canon EOS-1D X, EF15mm f/2.8 Fisheye lens, f/2.8 for 30 seconds, ISO 3200

PAGE 54: Aurora borealis, Brooks Range, Alaska, USA
The aurora borealis is an atmospheric phenomenon that occurs as electrically charged particles from the sun make gases glow in the upper atmosphere. The Brooks Range in Alaska lies within the Arctic Circle and thus provides a more predictable chance to see the aurora borealis.
Canon EOS-1N, EF17-35mm f/2.8 lens, f/2.8 for 30 seconds, Fujichrome Provia 400 film

PAGE 55 TOP AND BOTTOM: Milky Way and aurora borealis, Jökulsárlón, Iceland
We waited until one a.m. on the only clear morning of our weeklong trip to photograph the northern lights. When the lights came out and the stars shone, it was magic. It is a joyous moment as a photographer when you guess correctly and your effort is rewarded.
Canon EOS-1D X, Zeiss Distagon T 2.8/15 ZE lens, f/2.8 for 30 seconds, ISO 1600*

PAGES 56-57: Aurora borealis, Lofoten, Nordland, Norway
Canon EOS-1D X Mark II, EF16-35mm f/2.8L III USM lens, f/2.8 for 2.9 seconds, ISO 3200

PAGE 58: Rainbow, Vesturland, Iceland
Canon EOS-1D X, EF70-200mm f/2.8L IS II USM lens, f/14 for 1/320 second, ISO 1250

PAGE 59: Rainbow over boreal forest, Denali National Park and Preserve, Alaska, USA
SLR camera, f/11 for 1/30 second, Kodachrome 64 film

PAGE 60: Lightning storm, Benin
Canon EOS-1Ds Mark II, 70.0-200.0 mm f/4 lens, f/5.6 for 3.2 seconds, ISO 400

PAGE 61: Lightning and saguaros (Carnegiea gigantea), Saguaro National Park, Arizona, USA
Photographing after dark with the camera on flash setting, I held the shutter open while waiting for one or two flashes of lightning to illuminate the desert sky.
SLR camera, 20mm wide-angle lens, f/5.6, Kodachrome 64 film

PAGES 62-63: Aerial, Washington, USA
Pockets of forest of Douglas firs (*Pseudotsuga menziesii*) create abstract patterns of light and line as the tall trees cast their shadows over low-lying fog.
Film capture

PAGE 64 TOP: Rocky coastline, Point Lobos, California, USA
Canon EOS 5DS R, EF24-70mm f/4L IS USM lens, f/10 for 401 seconds, ISO100

PAGE 64 BOTTOM: Thor's Well, Cape Perpetua Scenic Area, Oregon, USA
Canon EOS 5DS R, EF24-70mm f/4L IS USM lens, f/22 for 3.2 seconds, ISO 100

PAGE 65: Sea water surges over black volcanic rock, Southern Region, Iceland
Canon EOS 5DS R, EF70-200mm f/2.8L IS II USM lens, f/18 for 122 seconds, ISO 50

PAGE 66: Seastacks along the Pacific Coast, Oregon, USA
Canon EOS R5, EF100-400mm f/4.5-5.6L IS II USM lens, f/16 for 1/3200 second, ISO 3200

PAGE 67: Karst mountains, Guilin, China
The early morning light gives the backlit ridges a translucent quality.
SLR camera, 200mm lens, f/11 for 1/60 second, Fujichrome 50 film

PAGES 68-69: Hay barns, Dolomites, South Tyrol, Italy
Canon EOS 5D Mark III, EF24-105mm f/4L USM lens, f/8 for 1/6 second, ISO 100

PAGE 70: Moon over Tre Cime di Lavaredo, Sexten Dolomites, South Tyrol, Italy
Canon EOS 5D Mark III, EF17-40mm f/4L USM lens, f/8 for 2.5 seconds, ISO 400

PAGE 71 TOP: Comet NEOWISE shoots over Mount Rainier, Mount Rainier National Park Washington, USA
Canon EOS 5D Mark IV, EF16-35mm f/2.8L II USM lens, f/2.8 for 30 seconds, ISO 1600

PAGE 71 BOTTOM: Moonlight over Yosemite Valley, Yosemite National Park, California, USA
Film capture

PAGES 72-73: Lotus stems, Lake Biwa, Honshu, Japan
Canon EOS-1D X, EF100-400mm f/4.5-5.6L IS II USM lens, f/22 for 1/125 second, ISO 100

PAGES 74-75: Moon over a snowbound northern forest. Lapland, Finland
Canon EOS 5DS R, EF24-70mm f/4L IS USM lens, f/14 for 0.6 second, ISO 100

PAGE 76: Sunrise, Austin Pass, Mount Baker Wilderness, Washington, USA
Film capture

PAGE 77: Moonrise, Lemaire Channel, Antarctica
The Lemaire Channel is a placid strait on the west coast of the Antarctic Peninsula.
Canon EOS-1D X, EF70-200mm f/2.8L IS II USM lens, f/7.1 for 1/320 second, ISO 800

PAGES 78-79: Cataviña Desert, Baja California, Mexico
Canon EOS-1Ds Mark III, EF16-35mm f/2.8L II USM lens, f/16 for 2 seconds, ISO 100

PAGE 80: Dust sifts through the acacia savanna of Amboseli National Park, Kajiado, Kenya
Canon EOS-1D X, EF200-400mm f/4L IS USM lens, f/18 for 1/2000 second, ISO 4000

PAGE 81: A storm rolls through Serengeti National Park, Mara, Tanzania
Film capture

PAGE 82 TOP: Milky Way over Avenue of the Baobabs, Menabe, Madagascar
Millions of stars comprise the Milky Way as it shines so brightly that it outlines the magnificent forms of the baobab trees (*Adansonia grandidieri*). These unique and ancient trees, with a lifespan of thousands of years, are one of the most recognized symbols of Madagascar, the earth's fourth largest island.
Canon EOS-1Ds Mark II, EF16-35mm f/2.8L USM lens, f/2.8 for 30 seconds, ISO 1000

PAGE 82 BOTTOM: Sunset and acacia, Amboseli National Park, Kajiado, Kenya
This is one of the best places in Africa for wildlife viewing. Just across the border in Tanzania rises Mount Kilimanjaro, whose snows feed this wondrous savanna.
Film capture

PAGE 83: Joshua trees (Yucca brevifolia) at sunrise, Joshua Tree National Park, California, USA
Film capture

PAGES 84-85: Bushfire, Arnhem Land, Northern Territory, Australia
A fire crackles through a woodland, but it is not completely destructive. It supports the ecological system by burning off dead grass and shrubs and stimulates regrowth. Trees remain largely unscathed by the swift fires, which appear with astounding frequency across Australia's vast stretches of open country.
Canon EOS-1Ds Mark II, EF16-35mm f/2.8L II USM lens, f/5 for 2.5 seconds, ISO 400

PAGE 86: Stars over calcified camel thorns (*Vachellia erioloba*), Namib-Naukluft National Park, Hardap, Namibia
Canon EOS-1D X Mark II, 20mm f/1.4 DG HSM | Art 015 lens, f/1.4 for 4 seconds, ISO 640

PAGE 87: Milky Way and alpine firs (*Abies lasiocarpa*), Mount Rainier National Park, Washington, USA
Canon EOS 5D Mark IV, 20mm F1.4 DG HSM | Art 015 lens, f/1.4 for 8 seconds, ISO 2000

PAGES 88-89: Jedediah Smith Redwoods State Park, California, USA
During the great fires of 2020, I photographed in the eerily smoke-darkened redwood forests of Northern California.
Canon EOS-5D Mark IV, EF16-35mm f/2.8L II USM lens, f/14 for 2 seconds, ISO 100

PAGE 90 TOP: Sunrise over Puget Sound, Olympic National Park, Washington, USA
Canon EOS 5D Mark II, EF70-200mm f/4L IS USM lens, f/14 for 1/8 second, ISO 100

PAGE 90 BOTTOM: Yellowstone Lake with Teton Range in distance, Yellowstone National Park, Wyoming USA
Canon EOS 5DS R, EF200-400mm f/4L IS USM lens, f/4 for 1/40 second, ISO 100

PAGE 91 TOP: Sunset over the Smoky Mountains, North Carolina, USA
Canon EOS 5D Mark III, EF70-200mm f/2.8L IS II USM lens, f/8 for 1/125 second, ISO 100

PAGE 91 BOTTOM: Mount Baker, Mount Baker Wilderness, Washington, USA
Canon EOS 5D Mark IV, EF100-400mm f/4.5-5.6L IS II USM lens, f/4.5 for 1/80 second, ISO 320

PAGE 92: Lake Powell, Glen Canyon National Recreation Area, Utah, USA
Canon EOS-1D X, EF70-200mm f/4L USM lens, f/10 for 1/5 second, ISO 100

PAGE 93: Monument Valley, Utah and Arizona, USA
Canon EOS 5D Mark IV, EF24-70mm f/4L IS USM lens, f/4.5 for 3.2 seconds, ISO 125

PAGES 94-95: Half Dome, Yosemite National Park, California, USA
Canon EOS 5D Mark IV, EF24-70mm f/4L IS USM lens, f/4 for 10 seconds, ISO 1000

PAGE 96: Full moon, Namib-Naukluft National Park, Hardap, Namibia
Canon EOS 5D Mark IV, EF100-400mm f/4.5-5.6L IS II USM lens, f/5.6 for 1/500 second, ISO 8000

PAGE 97: New moon, Yellowstone National Park, Wyoming, USA
A new moon sets behind a lodgepole pine forest (*Pinus contorta latifolia*) that burned in the massive 1988 fire.
Canon EOS-1N, EF500mm IS +2x lens, f/8 for 1/60 second, Fujichrome Provia 400 film

PAGES 98-99: Moonset, Iguazú Falls, Iguazú National Park, Argentina
I timed my visit to coincide with the full moon. Two exposures were required to accomplish this photograph since there was a great differential in the lighting of the two main elements, the moon and the falls. In the first exposure, I exposed for the moon; during the second exposure I blocked out the moon with a black card and exposed the waterfall.
Canon EOS-IV, EF80-200mm lens, first exposure: f/5.6 for 1/250 second, second exposure: f/2.8 for 4 minutes, Fujichrome Velvia film

PAGES 100-101: Black rhinoceros (Diceros bicornis), Etosha National Park, Kunene, Namibia
Canon EOS-1D X Mark II, EF70-200mm f/4L IS USM lens, f/4 for 1/80 second, ISO 8000

PAGE 102: Black rhinoceros (Diceros bicornis), Etosha National Park, Kunene, Namibia
Canon EOS-1D X Mark II, EF70-200mm f/4L IS USM lens, f/9 for 1/30 second, ISO 12800

PAGE 103: White rhinoceros (Ceratotherium simum) and calf, Etosha National Park, Kunene, Namibia
Canon EOS 5D Mark IV, EF100-400mm f/4.5-5.6L IS II USM lens, f/5.6 for 1/8000 second, ISO 4000

PAGE 104 TOP: Giant anteater (Myrmecophaga tridactyla), Pantanal, Mato Grosso, Brazil
The giant anteater is the largest of the anteaters, reaching up to 140 pounds. Native to Central and South America, they eat tens of thousands of ants and termites each night and day.
Canon EOS-1Ds Mark II, 70-200mm f/2.8 lens, f/4 for 1/15 second, ISO 400

PAGE 104 BOTTOM: Spotted hyenas (Crocuta crocuta) are active day and night, Okavango Delta, Ngamiland, Botswana
Film capture

PAGE 105 TOP: White-footed sportive lemur (Lepilemur leucopus), Toamasina, Madagascar
Canon EOS-1Ds Mark II, 500mm +2x lens, f/9 for 1/25 second, ISO 200

PAGE 105 BOTTOM: Serval (Leptailurus serval), Chyulu Hills National Park, Makuene, Kenya
Canon EOS R5, EF100-400mm f/4.5-5.6L IS II USM lens, f/5.6 for 1/200 second, ISO 12800

PAGE 106: African lion (Panthera leo), Maasai Mara National Reserve, Narok, Kenya
Canon EOS-1D X Mark II, EF800mm f/5.6L IS USM lens, f/5.6 for 1/500 second, ISO 4000

PAGE 107: African lions (Panthera leo), Okavango Delta, Ngamiland, Botswana
Film capture

PAGE 108: Alert for tigers, chital (Axis axis) graze at the margins of the day, Bandhavgarh National Park, Madhya Pradesh, India
Canon EOS-1D X Mark II, EF100-400mm f/4.5-5.6L IS II USM lens, f/8 for 1/80 second, ISO 1600

PAGE 109: Roosevelt elk bulls (Cervus canadensis roosevelti) spar in fog at dawn, Redwood National Park, California, USA
Canon EOS-IV, EF80-200mm f/4.5-5.6 II lens, f/5.6 for 1/60 second, Fujichrome Velvia film

PAGES 110-111: Common eland (Taurotragus oryx) and impala (Aepyceros melampus), Central District, Botswana
Canon EOS-1D X Mark II, EF24-70mm f/4L IS USM lens, f/4 for 1.3 seconds, ISO 320

PAGE 112: African bush elephant and calf (Loxodonta africana) on the move, Amboseli National Park, Kajiado, Kenya
Canon EOS-1D X, EF70-200mm f/2.8L IS II USM lens, f/2.8 for 1/1000 second, ISO 4000

PAGE 113: African bush elephants (Loxodonta africana), Olare Motorogi Conservancy, Narok, Kenya
Using a high ISO allows for a faster exposure in low-light situations such as this moment with elephants.
Canon EOS R5, EF100-400mm f/4.5-5.6L IS II USM lens, f/7.1 for 1/500 second, ISO 12800

PAGE 114: South American cougar or puma (Puma concolor concolor), Torres del Paine National Park, Magallanes and Chilean Antarctica, Chile
Canon EOS 5D Mark IV, EF600mm f/4L IS III USM lens, f/20 for 1/400 second, ISO 640

PAGE 115 TOP: South American cougar or puma (Puma concolor concolor), Torres del Paine National Park, Magallanes and Chilean Antarctica, Chile
Canon EOS 5D Mark IV, EF600mm f/4L IS III USM lens, f/8 for 1/250 second, ISO 1000

PAGE 115 BOTTOM: Cheetah and cub (Acinonyx jubatus), Serengeti National Park, Mara Region, Tanzania
A mother cheetah and cub catch the last rays of the setting sun while intently surveying the surrounding plains. A female has the sole obligation of raising her cubs and keeping them out of harm's way, a task made extremely difficult in a habitat shared with lions, leopards, and hyenas.
Canon EOS-1N, EF 600mm lens, f/11 for 1/30 second, Fujichrome Provia film

PAGES 116-117: Leopard (Panthera pardus) in thorn tree (Vachellia sp.), Chobe National Park, Ngamiland, Botswana
The gnarled branches of an ancient thorn tree play host to a resting leopard.
Canon EOS 5D, EF70-200mm f/2.8L IS USM lens, f/5.6 for 1/500 second, ISO 400

PAGE 118: Leopards (Panthera pardus), Mashatu Reserve, Central District, Botswana
Canon EOS-1D X, EF200-400mm f/4L IS USM EXT lens, f/6.3 for 1/1250 second, ISO 4000

PAGE 119: A leopard (Panthera pardus) heads out for a night of prowling, Okavango Delta, Botswana
Film capture

PAGES 120-121: Camels (Camelus dromedarius) on the Rann of Kutch, India
Camels facilitate a nomadic way of life in the Rann, which is a seasonal salt marsh. These camels are unique in that they can survive in both the desert and the mangrove swamps.
Canon EOS-1D X, Zeiss Distagon T 2.8/15 ZE lens, f/13 for 1/125 second, ISO 1250*

PAGE 122 TOP: Sturdy and weatherproof Icelandic horses, Southern Region, Iceland
Canon EOS-1D X, EF70-200mm f/2.8L IS II USM lens, f/9 for 1/250 second, ISO 1250

PAGE 122 BOTTOM: Plains zebras (Equus quagga), Amboseli National Park, Kajiado, Kenya
Canon EOS-1D X, EF200-400mm f/4L IS USM EXT lens, f/11 for 1/3200 second, ISO 4000

PAGE 123 TOP: Common wildebeest (Connochaetes taurinus), Lake Ndutu, Serengeti Plain, Arusha, Tanzania
A cloud of dust rises from the southern Serengeti Plain in Tanzania as a herd of common wildebeest moves toward a nearby waterhole.
Film capture

PAGE 123 BOTTOM: Guanacos (Lama guanicoe) are silhouetted on a windswept ridge, Torres del Paine National Park, Magallanes and Chilean Antarctica, Chile
Canon EOS-1D X, EF100-400mm f/4.5-5.6L IS II USM lens, f/18 for 1/1250 second, ISO 4000

PAGES 124-125: Camargue horses, Camargue, Bouches-du-Rhône, France
The Camargue horses of the Rhône River Delta offer a unique opportunity to photograph some very rare semi-wild horses that have adapted to living along the seashore. This herd eyes me with interest as I catch the twilight color behind them.
Canon EOS Rs, EF70-200mm lens, f/5.6 for 1/60 second, Fujichrome Provia film

PAGES 126-127: Endangered Galapagos hawks (Buteo galapagoensis), Galapagos Islands, Ecuador
Canon EOS-1D X, EF100-400mm f/4.5-5.6L IS II USM lens, f/22 for 1/400 second, ISO 4000

PAGE 128: Tube-lipped tailless bats (Anoura fistulata), Andean cloud forest, Ecuador
Bats are great pollinators as evidenced by the yellow pollen smeared on the neck of the bat on the right.
Canon EOS 5D Mark IV, EF100-400mm f/4.5-5.6L IS II USM lens, f/16 for 3.2 seconds, ISO 400

PAGE 129: Bats issue from Tham Khang Khao cave, Phu Pha Man National Park, Khon Kaen, Thailand
Millions of bats exit the cave every night to do what they do best: eat insects!
Canon EOS 5D Mark IV, EF100-400mm f/4.5-5.6L IS II USM lens, f/4.5 for 1/3200 second, ISO 4000

PAGE 130: Great grey owl (Strix nebulosa), Alberta, Canada
With acute ability to hunt by sound, a great grey owl strikes at unsuspecting prey deep under snow.
Canon EOS 5D Mark IV, EF600mm f/4L IS III USM lens, f/5 for 1/2000 second, ISO 2000

PAGE 131: Northern saw-whet owl (Aegolius acadicus), Washington, USA
A saw-whet owl prepares to leave its nesting cavity after having fed its young.
SLR camera, 80-200mm lens, f/11 for 1/60 second with flash, Fujichrome Velvia film

PAGES 132-133: King penguins (Aptenodytes patagonicus), South Georgia Island, British Overseas Territory
Canon EOS-1Ds Mark II, 70.0-200.0 mm f/2.8 lens, f/22 for 0.6 second, ISO 400

PAGES 134-135: Silhouette of feeding flamingos (Phoenicoparrus sp.), Eduardo Avaroa Andean Fauna National Reserve, Potosi, Bolivia
Canon EOS-1D X, EF100-400mm f/4.5-5.6L IS II USM lens, f/5.6 for 1/60 second, ISO 4000

PAGE 136: Sandhill cranes (Antigone canadensis), Bosque del Apache National Wildlife Refuge, New Mexico, USA
Canon EOS-1Ds Mark III, EF500mm f/4L IS USM lens, f/13 for 4 seconds, ISO 800

PAGE 137: Black crowned cranes (Balearica pavonina), Zakouma National Park, Guéra, Chad
Canon EOS-1D X Mark II, EF200-400mm f/4L IS USM EXT lens, f/18 for 1/1000 second, ISO 4000

PAGES 138-139: Sandhill cranes (Antigone canadensis), Bosque del Apache National Wildlife Refuge, New Mexico, USA
Canon EOS-1Ds Mark III, EF500mm f/4L IS USM lens, f/13 for 0.6 second, ISO 400

PAGE 140: Green sea turtle hatchling (Chelonia mydas), Mnemba Island, Tanzania
Hatchlings emerge at night to avoid predators. Theirs is a birth fraught with danger from birds and other predators.
Canon EOS-1D X, EF24-70mm f/4L IS USM lens, f/22 for 1/160 second, ISO 4000

PAGE 141: Green sea turtle hatchlings (Chelonia mydas), Mnemba Island, Tanzania
Canon EOS-1D X, EF24-70mm f/4L IS USM lens, f/18 for 1/200 second, ISO 4000

PAGES 142-143: Fishermen, Inle Lake, Shan, Myanmar
Here people practice a unique style of fishing, gently lowering thimble-shaped nets in a very shallow lake over fish hiding in the water grasses; they then rap their oar against the net, disturbing the fish and causing them to swim into the net.
Canon EOS-1D X, EF16-35mm f/2.8L II USM lens, f/6.3 for 1/125 second, ISO 1250

PAGE 144: Evening fire, Pushkar Fair, Rajasthan, India
As the sun disappears, temperatures in the desert plunge. This is time to connect with friends, and they will stay up all night talking. I photographed this approximately forty minutes after sunset, when the ambient light in the sky was the same degree as the firelight reflected on the men's white clothes.
Canon EOS-1Ds, EF17-40 mm f/4 lens, f/5.6 for 0.6 second, ISO 200

PAGE 145: Meghwal women gathered around a fire, Gujarat, India
Canon EOS-1D X, EF24-105mm f/4L IS USM lens, f/4 for 1/20 second, ISO 4000

PAGES 146-147: Kolkata, West Bengal, India
Diaphanous fabric offers a semblance of privacy for an exhausted day laborer.
Canon EOS-1Ds, EF70-200mm f/2.8 lens, f/16 for 1/5 second, ISO 200

PAGE 148: Goa, India
Sometimes less is more, especially in composition. The sun sets behind two ponytailed girls. You can imagine the brightness of their smiles!
Canon EOS-1Ds, EF70-200mm f/2.8 lens, f/5 for 1/320 second, ISO 400

PAGE 149: Evening offerings, Varanasi, Uttar Pradesh, India
The Hindu faith has many colorful, often flamboyant traditions, rituals, and ceremonies. Perhaps one of the more subdued traditions is that of setting diyas adrift on the sacred waters of the Ganges. These small votives comprising cups made of dried leaves, marigold flower petals, and a lit candle, are gently placed upon the river's surface at sundown.
Canon EOS-3, EF17-35mm f/2.8L lens, f/5.6 for 1/2 second, Fujichrome Velvia film

PAGES 150-151: Portrait of a young man in candlelight, Jaisalmer, Rajasthan, India
Canon EOS-1Ds Mark II, EF24-70mm f/2.8 lens, f/2.8 for 1/10 second, ISO 400

PAGE 152: Entertainers at the Kumbh Mela, Allahabad, Uttar Pradesh, India
During the Kumbh Mela mahouts parade on painted elephants.
Canon EOS 5D Mark III, EF15mm f/2.8 Fisheye lens, f/4 for 1/40 second, ISO 2500

PAGE 153: Entertainers at the Kumbh Mela, Allahabad, Uttar Pradesh, India
Horsemen and mahouts gather on their charges at the Kumbh Mela.
Canon EOS 5D Mark III, EF15mm f/2.8 fish-eye lens, f/4.5 for 1/60 second, ISO 2500

PAGE 154: Saffron-robed pilgrims worship around a warming fire, Kumbh Mela, Haridwar, Uttarakhand, India
Canon EOS-1D X, EF24-70mm f/4L IS USM lens, f/4 for 1/20 second, ISO 8000

PAGE 155: A river of movement parts around a solitary figure in Bundi, Rajasthan, India
Canon EOS-1Ds, EF70-200mm f/2.8 lens, f/32 for 3.2 seconds, ISO 125

PAGE 156: Ganga aarti, Varanasi, Uttar Pradesh, India
Canon EOS-1D X Mark II, EF100-400mm f/4.5-5.6L IS II USM lens, f/9 for 1/160 second, ISO 4000

PAGE 157 TOP: Ganga aarti, a ritual prayer to the Ganges River, on the sacred ghat of Har Ki Pauri, Haridwar, Uttarakhand, India
Canon EOS 5D Mark II, EF70-200mm f/4L IS USM lens, f/4 for 1/25 second, ISO 400

PAGE 157 BOTTOM: Ganga aarti, a ritual prayer to the Ganges River, on the sacred ghat of Har Ki Pauri, Haridwar, Uttarakhand, India
Canon EOS 5D Mark II, EF70-200mm f/4L IS USM lens, f/4 for 1/40 second, ISO 400

PAGES 158-159: Dancers at a Buddhist festival, Paro, Bhutan
Deer dancers wear traditional costumes for New Year's celebrations.
Canon EOS 5D Mark II, EF16-35mm f/2.8L II USM lens, f/14 for 1/250 second, ISO 400

PAGE 160: Kurjey Lhakhang Monastery, Bumthang Valley, Bhutan
One of my most memorable experiences was witnessing the amazing focus and dedication of the two hundred or so young monks as I quietly moved among them. Drums and long deep-toned horns accompanied the chanting, adding to the sense of mystery.
Canon EOS 5D Mark II, EF14mm f/2.8L II USM lens, f/5.6 for 2.5 seconds, ISO 800

PAGE 161: Shadow puppets, Bali, Indonesia
Canon EOS-1Ds Mark II, EF24-70mm f/2.8 lens, f/8 for 1/3 second, ISO 400

PAGES 162-163: Kecak, Bali, Indonesia
Based on the epic Ramayana, the kecak is a relatively recent phenomenon. Here a dancer portrays the burning of the monkey god Hanuman.
Canon EOS-1D X, EF70-200mm f/4L USM lens, f/5.6 for 1/250 second, ISO 6400

PAGE 164 TOP: Samburu herdsmen, Mpala, Nanyuki, Kenya
Canon EOS-1N, EF70-200mm lens, f/11 for 1/60 second, Fujichrome Velvia film

PAGE 164 BOTTOM: Karo tribesmen, South Omo, Ethiopia
Canon EOS-1Ds Mark III, EF16-35mm f/2.8L II USM lens, f/20 for 1/400 second, ISO 125

PAGE 165: San tribesmen at sunset, Makgadikgadi Pans National Park, Ngamiland, Botswana
Canon EOS 5DS R, EF100-400mm f/4.5-5.6L IS II USM lens, f/11 for 1/160 second, ISO 400

PAGES 166-167: Milky Way and San tribesmen, Makgadikgadi Pans National Park, Ngamiland, Botswana
Canon EOS-1D X Mark II, 20mm f/1.4 DG HSM | Art 015 lens, f/3.2 for 20 seconds, ISO 4000

PAGE 168: Aboriginal dancers, Northern Territory, Australia
For *Art Wolfe's Travels to the Edge*, I had the privilege of photographing Aboriginal men performing an ancient dance at dusk. A permit is required to travel in this region of Arnhem Land, an Aboriginal center.
Canon EOS-1Ds Mark II, EF16-35mm f/2.8L II USM lens, f/3.5 for 1/100 second, ISO 400

PAGE 169: Aboriginal dancer, Northern Territory, Australia
Canon EOS-1Ds Mark II, EF16-35mm f/2.8L II USM lens, f/10 for 1/30 second, ISO 400

PAGE 170: Djellaba-clad figure in one of the many arcades of the old Medina in Fez, Fez-Meknes, Morocco
Canon EOS-1Ds, 24.0-70.0 mm f/2.8 lens, f/8 for 1.6 seconds, ISO 200

PAGE 171: Marketplace in the old Medina of Fez, Fez-Meknes Morocco
Canon EOS-1Ds, EF70-200mm f/2.8 lens, f/11 for 1/2 second, ISO 200

PAGE 172: Saidai-ji Eyo Hadaka Matsuri, Okoyama, Honshu, Japan
The Naked Festival, held on a winter evening, features five thousand men in loincloths vying for a symbolic baton, which is tossed into the inebriated throng. Whoever ultimately possesses the baton receives good luck for the year. The scrum becomes tumultuous when one man catches the baton because anyone who touches him acquires the good luck as well.
Canon EOS-1Ds Mark II, EF70-200mm f/2.8 lens, f/5.6 for 1/25 second, ISO 400

PAGE 173: Oto Matsuri, Wakayama, Honshu, Japan
The Oto Matsuri is a purification ceremony involving both water and fire and has been taking place for 1400 years at the Kamikura Shinto shrine.
Canon EOS-1D X Mark II, EF100-400mm f/4.5-5.6L IS II USM lens, f/7.1 for 1/40 second, ISO 1000

PAGES 174-175: Day of the Dead, Pátzcuaro, Michoacán, Mexico
Día de Muertos is celebrated very intensely in the towns and villages around Lake Pátzcuaro. Preparations include major cleaning and repair of the local cemeteries and the creation of flowered arches for gates of the atriums of local churches.
Canon EOS 5D Mark II, EF24-105mm f/4L IS USM lens, f/7.1 for 0.8 second, ISO 800

PAGE 176: A clay pot simmers on a small barbeque, Yangon, Myanmar
Canon EOS-1Ds Mark III, EF70-200mm f/4L IS USM lens, f/7.1 for 1/5 second, ISO 400

PAGE 177 TOP: Mahagandayon Monastery, Mandalay, Myanmar
Young Buddhist novices meditate in the predawn hours.
Canon EOS-1Ds Mark III, EF24-70mm f/2.8L USM lens, f/7.1 for 0.3 second, ISO 800

PAGE 177 BOTTOM: Monks at mealtime, Mandalay, Myanmar
Canon EOS 5D Mark II, EF70-200mm f/4L IS USM lens, f/32 for 5 seconds, ISO 800

PAGE 178: Candles symbolizing the enlightenment of the Buddha burn at a temple, Yangon, Myanmar
Canon EOS 5D Mark III, EF24-105mm f/4L IS USM lens, f/4 for 1/800 second, ISO 400

PAGE 179: Cultural performance for visitors on the Li River, Yangshuo, Guangxi, China
Canon EOS-1Ds Mark III, EF24-105mm f/4L IS USM lens, f/4 for 1/30 second, ISO 800

PAGES 180-181: Fishermen casts nets on the Irrawaddy River, Mandalay, Myanmar
Canon EOS-1D X Mark II, EF24-70mm f/4L IS USM lens, f/5.6 for 1/800 second, ISO 4000

PAGE 182: Buddhists at prayer, Mandalay, Myanmar
Canon EOS 5D Mark II, EF15mm f/2.8 Fisheye lens, f/4 for 1/50 second, ISO 800

PAGE 183: Night market, Yangon, Myanmar
Canon EOS-1D X Mark II, EF24-70mm f/4L IS USM lens, f/4 for 1/60 second, ISO 8000

PAGES 184-185: Bagan, Mandalay, Myanmar
In the dusty dusk, shepherds drive their goats and cattle home. One of thousands of ancient pagodas in the area rises from the trees beyond.
Canon EOS 5D Mark III, EF70-200mm f/2.8L IS II USM +1.4x lens, f/10 for 1/250 second, ISO 100

PAGE 186 TOP: Cowboys, Fazenda Rio Negro, Pantanal, Mato Grosso, Brazil.
Canon EOS-1Ds Mark II, 70-200mm f/2.8 +1.4x lens, f/11 for 1/2500 second, ISO 400

PAGE 186 BOTTOM: Bahia, Brazil
Regally bred Lusitano horses and their riders gambol in the waves.
Canon EOS-1Ds Mark II, EF70-200mm f/2.8 lens, f/2.8 for 1/100 second, ISO 400

PAGE 187 TOP: Surfers, Cannon Beach, Oregon, USA
Canon EOS 5D Mark II, EF70-200mm f/2.8L IS USM +1.4x lens, f/9 for 1/40 second, ISO 100

PAGE 187 BOTTOM: Sailboats off Golden Gardens Park, Seattle, Washington, USA
Canon EOS-1Ds, focal length 190, f/8 for 1/80 second, ISO 100

PAGES 188-189: Stilt fishermen, Southern Province, Sri Lanka
Canon EOS 5D Mark III, EF24-105mm f/4L IS USM lens, f/9 for 1/200 second, ISO 500

PAGE 190: Asaro mudmen, Eastern Highlands Province, Papua New Guinea
Canon EOS-1D X, EF14mm f/2.8L II USM lens, f/2.8 for 1/25 second, ISO 4000

PAGE 191: Asaro mudmen gather around a fire, Eastern Highlands Province, Papua New Guinea
Canon EOS-1D X, EF14mm f/2.8L II USM lens, f/4.5 for 1/50 second, ISO 4000

PAGE 192: Fire performer, Burning Man, Nevada, USA
Canon EOS-1Ds, 70-200mm f/2.8 lens, f/10 for 3.2 seconds, ISO 200

PAGE 193: Lamplighters, Burning Man, Nevada, USA
Canon EOS-1Ds, 70-200mm f/2.8 lens, f/7.1 for 1/20 second, ISO 1250

PAGES 194-195: Shanti Stupa, Leh, Ladakh, India
Built on a mountain ledge with spectacular views, the Shanti Stupa is situated at a breathtaking 13,999-foot elevation. Enshrined in its base are relics of the Buddha. It is a Peace Pagoda, built by the Japanese and Ladakh Buddhists to promote world peace and commemorate 2500 years of Buddhism.
Canon EOS-1D X, EF70-200mm f/4L USM lens, f/11 for 2.5 seconds, ISO 200

PAGE 196: The famous Victorian homes, the Painted Ladies, Alamo Square, San Francisco, California, USA
Canon EOS-1D X Mark II, EF24-70mm f/4L IS USM lens, f/14 for 5 seconds, ISO 1000

PAGE 197: Eastern span of the San Francisco-Oakland Bay Bridge, California, USA
Canon EOS-1D X Mark II, EF24-70mm f/4L IS USM lens, f/7.1 for 1/2 second, ISO 800

PAGES 198-199: Golden Gate Bridge photographed from Marin County headlands looking south to San Francisco, California, USA
Canon EOS-1D X Mark II, EF24-70mm f/4L IS USM lens, f/14 for 8 seconds, ISO 1000

PAGE 200: Mauna Kea Observatories (MKO), Hawaii, USA
Canon EOS-1D X Mark II, EF11-24mm f/4L USM lens, f/4 for 30 seconds, ISO 4000

PAGE 201: Mauna Kea Observatories (MKO), Hawaii, USA
Canon EOS-1D X Mark II, EF24-70mm f/4L IS USM lens, f/4.5 for 1/500 second, ISO 2000

PAGES 202-203: Mauna Kea Observatories (MKO), Hawaii, USA
Canon EOS-1D X Mark II, EF11-24mm f/4L USM lens, f/4 for 30 seconds, ISO 3200

PAGE 204: Reine, Lofoten, Nordland, Norway
Canon EOS-1D X Mark II, EF100-400mm f/4.5-5.6L IS II USM lens, f/14 for 1/60 second, ISO 3200

PAGE 205: Peggy's Cove, Nova Scotia, Canada
Film capture

PAGES 206-207: Oxcarts, Bagan, Mandalay, Myanmar
Oxcarts are a chief form of local transport, towing tourists and locals alike.
Canon EOS 5D Mark II, EF70-200mm f/4L IS USM +1.4x lens, f/14 for 1/100 second, ISO 400

PAGE 208: Shwedagon Pagoda, Yangon, Myanmar
Canon EOS-1Ds Mark III, EF70-200mm f/4L IS USM lens, f/10 for 10 seconds, ISO 100

PAGE 209: Votives, Bouddhanath Stupa, Kathmandu, Nepal
Film capture

PAGE 210: Grand Mosque of Djenné, Mopti, Mali
The Great Mosque is the largest mud brick or adobe building in the world and is one of the most famous landmarks in Africa.
Canon EOS-1Ds Mark II, EF16-35mm f/2.8L USM lens, f/2.8 for 46 seconds, ISO 400

PAGE 211: Light beckons from the window of a traditional fisherman's cottage in Arniston, Western Cape, South Africa
Canon EOS 5D Mark II, EF24-105mm f/4L IS USM lens, f/10 for 25 seconds, ISO 125

PAGES 212-213: Oia, Santorini, Southern Aegean, Greece
Canon EOS 5D Mark III, EF24-105mm f/4L IS USM lens, f/22 for 1/6 second, ISO 100

PAGE 214 TOP: Windmills, Chora, Mykonos, Southern Aegean, Greece
Canon EOS 5D Mark III, EF24-105mm f/4L IS USM lens, f/11 for 1/200 second, ISO 2500

PAGE 214 BOTTOM: Orthodox church, Mykonos, Southern Aegean, Greece
Canon EOS 5D Mark III, EF17-40mm f/4L USM lens, f/11 for 1/8 second, ISO 200

PAGE 215 TOP: Oia, Santorini, Southern Aegean, Greece
Canon EOS 5D Mark III, EF24-105mm f/4L IS USM lens, f/10 for 15 seconds, ISO 1000

PAGE 215 BOTTOM: Belltowers, Oia, Santorini, Southern Aegean, Greece
Canon EOS 5D Mark III, EF24-105mm f/4L IS USM lens, f/8 for 15 seconds, ISO 1000

PAGES 216-217: Bajau seaborne settlement, Semporna, Sabah, Malaysia
Sometimes called sea gypsies, the Bajau have little allegiance to any country. They distrust Malaysia, the Philippines, and Indonesia. They live in boats and small stilted homes. They are fishermen and speak their own language.
Canon EOS 5D Mark III, EF70-200mm f/4L USM lens, f/14 for 1/6 second, ISO 100

PAGE 218: Basilica San Marco, Venice, Veneto, Italy
Film capture

PAGE 219: The medieval Ponte Vecchio spans the Arno River, Florence, Tuscany, Italy
Canon EOS-1Ds Mark II, EF70-200mm f/4 lens + 1.4x, f/14 for 1.6 seconds, ISO 100

PAGES 220-221: Gondolas, Venice, Veneto, Italy
Canon EOS-1Ds Mark II, EF70-200mm f/4 lens, f/5.6 for 1/25 second, ISO 400

PAGE 222: Sydney Opera House, Sydney, New South Wales, Australia
Canon EOS 5D Mark II, EF24-105mm f/4L IS USM lens, f/7.1 for 1/160 second, ISO 100

PAGE 223: Heceta Head lighthouse, Oregon, USA
Canon EOS 5DS R, EF100-400mm f/4.5-5.6L IS II USM lens, f/5 for 1/200 second, ISO 800

PAGES 224-225: Crescent moon and Woolworth Building, New York City, New York, USA
Canon EOS-1Ds Mark II, 70-200mm f/2.8 +2x lens, f/5.6 for 0.8 second, ISO 800

PAGES 226-227: Shinjuku, Tokyo, Honshu, Japan
Population density in Shinjuku, which was rebuilt after being 90 percent destroyed in World War II, is over 18,500 people per square kilometer.
Canon EOs-1DS, EF17-40 mm f/4 lens, f/13 for 20 seconds, ISO 50

PAGE 228: The Lujiazui Traffic Circle, Shanghai, East China, China
Canon EOS 5D Mark II, EF24-105mm f/4L IS USM lens, f/7.1 for 1/2 second, ISO 400

PAGE 229: Teeming streets of Hanoi, Hong River Delta, Vietnam
Canon EOS 5D Mark II, EF70-200mm f/4L USM lens, f/18 for 1/3 second, ISO 100

PAGE 230: Shinjuku freeway, Tokyo, Honshu, Japan.
Canon EOS-1Ds, EF70-200mm f/2.8 lens, f/13 for 25 seconds, ISO 50

PAGE 231: Shinjuku, Tokyo, Honshu, Japan
The Japanese work some of the longest hours in the world as evidenced by this well-lit office building.
Canon EOS-1Ds, EF500mm f/4 lens, f/6.3 for 0.6 second, ISO 50

PAGES 232-233: View of Manhattan down Sixth Avenue with Empire State Building on right, New York City, New York, USA
Canon EOS-1D X Mark II, EF24-70mm f/4L IS USM lens, f/4 for 1/125 second, ISO 8000

PAGE 234: Ginza, Tokyo, Honshu, Japan
Canon EOS-1Ds, EF70-200mm f/2.8 lens, f/20 for 4 seconds, ISO 50

PAGE 235: Tokyo Metro, Tokyo, Honshu, Japan
Daily and nightly, over eight million passengers ride the metro.
Canon EOS-1Ds, EF70-200mm f/2.8 lens, f/10 for 0.8 second, ISO 200

PAGE 236: Statue of Liberty, Liberty Island, New York City, New York, USA
Canon EOS-1D X Mark II, EF24-70mm f/4L IS USM lens, f/4 for 1/320 second, ISO 5000

PAGE 237 TOP: Times Square, New York City, New York, USA
Canon EOS-1D X Mark II, 20mm F1.4 DG HSM | Art 015 lens, f/7.1 for 1/500 second, ISO 2000

PAGE 237 BOTTOM: Pigeons (Columba livia) silhouetted against neon lights, New York City, New York, USA
Canon EOS-1Ds Mark II, 70-200mm f/2.8 +1/4x lens, f/4 for 1/1000 second, ISO 800

PAGE 238: Dubai cityscape, United Arab Emirates
Canon EOS 5D Mark IV, EF24-70mm f/4L IS USM lens, f/6.3 for 30 seconds, ISO 100

PAGE 239: British Columbia Day fireworks, Vancouver, British Columbia, Canada
Canon EOS-1Ds, 70-200mm f/2.8 +2x lens, f/10 for 15 seconds, ISO 400

PAGES 240-241: Seattle skyline with Space Needle and Mount Rainier, Washington, USA
Canon EOS 5D Mark IV, EF100-400mm f/4.5-5.6L IS II USM lens, f/10 for 15 seconds, ISO 100

PAGE 242: Champs d'Elysées and Arc de Triomphe, Paris, Île de France, France
Canon EOS-1Ds Mark II, EF70-200mm f/4 lens + 1.4x, f/16 for 4 seconds, ISO 125

PAGE 243: The Maritime Fountain and Eiffel Tower, Paris, Île de France, France
Canon EOS-1Ds Mark II, EF70-200mm f/4 lens + 1.4x, f/16 for 4 seconds, ISO 400

PAGE 244: Paseo de la Princessa, Old San Juan Historic District, Puerto Rico
Canon EOS-1Ds Mark II, 70-200mm f/2.8 +2x lens, f/5.6 for 1/500 second, ISO 400

PAGE 245: Raices Fountain, Old San Juan Historic District, Puerto Rico
Canon EOS-1Ds Mark II, EF24-70mm lens, f/5.6 for 1/10 second, ISO 640

PAGE 251: Stars shine bright over the lakes and mountains of the Altiplano, Potosi, Bolivia
Canon EOS-1Ds Mark II, EF16mm lens, f/2.8 for 45 seconds, ISO 800

PAGES 252-253: Owachomo Bridge, Natural Bridges National Monument, Utah, USA
Natural Bridges was the first designated International Dark Sky Park in 2007.
Canon EOS 5D Mark IV, EF16-35mm f/4L IS USM lens, f/4 for 20 seconds, ISO 6400

PAGE 254: On the summit of Mount Nyiragongo, Virunga National Park, North Kivu, Democratic Republic of Congo
Canon EOS 5DS R, EF24-70mm f/4L IS USM lens, f/9 for 2 seconds, ISO 400

PAGE 255: Moon over Puget Sound, Washington, USA
Canon EOS 5D Mark IV, EF100-400mm f/4.5-5.6L IS II USM lens, f/5.6 for 1/125 second, ISO 1000

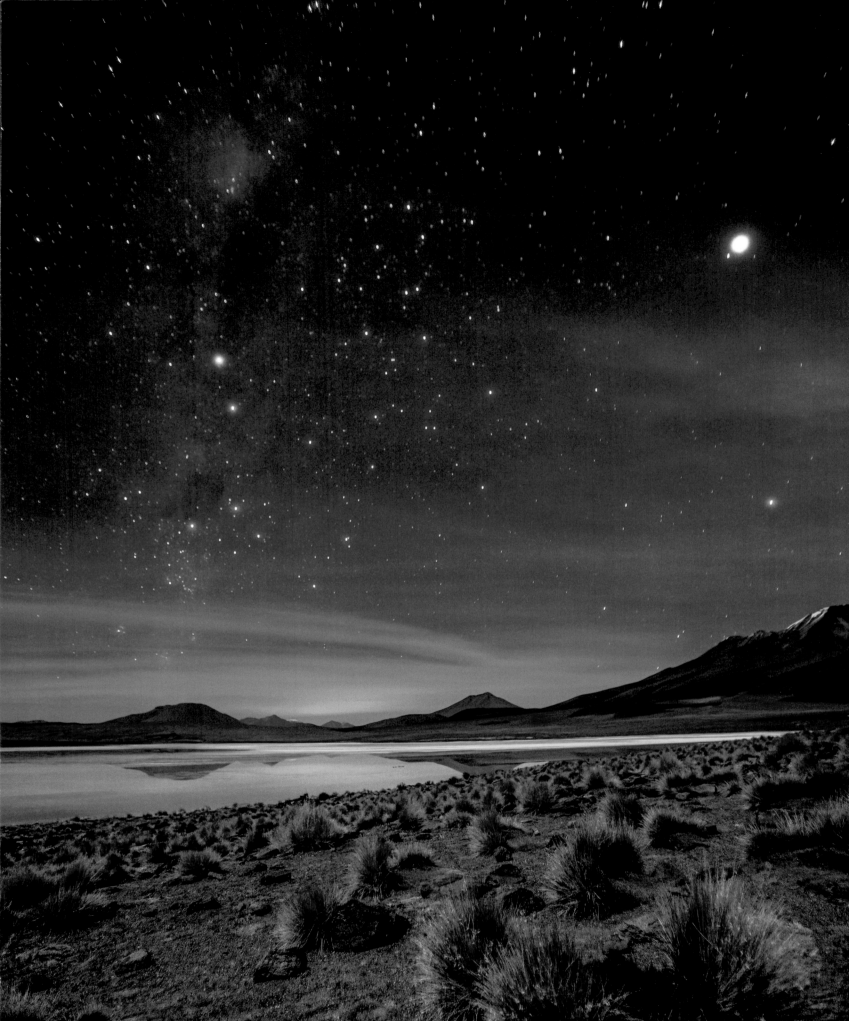

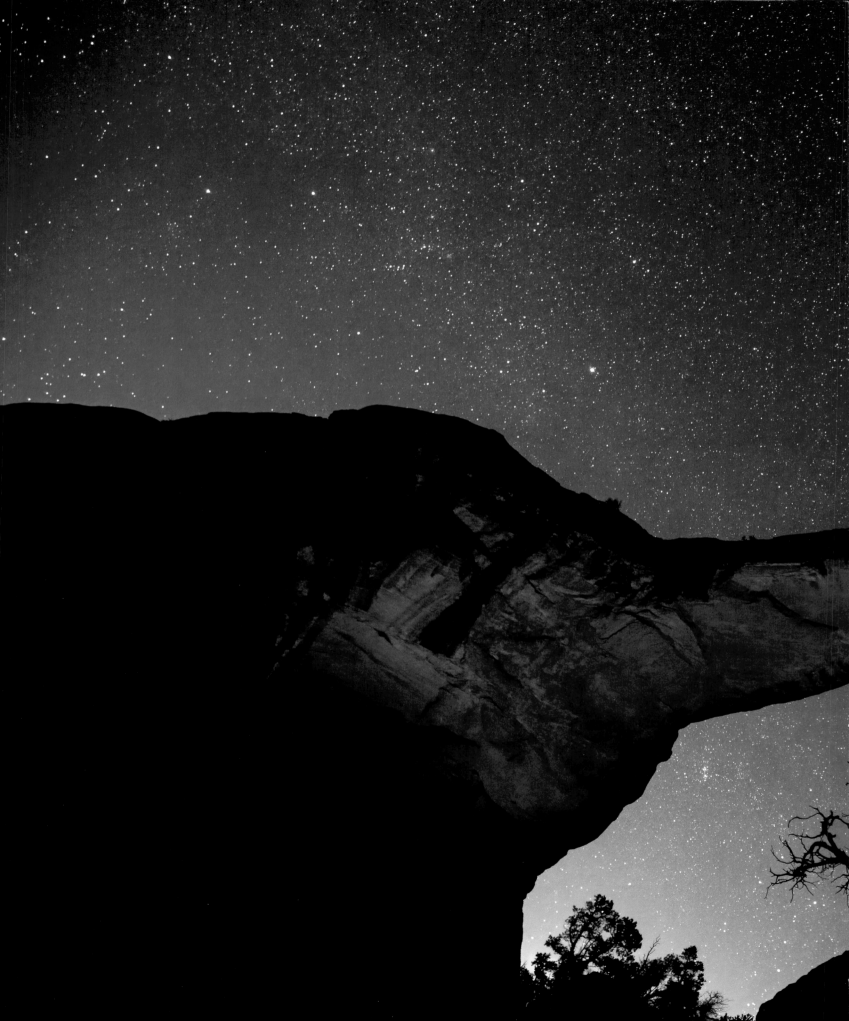

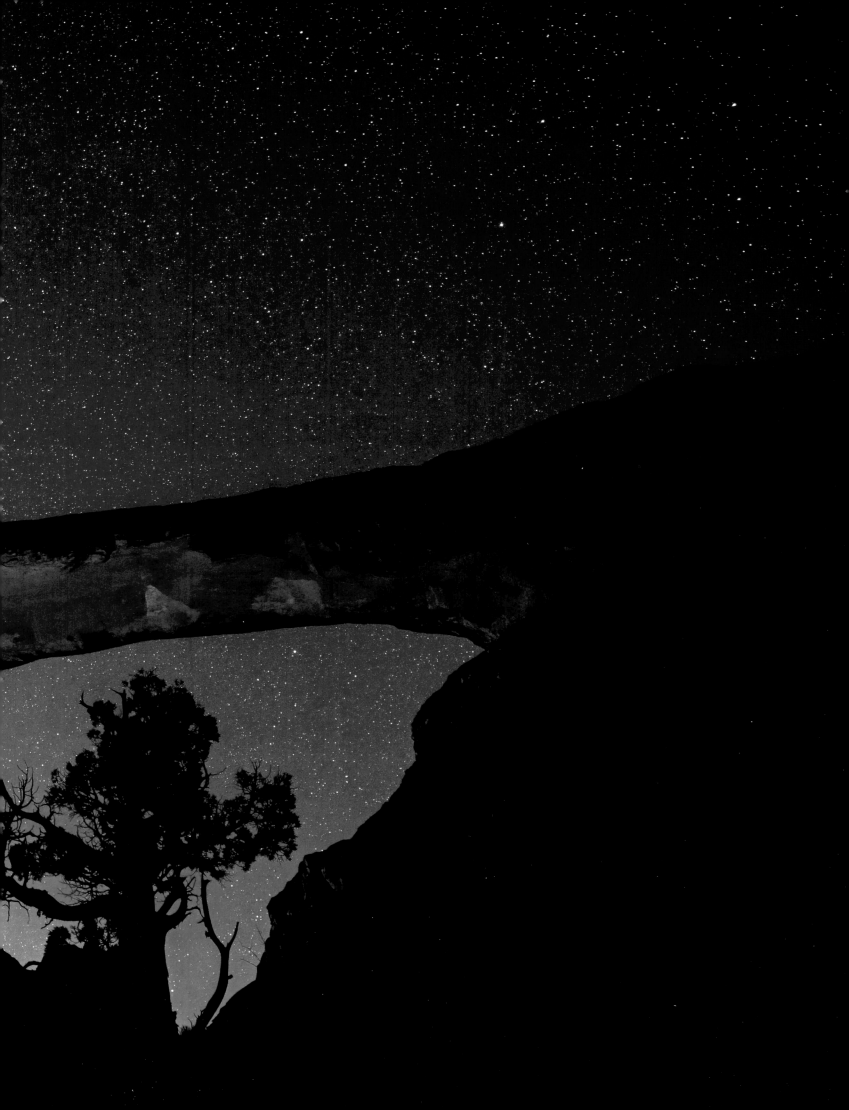

ACKNOWLEDGMENTS

THE TRAVEL DESTINATIONS I GO TO ARE NOT FOR EVERYONE. Planning and researching gets me there but so much is unpredictable. Each destination brings a combination of conditions including adventure, challenge, wonder, frustration, and almost always unbelievably amazing moments. It is meaningful to me when I'm able to share these experiences. It heightens the amazing and diminishes the frustrations. *Night on Earth* is dedicated to two fellow explorers, Ken Carroll and Kevin Coghlin—thank you for sharing some of the best memories in this book.

I also want to acknowledge the hard work of my staff, who allow me the luxury of the freedom to create: Deirdre Skillman, Kyle Jones, Christine Eckhoff, Libby Pfeiffer, and Caroline Alexander; special thanks to my agent Peter Beren, and Raoul Goff and the team at Earth Aware.

PAGE 251: Stars shine bright over the lakes and mountains of the Altiplano, Potosi, Bolivia
PREVIOUS PAGES: Owachomo Bridge, Natural Bridges National Monument, Utah, USA
ABOVE: On the summit of Mount Nyiragongo, Virunga National Park,
North Kivu, Democratic Republic of Congo
OPPOSITE: Moon over Puget Sound, Washington, USA

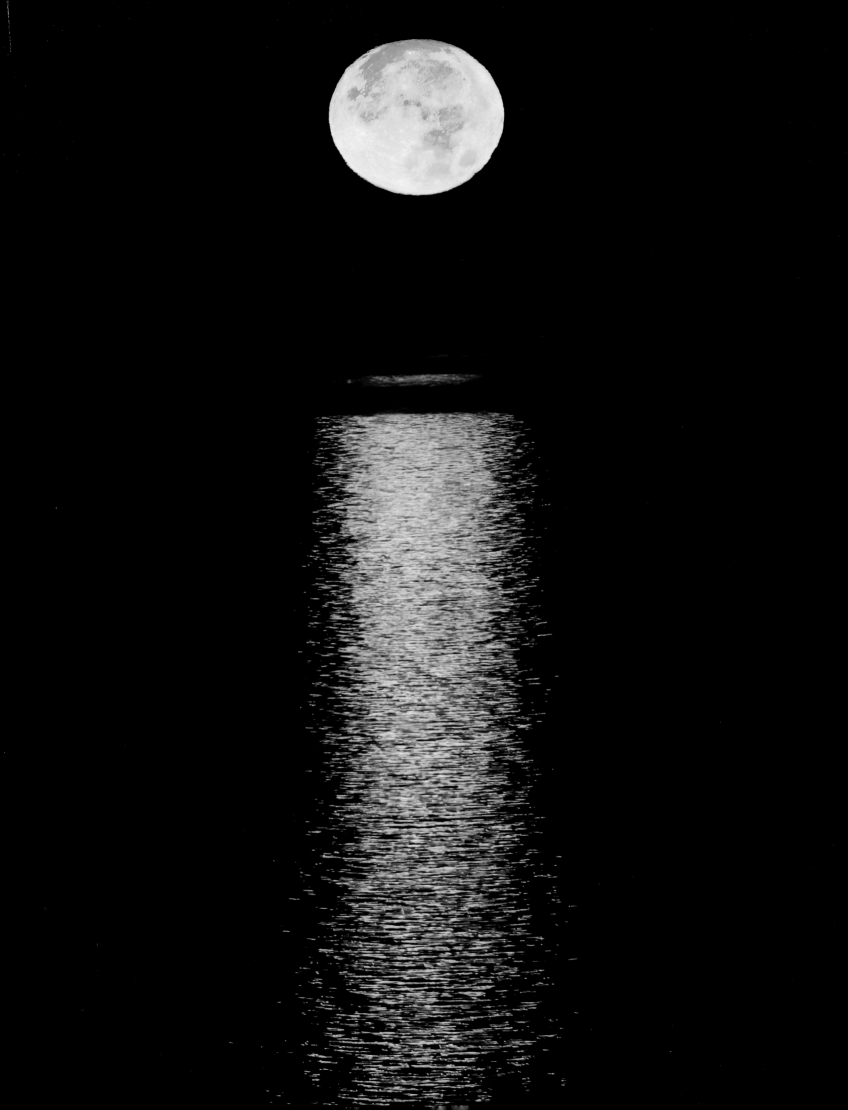

EARTH AWARE

An Imprint of MandalaEarth
PO Box 3088
San Rafael, CA 94912
www.MandalaEarth.com

Find us on Facebook: www.facebook.com/MandalaEarth
Follow us on Twitter: @MandalaEarth

Library of Congress Cataloging-in-Publication Data available.

ISBN: 978-1-68383-925-5

Publisher: Raoul Goff
Associate Publisher: Phillip Jones
VP of Creative: Chrissy Kwasnik
VP of Manufacturing: Alix Nicholaeff
Editorial Director: Katie Killebrew
Designer: Lola Villanueva
Editor: Matt Wise
Editorial Assistant: Sophia Wright
Production Manager: Greg Steffen
Senior Production Manager, Subsidiary Rights: Lina S Palma

ROOTS of PEACE 🌳 REPLANTED PAPER

Mandala Publishing, in association with Roots of Peace, will plant two trees for each tree used in the manufacturing of this book. Roots of Peace is an internationally renowned humanitarian organization dedicated to eradicating land mines worldwide and converting war-torn lands into productive farms and wildlife habitats. Roots of Peace will plant two million fruit and nut trees in Afghanistan and provide farmers there with the skills and support necessary for sustainable land use.

Manufactured in China by Insight Editions

10 9 8 7 6 5 4 3 2 1